# William Morris

## (1834–1896)

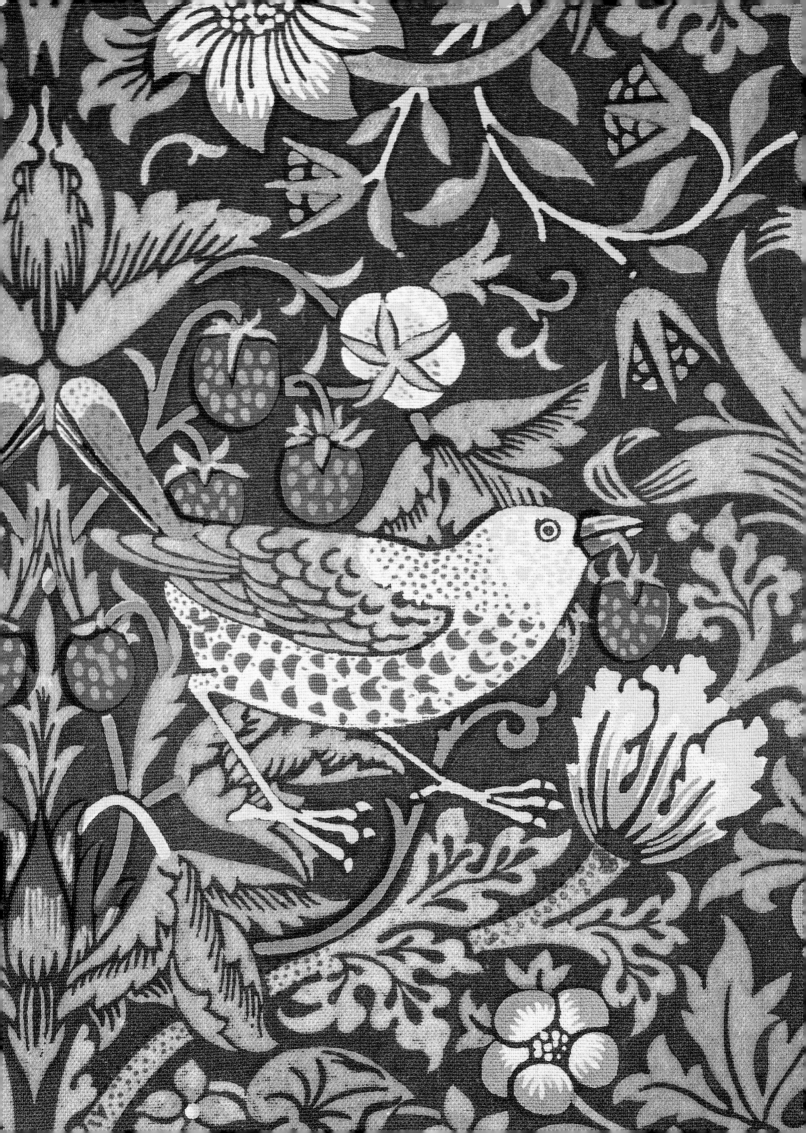

CHARLOTTE & PETER FIELL

# WILLIAM MORRIS
## (1834–1896)

**TASCHEN**

KÖLN LONDON MADRID NEW YORK PARIS TOKYO

ENDPAPER / VORSATZPAPIER / PAGES DE GARDE:
**William Morris:**
*Marigold* printed textile, registered 1875
Bedruckter Stoff *Ringelblume*, registriert 1875
Tissu imprimé *Souci*, enregistré en 1875

PAGE 2 / SEITE 2:
**William Morris:**
*Strawberry Thief* printed textile, registered 1883
Bedruckter Stoff *Erdbeerdieb*, registriert 1883
Tissu imprimé *Voleur de fraises*, enregistré en 1883

Edited by Susanne Husemann, Cologne
Cover design: Angelika Taschen, Claudia Frey, Cologne
Map design: Valeska Gimm, Rösrath/Forsbach
German translation by Antje Pehnt, Cologne
French translation by Joëlle Ribas, Munich

Printed in Italy
ISBN 3-8228-6617-2

# Contents / Inhalt / Sommaire

# WILLIAM MORRIS (1834–1896)

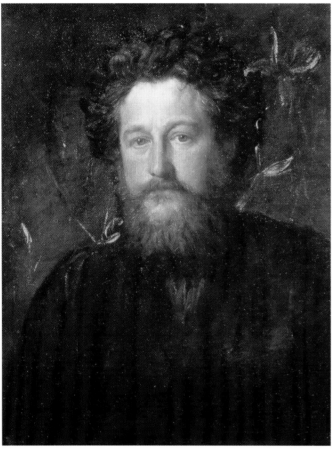

**George Frederic Watts:**
*William Morris, 1870*

William Morris was a revolutionary whose life and work were shaped by a dream of a medieval Arcadia and ultimately a vision of a fraternal Utopia. These illusory worlds that looked to the past and to the future provided him with, on the one hand, a means of escape from the age in which he lived and on the other, the inspiration to change it. Driven by his "hatred of modern civilization"[1], Morris sought to reform both art and society by demonstrating through practice a better and more ethical way of doing things.

In his own lifetime, Morris was most highly noted for his poetry and prose. Today, however, he is primarily remembered for the many designs he executed for stained glass, textiles, wallpapers, furniture and tiles that were manufactured and retailed by Morris & Co., a co-operative firm he established in 1861. Morris is also commemorated as a visionary political activist who, through educating, agitating and organizing the Socialists in his crusade for "Liberty, Equality and Fraternity", laid some of the foundations of the British Labour Movement.

Morris's activities must be seen within the context of the spirit of reform that permeated the latter half of the 19th century in a reaction to the unprecedented transformation taking place in the structure of Victorian society. The success of Britain's manufacturing industries and the exploitation of its extensive Empire had brought a prosperity which fuelled both the rise of the professional middle classes and the urbanization of the working classes. Although appearing superficially stable, at its core Victorian society was thus now deeply divided by class and economic inequality. Industrialization had polluted cities and destroyed social cohesion through the displacement of workers, while the division of labour turned skilled workers into an unskilled workforce that was becoming increasingly disconnected not only from the object of its labours but also from society in general.

The frantic commercial competition underpinning Britain's free market economy led many manufacturers to produce even more fanciful luxuries and gimmicks in order to rival their competitors. To this end, superfluous ornament was increasingly used to disguise the poor quality manufacture of products while workers became enslaved to the machines that produced them. Early design reformers such as Augustus Pugin (1812–1852), John Ruskin (1819–1900) and Owen Jones (1809–1874) recognized that the prevailing High Victorian style was the result of a society corrupted by greed, decadence and oppression and strove to change the status quo through a reform in art.

The repressive, conservative and often hypocritical values of the Victorian Age also gave rise to an artistic and idealistic rebellion in the mid-1840s, led by the painters Dante Gabriel Rossetti (1828–1882), William Holman Hunt (1827–1910) and John Everett

William Morris war ein Revolutionär, dessen Leben und Werk durch den Traum von einem mittelalterlichen Arkadien und später durch die Vision eines brüderlichen Utopia geprägt war. Diese Phantasiewelten, die sich auf Vergangenheit und Zukunft bezogen, verhalfen ihm einerseits zur Flucht aus der Zeit, in der er lebte, und lieferten ihm andererseits die Inspiration, sie zu ändern. Von seinem „Haß auf die moderne Zivilisation"[1] angetrieben, suchte Morris die Kunst und die Gesellschaft zu reformieren, indem er durch praktisches Handeln demonstrierte, wie die Dinge besser und ethischer gestaltet werden konnten.

Zu Lebzeiten fand Morris für seine Poesie und Prosa die größte Beachtung. Heute dagegen erinnert man sich in erster Linie an seine zahlreichen Entwürfe für Glasfenster, Textilien, Tapeten, Möbel und Fliesen, die von Morris & Co. hergestellt und vertrieben wurden, einem genossenschaftlichen Unternehmen, das er 1861 gründete. Morris ist auch als visionärer politischer Aktivist in Erinnerung geblieben, der mit seinem Kreuzzug für „Freiheit, Gleichheit und Brüderlichkeit" die Sozialisten beflügelte, zu ihrer Organisation und damit zur Begründung der britischen Labour-Bewegung beitrug.

Morris' Aktivitäten müssen im Zusammenhang mit den Reformbestrebungen gesehen werden, die sich in der zweiten Hälfte des 19. Jahrhunderts als Reaktion auf die tiefgreifenden Veränderungen in der viktorianischen Gesellschaft ausbreiteten. Der Aufschwung der britischen Industrie und die Einkünfte aus den ausgedehnten Kolonien des Weltreichs hatten zu einer Prosperität geführt, die sowohl den Aufstieg der Mittelschichten als auch die Urbanisierung der Arbeiterklasse vorantrieb. Obwohl die viktorianische Gesellschaft auf den ersten Blick stabil erschien, war sie im Kern nun deutlich durch Klassenunterschiede und ökonomische Ungleichheit gespalten. Die Industrialisierung hatte die Städte verrußt und verschmutzt und durch den Zustrom von Arbeitern den sozialen Zusammenhalt zerstört. Zugleich machte die Arbeitsteilung die ausgebildeten Werktätigen zu einer Armee von Hilfskräften, die immer weniger mit dem Produkt ihrer Arbeit und letztlich auch mit der Gesellschaft im allgemeinen verbunden waren.

Der ungebremste Wettbewerb in Großbritanniens freier Marktwirtschaft trieb viele Fabrikanten dazu, immer mehr Luxusgüter und Nippsachen herzustellen, um mit ihren Konkurrenten Schritt zu halten. Überflüssiges Dekor täuschte über die armselige Qualität der Produkte hinweg, und die Arbeiter wurden zu Sklaven der Maschinen, die sie bedienten. Frühe Reformer wie Augustus Pugin (1812–1852), John Ruskin (1819–1900) und Owen Jones (1809–1874) erkannten, daß der vorherrschende populäre Stil mit seinem historisierenden, überladenen Formvokabular den Geschmack einer Gesellschaft spiegelte, die durch Gier, Dekadenz und Un-

William Morris était un esprit révolutionnaire dont la vie et l'œuvre furent tout entières déterminées par le rêve d'une Arcadie médiévale et par la vision d'une utopie fraternelle. Ce sont ces mondes illusoires, tournés à la fois vers le passé et l'avenir, qui lui permirent de fuir son époque tout en lui inspirant des idées pour la changer. Guidé par sa « haine de la civilisation moderne »[1], Morris chercha sans relâche à réformer l'art et la société, et à prouver qu'il est possible d'agir autrement, de manière plus éthique.

De son vivant, Morris était célèbre pour ses poèmes et sa prose. Aujourd'hui, on connaît davantage ses nombreux motifs de vitraux, tissus, papiers peints, meubles et carrelages fabriqués et distribués par Morris & Co., la société coopérative qu'il fonda en 1861. Mais il a également laissé le souvenir d'un militant politique visionnaire qui, en se consacrant à la formation et au rassemblement des socialistes dans une véritable croisade en faveur du fameux « Liberté, Égalité, Fraternité », posa certains des fondements du Parti travailliste britannique.

Les multiples activités de Morris s'inscrivent dans l'esprit de réforme qui marqua la seconde moitié du XIXᵉ siècle, en réaction au formidable bouleversement social de l'époque victorienne. Le succès de l'industrie manufacturière britannique et l'exploitation de son vaste empire amenèrent une prospérité qui favorisa l'ascension des classes ouvrières moyennes et l'urbanisation du prolétariat. Bien qu'elle fût stable en apparence, la société victorienne était alors profondément divisée par l'inégalité des classes et des moyens économiques. L'industrialisation avait pollué les grandes villes et porté atteinte à la cohésion sociale en déplaçant les travailleurs ; la division du travail avait transformé d'habiles ouvriers en une main-d'œuvre non qualifiée, de plus en plus déconnectée de l'objet de son travail et surtout de la société en général.

La concurrence commerciale impitoyable entraîna un grand nombre de manufactures à produire de plus en plus d'articles de luxe et de gadgets fantaisistes, les ornements superflus servant à masquer la piètre qualité des marchandises. En même temps, les ouvriers se retrouvèrent de plus en plus asservis aux machines de production. Les premiers à vouloir réformer l'art et le design – Augustus Pugin (1812–1852), John Ruskin (1819–1900) et Owen Jones (1809–1874) – voyaient dans le style victorien qui prévalait alors l'expression d'une société corrompue par la cupidité, la décadence et l'oppression.

Les valeurs répressives et conservatrices de l'époque victorienne incitèrent, vers 1845, des artistes et idéalistes à se rebeller ; les peintres Dante Gabriel Rossetti (1828–1882), William Holman Hunt (1827–1910) et John Everett Millais (1829–1896) furent les instigateurs de ce mouvement. Ce désir romantique de s'évader du réel, popularisé par la fameuse « Confrérie préraphaélite », inspira par la suite un mouvement plus important qui rassembla des ar-

<em>"I neither, when I think of what history has been, am inclined to lament the past, to despise the present, or despair the future …
I believe all the change and stir about is a sign of the world's life, and that it will lead … to the bettering of all mankind."</em>
WILLIAM MORRIS

Millais (1829–1896). The romantic escapism popularized by this group, known as the Pre-Raphaelite Brotherhood, later inspired a larger movement of artists, designers, writers and poets which included among its members William Morris. Central to this second phase of Pre-Raphaelitism, as with the first, was the dream of a medieval Arcadia – a highly romanticized notion of pre-industrialized society that offered a refuge from the conditions of the time.

This intangible "vision of a past already lost and reconstructed by the past"[2], which looked upon community as a socially cohesive force and creative handiwork as the fountainhead of fellowship, wholly informed Morris's life and work. He was also guided by the reforming social and artistic theories of John Ruskin and, for his part, endeavoured to return dignity to labour and meaning to art through his activities at Morris & Co. This unique enterprise attempted to balance social conscience with business objectives by producing well-designed and executed objects that were handcrafted. From the outset, however, this means of reform was compromised by the economic conflict that exists between handcraftsmanship and affordability. This insurmountable dichotomy, together with Morris's distrust of mechanization for social reasons, meant that his ideal of a truly democratic or "popular" art was as unattainable as the dream that had inspired it.

The fundamental paradox between Morris's dream-worlds and the reality of the Victorian Age was only one of many that existed within his life and work: the rich man who preached revolution to the poor; the gentleman and the artisan; the bard and the businessman; the "idle singer of an empty day" driven "to do the work of ten men"; and the hopeless romantic caught in a loveless marriage.

The inherent contradictions surrounding Morris, however, do not lessen the validity of the essential and underlying meaning of his work. Indeed, these paradoxes make it all the more engaging because in most cases it can be seen to embody both a dream of the past and a vision of the future, while remaining a powerful testament to its own time. To fully appreciate Morris's many achievements one must comprehend the complex life, the strong personality and the phenomenal creative energy of the man who preached so relentlessly a morality based on Christian values and socialist theory. Crucially, it was Morris's ethical approach, founded on the belief that life should be lived worthily, that was the uniting feature of all the areas of his activities.

## A Privileged Childhood

William Morris was born on 24 March 1834 at Elm House in Clay Hill, Walthamstow. He was the third of nine surviving children and the eldest son of

terdrückung korrumpiert war. Ihr Ziel war es, diese Zustände durch eine Reform in der Kunst zu verändern.

Die repressiven, konservativen und häufig bigotten Werte der viktorianischen Ära gaben Mitte der 4oer Jahre des 19. Jahrhunderts Anlaß zu einer künstlerischen und intellektuellen Rebellion, die von den Malern Dante Gabriel Rossetti (1828–1882), William Holman Hunt (1827–1910) und John Everett Millais (1829–1896) angeführt wurde. Der romantische Eskapismus dieser als Präraffaelitische Bruderschaft bekannten Gruppe inspirierte später eine größere Bewegung von Künstlern und Schriftstellern, zu denen auch William Morris gehörte.

Diese unklare „Vision einer Vergangenheit, die verloren ist und als Vergangenheit wiederhergestellt wird"[2] betonte die Rolle der Gesellschaft als sozialen Zusammenhalt stiftende Kraft und sah im kreativen Handwerk die Quelle der Gemeinschaft; sie spielte in Morris' Leben und Werk eine entscheidende Rolle. Wichtig waren für ihn auch die sozial- und kunstreformerischen Theorien John Ruskins. Mit Hilfe seiner Firma Morris & Co. versuchte Morris, der Arbeit ihre Würde und der Kunst ihre Bedeutung wiederzugeben. In diesem einzigartigen Unternehmen wollte er soziales Bewußtsein mit geschäftlichen Zielen in Einklang bringen, indem er in Entwurf und Ausführung qualitätvolle, von Hand gearbeitete Gegenstände produzierte. Doch von Anfang an wurde dieses reformerische Ziel durch den ökonomischen Konflikt zwischen handwerklicher Fertigung und Erschwinglichkeit in Frage gestellt. Dieser unüberwindbare Zwiespalt und Morris' sozial begründetes Mißtrauen gegenüber der Mechanisierung bedeuteten, daß sein Ideal einer wahrhaft demokratischen oder „populären" Kunst ebensowenig realisierbar war wie der Traum, der ihn dazu inspiriert hatte.

Der Widerspruch zwischen Morris' Traumwelten und der Realität der viktorianischen Zeit war nur einer von vielen in seinem Leben und Werk: der reiche Mann, der den Armen die Revolution predigte; der Gentleman und der Kunsthandwerker; der Barde und der Geschäftsmann; der „müßige Sänger eines leeren Tages" und der hoffnungslose Romantiker, der in einer lieblosen Ehe gefangen ist.

Dennoch wird durch diese Widersprüche die grundsätzliche Bedeutung von Morris' Werk nicht geschmälert. Es scheint im Gegenteil durch solche Paradoxa um so eindringlicher, weil es in den meisten Fällen den Traum von der Vergangenheit ebenso verkörpert wie die Vision der Zukunft und zugleich ein illustratives Dokument seiner eigenen Zeit darstellt. Um Morris' Leistungen wirklich zu würdigen, muß man sein komplexes Leben verstehen, die starke Persönlichkeit und die enorme schöpferische Energie dieses Mannes, der so unermüdlich eine auf christlichen Werten und sozialistischer Theorie basierende Ethik predigte. Morris'

tistes, designers, écrivains et poètes, parmi lesquels William Morris.

Cette intangible « vision d'un passé révolu »[2], selon laquelle la communauté serait un moyen de cohésion sociale et le travail manuel créatif, la source de la fraternité, nourrit entièrement la vie et l'œuvre de Morris. Celui-ci, également guidé par les théories réformatrices sociales et artistiques de John Ruskin, entendait rendre sa dignité au travail et sa signification à l'art – les activités de Morris & Co. devaient aller dans ce sens. Unique en son genre, cette entreprise chercha à rétablir un équilibre entre conscience sociale et objectifs commerciaux ; les objets devaient répondre à une conception soigneuse et être fabriqués à la main. Dès le début toutefois, cette réforme fut compromise par les divergences économiques entre la main-d'œuvre artisanale et les exigences financières. Cette dichotomie insurmontable, due en partie à la méfiance de Morris envers la mécanisation, rendait l'idéal d'un art véritablement démocratique ou « populaire » tout aussi inaccessible que le rêve qui en était à l'origine.

L'opposition fondamentale entre l'univers auquel aspirait Morris et la réalité de l'époque victorienne ne constitue qu'un des nombreux paradoxes qui caractérisent la vie et l'œuvre de l'artiste : homme riche prêchant la révolution au pauvre, gentleman et artisan, aède et homme d'affaires, « chantre oisif d'un jour vide », romantique invétéré enfermé dans un mariage sans amour.

Les contradictions naturelles au cœur desquelles vécut Morris n'enlèvent pourtant rien à la pertinence, au sens profond de son œuvre. Ces paradoxes rendent en effet celle-ci d'autant plus saisissante que, dans la plupart des cas, elle incarne à la fois un rêve passéiste et une vision futuriste, tout en restant un remarquable témoignage sur son temps. Pour totalement apprécier l'imposant travail de William Morris, il faut d'abord comprendre la vie complexe, la forte personnalité et l'énergie créatrice exceptionnelle de cet homme, qui prônait avec la même conviction des valeurs chrétiennes et une doctrine socialiste. Car c'est précisément la démarche éthique de Morris, ancrée dans la conviction que la vie devait être vécue de manière digne, qui constitue le lien entre tous ses différents domaines d'activité.

## Une enfance privilégiée

William Morris est né le 24 mars 1834 à Elm House, à Clay Hill, Walthamstow. Fils aîné de William et Emma Morris, il est le troisième des neuf enfants qui survécurent. Le père de William était un prospère courtier d'escompte à la Lombard Street et travaillait à Londres pour la société Sandersons. Homme d'affaires remarquablement doué, il était nanti d'une certaine rudesse atavique – comme son fils, en digne héritier du caractère paternel, devait

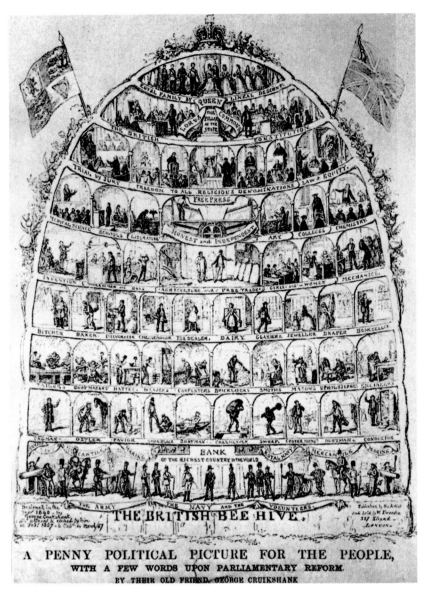

**George Cruikshank:**

*The Bee Hive*, 1867. Cartoon showing the social order of Victorian Britain

*Der Bienenstock.* Karikatur über die soziale Ordnung im viktorianischen England

*La Ruche.* Dessin humoristique montrant l'organisation sociale de la Grande-Bretagne victorienne

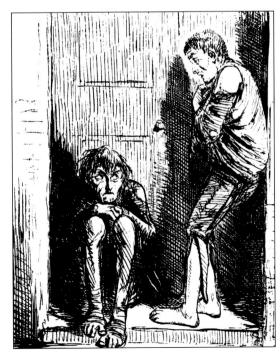

*The Homeless Poor*, 1859. Cartoon from *Punch*

*Die obdachlosen Armen.* Zeichnung aus *Punch*

*Le pauvre sans domicile.* Dessin humoristique publié dans *Punch*

William and Emma Morris. William Morris Snr. was
a successful Lombard Street discount-broker work-
ing in the City of London for Sandersons. He was
a remarkably shrewd businessman but did not lack
a certain ancestral ruggedness, as his son who in-
herited these qualities was to note in the 1860s:
"I am a boor, and a son of a boor".[3]

In 1840, having become prosperous, the Morris
family moved to more spacious accommodation at
Woodford Hall, a substantial Georgian mansion with
a 50-acre park then bordering Epping Forest. Their
social status was now on the ascent within the "bee-
hive" of the British class system, with the Herald's
College granting the family a coat-of-arms in 1843. It
was this essentially nouveau-riche background, de-
scribed by Morris as "the ordinary bourgeois style of
comfort"[4], that he was so fervently to rebel against.

The Morris family's financial fortunes continued
to rise. William Morris Snr. also became a venture
capitalist and helped to form a consortium to mine
the land of the 7th Duke of Bedford. On 26 July
1844 a lease was agreed, and work began on the
new Wheal Maria mine. A year later the enterprise
was officially registered as The Devonshire Great
Consolidated Copper Mining Company (also known
as Devon Great Consols). From the outset, the
Morris family held some 30 % of the company's
stock. The venture was to become one of the most
celebrated and lucrative mining interests of the
period and the Morris family profited handsomely
from it – the first year of operation brought them
the princely dividend of £19,312.

These extraordinary profits allowed Morris, ac-
cording to Walter Crane, the "fortunate circumstance
that he was never cramped by poverty in the develop-
ment of his aims"[5]. It was perhaps his sense of guilt
about how his family's wealth had been obtained –
through human exploitation and the despoiling of
nature – that in time drove Morris's ceaseless at-
tempts to right social wrongs. The horrific nature of
working conditions in mines had become common
knowledge as a result of a report drawn up by a com-
mission on the insistence of Lord Shaftesbury, which
cited shocking revelations. This damning account of
the Victorian mining industry enabled the heavily re-
sisted Mines Act of 1842 to be passed, but it was not
until 1860 that the employment in mines of children
under the age of ten was outlawed.

Sheltered from the harsh realities of the poor, the
young William Morris became an avid reader and by
the age of seven had reputedly read the complete
works of Walter Scott, whose popular historical
novels combined the picturesque with the romantic
and Gothic. Scott was to remain Morris's favourite
author, for he re-created a past with a "rose-tinted"
realism that was both atmospheric and seemingly
authentic. His boyhood imagination was transfixed
by the heroism and romanticism of medieval history,
especially the chivalry of knights.

ethische Haltung, die auf dem Glauben gründete,
daß das Leben würdig gelebt werden müsse, prägte
alle Bereiche seines Schaffens.

## Eine privilegierte Kindheit

William Morris wurde am 24. März 1834 im Elm
House in Clay Hill, Walthamstow, geboren. Er war
das dritte von neun überlebenden Kindern und der
älteste Sohn von William und Emma Morris. William
Morris sen. war ein erfolgreicher Börsenmakler, der
in der Londoner City für Sandersons arbeitete, und
ein bemerkenswert gewitzter Geschäftsmann mit
einer gewissen altväterlichen Rauhbeinigkeit, wie
sein Sohn, der diese Eigenschaften erbte, in den
1860er Jahren schreiben sollte: „Ich bin ein Grobian
und der Sohn eines Grobians."[3]

Als die Familie Morris 1840 zu Wohlstand gekom-
men war, zog sie nach Woodford Hall in ein stattli-
ches georgianisches Anwesen mit einem 40 Morgen
großen Park, der damals an den Epping Forest
grenzte. Von ihrem sozialen Aufstieg im britischen
Klassensystem zeugt die Tatsache, daß das Herald's
College der Familie 1843 ein Wappen zuwies. Gegen
eben diesen neureichen Hintergrund, den Morris als
„den üblichen bürgerlichen Komfortstil"[4] bezeich-
nete, sollte er später so leidenschaftlich rebellieren.

Das Vermögen der Familie wuchs weiter. William
Morris sen. engagierte sich auch als Risikospekulant
und beteiligte sich an der Gründung eines Konsor-
tiums für die Kupfergewinnung auf dem Anwesen
des 7. Duke of Bedford. Am 26. Juli 1844 wurde ein
Pachtvertrag geschlossen, und die Arbeit an der
neuen Wheal Maria Mine begann. Ein Jahr später
wurde das riskante, aber aussichtsreiche Abbauun-
ternehmen als The Devonshire Great Consolidated
Copper Mining Company (auch als Devon Great
Consols bekannt) offiziell registriert. Von Anfang an
hielt die Familie Morris etwa 30 Prozent der Anteile.
Das Unternehmen wurde zu einer der lukrativsten
Kupferminen jener Zeit, und Morris sen. strich
einen beachtlichen Profit ein.

Diese außerordentlich hohen Gewinne versetzten
Morris laut Walter Crane in „die glückliche Lage,
daß er an der Verfolgung seiner Ziele nie durch
Armut gehindert wurde".[5] Vielleicht gab sein
Schuldbewußtsein über die Art und Weise, wie seine
Familie ihr Vermögen erworben hatte – durch Aus-
beutung der Menschen und Plünderung der Natur
– den Anstoß zu Morris' stetem Streben nach sozia-
ler Gerechtigkeit. Die unmenschlichen Arbeitsbe-
dingungen in den Minen waren allgemein bekannt
geworden, nachdem eine auf Betreiben von Lord
Shaftesbury eingesetzte Kommission ihren Bericht
vorgelegt hatte. Diese niederschmetternde Darstel-
lung der Zustände in der viktorianischen Berg-
bauindustrie machte es trotz heftigen Widerstands
möglich, den Mines Act von 1842 durchzusetzen,

le noter dans les années 1860 : « Je suis un rustre et un fils de rustre. »[3]

En 1840, la famille Morris avait acquis une aisance qui lui permit de s'installer à Woodford Hall, dans un logement plus spacieux, une grande demeure géorgienne avec un parc d'environ 25 hectares bordant l'Epping Forest. Les Morris connurent une nouvelle ascension sociale lorsque le Herald's College leur concéda en 1843 un blason familial. C'est précisément contre ce milieu essentiellement nouveau riche, ce « confort typiquement bourgeois »[4], que Morris allait bientôt se rebeller avec ardeur.

La fortune de la famille Morris continua de croître. Tout en poursuivant ses activités de courtier d'escompte, le père se spécialisa dans le capital-risques et participa à la formation d'un consortium chargé de l'exploitation minière des terres du VIIe duc de Bedford. Le bail fut conclu le 26 juillet 1844 et l'exploitation de la nouvelle mine de Wheal Maria put commencer. Un an plus tard, cette entreprise de prospection, risquée mais rentable, était officiellement enregistrée sous le nom de Devonshire Great Consolidated Copper Mining Company, plus connue sous l'appellation de Devon Great Consols. D'emblée, la famille Morris détint environ 30 % des actions de la compagnie qui devint, dans son genre, l'une des plus célèbres et des plus lucratives de son époque.

Selon Walter Crane, cette fortune permit à Morris « de ne jamais être gêné par la pauvreté dans la poursuite de ses objectifs »[5]. Peut-être est-ce un sentiment de culpabilité généré par la manière dont sa famille s'était enrichie – en exploitant des hommes et en spoliant la nature – qui incita Morris à s'engager sans relâche dans la réparation des injustices sociales. Les effroyables conditions de travail dans les mines avaient été dénoncées dans un rapport établi par une commission formée à la demande expresse de Lord Shaftesbury. Ce compte rendu accablant sur l'industrie minière victorienne favorisa le vote du Mines Act de 1842, jusque-là fortement controversé. Mais ce n'est qu'à partir de 1860 que l'on interdit réellement le travail dans les mines des enfants de moins de dix ans.

Avec les conditions de vie faciles qu'il connut, le jeune William Morris eut tout le loisir de s'adonner à la lecture. On prétend qu'à l'âge de sept ans, il aurait lu l'œuvre complète de Walter Scott, dont les nouvelles historiques populaires mêlaient le pittoresque, le romanesque et le gothique. Scott devait d'ailleurs rester l'auteur favori de Morris. L'imagination du jeune Morris était exacerbée par l'héroïsme et le romantisme du Moyen Âge et, plus particulièrement encore, par les récits chevaleresques.

William Morris révéla très tôt des sentiments nobles et de fines qualités d'observation, et possédait une mémoire quasiment photographique – autant de qualités qui allaient favoriser ses élans créateurs. Il était encore enfant lorsqu'on lui donna un petit carré de jardin à cultiver, et c'est ainsi

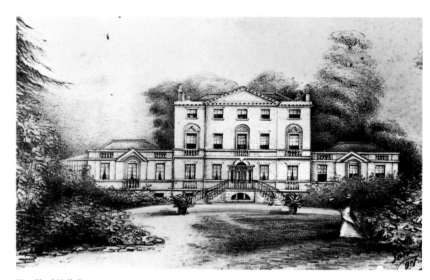

Woodford Hall, Essex
The family home from 1840 until 1848
Das Heim der Familie von 1840 bis 1848
La maison familiale de 1840 à 1848

From an early age, Morris was blessed with heightened senses, keen powers of observation and an almost photographic memory – attributes that were essential to his later connoisseurship and work as a designer. As a child he was given his own patch of garden to cultivate, which spawned an interest in botany that was to remain throughout his life. Long rambles through Woodford Hall's park and nearby Epping Forest also instilled in him a deep pantheistic love of and respect for the natural world.

During one childhood wandering in Epping Forest, Morris's sense of history was sharpened by his chance discovery of Queen Elizabeth I's almost forgotten Hunting Lodge at Chingford Hatch. With its Tudor masculinity and rich detailing, the lodge contrasted the sparse with the decorative – an effect which became a feature of Morris & Co. interiors. To Morris, this building was an embodiment of "Ye Olde Englande", and it was the mythology surrounding this romantic notion of English history that he was to pursue in different forms throughout his life. Another building that left an indelible impression on Morris was Canterbury Cathedral, which he visited with his father at the age of eight. Later in life Morris regarded such architectural beauty as the sublime expression of an ideal society.

Morris was initially taught by his elder sisters' governess at home, before beginning a formal education in 1843 at the age of nine when he was sent to the Misses Arundel's academy for young gentlemen, two miles away from Woodford Hall. A couple of years later the preparatory school moved nearer to Woodford Hall but Morris became a boarder and although each Sunday he saw his family in church, he was forbidden to speak to any of them.

A few months before Morris went to public school, his father died suddenly at the age of 50. This untimely death may well have been brought on by worries about the imminent collapse of Sandersons, which a week later had to suspend business. With no income from Sandersons and the loss of partnership capital, the mining shares of Devon Great Consols were a lifeline to the bereaved Morris family. By Christmas of 1848, the family had moved to a smaller and less expensive home, Water House in Walthamstow.

Before his death, William Morris Snr. had purchased a nomination for his son to attend Marlborough College, a newly founded public school in Wiltshire. This institution was utterly chaotic, as the number of boys attending was continually swelling and buildings were having to be rapidly constructed to accommodate them. Less expensive than other public schools, Marlborough was also less strict than similar teaching establishments. In line with all such institutions, however, it used a stultifying learning-by-rote system of teaching.

doch erst 1860 wurde die Beschäftigung von Kindern unter zehn Jahren in den Bergwerken verboten.

Abgeschirmt von der bitteren Lebenswirklichkeit der Armen, wurde der junge William Morris ein begeisterter Leser und hatte mit sieben Jahren angeblich bereits sämtliche Werke von Walter Scott gelesen, dessen populäre historische Romane pittoreske und romantische mit mittelalterlichen Elementen verbinden. Scott blieb sein Lieblingsautor. Morris' jugendliche Phantasien kreisten um das Heldentum und die Romantik des Mittelalters und vor allem um die Welt der Ritter.

Seit seiner Kindheit war Morris mit besonders sensiblen Sinnen, einer scharfen Beobachtungsgabe und einem nahezu photographischen Gedächtnis ausgestattet – Eigenschaften, die für sein späteres Kunstverständnis und seine Arbeit als Designer unerläßlich waren. Als Kind überließ man ihm ein eigenes Stück Garten zur Bearbeitung, und aus dieser Beschäftigung entwickelte sich ein lebenslanges Interesse an der Botanik. Auch die langen Wanderungen im Park von Woodford Hall und im nahen Epping Forest erweckten in ihm eine tiefe pantheistische Liebe und Ehrfurcht vor der Natur.

Während seiner frühen Wanderungen im Wald von Epping wurde auch Morris' Sinn für Geschichte geschärft, als er zufällig das fast vergessene Jagdhaus von Königin Elizabeth I. in Chingford Hatch entdeckte. Für Morris verkörperte dieser Bau das alte England. Die Mythologie, die diese romantische Vorstellung von der englischen Geschichte umwob, verfolgte er in unterschiedlicher Weise sein Leben lang. Ein anderes Bauwerk, das einen unauslöschlichen Eindruck bei ihm hinterließ, war die Kathedrale von Canterbury, die er im Alter von acht Jahren mit seinem Vater besichtigte. Später sah Morris in solcher architektonischen Schönheit den sublimen Ausdruck einer idealen Gesellschaft.

Morris wurde zunächst von der Gouvernante seiner älteren Schwestern zu Hause unterrichtet, bis er 1843 im Alter von neun Jahren an die Akademie der Damen Arundel für junge Gentlemen geschickt wurde, die zwei Meilen von Woodford Hall entfernt war. Die Schule zog einige Jahre später näher an Woodford Hall, doch Morris wurde Internatsschüler. Obwohl er seine Familie jeden Sonntag in der Kirche sah, war es ihm nicht gestattet, mit ihr zu sprechen.

Einige Monate bevor Morris auf die Public School kam, starb sein Vater plötzlich im Alter von 50 Jahren. An diesem frühen Tod hatten möglicherweise auch die Aufregungen wegen des bevorstehenden Zusammenbruchs von Sandersons ihren Anteil. Das Unternehmen mußte eine Woche später die Geschäfte einstellen. Ohne das Einkommen von Sandersons und nach dem Verlust des Teilhaberkapitals waren die Bergwerksanteile an der Devon Great Consols für die vaterlose Familie ein Rettungsanker. Weihnachten 1848 zog die Familie in das kleinere, weniger kostspielige Water House in Walthamstow um.

que commença sa passion pour la botanique. De longues promenades à travers le parc de Woodford Hall et dans la forêt d'Epping firent naître en lui l'amour et le respect de la nature.

Au cours de ses randonnées dans l'Epping Forest, Morris découvrit un jour, par hasard, le pavillon de chasse de la reine Élisabeth I<sup>re</sup>, à Chingford Hatch. Pour Morris, cet édifice illustrait parfaitement « Ye Olde Englande » (La Vieille Angleterre), et toute sa vie durant, il s'intéressera à la mythologie entourant cette conception romantique de l'histoire anglaise. L'autre bâtiment qui marqua le plus Morris fut la cathédrale de Canterbury, qu'il visita avec son père à l'âge de huit ans. Plus tard dans sa vie, Morris devait voir dans ce type de beauté architecturale l'expression sublimée d'une société idéale.

Après avoir reçu l'enseignement dispensé à la maison par la gouvernante de ses sœurs, William Morris fut envoyé en 1843 – il avait neuf ans – à l'Académie de Madame Arundel, réservée aux jeunes gens de bonne famille et située à quelque trois kilomètres de Woodford Hall. L'école privée qu'il fréquentait s'installa quelques années plus tard près de Woodford Hall ; Morris était entre-temps pensionnaire. Et bien qu'il vît sa famille tous les dimanches à l'église, il avait interdiction de lui adresser la parole.

Quelques mois avant d'entrer à la *public school*, William Morris perdit son père, qui était âgé de 50 ans. Cette mort prématurée avait été précédée par quantité d'ennuis causés par l'effondrement de Sandersons, qui, une semaine plus tard, dut suspendre toutes les affaires en cours. En l'absence de revenus du côté de Sandersons et compte tenu de la perte des capitaux investis dans l'entreprise, les actions minières étaient désormais vitales pour la famille Morris. À Noël 1848, celle-ci s'installa dans une maison plus petite, Water House, à Walthamstow.

Peu avant sa mort, le père avait acheté une nomination afin que son fils pût fréquenter le Marlborough College récemment créé, et situé en Wiltshire. Cette institution avait néanmoins de gros problèmes d'organisation, car le nombre sans cesse croissant des effectifs avait entraîné la construction rapide de nouveaux bâtiments. Moins chère que les autres *public schools* et dirigée par le docteur Wilkinson, Marlbourough laissait à désirer, mais était aussi moins stricte que les autres établissements scolaires. Mais en revanche, comme dans tant d'autres *public schools*, les méthodes d'apprentissage par cœur étaient abrutissantes.

Il n'est guère étonnant que dans ce contexte, William Morris, surnommé le « crabe », se soit ennuyé de sa famille et immergé dans les livres fournis par la bibliothèque de l'école, bien pourvue en ouvrages sur l'archéologie et l'architecture sacrée. Grâce à sa puissante imagination, Morris devint pour ses camarades un formidable conteur, bien que ceux-ci aient surtout retenu ses légendaires coups de colère.

Vers l'âge de 17 ans, le jeune homme révéla un

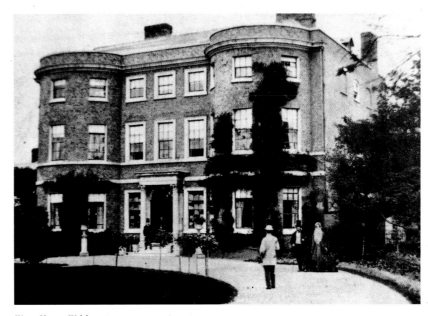

Water House, Walthamstow
The family home from 1849 until 1856
Das Heim der Familie von 1849 bis 1856
La maison familiale de 1849 à 1856

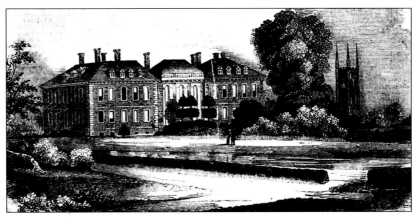

Marlborough College

In this environment, the homesick William Morris, who was nicknamed "Crab", immersed himself in the school's library, which was well stocked with books on archaeology and ecclesiastical architecture. With his great powers of imagination Morris became a favoured storyteller in the dormitories at night, although his peers best remembered him for his famous outbursts of temper.

By the age of 17, Morris had already developed a certain rebelliousness. Deploring the status quo of the Victorian Age and its decorative excesses, he refused to accompany his mother to the Great Exhibition of 1851 in London. Morris often professed to have learned nothing apart from rebellion at "Boy Farm" (Marlborough) and said of his time there: "One naturally defies authority"[6]. Whether he was involved in the alarming riot that occurred at the school in 1851 is not known, but shortly afterwards, he was later removed from the school and placed under the tutelage of the Rev. Frederick Guy, later to become Canon of St. Alban's.

Rev. Guy taught Morris theology, Latin and Greek and as a High Church Anglican who was sympathetic to the Anglo-Catholic Movement, his formative influence on Morris was significant. Interestingly, Guy was also a member of the Oxford Society for Promoting the Study of Gothic Architecture and must surely have grounded Morris in the arguments of the Gothic Revivalists to whom the Classical style was considered pagan. The Early Gothic style, on the other hand, was considered Christian and essentially at one with nature. Unlike 18th-century "Gothick", which was mainly a secular style and influenced by Perpendicular Gothic, the "Reformed Gothic" style of the 19th century was influenced by Early "muscular" Gothic and was ecclesiastical in nature.

**Oxford and the Reformers**

By now it was Morris's intention to read theology at Oxford before entering the Church, and in June 1852 he took his matriculation exam in the hall of Exeter College, Oxford. During the examination he sat next to Edward Burne-Jones, who also intended to take Holy Orders and who was to become his closest friend. Although Morris passed his entry into Exeter College, it was not until the spring of 1853 that he finally went up to university.

Morris described Oxford as "a vision of grey-roofed houses and a long winding street, and the sound of many bells"[7]. At the centre of university life during the first half of the 19th century was the Oxford Movement, which sought a renewal of Roman Catholic theology within the Church of England. Through the zeal of its members, known as Tractarians, the movement increased the use of ceremony and ritual within the Anglican service and

Vor seinem Tod hatte William Morris sen. für seinen Sohn einen Platz am Marlborough College erworben, einer neu gegründeten Privatschule in Wiltshire. In dieser Institution ging es recht chaotisch zu, da die Zahl der Schüler ständig anwuchs und in großer Eile neue Gebäude für ihre Unterbringung errichtet werden mußten. Marlborough war nicht nur billiger als andere Public Schools, sondern unter der keineswegs untadeligen Leitung von Dr. Wilkinson auch weniger streng als andere Schulen. Ähnlich wie in anderen Lehrinstituten bestand auch hier der Unterricht im mechanischen Auswendiglernen.

In diesem Umfeld vergrub sich der heimwehkranke William Morris, dem man den Spitznamen „Krabbe" gegeben hatte, in der Schulbibliothek, die mit Büchern über Archäologie und Sakralarchitektur gut ausgestattet war. Aufgrund seiner Phantasie wurde Morris nachts im Schlafsaal ein beliebter Geschichtenerzähler, obwohl seinen Schulkameraden vor allem seine berühmten Wutausbrüche in Erinnerung blieben.

Im Alter von 17 Jahren hatte Morris bereits rebellische Züge entwickelt. Er beklagte die dekorativen Exzesse der viktorianischen Ära und weigerte sich, seine Mutter zur Weltausstellung 1851 nach London zu begleiten. Häufig behauptete Morris, in der „Boy Farm" (Marlborough) nichts als Rebellion gelernt zu haben, und er sagte über seine Zeit dort: „Man setzt der Autorität natürlich Widerspruch entgegen."[6] Morris wurde später von der Schule genommen und der Obhut von Reverend Frederick Guy übergeben, dem künftigen Domherrn von St. Alban's.

Reverend Guy lehrte Morris Theologie, Latein und Griechisch und übte als Mitglied der anglikanischen Staatskirche mit Neigungen zur anglokatholischen Bewegung starken Einfluß auf ihn aus. Interessanterweise war Guy auch Mitglied der Oxford Society zur Förderung von Studien der gotischen Architektur und machte Morris sicherlich mit den Ideen der Neogotiker bekannt, die den klassischen Stil als heidnisch betrachteten. Der frühgotische Stil galt ihnen hingegen als christlich und im Einklang mit der Natur. Anders als das „Gothick" des 18. Jahrhunderts, ein überwiegend säkularer, vom „Perpendicular" beeinflußter Stil, war die Neugotik des 19. Jahrhunderts von der „muskulösen" Frühgotik geprägt und sakraler Natur.

**Oxford und die Reformer**

Mittlerweile hatte Morris den Entschluß gefaßt, in Oxford Theologie zu studieren und danach ein Kirchenamt zu übernehmen. Im Juni 1852, bei seiner Zulassungsprüfung zum Exeter College, Oxford, saß er neben Edward Burne-Jones, der ebenfalls Priester werden wollte und der bald sein engster Freund wurde. Obwohl Morris sein Examen für das Exeter

certain esprit de rébellion. Déplorant le statu quo de l'époque victorienne et ses excès décoratifs, il refusa par exemple d'accompagner sa mère à la Grande Exposition de 1851 à Londres. Il déclara souvent ne rien avoir appris à la « pension pour garçons » (Marlborough), si ce n'est le sens de la révolte. À propos de cette période, il disait volontiers : « On a une tendance naturelle à défier l'autorité. »[6] Il en fut retiré peu de temps après et placé sous la tutelle du Révérend Frederick Guy, qui devait devenir chanoine de Saint-Alban.

Le Révérend Guy enseigna à Morris la théologie, le latin et le grec. Anglican de la Haute Église et sympathisant du mouvement anglo-catholique, il eut une influence décisive sur la formation de Morris. Il est intéressant de noter que Guy était également membre de la Oxford Society pour la promotion des études de l'architecture gothique. Il est donc très probable qu'il ait sensibilisé Morris à l'argumentation des partisans du Gothic Revival, qui considéraient le style classique comme païen. Le premier gothique anglais était considéré par ailleurs comme chrétien et en parfaite union avec la nature. À la différence du style « très gothique » du XVIIIe siècle, essentiellement séculaire et influencé par le style « perpendiculaire », le gothique réformé du XIXe siècle était marqué par la vigueur du premier gothique anglais et était davantage de nature religieuse.

## Oxford et les Réformateurs

À l'époque, c'est Morris lui-même qui décida d'aller étudier la théologie à Oxford avant de rejoindre l'Église. En juin 1852, il passa l'examen d'entrée à l'Exeter College d'Oxford. Pendant l'examen, il se retrouva assis à côté d'Edward Burne-Jones, qui avait également l'intention de rentrer dans les ordres et allait devenir son meilleur ami. Bien que Morris réussît l'examen d'entrée à l'Exeter College, il n'intégra l'université qu'au printemps 1853.

Morris décrivait Oxford comme « un panorama de maisons aux toits gris et une longue rue sinueuse, avec quantité de cloches carillonnant »[7]. Dans la première moitié du XIXe siècle, la vie universitaire était axée autour de l'Oxford Movement, qui cherchait à faire revivre la théologie romaine catholique à l'intérieur de l'Église d'Angleterre. Connus sous le nom de Tractariens ses membres finirent par obtenir davantage de cérémonie et de rituel dans l'office anglican et même à établir des communautés monastiques anglicanes. Lorsque Morris arriva à Oxford, la ville était devenue le foyer missionnaire du pays et le lieu de débats virulents au sein de l'Église d'Angleterre, entre l'aile libérale et les anglo-catholiques.

Certainement très réceptif à ce climat grisant de controverses et de réformes, Morris fut cependant déçu d'avoir choisi ce collège. Exeter était scindé en deux groupes distincts : des érudits sérieux ou

Louis Haghe:

*The Medieval Court of the Great Exhibition of 1851*

*Mittelalter-Saal der Weltausstellung von 1851*

*La Medieval Court de la Grande Exposition de 1851*

Oxford High Street, 1860

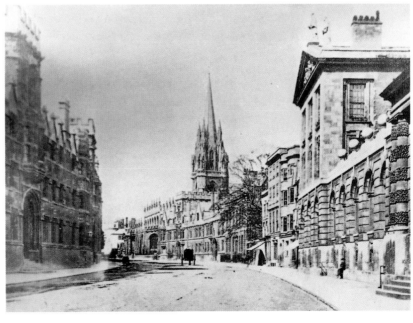

established Anglican monastic communities. By the time Morris arrived, Oxford had become the country's main missionary centre and a stage for fierce debates that raged within the Church of England between the Anglo-Catholics and its liberal wing.

Undoubtedly receptive to this heady climate of controversy and reform, Morris was nevertheless disappointed with his choice of college. Exeter was divided into two distinct groups: serious scholars or "reading men", and a rich, fast set, known as "Hearties", whose members pursued entertainment with mindless abandon. Although the latter were his social equals, Morris did not really fit in with either camp and preferred the company of fellow aesthetes such as Edward Burne-Jones, who came from a modest family, his widowed father being a frame-maker. Together with Burne-Jones, Morris eventually found the intellectual stimulation he craved through a close-knit group of friends known as "The Set", which included Pembroke College men William Fulford and Richard Watson Dixon (school friends of Burne-Jones), as well as Charles Faulkner and Cormell Price. The Set constantly teased Morris and nicknamed him "Topsy", no doubt because of his unruly mass of curly hair. Within the group, Morris quite happily played the role of buffoon, although occasionally his humour would forsake him and be replaced with fits of temper.

Disillusioned by the dullness of formal studies at Oxford, Morris found solace in the study of history and specifically medieval history. When Morris fell under the influence of High Church Anglicanism, both he and Burne-Jones toyed with the idea of converting to Catholicism. This brief affair with the Church of Rome was quickly remedied according to Morris by the progressive theories of John Ruskin and the Christian Socialist Charles Kingsley, who as a supporter of Charles Darwin sought to reconcile modern science with Christian doctrine. Like Charles Dickens, Kingsley would draw widespread attention to the plight of the underclass through his popular novel, *The Water Babies* (1863). The ideas of democracy and social welfare found in the writings of Ruskin and Kingsley were the seeds from which Morris's own social doctrine was to grow.

While at Oxford, Morris was also roused by Thomas Carlyle's book, *Past and Present* (1843), which attacked industrial capitalism by contrasting it unfavourably with the daily life of a 12th-century monastery. Studies into the Middle Ages such as this revealed the attractions of a pre-capitalist society made up of organic and socially cohesive communities. Carlyle looked to "Feudal Socialism", a term coined by Karl Marx and Friedrich Engels, as a means of social salvation. As with Ruskin and Kingsley, Carlyle's concepts of society and morality shaped Morris's view of the world. However, during these early years, his appetite for direct involvement

College bestand, wechselte er erst im Frühjahr 1853 zur Universität.

Morris beschrieb Oxford als „Vision grau überdachter Häuser mit einer langen, gewundenen Straße und dem Klang vieler Glocken".[7] Im Mittelpunkt des Universitätslebens stand in dieser Zeit die Oxford-Bewegung, die eine Erneuerung der römisch-katholischen Theologie innerhalb der Church of England anstrebte. Dank des Glaubenseifers ihrer Mitglieder, der Traktarianer, gelang es der Bewegung, Zeremonie und Ritual im anglikanischen Gottesdienst auszuweiten und anglikanische Klostergemeinschaften zu gründen. Als Morris nach Oxford kam, war die Stadt zum Zentrum der Mission und zur Bühne für erbitterte Diskussionen geworden, die in der Church of England zwischen dem Anglokatholizismus und dem liberalen Flügel ausgetragen wurden.

Morris war zwar für diese hitzige Stimmung der Kontroverse und Reform durchaus empfänglich, zeigte sich aber enttäuscht von der Wahl seines College. Exeter war in zwei Gruppen gespalten: ernsthafte Gelehrte oder „Bücherwürmer" und ein großer Kreis von lebenslustigen Studenten, „Hearties" genannt, die unbekümmert ihren Vergnügungen nachgingen. Obwohl letztere ihm sozial gleichgestellt waren, gehörte Morris keinem der beiden Lager an und bevorzugte die Gesellschaft anderer Ästheten wie Edward Burne-Jones, der aus einer einfachen Familie stammte (sein verwitweter Vater war Rahmenbauer). Gemeinsam mit Burne-Jones erhielt Morris schließlich intellektuelle Anregungen in einer eng verbundenen Gruppe von Freunden, die als „The Set" bekannt war. Zu ihr gehörten William Fulford und Richard Watson Dixon (Schulfreunde von Burne-Jones) vom Pembroke College sowie Charles Faulkner und Cormell Price. Auch diese neuen Gefährten stammten aus weniger privilegierten Verhältnissen als Morris und vermittelten ihm möglicherweise neue Einsichten in die sozialen Mißstände des viktorianischen England. Die Gruppe neckte Morris ständig und gab ihm den Spitznamen „Topsy" [topsy-turvy = umgedreht, auf den Kopf gestellt], sicherlich wegen seines widerspenstigen Lockenkopfs. Innerhalb der Gruppe spielte Morris durchaus bereitwillig die Rolle des Spaßmachers, obwohl sein Humor ihn gelegentlich im Stich ließ und Wutausbrüchen wich.

Von dem eintönigen methodischen Unterricht in Oxford enttäuscht, fand Morris Trost im Studium der Geschichte, insbesondere der des Mittelalters. Als er unter den Einfluß der anglikanischen Hochkirche geriet, spielte er ebenso wie Burne-Jones mit der Idee, zum Katholizismus überzutreten. Dieses kurze „Liebäugeln" mit der römisch-katholischen Kirche fand laut Morris ein abruptes Ende durch die progressiven Theorien John Ruskins und des christlichen Sozialisten Charles Kingsley, der als Anhänger von Charles Darwin die moderne Wissen-

«hommes de livres» et une bande de noceurs, sur-
nommés les «Hearties» (les gaillards) qui recher-
chaient avec désinvolture l'amusement à tout prix.
Bien que cette bande regroupât des individus de
même origine sociale que Morris, ce dernier ne
rejoignit aucun des deux camps. Préférant la compa-
gnie de jeunes esthètes comme Edward Burne-
Jones, issu quant à lui d'une famille modeste (son
père, veuf, était encadreur), il trouva enfin la stimu-
lation intellectuelle dont il avait besoin, également
à travers un groupe d'amis très unis, «The Set», qui
comptait des élèves du Pembroke College comme
William Fulford, Richard Watson Dixon (camarades
de classe de Burne-Jones), Charles Faulkner et Cor-
mell Price. Ces nouveaux compagnons venaient de
milieux moins privilégiés que celui de Morris et lui
firent certainement aussi découvrir de nouvelles
plaies sociales dans l'Angleterre victorienne. Sur-
nommé «Topsy» au sein du groupe – sans doute à
cause de sa tignasse bouclée – Morris y jouait vo-
lontiers le rôle de bouffon. Il lui arrivait pourtant
aussi de manquer d'humour.

Désillusionné par la monotonie de l'enseignement
académique dispensé à Oxford, Morris se consola
en se plongeant dans l'étude de l'histoire, et plus
particulièrement celle du Moyen Âge. Sous l'in-
fluence de la Haute Église anglicane, il envisagea, et
Burne-Jones avec lui, de se convertir au catholicis-
me. Mais ils furent vite guéris de cette brève incur-
sion dans l'Église romaine, lorsqu'ils découvrirent
les théories progressistes de John Ruskin et du so-
cialiste chrétien Charles Kingsley. Ce dernier, en
tant que défenseur des idées de Charles Darwin, en-
tendait réconcilier la science moderne et la doctri-
ne chrétienne. Comme Charles Dickens, Kingsley
voulait, avec son roman populaire *The Water Babies*
(*Les Bébés d'eau*), 1863, sensibiliser les lecteurs aux
difficultés des plus défavorisés. Les notions de dé-
mocratie et de solidarité définies par Ruskin et
Kingsley furent à l'origine de la propre doctrine so-
ciale de Morris.

Pendant son séjour à Oxford, Morris fut aussi for-
tement marqué par le livre de Thomas Carlyle, *Past
and Present* (*Passé et Présent*) 1843, qui s'en prenait au
capitalisme industriel en l'opposant de manière peu
flatteuse à la vie quotidienne d'un monastère au XII$^e$
siècle. De telles analyses médiévistes prônaient les
attraits d'une société précapitaliste constituée de
communautés présentant une réelle cohésion socia-
le. Carlyle s'intéressait au «socialisme féodal» –
terme forgé par Karl Marx et Friedrich Engels –
comme moyen de salut social. Comme Ruskin et
Kingsley, Carlyle et ses idées sociales et morales in-
fluencèrent la vision du monde de Morris ainsi que
sa volonté de contribuer à son amélioration.

Edward Burne-Jones rapporta plus tard à propos
de Morris: «D'emblée, j'ai senti à quel point il était
différent de tous les hommes que j'avais connus
jusque-là. Je ne l'ai jamais vu languissant ou fatigué.

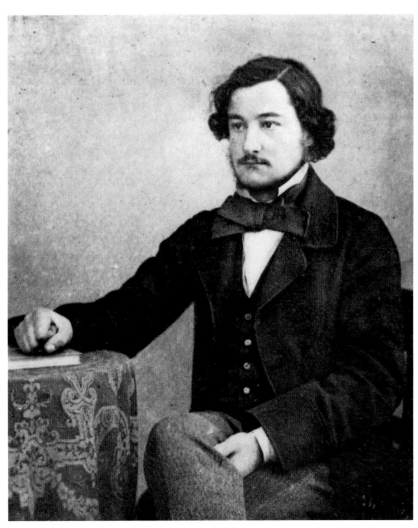

William Morris,
aged 23
im Alter von 23 Jahren
à l'âge de 23 ans

in the "muddle" of politics was overshadowed by his love of art and poetry.

Edward Burne-Jones later recollected of Morris: "From the first I knew how different he was from all the men I had ever met. He talked with vehemence, and sometimes with violence. I never knew him languid or tired. He was a slight figure in those days; his hair was dark brown and very thick, his nose straight, his eyes hazel-coloured, his mouth exceedingly delicate and beautiful."[8] During their first term together at Oxford, Morris and Burne-Jones submerged themselves not only in Anglo-Catholic tracts but also in Alfred Tennyson's *The Lady of Shallot*, a poem inspired by Sir Thomas Malory's tale, *Morte d'Arthur*, written about 1470. The Victorian fascination with the Arthurian legend had been ignited by Sir Walter Scott's rediscovery of Malory's text in the late 18th century. With its quasi-Christian morality based on the chivalric deeds and brotherhood of King Arthur and his Knights of the Round Table, the myth as recounted in *Morte d'Arthur* captured both the hearts and minds of the two young romantics and offered them an intellectual refuge from the reality of England's increasing industrial bleakness.

It was probably Burne-Jones who initially came up with the idea of making their "escape" real by founding a quasi-religious community involving vows of celibacy and monastic austerity. While this notion of an Arthurian-like brotherhood, which would embark on a "Crusade and Holy warfare against the age"[9], was clearly inspired by Malory, it was also prompted by the Pre-Raphaelite Brotherhood set up by William Holman Hunt, John Millais and Dante Gabriel Rossetti in 1848. The PRB was itself influenced by the earlier German Nazarene painters who, led by Peter Cornelius and Friedrich Overbeck, established the semi-theological Lukasbrüder community in Vienna in 1809. Similarly founded as a reformist movement in art, the PRB at the same time acted as a medium for the Romantic spirit of the mid-19th century, whose essence was a love of the past, and in particular of a dream-like medieval Golden Age.

The short-lived Pre-Raphaelite journal, *The Germ*, was especially influential upon Morris and his friends, who, in its wake, founded the *Oxford and Cambridge Magazine*. This art and literary periodical was heavily subsidized by Morris, who contributed prose stories, poems, poetry criticism, art and architecture criticism to ten of the twelve issues.

Perhaps the most important influence on Morris during his time at Oxford, however, were the writings of John Ruskin, and specifically the second volume of his *Stones of Venice* – a work that Morris regarded as revelational. Ruskin was one of the first to explore the social damage caused by materialism and to highlight the disconnection of creativity and labour within the industrial system. As a social re-

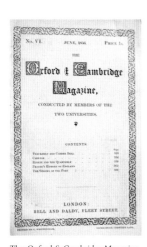

The *Oxford & Cambridge Magazine,* published by Bell & Daldy, no. VI, June 1856

veröffentlicht von Bell & Daldy, Nr. VI, Juni 1856

publié par Bell & Daldy, numéro VI, juin 1856

schaft mit der christlichen Doktrin zu versöhnen suchte. Wie Charles Dickens lenkte Kingsley mit seinem populären Roman *The Water Babies* (*Kinder des Wassers*) 1863, die Aufmerksamkeit auf das Elend der Unterschicht. Aus diesen Ideen von Demokratie und sozialer Fürsorge, die Morris in den Schriften Ruskins und Kingsleys kennenlernt, gingen seine eigenen sozialen Theorien hervor.

In Oxford wurde Morris durch Thomas Carlyles Buch *Past and Present* (*Vergangenheit und Gegenwart*), aus dem Jahr 1843, beeinflußt, das den industriellen Kapitalismus attackierte, indem es ihm das Alltagsleben in einem Kloster des 12. Jahrhunderts gegenüberstellte. Solche Studien des Mittelalters machten die Vorteile einer vorkapitalistischen Gesellschaft deutlich, die aus organischen Gemeinschaften von großem sozialen Zusammenhalt bestand. Carlyle sah im „Feudalsozialismus" (eine von Karl Marx und Friedrich Engels geprägte Bezeichnung) ein Mittel zur Rettung der Gesellschaft. Wie Ruskin und Kingsley prägte auch Carlyle Morris' Sicht der Welt und seine Vorstellungen davon, wie sie verbessert werden könnte.

Edward Burne-Jones erinnerte sich später: „Von Anfang an wußte ich, wie sehr er sich von allen Menschen, denen ich je begegnet war, unterschied. Ich habe ihn nie matt oder müde erlebt. Er war damals von schmächtiger Gestalt; sein Haar war dunkelbraun und sehr dicht, seine Nase gerade, seine Augen haselnußfarben, sein Mund sehr fein und schön."[8] In ihrem ersten gemeinsamen Semester in Oxford versenkten sich Morris und Burne-Jones nicht nur in anglokatholische Traktate, sondern auch in Alfred Tennysons *The Lady of Shallot*, ein Gedicht nach Sir Thomas Malorys Prosaerzählung *Morte d'Arthur* aus der Zeit um 1470. Das viktorianische Interesse an der Artuslegende war durch Sir Walter Scotts Wiederentdeckung von Malorys Text im späten 18. Jahrhundert geweckt worden. Mit seiner gleichsam christlichen Moral, die auf den Heldentaten und der Bruderschaft von König Artus und seinen Rittern der Tafelrunde basierte, faszinierte dieser Mythos in den Versen von *Morte d'Arthur* die beiden jungen Romantiker.

Burne-Jones hatte wahrscheinlich als erster die Idee, ihrer „Flucht" Realität zu verleihen, indem er eine religiöse Gemeinschaft mit Zölibatsgelübde und mönchischen Regeln gründete. Diese Tafelrunden-ähnliche Bruderschaft, die einen „Kreuzzug und Heiligen Krieg gegen das Zeitalter"[9] beginnen wollte, war deutlich von Malory inspiriert, aber auch von der Präraffaelitischen Bruderschaft, die William Holman Hunt, John Millais und Dante Gabriel Rossetti 1848 gegründet hatten. Die Präraffaelitische Bruderschaft ihrerseits war von den deutschen Nazarenern beeinflußt, die sich unter Führung von Peter Cornelius und Friedrich Overbeck 1809 in Wien im Lukasbund der Maler zusammengeschlossen hatten. Die Bruderschaft, die ebenfalls eine Reform der Kunst

Il était plutôt mince, à cette époque ; ses cheveux étaient châtain foncé, très épais, son nez droit, ses yeux couleur noisette, sa bouche d'une grande finesse. »[8] Pendant le premier trimestre qu'ils passèrent ensemble à Oxford, Morris et Burne-Jones se consacrèrent non seulement à la rédaction de tracts anglo-catholiques, mais aussi à la lecture de l'ouvrage d'Alfred Tennyson, *The Lady of Shallot*, poème inspiré d'un conte de Sir Thomas Malory, *Morte d'Arthur*, écrit vers 1470. La redécouverte par Sir Walter Scott du texte de Malory à la fin du XVIIIe siècle provoqua pendant toute la période victorienne une véritable fascination pour la légende d'Arthur. Avec sa moralité presque chrétienne fondée sur les hauts faits chevaleresques et l'amitié entre le roi Arthur et ses fidèles chevaliers de la Table Ronde, le mythe, tel qu'il est rapporté dans *Morte d'Arthur*, offrit un véritable refuge intellectuel à ces deux jeunes romantiques.

C'est Burne-Jones qui eut probablement le premier l'idée de concrétiser leur « fuite » en fondant une sorte de communauté religieuse, avec vœu de célibat et ascétisme monacal. Cette notion de fraternité « arthurienne », qui commencerait par « une croisade et une guerre sainte contre l'époque actuelle »[9], était certes clairement inspirée de Malory, mais fut également initiée en 1848 par la Confrérie préraphaélite de William Holman Hunt, John Millais et Dante Gabriel Rossetti. De son côté, la Confrérie fut influencée par les premiers peintres nazaréens allemands qui, sous la houlette de Peter Cornelius et Friedrich Overbeck, établirent à Vienne, en 1809, la communauté semi-théologique des Frères de Luc. Également fondée comme un mouvement réformiste de l'art, la Confrérie préraphaélite se voulait un vecteur de l'esprit romantique du milieu du XIXe siècle, caractérisé essentiellement par l'amour du passé et le rêve d'un âge d'or médiéval.

Le journal préraphaélite éphémère *The Germ* exerça une influence particulière sur Morris et ses amis qui créèrent, quant à eux, l'*Oxford and Cambridge Magazine*. Ce périodique consacré aux arts et à la littérature était fortement subventionné par Morris. Il apporta sa contribution à dix numéros sous forme d'histoires en prose, de poèmes et de critiques littéraires ou artistiques.

Mais l'influence la plus forte que subit Morris pendant son séjour à Oxford fut sans doute celle des textes de John Ruskin, et plus particulièrement du second volume des *Stones of Venice* (*Pierres de Venise*) – une véritable révélation pour Morris. Ruskin fut l'un des premiers à étudier sous tous leurs aspects les préjudices sociaux causés par le matérialisme et à souligner le fossé existant entre la créativité et le travail au sein du système industriel. Réformateur social, Ruskin avait compris la dignité de la création manuelle et les interférences entre art et société. Il prônait une société de « gentilhommes » et, à la différence de Carlyle qui jugeait tout travail noble, sou-

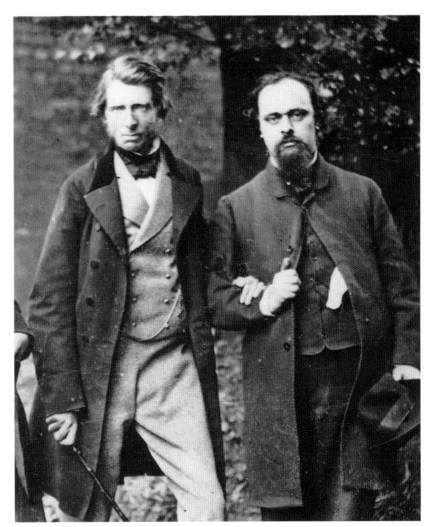

John Ruskin & Dante Gabriel Rossetti, 1863

former, Ruskin understood the dignity of manual creativity and the interconnection of art and society. Above all he desired a society made up of "gentle-men". Unlike Carlyle, who believed all labour to be noble, Ruskin maintained it was only creative work that would benefit society as a whole. For Ruskin, the division of labour was the primary cause of social alienation, and he believed that the precision of machine-made objects signified the increasing estrangement of the worker – who was neither creatively nor intellectually engaged – from his work. Morris was later to acknowledge Ruskin as his ideological mentor and put many of his theories into practice.

At Exeter College, Morris began to write evocative and extremely pantheistic poetry. These poems or "Grinds", as they were referred to by The Set, came to him naturally, and he said of them: "Well, if this is poetry, it is very easy to write"[10].

During his final summer vacation of 1855, Morris made his second trip to France – this time with Burne-Jones and Fulford. It was to be a walking tour and a journey of discovery with the friends visiting a total of nine cathedrals, including Abbeville, Amiens, Beauvais, Coutances and Chartres, and 24 churches. As Ruskin's disciples made their tour of medieval France they were following in the footsteps of the Gothic Revivalists George Edmund Street, Gilbert Scott and William Burges, who had earlier also visited these sites. Morris regarded architecture as the supreme discipline, because it provided a unique focus for all the arts. For him, the undeniable perfection of Chartres Cathedral, connected holistically to its surrounding townscape, validated the social system that gave rise to it – medieval feudalism or "commune-ism". It was this idea of a whole community pulling together creatively – making, building, doing – that appealed to Morris above all else.

One evening, while strolling alongside the quay at Le Havre towards the end of their tour, Morris and Burne-Jones made the momentous decision to embark on "a life of art"[11] instead of taking Holy Orders as originally planned. It was decided that Burne-Jones would become a painter and that Morris would pursue a career as an architect.

**"A Life of Art"**

Shortly after his return from France, Morris informed his mother that he was to abandon theology in favour of architecture. Morris, nevertheless, did return to Oxford on the insistence of his mother to take his theology degree in the autumn of 1855. Following this, in January 1856, he became articled to the architect George Edmund Street, whose office from 1852 had been based in Oxford. As a leading Gothic Revivalist, Street was mainly involved in

anstrebte, war zugleich ein Medium für den romantischen Geist in der Mitte des 19. Jahrhunderts, der die Vergangenheit und besonders ein mittelalterliches Goldenes Zeitalter heraufbeschwor.

Die kurzlebige präraffelitische Zeitschrift *The Germ* übte einen starken Einfluß auf Morris und seine Freunde aus, die daraufhin das *Oxford and Cambridge Magazine* gründeten. Dieses Kunst- und Literaturmagazin wurde finanziell von Morris unterstützt, und er trug mit Prosa, Gedichten sowie Lyrik-, Kunst- und Architekturkritik zu zehn der zwölf Ausgaben bei.

Den wohl tiefsten Eindruck hinterließen bei Morris in seiner Oxforder Zeit freilich die Schriften John Ruskins und vor allem der zweite Band von *Stones of Venice* (*Die Steine von Venedig*). Ruskin untersuchte als einer der ersten den schädlichen Einfluß des Materialismus auf die Gesellschaft und wies auf die Kluft zwischen Kreativität und Arbeit im industriellen System hin. Als Sozialreformer war er sich des Wertes der schöpferischen Handarbeit und der Verbindung von Kunst und Gesellschaft bewußt. Er träumte von einer Gesellschaft von „gentle-men". Anders als für Carlyle, der jede Arbeit für edel hielt, war für Ruskin nur schöpferische Arbeit von gesellschaftlichem Nutzen. Für Ruskin war die Arbeitsteilung die Hauptursache der sozialen Zerrissenheit. Er glaubte, die Präzision der von Maschinen hergestellten Objekte führe zur Entfremdung des Arbeiters – der weder kreativ noch intellektuell beteiligt sei – von seinem Produkt. Morris sah später in Ruskin seinen ideologischen Mentor und setzte viele von dessen Theorien in die Praxis um.

Am Exeter College begann Morris Gedichte zu schreiben. Sie flogen ihm einfach zu; er bemerkte dazu: „Nun, wenn das Poesie ist, ist sie sehr einfach zu schreiben."[10]

In seinen letzten Semesterferien 1855 unternahm Morris seine zweite Reise nach Frankreich – diesmal mit Burne-Jones und Fulford. Es wurde eine Wandertour, auf der Morris mit seinen Freunden insgesamt neun Kathedralen und 24 Kirchen besichtigte – allesamt ehrfurchtgebietende Beispiele der gotischen Architektur. Auf ihrer Wanderung durch das mittelalterliche Frankreich folgten die Schüler Ruskins den Spuren der Neogotiker George Edmund Street, Gilbert Scott und William Burges, die vor ihnen ebenfalls diese Orte besucht hatten. Für Morris war die Baukunst die größte aller Künste, weil in ihr alle anderen zusammenflossen. Für ihn entsprach die eng in die Stadtstruktur eingebundene Kathedrale von Chartres dem damaligen Gesellschaftssystem – dem mittelalterlichen Feudalismus oder „Kommune-ismus". Vor allem faszinierte Morris die Idee, daß eine ganze Gemeinschaft sich kreativ zusammenschloß – entwerfend, bauend, arbeitend.

Eines Abends, als sie gegen Ende ihrer Tour am Quai von Le Havre spazierengingen, trafen Morris und Burne-Jones spontan die Entscheidung, ein „Leben für die Kunst"[11] zu beginnen, statt, wie ur-

tenait que seul le travail créatif pris dans son ensemble pouvait profiter à la société. Pour Ruskin, la division du travail était la cause première de l'aliénation sociale. Selon lui, la précision des objets fabriqués par la machine éloigne de plus en plus l'ouvrier de son propre travail et l'empêche de s'engager de manière créative et réfléchie. Morris allait reconnaître en Ruskin son mentor idéologique et appliquer un grand nombre de ses théories.

À l'Exeter College, Morris se mit à écrire de la poésie. Les poèmes venaient tout naturellement à Morris, si bien que lui-même disait : « Eh bien, si c'est cela la poésie, c'est très facile d'écrire. »[10]

Au cours de l'été 1855, Morris entreprit un second voyage en France, cette fois-ci avec Burne-Jones et Fulford. Les trois camarades optèrent pour un voyage pédestre, qui les amena à visiter neuf cathédrales ainsi que 24 églises – toutes des exemples impressionnants d'architecture gothique. En faisant ainsi le tour de la France médiévale, les disciples de Ruskin suivaient les pas des revivalistes George Edmund Street, Gilbert Scott et William Burges qui avaient visité ces lieux avant eux. Pour Morris, l'architecture était la discipline suprême, parce qu'elle constituait le point de convergence de tous les autres arts. Selon lui, la perfection de la cathédrale de Chartres, rattachée au paysage urbain environnant, justifiait le système social qui lui avait permis d'exister – le féodalisme médiéval ou « commune-isme ». Morris était séduit avant tout par l'idée d'une communauté totale, s'efforçant de créer ensemble, de fabriquer, de construire.

Un soir, vers la fin de leur séjour, alors qu'ils flânaient le long des quais du Havre, Morris et Burne-Jones prirent la résolution de se lancer dans « une vie consacrée à l'art »[11] plutôt que de rentrer dans les ordres comme ils l'avaient d'abord envisagé. Il fut décidé que Burne-Jones deviendrait peintre et que Morris poursuivrait une carrière d'architecte.

## « Une vie consacrée à l'art »

Peu après son retour de France, Morris informa sa mère qu'il allait abandonner la théologie pour l'architecture. À l'automne 1855, il retourna cependant à Oxford, sur l'insistance de sa mère, pour passer son diplôme en théologie. En janvier 1856, il commença un apprentissage chez l'architecte George Edmund Street, dont le bureau était à Oxford depuis 1852. Chef de file du Gothic Revival, Street s'occupait surtout d'aménagement et de restauration d'édifices religieux. Partisan du style premier gothique anglais, robuste et vernaculaire, Street considérait l'architecture de façon organique, ce qui, aux yeux de Morris, revêtait une importance particulière.

Les élèves les plus éminents de Street étaient alors Philip Webb, John Sedding et Norman Shaw. Morris fut d'abord placé sous la tutelle de Webb, de trois ans son aîné, et qui devint un ami et un collègue

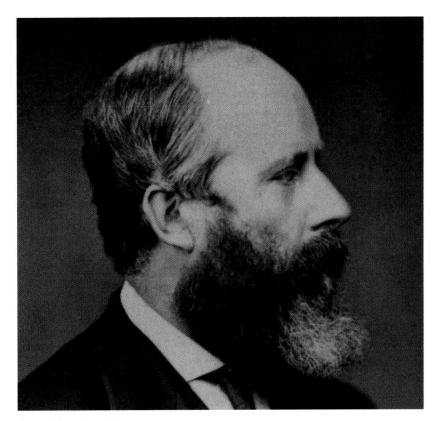

George Edmund Street, 1877

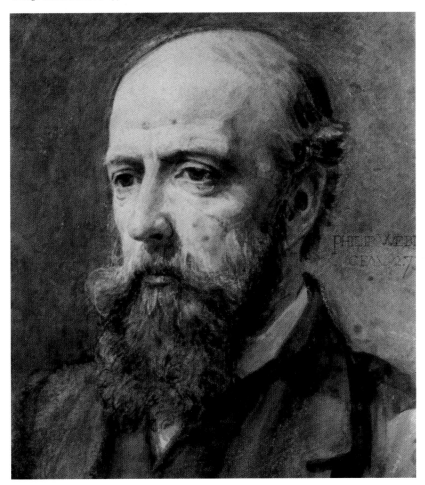

**Charles Fairfax Murray** :
Philip Webb, 1873

the design and restoration of ecclesiastical build-
ings. By favouring the more robust and vernacular
style of Early Gothic, Street's approach to architec-
ture verged on the organic and this was of particu-
lar importance to Morris.

Street's most notable pupils were Philip Webb,
John Sedding and Norman Shaw, and upon entering
the office Morris was placed under the supervision
of Webb, who was three years his senior and was
to become a long-standing friend and colleague.
Ironically, in later life Morris decried Street's work
and became the most vehement critic of his former
master's "restorations".

During his time in Street's office, Morris contin-
ued to write poetry in the evenings. In June 1856
the office moved to London, where Burne-Jones
was now also living. At the instigation of Ruskin,
Burne-Jones had finally met his hero, Dante Gabriel
Rossetti. Although only five years older than Burne-
Jones, Rossetti was much more experienced and al-
together more worldly. He was already a notable fig-
ure in artistic circles, having been a founding
member of the Pre-Raphaelite Brotherhood.

Rossetti was also highly charismatic, and from
their very first meeting Morris fell under his
Svengali-like influence. By July 1856, upon the urg-
ings of Rossetti, Morris abandoned his short-lived
architectural career and decided to become a
painter. He wrote to a friend: "Rossetti says I ought
to paint, he says I shall be able to; now as he is a
very great man and speaks with authority and not as
the scribes, I *must* try"[12].

For a while Morris and Burne-Jones shared rooms
at 1, Upper Gordon Square, and there Burne-Jones
became engaged to Georgiana MacDonald. At the
suggestion of Rossetti, in late November 1856 the
two friends moved into three large unfurnished
rooms at 17, Red Lion Square. Morris immediately
busied himself with the decoration of their new ac-
commodation, and finding only shoddy and poorly
constructed furniture available, set about designing
his own. The exceptionally medieval and monumen-
tal chair designs that resulted were painted with
scenes from Morris's poem, *Sir Galahad: A Christmas
Mystery*.

In the summer of 1857, Rossetti gathered around
him a group of like-minded artists, including Morris
and Burne-Jones, and set off to paint murals of scenes
from Malory's *Morte d'Arthur* on the walls of the Ox-
ford Union Library. While Morris thoroughly enjoyed
the *bonhomie*, the project itself was ill-founded as cor-
rect preparation procedures were disregarded and
the unfinished murals began to fade within six
months. Rossetti, who from 1852 had been unoffi-
cially betrothed to the consumptive Lizzie Siddal,
scoured Oxford for "stunners" who could sit as
models for the murals. One such girl was an 18-year-
old raven-haired ostler's daughter, Jane Burden,
whom he met at a theatre. She subsequently agreed

*"It is a dream, you
may say, of what has
never been and never
will be; true ... but
dreams have before
now come about of
things so good and ne-
cessary to us, that we
scarcely think of them
more than daylight:
though once people
had to live without
them, without even the
hope of them."*
WILLIAM MORRIS

sprünglich geplant, in das Priesteramt einzutreten.
Sie beschlossen, daß Burne-Jones Maler und Morris
Architekt werden sollte.

## „Ein Leben für die Kunst"

Kurz nach seiner Rückkehr aus Frankreich teilte
Morris seiner Mutter mit, daß er die Theologie zu-
gunsten der Architektur aufgeben werde. Allerdings
ging er auf Wunsch seiner Mutter nach Oxford
zurück, um im Herbst 1855 sein theologisches Ex-
amen abzulegen. Im Januar 1856 trat er eine Lehre
bei dem Architekten George Edmund Street an, der
1852 ein Büro in Oxford eröffnet hatte. Als wichtiger
Neogotiker führte Street hauptsächlich Entwürfe
und Restaurierungen von Kirchenbauten aus. Da
Street zum robusteren Stil der Frühgotik tendierte,
stand er in seiner Haltung zur Architektur dem Or-
ganischen nahe, was Morris besonders wichtig war.

Streets bekannteste Schüler waren Philip Webb,
John Sedding und Norman Shaw. Bei seinem Eintritt
in das Büro wurde Morris unter die Aufsicht von
Webb gestellt, der drei Jahre älter war und über
lange Jahre sein Freund und Kollege bleiben sollte.
Ironischerweise äußerte sich Morris später negativ
über Streets Arbeiten und wurde der vehementeste
Kritiker der „Restaurierungen" seines früheren
Lehrherrn.

Während seiner Zeit in Streets Büro schrieb Mor-
ris weiterhin abends Gedichte. Im Juni 1856 zog das
Büro nach London, wo nun auch Burne-Jones lebte.
Durch die Vermittlung von Ruskin hatte Burne-Jones
endlich seinen Helden kennengelernt, Dante Gabri-
el Rossetti. Dieser war nur fünf Jahre älter als Burne-
Jones, aber weitaus erfahrener und weltgewandter.
In Künstlerkreisen war er als Mitbegründer der
Präraffaelitischen Bruderschaft bereits wohlbekannt.

Rossetti war eine überaus charismatische Gestalt,
und Morris verfiel sogleich seinem Einfluß. Im Juli
1856 beendete Morris auf Drängen Rossettis seine
kurze Architektenlaufbahn und beschloß, Maler zu
werden. An einen Freund schrieb er: „Rossetti sagt,
ich müsse malen, er sagt, ich kann es; da er ein sehr
großer Mann ist und mit Autorität spricht ..., *muß*
ich es versuchen."[12]

Eine Zeitlang wohnten Morris und Burne-Jones
gemeinsam am Upper Gordon Square 1, und dort
verlobte sich Burne-Jones mit Georgiana MacDo-
nald. Auf Vorschlag Rossettis zogen die beiden
Freunde Ende November 1856 in drei große un-
möblierte Räume am Red Lion Square 17. Morris be-
gann sofort mit der Ausstattung ihrer neuen Woh-
nung. Da er feststellen mußte, daß es nur
minderwertige, schlecht gebaute Möbel zu kaufen
gab, entwarf er eigene. Die ungewöhnlichen mittel-
alterlich-monumentalen Stühle, die nach diesen
Entwürfen entstanden, waren mit Szenen aus Mor-
ris' Gedicht *Sir Galahad: A Christmas Mystery* bemalt.

pour la vie. Ironie du sort, Morris devait par la suite décrier le travail de Street et devenir l'un des plus grands détracteurs des « restaurations » de son maître d'autrefois.

Pendant la période qu'il passa chez Street, Morris continua, le soir, d'écrire ses poèmes. En juin 1856, le bureau déménagea à Londres, où Burne-Jones vivait aussi désormais. Sur l'instigation de Ruskin, Burne-Jones avait fini par rencontrer son « héros », Dante Gabriel Rossetti. Il n'avait certes que cinq ans de plus que Burne-Jones, mais Rossetti avait beaucoup plus d'expérience ; il était aussi beaucoup plus mondain et déjà bien implanté dans les milieux artistiques, dans la mesure où il avait été membre fondateur de la Confrérie préraphaélite.

Rossetti était un personnage extrêmement charismatique, et, dès leur première rencontre, Morris fut fasciné. Vers le mois de juillet 1856, poussé par Rossetti, Morris abandonna sa brève carrière d'architecte et décida de devenir peintre. Il écrivit alors à un ami : « Rossetti dit que je devrais peindre, il affirme que j'en suis capable ; alors, comme c'est un très grand homme qui parle avec autorité et non comme les scribes, je *dois* essayer. »[12]

Pendant un temps, Morris et Burne-Jones partagèrent un petit appartement au numéro 1 de Upper Gordon Square. Burne-Jones se fiança alors avec Georgiana MacDonald, et sur la suggestion de Rossetti, à la fin du mois de novembre 1856, les deux amis s'installèrent dans un grand appartement de trois pièces, au 17, Red Lion Square. Morris s'occupa immédiatement de la décoration de ce nouveau logement. Comme il ne trouvait que des meubles de mauvaise qualité, il se mit à créer son propre mobilier. Les esquisses de chaises médiévales monumentales étaient inspirées du poème de Morris *Sir Galahad : A Christmas Mystery*.

Au cours de l'été 1857, Rossetti réunit autour de lui un groupe d'artistes animés de sentiments communs et dont faisaient partie Morris et Burne-Jones ; il réalisa aussi, à la Oxford Union Library, des peintures murales représentant des scènes tirées de *Morte d'Arthur* de Malory. Morris avait beau apprécier la bonhomie de ce projet, celui-ci se révéla fort mal préparé, si bien que les peintures murales inachevées s'estompèrent en l'espace de six mois. Rossetti, parcourut tout Oxford à la recherche de « superbes filles » qui accepteraient de poser pour ses peintures murales. Il en rencontra une dans un théâtre, Jane Burden, fille d'un valet d'écurie, âgée de dix-huit ans. Elle accepta de lui servir de modèle pour le personnage de la reine Guenièvre. Il est probable que c'est au cours de ces séances que Jane succomba au charme de Rossetti et lui à la beauté saisissante de la jeune fille. Au mois de novembre, Rossetti dut cependant quitter brusquement Oxford pour rejoindre sa fiancée phtisique, Lizzie Siddal, d'une patience à toute épreuve. Jane commença alors à poser pour Morris, pour son tableau de *La*

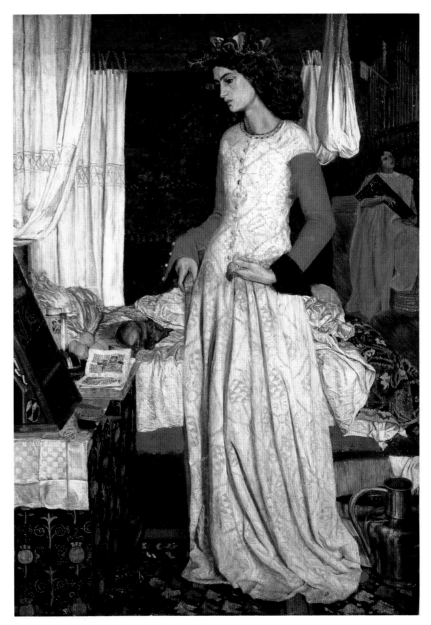

**William Morris:**
*La Belle Iseult*, 1858–1859

to sit for him as Queen Guinevere, and it is likely that it was over the following sessions that Jane succumbed to Rossetti's spell and he to her unconventional yet striking beauty. In November, however, Rossetti had to suddenly leave Oxford to rejoin the long-suffering Siddal, and Jane began to model for Morris and his painting of the *La Belle Iseult* – ironically, the unfaithful wife of the King of Cornwall in Malory. The inexperienced Morris fell hopelessly in love with Jane and reputedly inscribed on the back of the canvas, "I cannot paint you but I love you"[13], thus acknowledging both his infatuation with her and his struggle with the medium.

The besotted Morris wrote several poems which were inspired by Jane's beauty and these, together with other non-moralizing verses, were eventually published in March 1858 at Morris's own expense as *The Defence of Guinevere*. This was the first anthology of Pre-Raphaelite poetry to be published and it was met with general derision due to its rough eroticism and earthy archaic style. Although Jane was in love with Rossetti and later maintained she had never loved Morris, she nonetheless became engaged to him in the summer of 1858. Coming from a very humble background, it is unlikely Jane was in much of a position to do anything else, and between the time of her engagement and her marriage to Morris she was probably coached in the skills needed for her forthcoming ascent in the class system. Rossetti and the disapproving Morris family were notable by their absence at William and Jane's wedding, which took place at St Michael's church, Oxford on 26 April 1859.

On their return from a six-week honeymoon the Morrises lived in Great Ormond Street while their marital home was being built in Bexleyheath. The Red House, dubbed by Rossetti the "Towers of Topsy", was designed by Philip Webb in close collaboration with Morris. Both men supervised its construction, and upon completion it was furnished by Morris and his circle of friends with embroidered hangings, murals, stained glass and heavy painted furniture (such as the *Prioress's Tale* wardrobe, a wedding gift to the Morrises from Burne-Jones) that were inspired by the 13th-century Gothic style. The ensuing fellowship and general high spirits of this collaborative interior-decorating project led to the formation of Morris, Marshall, Faulkner & Co. The Red House was a veritable palace of art and a reification of Morris's dreams of a medieval Arcadia.

In January 1861, Jane Alice (Jenny) was born, the first of two Morris children. A few months later Rossetti and Siddal, who had married in 1860, were devastated by the birth of a stillborn daughter. Lizzie, who for years had had to cope with Rossetti's numerous infidelities, including his blatant affair with Fanny Cornforth, one of his models, now became addicted to the opiate sleeping draught, laudanum. A few months before the Morrises' second

Im Sommer 1857 versammelte Rossetti eine Gruppe gleichgesinnter Künstler um sich, darunter auch Morris und Burne-Jones, um die Wände der Oxford Union Library mit Szenen aus Malorys *Morte d'Arthur* zu bemalen. Morris genoß die Zusammenarbeit, doch der Malgrund war schlecht vorbereitet, so daß die unvollendeten Fresken nach sechs Monaten zu verblassen begannen. Rossetti suchte in Oxford nach schönen Frauenmodellen für die Wandbilder. Eines dieser Mädchen war die 18jährige Jane Burden, die Tochter eines Stallknechts, die er in einem Theater kennenlernte. Sie saß für ihn als Queen Guenevere Modell, und wahrscheinlich erlag sie bei diesen Sitzungen Rossettis Charme und er ihrer ungekünstelten, aber unübersehbaren Schönheit. Im November mußte Rossetti jedoch plötzlich Oxford verlassen, weil seine lungenkranke Verlobte Lizzie Siddal auf einem Wiedersehen bestand. Jane begann für Morris und sein Bild *La Belle Iseult* Modell zu stehen, also ironischerweise für Malorys Figur der treulosen Gattin des Königs von Cornwall. Der unerfahrene Morris verliebte sich rettungslos in Jane und schrieb angeblich auf die Rückseite der Leinwand: „Ich kann dich nicht malen, aber ich liebe dich."[13]

In seiner Verliebtheit verfaßte Morris mehrere Gedichte, die von Janes Schönheit inspiriert waren. Sie wurden schließlich zusammen mit anderen freizügigen Versen im März 1858 auf Morris' Kosten als *The Defence of Guinevere* (*Die Verteidigung der Guenevere*) veröffentlicht. Es handelt sich um die erste Anthologie präraffaelitischer Poesie, und sie wurde wegen ihrer kruden Erotik und des erdverbundenen archaischen Stils allgemein mit Spott aufgenommen. Obwohl Jane ihr Herz Rossetti geschenkt hatte und sie später behauptete, sie habe Morris nie geliebt, verlobte sie sich im Sommer 1858 mit ihm. Rossetti und die Familie Morris, die die Verbindung mißbilligte, blieben der Hochzeit von William und Jane fern, die am 26. April 1859 in der St. Michael's Church in Oxford stattfand.

Nach ihrer Rückkehr von einer sechswöchigen Hochzeitsreise lebten die beiden in der Great Ormond Street, während in Bexleyheath ihr Haus gebaut wurde. Das Red House, von Rossetti als „Topsys Türme" bezeichnet, wurde von Philip Webb in enger Zusammenarbeit mit Morris entworfen. Nach der Fertigstellung statteten Morris und seine Freunde es mit bestickten Vorhängen, Wandbildern, Glasmalerei und schweren bemalten Möbeln aus (darunter befand sich auch der Schrank *Die Geschichte der Priorin*, ein Hochzeitsgeschenk von Burne-Jones), die von der Gotik des 13. Jahrhunderts inspiriert waren. Die freundschaftliche, anregende Zusammenarbeit bei der Innendekoration führte schließlich auch zur Gründung von Morris, Marshall, Faulkner & Co. Mit dem Red House, einem wahren Palast der Kunst, war Morris' Traum von einem mittelalterlichen Arkadien Wirklichkeit geworden.

Im Januar 1861 wurde Jane Alice (Jenny) Morris

*Belle Iseult* – la femme infidèle du roi de Cornouailles dans Malory. Le jeune homme naïf ne tarda pas à tomber désespérément amoureux de Jane et aurait inscrit au dos des toiles « Je ne sais pas vous peindre, mais je vous aime. »[13]

Éperdument amoureux, Morris écrivit plusieurs poèmes inspirés par la beauté de Jane. En mars 1858, ils finirent par être publiés aux frais de Morris, avec d'autres vers, sous le titre *The Defence of Guinevere* (*La défense de Guenièvre*). C'était la première anthologie de poésie préraphaélite qui paraissait. Elle fut raillé par le public, en raison de son érotisme cru et de son style archaïque un peu plat. Bien que Jane fût amoureuse de Rossetti et déclarât par la suite n'avoir jamais aimé Morris, elle se fiança néanmoins avec ce dernier pendant l'été 1858. Rossetti et la famille Morris, qui désapprouvaient cette union, n'assistèrent pas au mariage de William et Jane qui eut lieu le 26 avril 1859 en l'église Saint-Michel d'Oxford.

À leur retour, les Morris emménagèrent dans la Great Ormond Street, en attendant que leur maison de Bexleyheath fût terminée. La Red House, surnommée par Rossetti les « Tours de Topsy », fut conçue par Philip Webb en étroite collaboration avec Morris. Elle fut également meublée par Morris et ses amis : rideaux brodés, peintures murales, vitraux et meubles peints de manière chargée (comme la penderie *L'histoire de la prieure*, un cadeau de mariage de la famille Morris, réalisée par Burne-Jones), inspirés du style gothique du XIIIᵉ siècle. La camaraderie et l'entrain général qui présidèrent à ce projet commun aboutirent à la fondation de l'association Morris, Marshall, Faulkner & Co. Avec la Red House, véritable palais des arts, le rêve de Morris prenait forme.

En janvier 1861 naquit Jane Alice (Jenny), le premier des deux enfants des Morris. Quelques mois plus tard, Rossetti et Siddal, qui s'étaient mariés en 1860, furent terrassés par la naissance d'une petite-fille mort-née. Lizzie, qui pendant des années avait dû faire face aux nombreuses infidélités de Rossetti (y compris avec son modèle Fanny Cornforth), s'abandonna alors à une drogue opiacée. Quelques mois avant la naissance du second enfant des Morris, Mary (May), Lizzie succomba à une dose excessive de laudanum. Tourmenté par sa conscience et, tout à son chagrin, Rossetti alla chercher du réconfort auprès de Jane. Ce fut le début d'un scandaleux « ménage à trois ».

## Morris, Marshall, Faulkner & Co.

En 1861 Morris qui, jusqu'ici, n'avait jamais eu d'emploi rémunéré ni touché quelque revenu que ce soit depuis la publication de *The Defence of Guinevere*, résolut de se trouver une profession – aussi parce que les bénéfices que lui rapportaient les parts de la Devon Great Consols commençaient à être très incertains. Il avait un sens aigu de la qualité et comme

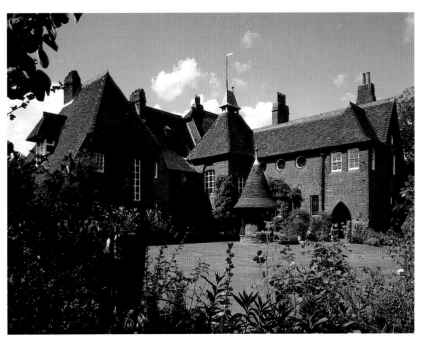

The Red House
Southeast façade seen from the garden
Südostfassade vom Garten gesehen
Façade nord-ouest, vue du jardin

child, Mary (May), was born, Lizzie took an overdose of laudanum and died. Rossetti was racked with guilt at her death. In his grief he turned to Jane for consolation and so began an infamous liaison.

## Morris, Marshall, Faulkner & Co.

In 1861 Morris, who had never had any gainful employment nor income from *The Defence of Guinevere*, now resolved to find a career for himself – mainly because his dividends from Devon Great Consols shares were beginning to falter. Despite abandoning the church, architecture and painting, Morris had nonetheless developed a connoisseur's eye for quality and a natural empathy for materials, texture, colour and pattern. These were attributes that were vital to the success of his future enterprise. As a result of his experience with the decoration of the Red House, Morris decided, probably at the instigation of Ford Madox Brown, to form an association of artists to produce better designed and executed objects. The establishment of Morris, Marshall, Faulkner & Co. was no doubt influenced by Henry Cole's earlier Summerley's Art Manufactures venture, although the two enterprises differed significantly. Whereas Cole sought to reform mainstream design through the Establishment, Morris – inspired by the theories of Ruskin – attempted a revolutionary approach that tackled the social aspects of design head-on and which involved, for the most part, a rejection of the industrial process.

Initially, only two of the seven partners of the Firm received a salary, Morris and Faulkner, while the other key partners, Brown, Rossetti, Burne-Jones and Webb, were paid piecemeal for their design work. In April 1861, the Firm issued its first prospectus, which announced: "These Artists having been for many years deeply attached to the study of the Decorative Arts of all time and countries, have felt more than most people the want of some place, where one could either obtain or get produced work of a genuine and beautiful character. They have therefore now established themselves as a firm." It was declared that the company would undertake the design and production of mural decoration, carving, stained glass, metalwork and furniture. Burne-Jones already had experience in the design of stained-glass windows and it was in this area that the Firm achieved its earliest success.

In the beginning, Morris, Marshall, Faulkner & Co. used the first-floor rooms of a house in Red Lion Square as showrooms and offices, and set up a furnace in the basement for the firing of stained glass and tiles. The Firm also subcontracted work to a nearby cabinetmaker, Mr. Curwen, and to the glass manufacturer James Powell & Sons. The wives and sisters of the partners were drawn into the Firm, while other independent designers such as William

geboren, die erste der beiden Töchter. Einige Monate später erschütterte Rossetti und Lizzie Siddal, die 1860 geheiratet hatten, die Totgeburt einer Tochter. Lizzie, die jahrelang Rossettis zahlreiche Affären, darunter die spektakuläre Liaison mit einem seiner Modelle, Fanny Cornforth, erduldet hatte, wurde nun abhängig von dem Opiat Laudanum. Wenige Monate vor der Geburt des zweiten Morris-Kindes, Mary (May), nahm Lizzie eine Überdosis Laudanum und starb. Rossetti war bei ihrem Tod von Schuldgefühlen überwältigt, und in seinem Schmerz suchte er Trost bei Jane. So begann eine skandalöse Dreiecksbeziehung.

## Morris, Marshall, Faulkner & Co.

1861 beschloß Morris, der zuvor weder einer mit einem Einkommen verbundenen Beschäftigung nachgegangen war noch Einkünfte aus *The Defence of Guinevere* bezogen hatte, sich eine Tätigkeit zu suchen – vor allem, weil er sich auf seine Dividenden aus der Devon Great Consols nicht mehr verlassen konnte. Er hatte einen Kennerblick für Qualität und ein natürliches Gespür für Materialien, Struktur, Farbe und Muster entwickelt. Diese Fähigkeiten waren wichtig für den Erfolg seines künftigen Unternehmens. Nach seiner Erfahrung mit der Innenausstattung des Red House faßte Morris, vielleicht auf Anregung von Ford Madox Brown, den Entschluß, eine Künstlergemeinschaft zu gründen, die in Entwurf und Ausführung qualitätvolle Objekte herstellen sollte. Die Firma Morris, Marshall, Faulkner & Co. war sicherlich von Henry Coles älterem Unternehmen Summerley's Art Manufactures beeinflußt, obwohl es deutliche Unterschiede gab. Während Cole das vorherrschende Design innerhalb der Gesellschaft reformieren wollte, hatte Morris – durch Ruskins Theorien inspiriert – ein revolutionäres Konzept, das die sozialen Aspekte der Gestaltung direkt anging und industrielle Methoden weitgehend verwarf.

Ursprünglich erhielten nur Morris und Faulkner ein Gehalt, während die anderen Partner, Brown, Rossetti, Burne-Jones und Webb, jeweils für ihre Entwürfe bezahlt wurden. Im April 1861 gab die Firma ihren ersten Prospekt heraus, in dem es hieß: „Diese Künstler haben sich jahrelang intensiv mit dem Studium der dekorativen Künste aller Zeiten und Länder beschäftigt und daher stärker als viele andere Menschen gespürt, daß es an einer Stätte mangelt, wo man wahrhaft schöne und unverfälschte Werke entweder erwerben oder herstellen lassen kann. Deshalb haben sie sich zu einer Firma zusammengeschlossen." Das Unternehmen empfahl sich für Entwurf und Herstellung von Wanddekorationen, Schnitzereien, Glasfenstern, Metallarbeiten und Möbeln. Burne-Jones konnte bereits Erfahrungen mit farbigen Glasfenstern vorweisen, und so hatte die Firma auf diesem Gebiet ihre ersten Erfolge.

une empathie naturelle pour les matériaux, la texture, la couleur et les motifs – autant de dons indispensables au succès de sa future entreprise. Suite à l'expérience faite avec la décoration de la Red House, Morris décida, probablement à l'instigation de Ford Madox Brown, de former une association d'artistes qui produirait des objets mieux conçus et mieux fabriqués. La création de Morris, Marshall, Faulkner & Co. s'inspira sans aucun doute du projet des Henry Cole Summerley's Art Manufactures, même si les deux entreprises étaient très différentes. Tandis que Cole cherchait à réformer le design au goût du jour par le biais de l'Establishment, Morris – marqué par les théories de Ruskin – tentait une approche révolutionnaire, qui condamnait totalement les aspects sociaux du design et rejetait en partie les méthodes industrielles.

Au départ, deux des sept partenaires seulement reçurent un salaire : Morris et Faulkner. Les autres, Brown, Rossetti, Burne-Jones et Webb, étaient payés à la tâche. Au mois d'avril 1861, la Firme publia une première brochure qui annonçait : « Ces artistes se sont consacrés pendant de nombreuses années à l'étude des arts décoratifs de tous les temps et de tous les pays. Mieux que quiconque, ils ont senti qu'il manquait un lieu où l'on pourrait se procurer des produits à la fois authentiques et beaux. C'est la raison pour laquelle ils ont aujourd'hui créé leur propre firme. » Il était également précisé que l'entreprise se chargeait de tout ce qui touchait à la décoration intérieure et de la réalisation des ornements muraux, de la sculpture, des vitraux, de la ferronnerie et du mobilier. Burne-Jones était déjà expérimenté dans la création de vitraux et c'est dans ce domaine que la Firme connut ses premiers succès.

Les artistes de Morris, Marshall, Faulkner & Co. commencèrent par utiliser comme salles d'expositions et comme bureaux les pièces du premier étage d'une maison située au Red Lion Square ; ils installèrent au sous-sol un four pour la cuisson des vitraux et des carrelages. La Firme confia également du travail en sous-traitance à un ébéniste voisin, M. Curwen, ainsi qu'à la verrerie James Powell & Sons. Les femmes et les sœurs des partenaires furent elles aussi amenées à travailler dans l'entreprise, tandis que des décorateurs indépendants, comme William De Morgan et W. A. S. Benson fournissaient des concepts. En outre, de jeunes Londoniens originaires de East End, sans ressources et sans compétence professionnelle particulière, étaient également employés et formés dans les ateliers.

En concentrant ses efforts principalement sur le travail manuel et sur les aspects commerciaux, Morris – un membre cultivé de la classe moyenne supérieure – répudiait les conventions sociales victoriennes séparant les « gentlemen » du prolétariat, et devint ainsi un artisan commerçant. Compte tenu de ses origines sociales, c'était là une activité jugée plutôt déshonorante. La Firme commença néanmoins à

**Philip Webb:**

Pair of candlesticks, 1861–1863

Kerzenhalter

Paire de chandeliers

**W. A. S. Benson:**

Table lamp retailed by Morris & Co., c. 1890

Tischlampe von Morris & Co., ca. 1890

Lampe de table, vendue par Morris & Co., vers 1890

**William De Morgan:**

Four-tile panel, 1890s

Vierfeldfliesen, 1890er Jahre

Panneau de quatre carreaux, années 1890

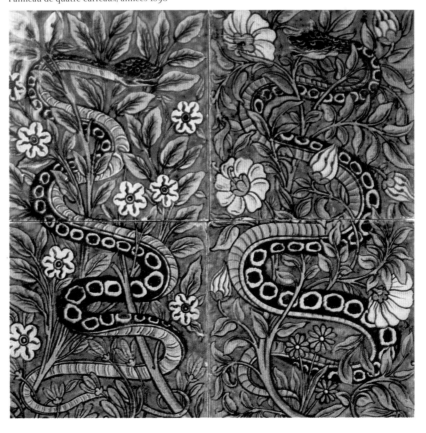

De Morgan and W. A. S. Benson supplied designs to it. Destitute and unskilled boys from London's East End were also employed and trained to work in the workshops.

By turning his attentions primarily to the practice of handwork and commercial endeavour, Morris – an educated member of the upper middle classes – repudiated the Victorian social convention that separated "gentlemen" from the working classes by becoming, in essence, a trading artisan. Given his background and social rank, this was considered a rather disreputable thing to do. Nevertheless, the Firm began to receive commissions, many of them ecclesiastical; fortuitously, the 1860s marked a highpoint in Victorian church building and restoration. Morris, Marshall, Faulkner & Co. exhibited its work, including the *King René's Honeymoon* cabinet designed by John Pollard Seddon and decorated by Morris, Burne-Jones, Rossetti and Ford Madox Brown, in the Medieval Court at the 1862 International Exhibition at South Kensington, to both acclaim and ridicule. The Firm was awarded two gold medals, not for its design innovation but for how faithfully it had reproduced the crafts of the Middle Ages.

Morris, Marshall, Faulkner & Co. owed its success almost entirely to Morris's ability to control and coordinate the Firm's creative output, and he threw himself wholeheartedly into numerous projects. As artistic director, Morris forged an instantly recognizable "look" which promoted the virtues of simplicity, utility, beauty, symbolism and quality. The many individual designs produced by the Firm not only fulfilled these criteria but also exemplified the attributes which Morris advocated through his well-known dictum – that one should "have nothing in your house that you do not know to be useful or believe to be beautiful"[14]. During his prolific career, Morris created over 600 designs for wallpapers and textiles and over 150 designs for stained glass.

In late 1864 Morris was recovering from a bout of rheumatic fever and was becoming tired of his daily commute from Bexleyheath to Red Lion Square. His visions of an artistic community centred at Red House, in which the Burne-Jones family would live in a proposed extension, were dashed by the latter's decision to remain in London due to a lack of funds, ill health and the loss of an infant through scarlet fever. Morris also had financial worries brought on by the poor financial performance of Morris, Marshall, Faulkner & Co., and the dwindling income received from Great Devon Consols stock. Eventually, he decided to move his family back to London. During this time, his marital relations with Jane worsened considerably, and it is probable she demanded the move back to the city which led to the sale of his beloved Red House the following year. With the increasing financial pressures and the dawning realization that his marriage would remain

Anfangs nutzten Morris, Marshall, Faulkner & Co. das erste Obergeschoß eines Hauses am Red Lion Square als Ausstellungs- und Büroetage und stellten im Keller einen Ofen für das Brennen von Glasscheiben und Fliesen auf. Die Firma gab auch Aufträge an den benachbarten Kunsttischler Curwen und an den Glashersteller James Powell & Sons weiter. Selbst die Frauen und Schwestern der Partner wurden in die Firma einbezogen, während andere unabhängige Gestalter wie William De Morgan und W. A. S. Benson Entwürfe lieferten. Auch notleidende ungelernte Jugendliche aus dem Londoner East End wurden angestellt und in den Werkstätten ausgebildet.

Mit seiner Hinwendung zum praktischen Handwerk und kommerziellen Unternehmertum verstieß Morris – ein gebildetes Mitglied der oberen Mittelschicht – gegen die gesellschaftlichen Regeln der viktorianischen Zeit, die „gentlemen" streng von der arbeitenden Bevölkerung schied. In seiner sozialen Stellung war es geradezu unehrenhaft, mit Kunsthandwerk Handel zu treiben. Dennoch erhielt die Firma immer mehr Aufträge, viele auch von der Kirche, denn die 60er Jahre erlebten einen Höhepunkt im viktorianischen Kirchenbau und in der Restaurierung von Sakralbauten. Die Firma stellte ihre Arbeiten, darunter die Truhe *König Renés Hochzeitsreise*, die John Pollard Seddon entworfen und Morris, Burne-Jones, Rossetti und Ford Madox Brown dekoriert hatten, 1862 im Mittelaltersaal der International Exhibition of Art and Industry in South Kensington vor. Sie erhielt zwei Goldmedaillen, nicht wegen ihres innovativen Designs, sondern wegen ihrer originalgetreuen Wiederbelebung mittelalterlicher Handwerkstechniken.

Morris, Marshall, Faulkner & Co. verdankten ihren Erfolg vor allem Morris' Fähigkeit, die Produktionszweige der Firma zu koordinieren. Er stürzte sich rückhaltlos in eine Vielzahl von Projekten. Als künstlerischer Direktor prägte Morris einen sofort erkennbaren „Stil", der die Tugenden von Einfachheit, Nützlichkeit, Schönheit, symbolischem Ausdruck und Qualität repräsentieren sollte. Die vielen individuellen Entwürfe der Firma erfüllten nicht nur diese Kriterien, sondern entsprachen auch Morris' bekanntem Diktum, man solle „nichts im Haus haben, was man nicht nützlich findet oder für schön hält".[14] Während seiner Laufbahn fertigte Morris mehr als 600 Entwürfe für Tapeten und Textilien und mehr als 150 Zeichnungen für farbige Glasfenster an.

Gegen Ende des Jahres 1864 wurde Morris von einem Anfall fiebrigen Gelenkrheumatismus geschwächt, und er war des täglichen Pendelns zwischen Bexleyheath und dem Red Lion Square müde. Sein Wunschtraum von einer Künstlergemeinschaft im Red House, wo die Familie Burne-Jones einen geplanten Anbau bewohnen sollte, zerrann, weil Burne-Jones sich entschloß, in London zu bleiben – wegen Geldmangels, seiner schlechten Gesundheit und des Todes eines seiner Kinder durch Scharlach.

Watercolour design from the Morris & Co. workshop, c. 1880s
Aquarellentwurf aus der Werkstatt von Morris & Co., 1880er Jahre
Aquarelle réalisée par l'atelier de Morris & Co., années 1880

**John Parsons:** Jane Morris
posed by Dante Gabriel Rossetti in his Cheyne Walk garden, July 1865
steht Dante Gabriel Rossetti in seinem Garten am Cheyne Walk Modell, Juli 1865
posant comme modèle pour Dante Gabriel Rossetti dans son jardin de Cheyne Walk, en juillet 1865

recevoir des commandes, beaucoup d'entre elles de
la part d'écclésiastiques. C'est dans les années 1860
du reste que culminèrent la construction et la res-
tauration des églises de l'époque victorienne. Mor-
ris, Marshall, Faulkner & Co. exposa ses objets manu-
facturés, y compris le cabinet *La Lune de Miel du Roi
René* (conçu par John Pollard Seddon et décoré par
Morris, Burne-Jones, Rossetti et Ford Madox Brown),
dans la Medieval Court de l'Exposition international-
le de 1862, à South Kensington. Deux médailles d'or
vinrent récompenser la Firme, non pas pour son in-
novation créatrice mais pour la fidélité avec laquelle
étaient reproduits les métiers du Moyen Âge.

Le succès de Morris, Marshall, Faulkner & Co.
était dû en grande partie au talent de Morris en ma-
tière de contrôle et de coordination de la produc-
tion. Il se lança lui-même à corps perdu dans de
nombreux projets. En qualité de directeur artis-
tique, Morris sut forger un « style » immédiatement
reconnaissable, prônant les vertus de la simplicité,
de l'utilité, de la beauté, du symbolisme et de la qua-
lité. Les nombreuses créations exclusives de la Firme
répondaient non seulement à ces critères mais illus-
traient aussi la fameuse maxime de Morris selon la-
quelle il ne faudrait « rien posséder chez soi que l'on
ne considère utile ou beau »[14]. Au cours de sa car-
rière, Morris créa plus de 600 motifs pour papiers
peints et textiles, et plus de 150 cartons de vitraux.

En 1864, Morris fut très affaibli par une fièvre rhu-
matismale. De plus, il était fatigué de faire la navette
entre Bexleyheath et Red Lion Square. Son idée
d'une communauté artistique basée à Red House –
la famille Burne-Jones aurait pu vivre dans une ex-
tension de la maison – ne put se réaliser. Le manque
de fonds et d'autres soucis, liés entre autres à la
perte d'un enfant mort de la scarlatine, l'obligèrent
à rester à Londres. Morris, Marshall, Faulkner & Co.
ne rapportait pas suffisamment, ni les actions de la
Great Devon Consol. Pendant toute cette période,
les relations conjugales des Morris se dégradèrent
considérablement et il est probable que ce soit Jane
qui ait demandé à revenir à Londres. La Red House,
si chère à Morris, fut vendue l'année suivante. De
plus en plus accablé par les problèmes financiers et
la prise de conscience que son mariage était un
échec – sa femme aimait un autre homme –, Morris
se plongea complètement dans son travail et entra
dans une période d'activité intense.

## Queen Square

À l'automne 1865, la famille Morris s'installa dans
une grande maison, au 26 Queen Square, à Blooms-
bury, suffisamment spacieuse pour accueillir aussi
Morris, Marshall, Faulkner & Co. Comme la Red
House, Queen Square permettait de présenter les
tapisseries à leur avantage. Pour compléter la déco-
ration intérieure, Jane, langoureuse maîtresse des

The Morris & Burne-Jones families, 1874
Die Familien Morris und Burne-Jones
Les familles Morris et Burne-Jones

loveless because his wife loved another, Morris immersed himself in his work and entered into a period of intense activity.

## Queen Square

In the autumn of 1865, the Morris family moved into a large house at 26, Queen Square. This Bloomsbury address also provided Morris, Marshall, Faulkner & Co. with the larger premises it now required. Like the Red House, Queen Square functioned as a showhouse and complementing the decorative scheme, Jane, the languorous mistress of the house, wore flowing unrestricting medieval-style costume. Effectively "living over the shop", Morris found he was becoming increasingly involved in the day-to-day running of the Firm. Of his fellow partners, too, Marshall had resumed his career as a surveyor and sanitary engineer, Faulkner had returned to Oxford and Rossetti was dedicating the majority of his time to painting. Despite the many orders it had received from the beginning, by 1865 the Firm was in trouble. This all came down to Morris, for although he was a highly competent design manager, he was not as financially astute as he could have been. This was due largely to Morris's personal expenditure and his over-generosity to his partners.

Realising that the Firm would fail unless it could be brought under financial control, Morris appointed George Warington Taylor as its business manager. Taylor, who suffered from consumption, held this position until his premature death in 1870 and was solely responsible for the Firm's dramatic financial turnaround. In 1869 Taylor decreed that Morris had to end his lavish entertaining and reduce his wine consumption to two-and-a-half bottles a day or he would bankrupt the Firm.

By introducing a more business-like ethos into the Firm and by curtailing Morris's spending, Taylor transformed the co-operative of artists into a well-run and increasingly profitable organization. Its range of designs became more market-orientated, with the Firm now producing somewhat plainer, English vernacular-inspired items such as the Sussex and Rossetti chairs, which were less costly than the earlier, highly decorated medieval-style furnishings. These new designs articulated a simpler, more democratic and accessible style that was to have much influence on later generations of designers.

In 1866 the Firm secured two important public commissions: the redecoration of the Armoury and Tapestry Room at St James's Palace and the interior design of the Green Dining Room at the South Kensington Museum. These projects brought official recognition to the Firm as well as much-needed profits. Both schemes are in the company's highly decorated "state" style with a plethora of different patterns producing a feeling of overwhelming rich-

Auch Morris hatte finanzielle Sorgen, weil die Firma nicht genug einbrachte und die Einkünfte aus der Devon Great Consols dahinschwanden. Schließlich entschied er sich, mit seiner Familie nach London zurückzukehren. Zu dieser Zeit gab es bereits schwere Spannungen in seiner Ehe mit Jane. Es ist möglich, daß sie die Rückkehr in die Stadt forderte, was dazu führte, daß Morris sein geliebtes Red House im folgenden Jahr verkaufte. Angesichts des wachsenden finanziellen Drucks und der Erkenntnis, daß seine Ehe ohne Zuneigung bleiben würde, weil seine Frau einen anderen liebte, vertiefte sich Morris in seine Arbeit, und es begann eine Periode intensiver Aktivität.

## Queen Square

Im Herbst 1865 zog die Familie Morris in ein großes Haus am Queen Square 26. In diesem Gebäude in Bloomsbury fand auch die Firma Morris, Marshall, Faulkner & Co. die nun benötigten größeren Räume. Queen Square diente auch als Ausstellungsstätte, und passend zum Dekor trug Jane, die Hausherrin, fließende Gewänder im mittelalterlichen Stil. Da Morris nun „über dem Laden" wohnte, war er stärker in den täglichen Betrieb der Firma eingebunden. Sein Partner Marshall hatte seine Tätigkeit als Vermessungs- und Sanitäringenieur wieder aufgenommen, Faulkner war nach Oxford zurückgekehrt, und Rossetti widmete sich meistens der Malerei. Trotz der vielen Aufträge, die sie von Anfang an erhalten hatte, geriet die Firma um 1865 in Schwierigkeiten. Dies alles stürzte nun auf Morris ein, der zwar ein sehr fähiger künstlerischer Leiter, in finanziellen Belangen aber nicht unbedingt geschickt war – nicht zuletzt wegen seiner hohen persönlichen Ausgaben und seiner Großzügigkeit gegenüber den Partnern.

Als er merkte, daß die Firmenbilanz außer Kontrolle geriet, ernannte Morris George Warington Taylor zum Geschäftsführer. Taylor hatte diese Stellung bis zu seinem frühen Tod an Schwindsucht im Jahr 1870 inne, und die deutliche Verbesserung der finanziellen Verhältnisse war allein ihm zu verdanken. 1869 brachte er Morris dazu, seine kostspieligen Einladungen einzustellen und den Weinkonsum auf zweieinhalb Flaschen pro Tag zu beschränken; andernfalls würde die Firma bankrott gehen.

Mit der stärkeren Konzentration auf die kaufmännische Effizienz der Firma und der Beschränkung von Morris' Ausgaben verwandelte Taylor die Künstlergenossenschaft in ein florierendes und zunehmend profitables Unternehmen. Die Entwürfe orientierten sich stärker am Markt. Die Firma stellte nun einfachere, von englischen Regionalstilen inspirierte Objekte wie die Sussex- und die Rossetti-Stühle her, die preiswerter waren als die älteren Möbel mit reichem Dekor im mittelalterlichen Stil. Diese

*"Simplicity of life, even the barest, is not a misery, but the very foundation of refinement. This simplicity you may make as costly as you please or can."*
WILLIAM MORRIS, 1880

**Dante Gabriel Rossetti:**
*The Bard and Petty Tradesman,* 1868
*Der Barde und der kleine Geschäftsmann*
*Le Barde et le Petit Commerçant*

lieux, portait d'amples vêtements de style médiéval.
Comme il vivait «au-dessus du magasin», Morris
était fortement impliqué dans les affaires quoti-
diennes de la Firme. Marshall avait repris sa carrière
d'expert et d'ingénieur sanitaire, Faulkner était re-
parti à Oxford et Rossetti consacrait la majeure par-
tie de son temps à sa peinture. Malgré les nom-
breuses commandes qu'elle avait reçues depuis sa
création, la Firme dut affronter en 1865 d'impor-
tantes difficultés. Tout cela retombait sur Morris, ex-
cellent directeur artistique mais gestionnaire finan-
cier peu adroit, ce qui s'expliquait en grande partie
par les dépenses personnelles de Morris et par sa
générosité excessive à l'égard de ses partenaires.

Morris finit par admettre que la Firme courait à
la ruine si elle n'était pas rapidement placée sous
contrôle financier. Il engagea donc George Waring-
ton Taylor comme directeur commercial. Taylor, qui
souffrait de consomption, assura cette charge
jusqu'à sa mort précoce en 1870. C'est à lui seul que
revient le revirement financier spectaculaire de l'en-
treprise. En 1869, Taylor décréta que Morris devait
mettre fin à son hospitalité prodigue et réduire sa
consommation de vin à deux bouteilles et demie par
jour, s'il ne voulait pas mener la Firme à la faillite.

En renforçant le credo commercial au sein de
l'entreprise et en restreignant les dépenses de
Morris, Taylor fit de la coopérative d'artistes une
compagnie bien gérée et de plus en plus rentable.
Les produits proposés, plus simples et d'inspiration
traditionnelle locale, comme les chaises du Sussex
conçues par Rossetti, répondaient désormais davan-
tage aux besoins du marché et étaient beaucoup
moins coûteux que les premiers meubles de style
médiéval richement décorés. Ces nouvelles créa-
tions déclinaient un style plus familier, plus démo-
cratique, plus accessible, qui allait exercer une forte
influence sur les générations suivantes de designers.

En 1866, la Firme reçut deux commandes pu-
bliques importantes : la restauration de la salle des
armes et des tapisseries de St James's Palace et la
décoration intérieure de la salle à manger verte du
South Kensington Museum. Ces projets apportèrent
non seulement la reconnaissance officielle à la
Firme, mais aussi des gains dont elle avait grande-
ment besoin. Ces deux projets, réalisés dans le style
« apparat » caractéristique de l'entreprise – profu-
sion de motifs ornementaux –, donnent avant tout
une impression d'opulence. La Firme réalisa égale-
ment plusieurs projets de décoration intérieure
pour des clients comme les artistes Birket Foster et
Val Prinsep. Depuis que Taylor occupait le poste de
directeur commercial, Morris pouvait davantage se
consacrer à la poésie qui lui permettait aussi
d'échapper à sa pénible situation conjugale.

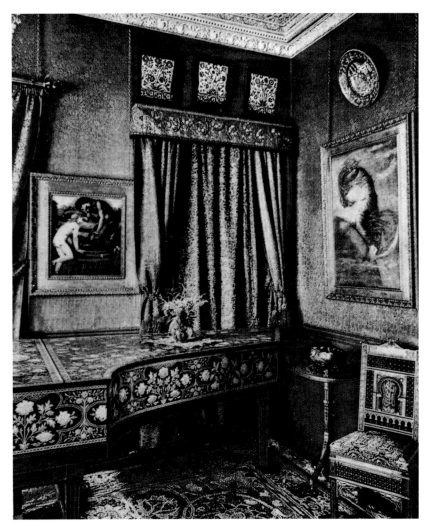

The second drawing room at 1, Holland Park, London, 1893 (*Art Journal* 1893)
Zweiter Salon in Holland Park 1, London
Le second salon de la résidence londonienne du 1, Holland Park

The Earl of Carlisle's residence, at 1, Palace Gate, London, designed by Philip Webb and decorated by
William Morris incorporating the *Cupid and Psyche* frieze painted by Edward Burne-Jones
Die Residenz des Earl of Carlisle, Palace Gate 1, London, entworfen von Philip Webb, Innenausstattung
von William Morris mit dem gemalten Fries *Cupid and Psyche* von Edward Burne-Jones
La résidence du comte de Carlisle, au 1, Palace Gate, Londres, conçue par Philip Webb et décorée par
William Morris. Edward Burne-Jones a peint la frise *Cupidon et Psyché*

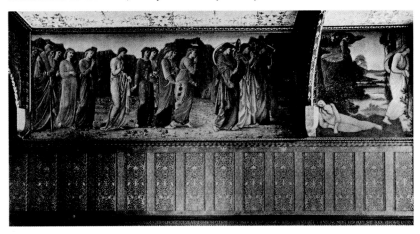

**John R. Parsons:** Jane Morris
posed by Dante Gabriel Rossetti
in his Cheyne Walk garden, July
1865
sitzt Dante Gabriel Rossetti in
seinem Garten am Cheyne Walk
Modell, Juli 1865
posant comme modèle pour
Dante Gabriel Rossetti dans son
jardin de Cheyne Walk, en juillet
1865

**Dante Gabriel Rossetti:**
*The M's at Ems,* 1869
*Die M's in Ems*
*Les M's à Ems*

ness. The Firm also undertook many private interior design projects for clients such as the artists Birket Foster and Val Prinsep. With Taylor as business manager, Morris was now able to devote more time to poetry and this offered an escape from his difficult marital arrangements.

### The Earthly Paradise

Morris began composing *The Earthly Paradise* in 1865. The form of this cycle of narrative poems, his most famous written work, was inspired both by Chaucer's *Canterbury Tales* and more specifically by Boccaccio's *Decameron*. This 40,000 line epic poem, which Morris referred to as "The Big Story Book", included 23 stories from Greek mythology and Norse legends and one of Arabic origin. Edward Burne-Jones designed over 500 woodcut illustrations for it. Of these, Morris cut over 50 himself and in so doing, mastered the art of block cutting. When it was first published, however, only one woodcut was used and that was placed on the frontispiece.

For Morris, poetry was not a special vocation but just another craft to be mastered. Unlike *The Defence of Guinevere*, the first volume of *The Earthly Paradise*, which was published in 1868, received much critical acclaim and sold extremely well. Its title predicts Morris's later political struggle against "the ugliness of life lived penuriously and repressively"[15] and his yearning for a modern and humane Utopia. For a decade after its publication, Morris was the most popular poet in England.

Paradoxically, although Morris was one of the most celebrated Romantic poets of his time, he acknowledged his own emotional retentiveness and blamed it on his Englishness. Nevertheless, he had deeply held libertarian views, and it was in this light that he attempted to ignore his wife's infidelities. While Morris was always more at ease in the company of men, he did become a close confidant of Georgiana Burne-Jones when her husband fell in love with the Greek sculptress Mary Zambaco. It is likely that Morris and Georgiana had a brief affair and certainly they remained emotionally, if not physically, tied for many years. Morris was later to become an advocate of free love.

While living at Queen Square, Jane's relationship with Rossetti deepened, and with Morris's complicity she frequently sat unchaperoned for him at his house in Cheyne Walk. The series of professionally taken photographs of Jane posed by Rossetti in his garden from July 1865 have distinct erotic undertones and bear witness to their intimacy. By now, Jane and Rossetti's affair was common knowledge in certain London circles. Revealingly, Rossetti's poetry from this period regales the joys of love, while Morris's *Earthly Paradise* laments autobiographically over the loss of love and the pain of unrequited love.

neuen Entwürfe waren Ausdruck eines einfacheren, demokratischeren und populäreren Stils, der einen starken Einfluß auf spätere Designergenerationen ausüben sollte.

1866 erhielt die Firma zwei wichtige öffentliche Aufträge: die Neudekoration des Armoury and Tapestry Room im St. James's Palace und die Innenausstattung des Grünen Speisezimmers im South Kensington Museum. Diese Projekte brachten der Firma offizielle Anerkennung und den so sehr benötigten Profit ein. Beide waren im stark ornamentalen „Prachtstil" des Unternehmens mit einer Überfülle unterschiedlicher Muster gehalten und riefen den Eindruck überwältigenden Reichtums hervor. Die Firma führte auch zahlreiche private Aufträge für Kunden wie die Künstler Birket Foster und Val Prinsep aus. Da Taylor nun die Geschäfte leitete, hatte Morris mehr Zeit zum Dichten und konnte so seinen Eheproblemen entfliehen.

### Das irdische Paradies

Morris begann die Arbeit an *The Earthly Paradise* (*Das irdische Paradies*), seinem bekanntesten schriftstellerischen Werk, im Jahre 1865. Der Zyklus epischer Gedichte ist von Chaucers *Canterbury Tales* und vor allem von Boccaccios *Decamerone* inspiriert und spielt im 14. Jahrhundert. Dieses 40 000 Verse umfassende Werk, das Morris selbst als „großes Geschichtenbuch" bezeichnete, enthält 23 Erzählungen aus der griechischen Mythologie und der nordischen Sagenwelt sowie eine arabischen Ursprungs. Edward Burne-Jones entwarf über 500 Holzschnitte zur Illustration des Buches, und Morris schnitt mehr als 50 davon selbst und erlernte dabei diese Fertigkeit. Doch für die Erstveröffentlichung wurde nur ein Holzschnitt verwendet – auf dem Frontispiz.

Für Morris war das Dichten keine besondere Berufung, sondern lediglich ein weiteres Handwerk, das er meistern konnte. Anders als *The Defence of Guinevere* wurde der erste Band von *The Earthly Paradise* (1868 veröffentlicht) begeistert aufgenommen und verkaufte sich hervorragend. Der Titel nimmt Morris' zukünftigen politischen Kampf gegen „die Häßlichkeit eines Lebens in Kargheit und Unterdrückung"[15] und seine Sehnsucht nach einem modernen, humanen Utopia vorweg. Nach der Veröffentlichung war Morris für ein Jahrzehnt der populärste Dichter Englands.

Obwohl Morris einer der gefeiertsten romantischen Dichter seiner Zeit war, stellte er bei sich selbst paradoxerweise eine große emotionale Zurückhaltung fest, die er seiner englischen Herkunft zuschrieb. Er hatte zutiefst liberale Überzeugungen und versuchte deshalb, die Untreue seiner Frau zu ignorieren. Er fühlte sich in der Gesellschaft von Männern stets wohler, wurde aber ein enger Vertrauter von Georgiana Burne-Jones, als deren Ehe-

## Le Paradis terrestre

Morris commença à écrire *The Earthly Paradise* (*Le Paradis terrestre*), son œuvre la plus célèbre, en 1865. La forme s'inspire des *Contes de Canterbury* de Chaucer, et peut-être plus encore du *Décaméron* de Boccace. L'action se déroule au XIVe siècle. Ce poème épique de 40.000 vers, que Morris qualifia de « Livre de la grande Histoire », comprend 23 récits tirés de la mythologie grecque et des légendes nordiques, et un récit d'origine arabe. Edward Burne-Jones réalisa plus de 500 illustrations gravées sur bois et Morris grava lui-même plus de 50 de ces dessins, ce qui lui permit de parfaitement maîtriser cet art. Pour la première édition cependant, une seule gravure fut utilisée et placée en frontispice.

Pour Morris, la poésie n'était pas une vocation particulière, juste une autre forme artistique qu'il voulait maîtriser. À la différence de *The Defence of Guinevere*, ce premier volume du *Earthly Paradise*, publié en 1868, fut acclamé par la critique et se vendit extrêmement bien. Son titre annonce la lutte politique que Morris allait bientôt mener contre « la laideur de la vie vécue dans la pénurie et la répression »[15] et son aspiration à une utopie moderne et humaine. Pendant les dix années qui suivirent la publication de ce livre, Morris fut le poète le plus populaire d'Angleterre.

Paradoxalement, bien qu'il fût un des poètes romantiques les plus célébrés de son temps, Morris reconnaissait avoir une certaine réserve émotionnelle qu'il mettait sur le compte de son « anglicité ». Il avait toutefois des idées profondément libérales et c'est à leur lumière qu'il tentait d'ignorer les infidélités de sa femme. Alors que Morris s'était toujours senti plus à l'aise en compagnie des hommes, il devint le confident intime de Georgiana Burne-Jones lorsque son mari tomba amoureux du sculpteur grec Mary Zambaco. Il est probable que Morris et Georgiana eurent une brève relation, et ils restèrent liés pendant de nombreuses années. Morris devait par la suite devenir un défenseur de l'amour libre.

À Queen Square, la relation entre Rossetti et Jane s'intensifiait. C'est même avec la complicité de Morris que sa femme posait fréquemment pour son amant, dans sa maison de Cheyne Walk. Les photographies de Jane dans le jardin de Rossetti à partir de juillet 1865 ont des tonalités nettement érotiques et témoignent de l'intimité des deux amants. La liaison de Jane et de Rossetti était désormais de notoriété publique dans certains cercles londoniens. La poésie de Rossetti datant de cette période chante de manière révélatrice les joies de l'amour, tandis que le *Earthly Paradise* de Morris déplore le manque d'amour et la douleur de l'amour non partagé.

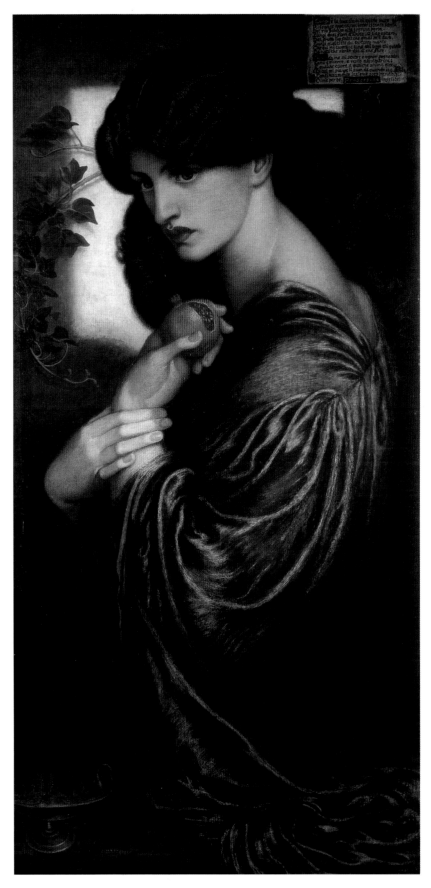

**Dante Gabriel Rossetti:** *Prosperine*, 1874

Between 1871 and 1877, Rossetti painted Jane Morris as Prosperine, the Queen of Hades, a total of eight times. Rossetti may well have seen Jane as queen of his own personal hell and his addiction to her as a force driving him to self-destruction.

Zwischen 1871 und 1877 malte Rossetti Jane Morris insgesamt achtmal als Proserpina, Herrscherin des Hades. Vielleicht sah er Jane als Herrscherin seiner persönlichen Hölle und seine Abhängigkeit von ihr als Selbstzerstörung.

Entre 1871 et 1877, Rossetti peignit huit fois Jane Morris dans le rôle de Prosperine, la Reine des Enfers. Il est possible que Rossetti ait considéré Jane comme la reine de son propre enfer et que son attachement pour elle l'ait conduit à l'autodestruction.

## Bad Ems and marital problems

From early August 1869, Jane and Morris spent six weeks at the German spa town of Bad Ems so that she could take a cure for what was in all likelihood a gynaecological ailment. The copious correspondence between Jane and Rossetti must have been vexing for Morris: many of the letters from Rossetti were illustrated with darkly satirical cartoons that were sarcastic references to the Morrises' marriage. While the Morrises were at Bad Ems, Rossetti became deeply melancholic and began to display suicidal tendencies.

Shortly after his return from Bad Ems, Morris turned his attention to the art of calligraphy, and between 1870 and around 1875 planned and to varying degrees executed some 21 manuscript books. Of these, only two were completed, while the other unfinished projects were represented by trial pages and manuscript fragments. Morris was also busy with his translations of Icelandic sagas during this same period, and it is not surprising that many of his manuscript books borrowed texts from these works. Inspired by medieval, Carolingian and Renaissance manuscripts, Morris used a quill rather than a steel nib and developed five scripts for the books. Through his efforts, Morris revived and renewed the painstaking art of calligraphy and his manuscript books should be considered intensely personal expressions of his creativity. One such work, *A Book of Verse*, was given to Georgiana Burne-Jones as a birthday present, and with its remarkably rich detailing, was truly a labour of love. But by now, Morris had another intimate female confidante, Aglaia Coronio, the daughter of his friend and client, Alexander Ionides.

In the spring of 1871, Morris began searching for a country residence for the ostensible reason that his daughters' health would benefit from the change of air. It is quite likely, however, that Morris realized his wife's affair with Rossetti needed to be conducted away from the scrutiny of London circles if the family were to avoid public scandal. On 21 May, Morris and Rossetti duly signed a joint lease on Kelmscott Manor, a beautiful Elizabethan house set deep in the Cotswold countryside. The unpretentious manor house became his rural ideal.

Rossetti moved into Kelmscott Manor prior to Jane and her daughters' arrival in June and commandeered the Tapestry Room for a studio. As soon as his family was installed, Morris left for Iceland, although prior to his departure he wrote to his wife entreating her to find happiness. By taking out the joint tenancy of Kelmscott with Rossetti, Morris provided a more stable environment for Rossetti's affair with Jane and in so doing, clearly demonstrated his acquiescence to it.

mann sich in die griechische Bildhauerin Mary Zambaco verliebte. Wahrscheinlich hatten Morris und Georgiana eine kurze Affäre. Sicher ist, daß sie auf einer emotionalen, wenn nicht darüber hinausgehenden Ebene viele Jahre miteinander verbunden blieben. Morris wurde später zu einem engagierten Verfechter der Entscheidungsfreiheit in Sachen Liebe.

In der Zeit am Queen Square vertiefte sich Janes Beziehung zu Rossetti. Mit Morris' stillschweigendem Einverständnis saß sie dem Maler häufig allein in seinem Haus am Cheyne Walk Modell. Die Serie professioneller Fotografien, die im Juli 1865 in Rossettis Garten entstand, hat eine deutliche erotische Färbung und zeugt von der Intimität zwischen Jane und Rossetti. Mittlerweile war die Affäre zwischen den beiden in London allgemein bekannt. Es spricht für sich, daß Rossettis Gedichte aus dieser Zeit die Freuden der Liebe besingen, während Morris' *Earthly Paradise* den Liebesverlust und den Schmerz unerwiderter Liebe beklagt.

## Bad Ems und häusliche Probleme

Ab Anfang August 1869 verbrachten Jane und Morris sechs Wochen in dem deutschen Kurort Bad Ems, wo sie wahrscheinlich ein Frauenleiden behandeln lassen wollte. Besonders quälend für Morris war sicherlich der umfangreiche Briefwechsel zwischen Jane und Rossetti: Viele Briefe Rossettis waren mit finsteren satirischen Zeichnungen illustriert, die das Eheleben der Familie Morris kommentierten. Während Jane und Morris in Bad Ems weilten, fiel Rossetti in eine tiefe Melancholie und begann, sich mit Selbstmordgedanken zu tragen.

Kurz nach der Rückkehr aus Bad Ems wandte sich Morris der Kalligraphie zu. Zwischen 1870 und 1875 plante er 21 handgeschriebene Bücher. Nur zwei wurden vollendet, während von den unfertigen Projekten Probeseiten und Manuskriptfragmente erhalten blieben. Zugleich beschäftigte sich Morris mit der Übersetzung isländischer Sagas, und es überrascht nicht, daß viele seiner Bücher Texte aus diesen Werken enthielten. Von den Handschriften der Karolinger, des Mittelalters und der Renaissance inspiriert, benutzte Morris einen Federkiel statt einer Stahlspitze und entwickelte fünf Schrifttypen für die Bücher. Er verlieh der Sorgfalt erfordernden Kunst der Kalligraphie neues Leben, und seine handgeschriebenen Bücher sollten als intensiver Ausdruck seiner persönlichen Kreativität betrachtet werden. Eines dieser Werke, *A Book of Verse*, schenkte er Georgiana Burne-Jones zum Geburtstag. Mit seinem außergewöhnlichen Detailreichtum war es sicherlich Ausdruck seiner Zuneigung zu ihr.

Im Frühjahr 1871 begann Morris ein Haus auf dem Lande zu suchen, vorgeblich, weil der Ortswechsel der Gesundheit seiner Töchter förderlich sei. Wahr-

## Bad Ems et les problèmes conjugaux

Au début du mois d'août 1869, Jane et Morris partirent passer six semaines en Allemagne, dans la station thermale de Bad Ems, afin que Jane pût soigner ce qui avait tout lieu de ressembler à une affection gynécologique. Pour Morris, le copieux échange épistolaire entre Jane et Rossetti fut particulièrement irritant, d'autant plus que de nombreuses lettres de Rossetti étaient illustrées de dessins tristement satiriques et profondément sarcastiques à l'égard du mariage des Morris. Pendant que les Morris étaient à Bad Ems, Rossetti sombra dans une profonde mélancolie et commença même à présenter des tendances suicidaires.

Peu après son retour de Bad Ems, Morris s'intéressa à l'art de la calligraphie, et entre 1870 et 1875 conçut quelque 21 livres manuscrits. Sur l'ensemble, deux seulement furent terminés, tandis que les autres projets restés inachevés furent présentés sous forme de pages choisies et de fragments manuscrits. Parallèlement, Morris était fort occupé par ses traductions de sagas islandaises dans lesquelles il puisa des textes pour ses propres livres manuscrits. Inspiré par des récits de l'époque carolingienne, du Moyen Âge et de la Renaissance, Morris utilisait une penne d'oie plutôt qu'une plume d'acier et recourut à cinq écritures différentes. Par son travail, il contribua à ressusciter, tout en le renouvelant, l'art minutieux de la calligraphie. Ses ouvrages manuscrits sont autant d'expressions intimes de sa créativité. Il offrit une de ces œuvres, *A Book of Verse*, à Georgiana Burne-Jones pour son anniversaire – véritable preuve d'amour, si l'on considère la remarquable richesse des détails.

Au printemps 1871, Morris se mit en quête d'une résidence à la campagne, sous prétexte que le changement d'air ferait du bien à ses filles. Il est beaucoup plus probable qu'il se soit rendu compte que la liaison de sa femme avec Rossetti devait être tenue loin de la curiosité des cercles londoniens si la famille voulait éviter le scandale. Le 21 mai, Morris et Rossetti signèrent dûment et conjointement un bail pour Kelmscott Manor, une superbe maison élisabéthaine, nichée au cœur du paysage rural des Cotswolds. Ce manoir sans prétention ne devait pas tarder à devenir son idéal rural.

Rossetti vint s'installer au Kelmscott Manor avant l'arrivée de Jane et de ses filles prévue pour le mois de juin, et réquisitionna la salle des Tapisseries pour en faire son atelier. Dès que sa famille eut emménagé, Morris partit pour l'Islande. Avant son départ, il écrivit une lettre à sa femme dans laquelle il l'exhortait à trouver le bonheur. En consentant à louer Kelmscott avec Rossetti, Morris procurait un environnement plus stable à sa liaison avec Jane, et par là même, signifiait clairement son acquiescement.

Kelmscott Manor
Part of the west façade from the garden
Teil der Westfassade vom Garten gesehen
Partie de la façade ouest, vue du jardin

## The Icelandic Saga

Morris made two trips to Iceland, one in the summer of 1871 and the other in 1873. These journeys to a land untouched by industrialization were to have a great effect on Morris's political thinking. Although he encountered the "grinding poverty" of its people, he felt these poor citizens were better off than their "wage-slave" contemporaries in Britain, because they did not exist in a society torn apart by a class system. For him, Iceland's early and primitive democracy was a protomedieval manifestation of a socialist system and therefore worthy of deep admiration.

Travelling with three male companions on his first six-week visit, Morris was able to escape the insidious and damaging influence of Rossetti. His fellow travellers were his long-time colleague Charles Faulkner, Mr W. H. Evans of Forde Abbey in Dorset (a recent acquaintance) and the Icelandic linguist Eiríkr Magnússon. From their first meeting in 1869, Magnússon had taught Icelandic to Morris and assisted him with his translations of the sagas.

Experiencing nature at its most extreme, Morris and his friends set off on a pilgrimage to the landmarks described in the sagas he knew and loved so well. The near-monastic simplicity of life in Iceland powerfully reinforced Morris's belief in the inherent morality of dematerialism in design and the social importance of crafts. Indeed, this Icelandic odyssey marked a turning point in his life – having been pushed to his physical and mental limits, he now returned to England spiritually rejuvenated.

## The Rural Ideal

On his return home, Morris delighted in his new country residence, Kelmscott Manor, a modestly sized Elizabethan manor house that he described as "heaven on earth". Morris came to view the Cotswolds as the mystic centre of England's beautiful verdant countryside. The small and remote hamlet of Kelmscott itself corresponded entirely with his ideal of a self-sufficient rural community and inspired his later Utopian novel, *News from Nowhere*. Importantly, Morris's promotion of communities such as these influenced later social reformers and led to the building of garden cities.

In the spring of 1872, Morris went down to Kelmscott with the plan that Jane and their children would follow in the summer. When the time came, however, they were delayed in London because Rossetti had suffered a complete nervous breakdown. By early June, Rossetti descended into increasing paranoia and began hearing voices and ringing bells. By the end of September he nevertheless returned to Kelmscott and remained there until 1874, when even Jane had to accept the seriousness

scheinlich wollte er jedoch eher die Affäre seiner Frau mit Rossetti dem Blickfeld der Londoner Gesellschaft entziehen, um einen öffentlichen Skandal zu vermeiden. Am 21. Mai unterschrieben Morris und Rossetti einen gemeinsamen Mietvertrag für Kelmscott Manor, ein schönes elisabethanisches Haus in den ländlichen Cotswolds. Dieses Herrenhaus wurde Morris' ländliches Ideal.

Rossetti zog in Kelmscott Manor ein, bevor Jane und ihre Töchter im Juni ankamen, und beanspruchte den Tapisserieraum als Atelier. Sobald seine Familie sich eingerichtet hatte, fuhr Morris nach Island. Zuvor schrieb er noch an seine Frau, um ihr Glück zu wünschen. Durch den gemeinsamen Mietvertrag mit Rossetti hatte er eine stabilere Umgebung für dessen Beziehung zu Jane geschaffen und damit auch eindeutig seine Einwilligung demonstriert.

## Die Island-Saga

Morris unternahm zwei Reisen nach Island, eine im Sommer 1871 und eine weitere 1873. Diese Fahrten in ein Land, das von der Industrialisierung unberührt geblieben war, hinterließen einen starken Eindruck bei ihm und beeinflußte sein politisches Denken. Obwohl er die „bittere Armut" der Menschen kennenlernte, fand er ihr Los erträglicher als das der „Lohnsklaven" in England, weil sie nicht in einer Gesellschaft lebten, die durch ein Klassensystem gespalten war. Für ihn war die frühe, primitive Demokratie Islands die Urform eines sozialistischen Systems und deshalb tiefer Bewunderung würdig.

Durch die erste sechswöchige Fahrt mit drei Gefährten konnte Morris sich dem negativen Einfluß Rossettis entziehen. Die Mitreisenden waren sein langjähriger Kollege Charles Faulkner, W. H. Evans aus Forde Abbey in Dorset (ein neuerer Bekannter) und der isländische Linguist Eiríkr Magnússon. Seit ihrer ersten Begegnung 1869 hatte Magnússon Morris Isländisch gelehrt und ihm bei der Übersetzung der Sagas geholfen.

Morris und seine Freunde begaben sich in der extremen Natur auf eine Pilgerreise zu den Orten, die in den Sagas beschrieben wurden und die Morris so gut kannte. Tatsächlich markierten diese isländischen Reiseeindrücke einen Wendepunkt in seinem Leben. Er war bis an seine physischen und psychischen Grenzen gegangen und kehrte nun seelisch verjüngt nach England zurück.

## Das ländliche Ideal

Nach seiner Rückkehr genoß Morris sein neues Landhaus Kelmscott Manor, einen bescheidenen elisabethanischen Herrensitz, den er als „Himmel auf Erden" bezeichnete. Die Cotswolds wurden für

*"The greatest side of art is the art of daily life which historical buildings represent … for making the past part of the present."*
WILLIAM MORRIS

## La saga islandaise

Morris entreprit deux voyages en Islande, l'un pendant 1871, l'autre en 1873. Ces expéditions dans ce pays épargné par l'industrialisation eurent un impact important sur la pensée politique de Morris. Bien qu'il fût confronté à «l'accablante pauvreté» de ses habitants, il sentait que dans leur dénuement ces gens allaient beaucoup mieux que leurs contemporains britanniques, «esclaves salariés», parce qu'ils ne vivaient pas dans une société déchirée par un système de classes. À ses yeux, la toute première démocratie de l'Islande était la manifestation «protomédiévale» d'un système socialiste et donc admirable.

Morris voyagea en compagnie de trois amis pendant les six premières semaines de son séjour et put ainsi échapper à l'influence insidieuse et nocive de Rossetti. Ses compagnons de voyage étaient ses collègues de longue date, Charles Faulkner, M. W. H. Evans de Forde Abbey, dans le Dorset (une connaissance récente), et le linguiste islandais Eiríkr Magnússon. Depuis leur première rencontre en 1869, Magnússon avait appris l'islandais à Morris et l'avait aidé dans ses travaux de traduction.

Morris et ses camarades firent l'expérience extrême de la nature. Ils entreprirent un pèlerinage vers les points de repère décrits dans les sagas que Morris connaissait si bien et qu'il aimait tant. L'odyssée islandaise marqua effectivement un tournant dans sa vie. À bout de ses limites physiques et nerveuses, il rentra en Angleterre rajeuni sur le plan spirituel.

## L'idéal rural

À son retour, Morris retrouva avec plaisir sa nouvelle résidence de Kelmscott Manor, ce petit manoir qui était pour lui «le paradis sur terre». Cette retraite pastorale on ne peut plus idyllique renforça chez Morris le goût de la nature. Il en vint même à considérer les Cotswolds comme le cœur mystique du magnifique paysage verdoyant anglais. Le petit hameau isolé de Kelmscott correspondait entièrement à son idéal de communauté rurale autarcique et inspira son dernier roman utopique *News from Nowhere* (*Nouvelles de nulle part*).

Au printemps 1872, Morris se rendit à Kelmscott avec l'idée que Jane et les enfants suivraient dès l'été. Or quand le moment fut venu, ils furent retenus à Londres, à cause de Rossetti, en proie à une profonde dépression nerveuse. Au début du mois de juin, celui-ci, atteint de paranoïa, se mit à entendre des voix et des sons de cloches. Fin septembre, il retourna néanmoins à Kelmscott et y resta jusqu'en 1874 ; Jane finit par admettre la gravité de son état mental. Les pressions sur Morris étaient à ce moment-là très fortes. Pendant cette période, il publia

Kelmscott Manor
View from the kitchen garden, from a drawing by E. H. New
Blick aus dem Küchengarten, nach einer Zeichnung von E. H. New
Depuis le jardin côté cuisine, d'après un dessin de E. H. New

of his mental condition. The pressures on Morris at the time were immense. During this period Morris published *Love is Enough*, a poem which reflected his own complex relationships with Rossetti, Jane and Georgiana.

In 1872 the Morris family and the Firm moved to Horrington House in Turnham Green, to allow for more showroom space and a small dye house at Queen Square. A year later Morris designed his first chintzes, which were produced by Thomas Clarkson. Unhappy, however, with the fastness of the dyes used, Morris began exploring the techniques of textile dyeing and made frequent visits to Leek in Staffordshire, then a major centre for the silk industry. Here he was introduced to the art of dyeing by Thomas Wardle. With his arms plunged into enormous vats of indigo and wearing a workman's blouse and sabots, Morris was filled with joy as he undertook this "delightful work, hard for the body and easy for the mind"[16].

The trips to Leek also brought Morris to a better understanding of the effects of industrialization. Although he did not disagree with the workers' long hours, he found the mind-numbing repetition of the production line repugnant. It was the compartmentalization of the industrial process that was of most concern to him, because he believed that through the division of labour the worker's well-being and the arts as a whole were harmed. But Morris was not opposed to mechanization if it could be used to produce items of quality, and indeed some Morris & Co. carpets were machine woven. He did, however, object to modern aniline dyes which were unstable and often garish in tone and insisted on the use of age-old vegetable dye recipes which provided subtler tones.

During this period, Jane spent the majority of her time at Kelmscott with the increasingly erratic Rossetti. By the spring of 1874, however, Morris could no longer bear his presence there and threatened to relinquish his own share of the lease on the Manor unless Rossetti moved out. Over this turbulent period, the Morris family holidayed in Bruges with the Burne-Joneses. While they were away, Rossetti had an ugly contretemps with a group of anglers whom he believed were persecuting him and so, requiring no more persuading, was hastily removed from Kelmscott by his hangers-on.

Now Rossetti-free, Kelmscott was to become Morris's most cherished haven. He also resolved at this time to dissolve the partnership of Morris, Marshall, Faulkner & Co. and buy out his partners so as to take sole control of the Firm. He did this in October, renaming the company Morris & Co. His friendship with Burne-Jones and Webb prevailed but Ford Madox Brown remained extremely bitter about it for many years afterwards. True to form, Rossetti would only agree to the dissolving of the partnership if his financial compensation of £1,000

ihn zum mystischen Mittelpunkt der schönen, grünen englischen Landschaften. Auch der entlegene Weiler Kelmscott selbst entsprach seinem Ideal einer autarken ländlichen Gemeinschaft und inspirierte ihn später zu seinem utopischen Roman *News from Nowhere* (*Kunde von Nirgendwo*).

Im Frühjahr 1872 kam Morris nach Kelmscott. Jane und die Kinder sollten im Sommer folgen, doch sie wurden in London festgehalten, weil Rossetti einen schweren Zusammenbruch erlitten hatte. Anfang Juni begann er unter Verfolgungswahn zu leiden und Stimmen und Glockengeläut zu hören. Dennoch kehrte er Ende September nach Kelmscott zurück und blieb dort bis 1874, als sogar Jane seinen kritischen Geisteszustand erkennen mußte. Morris selbst stand in diesen Monaten unter starkem Druck. In dieser Zeit veröffentlichte er *Love is Enough*, ein Gedicht, das seine komplexen Beziehungen zu Rossetti, Jane und Georgiana reflektiert.

1872 zog Morris mit der Firma in das Horrington House in Turnham Green, das mehr Ausstellungsraum und eine kleine Färberei am Queen Square bot. Ein Jahr später entwarf Morris seine ersten Chintzstoffe, die von Thomas Clarkson gewebt wurden. Weil er mit der Haltbarkeit der Farben nicht zufrieden war, begann Morris die Technik der Textilfärberei zu erforschen und fuhr häufig nach Leek in Staffordshire, damals ein Zentrum der Seidenindustrie. Hier wurde er von Thomas Wardle in die Kunst des Färbens eingeführt. In Arbeitskleidung und mit den Armen in riesigen Farbbottichen rührend, empfand Morris tiefe Freude über diese „wunderbare Arbeit, schwer für den Körper und leicht für den Geist".[16]

Die Besuche in Leek führten Morris auch die Folgen der Industrialisierung deutlicher vor Augen. Obwohl er an den langen Arbeitszeiten nichts auszusetzen hatte, empfand er die eintönige Tätigkeit an den Fertigungsstraßen als abstoßend. Die Zersplitterung des industriellen Arbeitsprozesses störte ihn am meisten, denn er war der Überzeugung, daß durch die Arbeitsteilung das Wohlergehen des Arbeiters und die Kunst als Ganzes Schaden nähmen. Er war aber nicht gegen die Mechanisierung, wenn sie genutzt werden konnte, um qualitätvolle Produkte herzustellen. So waren einige Teppiche von Morris & Co. maschinengewebt. Allerdings wendete er sich gegen die häufig zu grellen, wenig haltbaren modernen Anilinfarben und bestand auf den traditionellen Pflanzenfarben, die sanftere Tönungen hervorbrachten.

Jane verbrachte die meiste Zeit in Kelmscott mit dem zunehmend verwirrten Rossetti. Im Frühjahr 1874 konnte Morris dessen Gegenwart nicht länger ertragen und drohte, seinen Anteil am Mietvertrag zu kündigen, wenn Rossetti nicht auszöge. In dieser turbulenten Zeit machte die Familie Morris mit den Burne-Jones' Ferien in Brügge. Rossetti hatte unterdessen einen häßlichen Streit mit einer Gruppe von Anglern, von denen er sich verfolgt glaubte, und

le poème *Love is Enough*, qui reflétait ses rapports complexes avec Rossetti, Jane et Georgiana.

En 1872, la famille Morris alla s'installer à Horrington House, à Turnham Green, ce qui permettait de disposer d'une surface d'exposition plus grande et d'une petite teinturerie à Queen Square. Un an plus tard, Morris créait ses premiers chintz, réalisés ensuite par Thomas Clarkson. Déçu toutefois par la qualité des teintes utilisées, Morris se mit à expérimenter différentes techniques de teinture des étoffes et se rendit à plusieurs reprises à Leek, dans le Staffordshire, haut lieu de l'industrie de la soie. Là, il fut initié à l'art de la teinture par Thomas Wardle. Les bras plongés dans d'énormes cuves d'indigo, vêtu d'un tablier d'ouvrier et chaussé de sabots, Morris jubilait à exercer ce « travail merveilleux, dur pour le corps et facile pour l'esprit »[16].

Les déplacements à Leek lui permirent également de mieux comprendre les effets de l'industrialisation. Bien qu'il ne fût pas opposé aux longues journées de travail des ouvriers, il trouvait insupportable la routine des chaînes de production. C'est le cloisonnement du processus de fabrication industrielle qui l'intéressait le plus, car il était convaincu que la division du travail était préjudiciable au bien-être du travailleur et à l'ensemble des arts. Morris n'était pas contre la mécanisation si celle-ci pouvait servir à produire des articles de qualité. En effet, certains tapis de chez Morris & Co. étaient tissés à la machine. Certaines teintures modernes colorées à l'aniline étant instables et souvent criardes, la manufacture choisit de recourir à des recettes ancestrales de teintures végétales qui donnaient des nuances plus subtiles.

Jane passait la majeure partie de son temps à Kelmscott avec un Rossetti de plus en plus cyclothymique. Au printemps 1874, Morris ne supporta plus sa présence et menaça de renoncer à sa part de loyer si Rossetti ne déménageait pas. Pendant cette période troublée, la famille Morris passa des vacances à Bruges avec les Burne-Jones. Pendant leur absence, Rossetti eut une pénible altercation avec un groupe de pêcheurs par lesquels il se sentait harcelé. Dans son délire de persécution, il ne se fit pas prier pour quitter rapidement Kelmscott.

Maintenant que Rossetti en était parti, Kelmscott allait devenir le havre favori de Morris. Il décida également de dissoudre l'association Morris, Marshall, Faulkner & Co. et de racheter l'affaire à ses partenaires afin de pouvoir prendre seul le contrôle de la Firme – ce qu'il fit en octobre, rebaptisant la compagnie Morris & Co. L'amitié avec Burne-Jones et Webb fut préservée, mais Ford Madox Brown lui en voulut terriblement pendant de nombreuses années. Respectueux des formes, Rossetti ne s'opposa pas à la rupture de leur partenariat, à condition que sa compensation financière de mille livres revienne comme fidéicommis à Jane – ce qui, il le savait, ne manquerait pas d'irriter Morris.

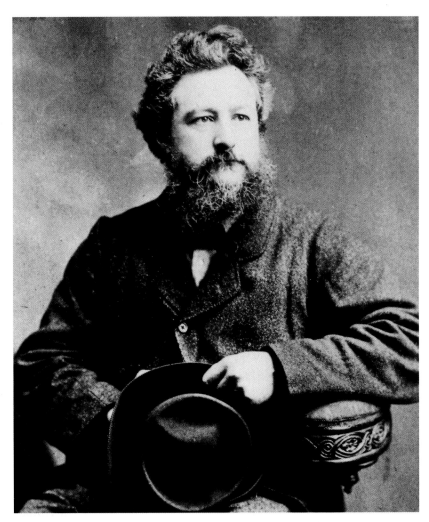

William Morris, 1877

was placed in a trust for Jane – a condition he knew would irk Morris.

Morris began delivering a series of lectures that over time became progressively political in content. These were informed by his earlier forays into British industry at Leek and began in 1877 with an address entitled *The Lesser Arts*, which was given to the members of the Trades Guild in Oxford. In this, he argued that the decorative arts were more relevant to society than the fine arts because people through necessity interacted with objects for use on a daily basis. He also reaffirmed that decoration should only be used if it had "a use or a meaning" and that the beauty of objects was the sole result of their forms being in accord with nature – not mimicking it. To Morris, a naturalness of form possessed an inherent rightness.

Importantly, through these lectures, Morris was one of the first to promote the idea that "art" would suffer if it were allied with luxury rather than utility and that it should be "popular" or democratic in its appeal. He implored designers to produce well-conceived products that were true to nature and history yet characteristic of the time in which they were made, and insisted that designers and manufacturers had a moral obligation to society to produce objects of quality.

Incensed by Street's unsympathetic restoration of St John the Baptist's Church in Burford and horrified at the proposed restoration of Tewkesbury Abbey by Sir Gilbert Scott, Morris founded the Society for the Protection of Ancient Buildings in 1877 nicknamed "Anti-Scrape". The SPAB opposed the destruction of original architecture – particularly through insensitive and irreversible restoration – and called for the responsible conservation of intact ancient buildings for the sake of future generations. So strongly did Morris feel about this campaign that from 1877 he refused to supply stained glass to any building undergoing restoration – a line of business that had hitherto been one of the most lucrative for the Firm.

## Kelmscott House

In April 1879, while Jane was vacationing in Italy, Morris began house-hunting and eventually leased a large Georgian house overlooking the Thames in Hammersmith. He renamed his new London home Kelmscott House, paying homage to his other cherished riverside home. Having played down the riverside location's main drawbacks of flooding and damp, Morris went on to spend over £1,000 on refurbishments and the resulting interiors were in his mature style. The long drawing room on the first floor comprised an eclectic mix of objects set against the swirling floral patterns of Morris & Co. wallpapers and textiles, while Morris's own study ex-

wurde deshalb, ohne daß es weiterer Überredung bedurft hätte, von seinen Freunden eilig aus Kelmscott entfernt.

Mit der Abwesenheit Rossettis war Kelmscott zu Morris' Lieblingsaufenthaltsort geworden. Er beschloß, die Gemeinschaft Morris, Marshall, Faulkner & Co. aufzulösen und seine Partner auszuzahlen, um allein die Leitung der Firma zu übernehmen. Dies geschah im Oktober, und die Firma erhielt den neuen Namen Morris & Co. Morris' Freundschaft mit Burne-Jones und Webb blieb bestehen, doch Ford Madox Brown nahm ihm dies noch viele Jahre später übel. Rossetti wollte in die Auflösung der Partnerschaft nur einwilligen, wenn seine Entschädigung von 1000 Pfund in einen Treuhandfonds für Jane einbezahlt würde – eine Bedingung, mit der er Morris ärgern wollte.

Morris begann mit einer Reihe von Vorträgen, deren Inhalt nach und nach immer politischer wurde. Das erste dieser von seinen Ausflügen in die britische Industrie in Leek inspirierten Referate mit dem Titel *The Lesser Arts* hielt er 1877 vor der Handelskammer in Oxford. Er betonte, daß die angewandte Kunst für die Gesellschaft wichtiger sei als die schönen Künste, weil die Menschen notwendigerweise mit Gegenständen des Alltags stärker zu tun hätten. Dekor solle, so sein Credo, nur eingesetzt werden, wenn es „Nutzen oder Bedeutung" habe, und die Schönheit von Objekten gehe allein auf die Übereinstimmung ihrer Formen mit der Natur – und nicht deren Nachahmung – zurück.

Mit seinen Vorträgen vertrat Morris als einer der ersten die Theorie, daß die „Kunst" darunter leidet, wenn sie sich mit Luxus statt mit Nützlichkeit verbindet, und daß sie in ihrer Wirkung „populär" oder demokratisch sein solle. Er forderte die Designer auf, wohldurchdachte Produkte herzustellen, die der Natur und der Vergangenheit verpflichtet, aber dennoch für ihre Zeit charakteristisch sind. Für ihn hatten Gestalter und Hersteller eine moralische Verpflichtung gegenüber der Gesellschaft, qualitätvolle Objekte zu produzieren.

Erbost über Streets unsensible Restaurierung der St. John the Baptist's Church in Burford und entsetzt über die geplante Restaurierung von Tewkesbury Abbey durch Sir Gilbert Scott, gründete Morris 1877 die Society for the Protection of Ancient Buildings (SPAB), auch „Anti-Scrape" genannt. Sie protestierte gegen die Zerstörung originaler Architektur, besonders durch verfälschende Restaurierungen, und forderte den Erhalt intakter alter Bauwerke für künftige Generationen. Morris engagierte sich so stark für die Organisation, daß er ab 1877 keine farbigen Glasfenster mehr für Restaurierungen lieferte – ein Geschäftszweig, der bis dahin einer der lukrativsten für die Firma gewesen war.

Morris donna alors une série de conférences dont le contenu, avec le temps, devenait de plus en plus politique. Inspirées par ses incursions d'autrefois dans l'industrie britannique, à Leek, ces conférences débutèrent en 1877 avec une allocution intitulée *The Lesser Arts* qui fut prononcée devant les membres de la guilde des commerçants, à Oxford. Dans ce discours, il prétendait que les arts décoratifs étaient plus utiles à la société que les beaux-arts, parce que les gens communiquent nécessairement au moyen des objets dont ils se servent au quotidien. Il y réaffirmait également que l'on ne devait recourir à la décoration que si elle avait « une quelconque utilité ou signification », et que la beauté des objets résultait de la seule harmonie des formes lorsque celles-ci s'accordaient avec la nature – et non lorsqu'elles l'imitaient.

Par le biais de ces conférences, Morris fut l'un des premiers à promouvoir l'idée d'un « art » qui pâtirait s'il était tributaire du luxe plutôt que de l'utilité, et qui devait absolument être « populaire » ou démocratique. Il appela les designers à produire des objets bien conçus, authentiques par rapport à la nature et à l'histoire, mais aussi caractéristiques de l'époque à laquelle ils étaient fabriqués. Il insistait sur le fait que les designers et les fabricants avaient l'obligation morale envers la société de produire des articles de qualité.

À partir de la fin des années 1870, Morris se préoccupa de plus en plus de politique et autres sujets d'intérêt public. Révolté par la restauration aberrante de l'église Saint-Jean-Baptiste de Burford et horrifié par celle que Sir Gilbert Scott proposait pour l'abbaye de Tewkesbury, Morris fonda en 1877 la « Society for Protection of Ancient Buildings », qui s'opposait à la destruction de l'architecture d'origine – particulièrement par le biais de restaurations insensées et irréversibles – et appelait à la conservation sensée des bâtiments anciens encore intacts pour l'amour des générations à venir. Morris était tellement convaincu par cette campagne, qu'à partir de 1877, il refusa de fournir des vitraux à tout bâtiment en restauration, alors que les vitraux mêmes avaient constitué jusqu'ici l'une des activités les plus lucratives de la Firme.

## Kelmscott House

Au mois d'avril 1879, alors que Jane passait des vacances en Italie, Morris se mit à la recherche d'une maison et finit par louer une grande demeure géorgienne qui surplombait la Tamise, à Hammersmith. Après avoir minimisé les principaux inconvénients – humidité et risques d'inondations – de cette location en bordure du fleuve, Morris dut dépenser plus de mille livres pour la remettre à neuf. Le résultat témoignait de la maturité du style de l'artiste. La longue salle de réception du premier étage abritait

Kelmscott House, William Morris's bedroom, 1896
William Morris' Schlafzimmer
La chambre à coucher de William Morris

Kelmscott House, west view of the drawing room, 1896
Westansicht des Salons
Vue occidentale du salon

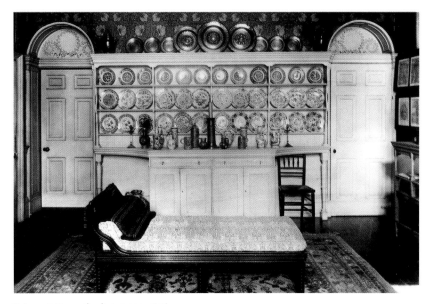

Kelmscott House, the dining room, 1896
Westansicht des Salons
La salle à manger

Wallpaper printing block
Druckplatte für Tapeten
Tampon pour imprimer le papier
peint

**William Morris (or/oder/ou
J. H. Dearle):**
*Blackthorn* wallpaper, designed
1892

Tapete *Schwarzdorn*, entworfen
1892

Papier peint *Prunellier*, dessiné en
1892

uded a near-monastic simplicity with its book-lined walls and unpolished oak table.

Since becoming sole proprietor of the Firm in March 1875, Morris had been determined to make a go of it. He desperately needed some financial success: not only had it cost him £3,000 to buy out his partners, but Devon Great Consols was no longer providing any income as the company had been liquidated the previous year. In 1877, he opened a shop in Oxford Street which marked a new commercial departure for Morris & Co.

Many of the clients who commissioned Morris to design complete interior schemes were either from the aristocracy or wealthy self-made northern industrialists. It caused Morris endless frustration that he had to spend his time "ministering to the swinish luxury of the rich"[17], yet he knew full well that it was largely this clientele that enabled his business to survive.

Middle-class artistic types also purchased Morris & Co. products, and the Morris "look" became virtually *de rigueur* for the aesthetes residing in the very fashionable Bedford Park estate built in West London in the late 1870s. In 1877 the Firm began producing woven textiles in rented premises in Great Ormond Yard under the eye of a professional silk weaver recruited from Lyons.

Realizing that any craft discipline required an indepth knowledge of materials and techniques, Morris researched, experimented in and finally mastered the art of carpet making. He subsequently converted the stable and coach house of Kelmscott House into a carpet workshop-cum-factory for the production of hand-knotted Hammersmith carpets and rugs. Morris also executed carpet designs for Axminster, Wilton and Kidderminster – the mechanized production of which was subcontracted to the Wilton Royal Carpet Factory Co. – and thereby considerably increased the range of products offered by the Firm.

Also at Kelmscott House, Morris turned his attention to tapestry and set up a loom in his bedroom. Having sufficiently mastered the art of weaving, Morris established a weaving workshop at Queen Square that was managed by the young J. H. Dearle. Under Morris's artistic direction, by the 1880s the Firm was retailing a wide and stylistically integrated range of products, which included stained glass, furniture, glassware, tiles, chintzes, wallpapers, embroideries, tapestries, and carpets. Morris & Co. also offered a complete interior design service and promoted an unpretentious, tasteful and comfortable "look" that combined the practical with the beautiful. This aesthetic reflected Morris's dematerialist approach to design and his belief that: "Simplicity of life, even the barest, is not a misery, but the very foundation of refinement."[18]

## Kelmscott House

Im April 1879, als Jane Ferien in Italien machte, begann Morris mit der Suche nach einem neuen Heim und mietete schließlich ein großes georgianisches Haus mit Blick auf die Themse in Hammersmith, das er in Erinnerung an Kelmscott Manor Kelmscott House nannte. Morris sah über die Nachteile der Flußlage – Überschwemmungsgefahr und Feuchtigkeit – hinweg und gab mehr als 1000 Pfund für die Neuausstattung aus. Die Innenräume waren von seinem reifen Stil geprägt. In dem langen Salon im ersten Stock hob sich eine eklektische Mischung von Objekten gegen die bewegten floralen Muster der Tapeten und Textilien von Morris & Co. ab, während Morris' eigenes Studio mit seinen Bücherwänden und dem unpolierten Eichentisch eine geradezu mönchische Einfachheit ausstrahlte.

Als Morris im März 1875 Alleininhaber der Firma geworden war, zeigte er sich entschlossen, sie voran zu bringen. Finanzieller Erfolg war dringend notwendig: Es hatte ihn nicht nur 3000 Pfund gekostet, seine Partner auszuzahlen, sondern er erhielt auch kein Einkommen mehr von der Devon Great Consols, weil das Unternehmen im Jahr zuvor in Konkurs gegangen war. 1877 eröffnete er ein Geschäft in der Oxford Street – ein neuer kommerzieller Aufbruch für Morris & Co.

Viele der Kunden, die Morris mit dem Entwurf ganzer Innenausstattungen beauftragten, gehörten entweder der Aristokratie an oder waren reiche Industrielle aus dem Norden. Es war für Morris ungeheuer frustrierend, daß er seine Zeit damit zubrachte, „dem schweinischen Luxus der Reichen zu dienen"[17], doch er wußte wohl, daß gerade diese Klientel seinem Unternehmen das Überleben sicherte.

Auch die künstlerisch aufgeschlossene Mittelschicht kaufte Produkte von Morris & Co. Für die Ästheten des eleganten Wohnviertels Bedford Park, das Ende der 70er Jahre im Westen Londons entstand, wurde der „Morris-Look" geradezu unverzichtbar. Die Firma begann 1877 mit dem Weben von Textilien in gemieteten Räumen im Great Ormond Yard, unter der Aufsicht eines professionellen Seidenwebers, den man in Lyon abgeworben hatte.

Morris wußte, daß jedes Handwerk eine gründliche Kenntnis von Materialien und Techniken erfordert. Deshalb forschte und experimentierte er und beherrschte schließlich die Kunst des Teppichknüpfens. Er verwandelte Stall und Remise von Kelmscott House in eine Werkstatt mit angeschlossener Manufaktur für die handgeknüpften Hammersmith-Teppiche und -Brücken. Morris führte auch Teppichentwürfe für Axminster, Wilton und Kidderminster aus, deren mechanische Produktion er an die Wilton Royal Carpet Factory weitervermittelte. Damit erweiterte sich die Produktpalette der Firma beträchtlich.

Ebenfalls im Kelmscott House wandte sich Morris der Tapisserie zu und stellte einen Webstuhl in sei-

un mélange éclectique d'objets sur fond de papiers peints et de tissus d'ameublement aux motifs de volutes florales. Le bureau de Morris, en contrepartie, respirait une sobriété presque monastique, avec ses rayonnages de livres recouvrant les murs et sa table de chêne brut.

Depuis qu'il était devenu, en mars 1875, seul propriétaire de la Firme, il était bien déterminé à là faire prospérer : non seulement le rachat de ses partenaires lui avait coûté cher (3.000 livres), mais la Devon Great Consols ne lui rapportait plus rien depuis la liquidation de la compagnie, l'année précédente. En 1877, il ouvrit un magasin dans la Oxford Street, marquant ainsi un nouveau démarrage commercial pour Morris & Co.

Une grande partie de la clientèle de Morris était issue des classes supérieures : aristocrates ou riches industriels du Nord. Contrarié de devoir passer autant de temps « à s'occuper du luxe écœurant des riches »[17], il savait pourtant très bien que c'était essentiellement ces clients-là qui pouvaient assurer la survie de son affaire.

Certains artistes issus de la classe moyenne achetaient aussi chez Morris & Co. La griffe Morris était alors quasiment de rigueur pour tous les amateurs de belles choses résidant dans le quartier en vogue de Bedford Park, bâti dans la partie ouest de Londres à la fin des années 1870. En 1877, la Firme se mit à créer des étoffes, tissées dans des locaux loués pour la circonstance à Great Ormond Yard, sous le contrôle d'un tisseur de soie professionnel, tout droit venu de Lyon.

Réalisant qu'aucune discipline professionnelle ne nécessitait une connaissance vraiment approfondie des matériaux et des techniques, Morris se lança dans une série de recherches et d'expérimentations, et finit par maîtriser la fabrication des tapis. Par la suite, il transforma l'écurie et le hangar à voitures de Kelmscott House en un atelier-usine destiné à la production de tapis et de carpettes Hammersmith noués à la main. Il créa également des tapis pour Axminster, Wilton et Kidderminster – la fabrication industrielle fut sous-traitée par la Wilton Royal Carpet Factory Co. – et put ainsi considérablement élargir le choix des articles proposés.

C'est à Kelmscott House également que Morris se mit à s'intéresser à la tapisserie. Il alla même jusqu'à installer un métier à tisser dans sa chambre. Maîtrisant suffisamment l'art du tissage, il ouvrit un atelier à Queen Square, qu'il confia au jeune J. H. Dearle. Sous la direction artistique de Morris, la Firme proposait dans les années 1880 un large éventail de produits de qualité : vitraux, meubles, carrelages, velvets, papiers peints, broderies et tapis. Morris & Co. offrait également ses services dans le domaine de la décoration intérieure, promouvant ainsi un style sans prétention, de bon goût et agréable, qui combinait le pratique et l'esthétique. Cette démarche était en soi typiquement britannique, mais

**Lexden Lewis Pocock:**
*The Pond at William Morris's Works at Merton*, after 1881
*Der Teich in William Morris' Betrieb in Merton*, nach 1881
*La Mare de la Fabrique de William Morris à Merton*, après 1881

Two young Morris & Co. apprentices weaving trial samples, early 20th century
Zwei junge Lehrlinge von Morris & Co. weben Musterstücke, frühes 20. Jahrhundert
Deux jeunes apprentis de chez Morris & Co. tissant des échantillons, au début du XXe siècle

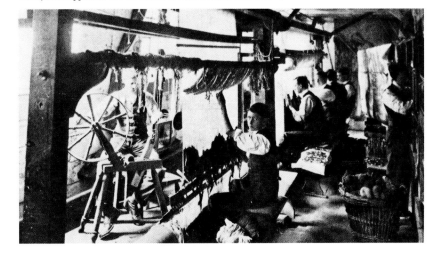

## A Glimpse of Utopia

To broaden his manufacturing capacity and lessen his reliance on subcontractors, Morris began looking for larger workshop premises. The ceramicist William De Morgan, whose tiles were sold through Morris & Co., eventually found an appropriate site on the banks of the River Wandle at Merton, some seven miles outside London. The existing buildings there had previously been used for silk-weaving by Huguenot émigrés. A lease for the works was signed in June 1881 and subsequently the stained-glass, carpet-making, weaving and dyeing workshops were moved to this (then) picturesque setting.

The works at Merton Abbey were run as ethically as possible without compromising the Firm financially. Morris's employees were better paid, worked fewer hours and enjoyed significantly better working conditions than was the norm at the time. The adolescent boys who worked in the tapestry workshop were provided with a dormitory to sleep in and were encouraged to educate themselves through the provision of a circulating library. Although these boys could have been considered child labour, they were really following apprenticeships that gave them the opportunity of securing stable careers as adults. Morris also partially instituted a profit-sharing scheme for his managers, such as George Wardle. The surrounding meadows at Merton Abbey were used for the drying of cloth that had been rinsed in the nearby river. The rest of the works' ample grounds were planted with fast-growing poplars, shrubs and flowers as well as a vegetable garden and an orchard so as to provide as pleasant a working environment as possible.

Morris got closer to realizing his vision of an idyllic rural working community at Merton than at any other point in his life, and disseminated the knowledge he gained there through lectures and articles such as *A Factory as it Might Be* of about 1884, in which he argued for civilized places of work that could be both educational and pleasurable for their employees. The importance of Merton Abbey cannot be overstated, for it also offered a three-dimensional blueprint of how ethical issues can be addressed through both the design and manufacturing processes. Morris's inspired experiment at Merton, however, ultimately fell short of his Utopian objectives because it was compromised, he believed, by having to operate within a capitalist system.

To Morris's extreme vexation, the printing of textiles at Merton took some time to perfect. The setting up of a new dye house, weaving sheds and workshop for tapestries and carpets also proved difficult, while the two-hour journey to and from Hammersmith grew evermore tiresome. From 1883, therefore, Morris began to delegate the running of Merton Abbey to George Wardle and the design of wallpapers and textiles for Morris & Co. to J. H.

nem Schlafzimmer auf. Als er die Kunst des Webens ausreichend beherrschte, richtete er am Queen Square eine Weberei ein, die von dem jungen J. H. Dearle geführt wurde. Unter Morris' künstlerischer Leitung verkaufte die Firma in den 80er Jahren eine Vielzahl stilistisch einheitlicher Produkte, darunter farbige Glasfenster, Möbel, Fliesen, Stoffe, Tapeten, Stickereien und Teppiche. Morris & Co. bot auch einen kompletten Service für die Innenausstattung in einem unprätentiösen, geschmackvollen und behaglichen Stil, der das Praktische mit dem Schönen verband. Diese Ästhetik war im Grunde sehr britisch, reflektierte aber auch Morris' reduktionistische Auffassung von Gestaltung und seine Überzeugung, daß „Einfachheit des Lebens, selbst des ärmsten, nicht Elend ist, sondern die Grundlage der Verfeinerung".[18]

## Eine Ahnung von Utopia

Um seine Produktionskapazität zu erweitern und weniger von Subunternehmern abhängig zu sein, begann Morris, nach größeren Werkstatträumen zu suchen. Der Keramiker William De Morgan, dessen Fliesen von Morris & Co. verkauft wurden, fand schließlich ein geeignetes Grundstück am Fluß Wandle in Merton, etwa sieben Meilen außerhalb Londons. Die hier vorhandenen Gebäude waren zuvor von hugenottischen Immigranten für die Seidenweberei genutzt worden. Im Juni 1881 wurde ein Mietvertrag unterzeichnet, und anschließend zogen die Werkstätten für farbige Glasfenster und Teppiche, der Weberei und Färberei in diese zu jener Zeit pittoreske Umgebung.

Der Betrieb in Merton Abbey wurde nach ethischen Prinzipien geführt, soweit dies möglich war, ohne die Firma finanziell zu gefährden. Morris' Angestellte wurden besser bezahlt, arbeiteten kürzer und hatten deutlich bessere Arbeitsbedingungen als damals üblich. Die Jugendlichen, die in der Teppichwerkstatt arbeiteten, hatten einen Schlafsaal zur Verfügung und konnten sich mit Hilfe einer Leihbibliothek weiterbilden. Dies war Kinderarbeit, doch die Mädchen und Jungen erhielten so eine echte Ausbildung, die ihnen eine Beschäftigung als Erwachsene sicherte. Morris führte auch eine Gewinnbeteiligung für seine Manager, etwa George Wardle, ein. Die Wiesen im Umkreis von Merton Abbey wurden zum Trocknen der Stoffe genutzt, die man im nahen Fluß spülte. Der Rest des großen Grundstücks wurde mit schnell wachsenden Pappeln, Sträuchern und Blumen sowie einem Gemüsegarten und Obstbäumen bepflanzt.

In Merton kam Morris seiner Vision einer idyllischen ländlichen Arbeitskommune in seinem Leben am nächsten. Seine Erkenntnisse verbreitete er in Vorträgen und Artikeln wie *A Factory as it Might Be* aus der Zeit um 1884, in dem er für Arbeitsplätze

elle reflétait aussi l'approche non matérialiste que Morris avait du design, fidèle à la conviction que « la simplicité de la vie, fût-elle la plus extrême, n'est pas de la pauvreté, mais le fondement même du raffinement »[18].

## Un brin d'utopie

Afin d'élargir la capacité de sa manufacture et, en même temps, de réduire sa dépendance à l'égard des sous-traitants, Morris se mit à rechercher de locaux pouvant abriter un atelier plus spacieux. Le céramiste William De Morgan, dont les carrelages étaient vendus par Morris & Co., finit par trouver un lieu approprié sur les rives de la River Wandle à Merton, à une douzaine de kilomètres de Londres. Les bâtiments existants avaient jadis servi au tissage de la soie par des émigrés huguenots. Un contrat fut signé pour les travaux en juin 1881, puis les unités de fabrication des vitraux et des tapis, ainsi que les ateliers de tissage et de teinture purent être aménagés dans ce site pittoresque.

Les travaux de Merton Abbey furent conduits avec beaucoup de rigueur afin de ne pas compromettre les finances de la Firme. Les employés de Morris étaient mieux payés et travaillaient moins que partout ailleurs, et, de toute évidence, étaient fort satisfaits de leurs conditions de travail. Les jeunes gens occupés dans l'atelier de tapisserie disposaient d'un dortoir et d'une bibliothèque itinérante bien pourvue. Ces garçons, bien souvent encore des enfants, bénéficiaient d'un apprentissage qui leur assurait une bonne évolution professionnelle. Morris introduisit également pour les cadres, comme George Wardle, un système de participation aux bénéfices. Les prairies environnantes étaient utilisées pour le séchage des étoffes que l'on rinçait dans la rivière voisine. Le reste des terres concédées au travail était planté de peupliers à croissance rapide, d'arbustes, de fleurs, de légumes et d'arbres fruitiers.

C'est à Merton que Morris fut le plus près de réaliser son rêve de communauté artisanale rurale. Les connaissances qu'il y acquit, il les dispensait en donnant des conférences ou en publiant des articles (*A Factory as It Might Be*, vers 1884), dans lesquels il préconisait la création d'emplois à la fois formateurs et agréables. Morris & Co. fut l'une des premières entreprises commerciales à pratiquer une forme de philanthropie qui profitât directement et réellement à ses employés. Malgré cette expérience inspirée, Morris n'atteignit pas complètement ses objectifs utopistes, parce que tout était compromis, selon lui, par l'obligation d'opérer dans un système capitaliste.

Au désespoir de Morris, la mise au point de l'impression des étoffes prit beaucoup de temps. L'installation d'une nouvelle teinturerie, d'ateliers de tissage et d'un local pour les tapisseries et les tapis fut difficile, car le trajet aller-retour de Hammer-

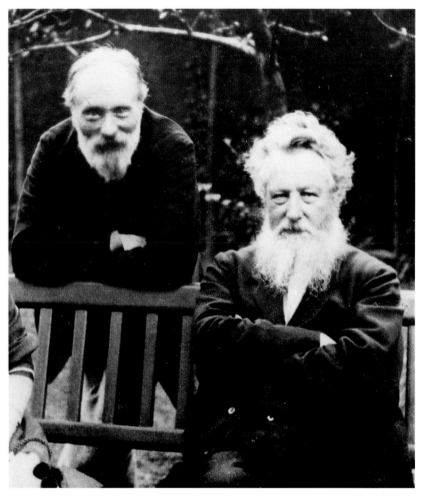

Edward Burne-Jones & William Morris,
1880s
1880er Jahre
dans les années 1880

Dearle. This allowed him more time to pursue his other interests, including politics.

### Comrade Morris

In the autumn of 1881 Rossetti's health began to deteriorate as a result of his addiction to the lethal combination of laudanum, morphia and whisky. When he eventually died in April 1882, Jane was struck with inconsolable grief. At home, Morris also had the additional worry of his eldest daughter Jenny's worsening epilepsy. Nevertheless, the early 1880s marked the beginning of a period of intense political activity which was to last nearly a decade. In 1882 Morris read Karl Marx's *Das Kapital* and found much in it that concurred with his own long-held beliefs, including a revolutionary rather than parliamentary approach to politics.

In January 1883, Morris joined the recently formed Democratic Federation, a socialist organization that sought to bring about radical change. Karl Marx's daughter, Eleanor, was a highly active member and this undoubtedly bolstered their revolutionary credentials. Morris abhorred the idea of authoritarian State socialism – his socialist vision could only be brought about by revolution. But given revolution, he believed that if individual freedoms were promoted over the needs and concerns of society as a whole, anarchy would result. Morris's earlier Pre-Raphaelite dream of a medievally inspired Arcadia led him to the idea of glorious revolution and a potentially more realistic vision of a fraternal Utopia.

Shortly after joining the Democratic Federation the zealous Morris became a "street-preacher" for it, and began spreading the socialist message from a soapbox on street corners in all kinds of weather.

Between 1883 and 1884, Morris travelled up and down the country to deliver numerous formal lectures outlining his vision of a socialist and more humanistic future. One of his first lectures, *Art under Plutocracy*, which was delivered at University College, Oxford in November 1883, stressed his environmental concerns: "To keep the air pure and the rivers clean, to take some pains to keep meadows and tillage as pleasant as reasonable use will allow them to be … to leave here and there some piece of waste or mountain sacredly free."[19] Morris argued that, as trustees of the shared environment, all men had a responsibility to stem the advance of industrial production which had turned cities into ugly pits of grime-streaked squalor.

In his lecture *Useful Work versus Useless Toil*, delivered in early 1884 at the Hampstead Liberal Club, Morris highlighted the parasitic nature of the Victorian bourgeoisie, who profited from the drudgery of the working classes. Morris asserted that it was the mindless production of useless luxuries, which he referred to as "slave wares", that per-

plädierte, die den Mitarbeitern sowohl Bildung als auch Annehmlichkeiten vermittelten. Die Bedeutung von Merton kann nicht stark genug betont werden, ließ sich dort doch am Modell beobachten, wie ethische Ziele im Entwurfs- und Herstellungsprozeß verfolgt werden können. Doch Morris' Experiment in Merton erfüllte letztlich nicht seine utopischen Träume. Es wurde, wie Morris glaubte, dadurch beeinträchtigt, daß es innerhalb eines kapitalistischen Systems funktionieren mußte.

Zu Morris' großem Verdruß nahm die Einrichtung der Textildruckerei einige Zeit in Anspruch. Auch der Aufbau einer neuen Färberei, der Weberei und der Werkstatt für Tapisserien und Teppiche erwies sich als schwierig. Zudem wurde die zweistündige Fahrt von und nach Hammersmith zunehmend lästig. Deshalb delegierte Morris 1883 die Leitung von Merton Abbey an George Wardle und den Entwurf von Tapeten und Textilien für Morris & Co. an J. H. Dearle. So gewann er mehr Zeit für seine übrigen Interessen, einschließlich der Politik.

### Genosse Morris

Ab Herbst 1881 verschlechterte sich Rossettis Gesundheitszustand aufgrund seiner Abhängigkeit von der bald tödlichen Kombination aus Laudanum, Morphium und Whisky rapide. Als er im April 1882 starb, war Jane gebrochen. Zu Hause sorgte sich Morris zusätzlich um die sich verschlimmernde Epilepsie seiner ältesten Tochter Jenny. Dennoch begann in den frühen 80er Jahren für ihn eine Periode intensiver politischer Aktivität, die nahezu ein Jahrzehnt andauern sollte. 1882 las Morris *Das Kapital* von Karl Marx und fand darin vieles, was mit seinen eigenen Überzeugungen übereinstimmte, darunter auch die Vorstellung von einem eher auf revolutionärem als auf parlamentarischem Wege zu erreichenden politischen Wandel.

Im Januar 1883 trat Morris der neugegründeten Democratic Federation bei, einer sozialistischen Organisation, die sich für radikale Veränderungen einsetzte. Daß Karl Marx' Tochter Eleanor dort ein sehr aktives Mitglied war, trug zweifellos zu deren revolutionärer Glaubwürdigkeit bei. Morris verabscheute die Idee eines autoritären Staatssozialismus – seine sozialistische Vision konnte nur durch eine Revolution verwirklicht werden. Doch wenn bei einer solchen Revolution die individuellen Freiheiten über die Bedürfnisse der Gesellschaft als Ganzes gestellt würden, entstünde, so glaubte er, Anarchie. Sein früherer präraffaelitischer Traum von einem mittelalterlich inspirierten Arkadien führte ihn zu der Idee einer glorreichen Revolution und einer potentiell realistischeren Vision eines brüderlichen Utopia.

Kurz nach seinem Eintritt in die Democratic Federation wurde Morris zum fanatischen „Straßenprediger" für deren Ziele. An einer Straßenecke auf

smith, qui durait deux heures, devenait de plus en plus fatigant. C'est pourquoi, à partir de 1883, Morris se mit à déléguer l'administration de Merton Abbey à George Wardle et la création de papiers peints et de tissus pour Morris & Co. à J. H. Dearle. En se déchargeant de quelques-unes de ses fonctions, il s'octroyait davantage de temps pour se consacrer à ses autres centres d'intérêts, y compris la politique.

## Le camarade Morris

De l'automne 1881 au printemps 1882, la santé de Rossetti se détériora. Il était devenu complètement dépendant d'une combinaison meurtrière de drogues : le laudanum, la morphine et le whisky. Lorsqu'il s'éteignit au mois d'avril 1882, Jane sombra dans un profond chagrin. De plus, les crises d'épilepsie de sa fille aînée Jenny s'aggravèrent. Morris lui-même était sur le point de s'effondrer : sa santé n'était pas bonne et il était en proie à une pénible dépression nerveuse. Néanmoins, il s'engagea dès le début des années 1880 dans une intense activité politique. En 1882, Morris lut *Le Capital* de Karl Marx et y trouva beaucoup de points communs avec ses propres idées, comme par exemple une approche de la politique plus révolutionnaire que parlementaire.

En janvier 1883, Morris rejoignit la « Democratic Federation ». C'était une organisation socialiste qui aspirait à un changement radical. La fille de Karl Marx, Eleanor, était un membre actif de la Democratic Federation, ce qui ne devait pas manquer de renforcer les références révolutionnaires de l'organisation. Morris avait en horreur l'idée d'un état socialiste autoritaire – sa vision socialiste ne pouvait être réalisée que par une révolution. Mais à supposer que la révolution ait lieu, il était d'avis que si les libertés individuelles étaient encouragées par les besoins et les intérêts de la société prise dans son ensemble, ce serait alors l'anarchie.

Peu après avoir rejoint la Democratic Federation, le dévoué Morris en devint le « prédicateur public » et, par tous les temps, propagea le message socialiste depuis une tribune improvisée au coin des rues.

Entre 1883 et 1884, Morris voyagea dans tout le pays pour donner des conférences magistrales définissant sa vision d'un avenir socialiste plus humain. Dans l'une de ses premières conférences, *Art under Plutocracy*, qui fut donnée au University College d'Oxford en novembre 1883, il mit l'accent sur les questions touchant à l'environnement : « pour garder l'air pur et les rivières propres, pour s'efforcer de maintenir les prairies et les guérets aussi agréables que l'usage normal le permet … et de laisser ici et là quelques arpents de friche ou de montagne respectueusement libres »[19]. Pour Morris, tout homme, en tant que membre d'un environnement qu'il devait partager avec ses semblables, se devait de contenir

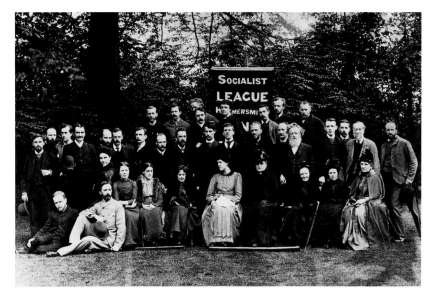

The Hammersmith branch of the Socialist League, including William, Jenny and May Morris, 1885
Zweigstelle Hammersmith der Socialist League, mit William, Jenny und May Morris
La Section Hammersmith de la Socialist League, dont faisaient partie William, Jenny et May Morris

Kelmscott Manor
Meeting hall, formerly the coach house
Versammlungssaal, zuvor Remise
Salle de réunion, autrefois hangar à voitures

petuated the workers' bondage, and proposed that all men should labour worthily.

Morris found himself disagreeing with some of his comrades at the Democratic Federation, which – as the then only true socialist organization in England – harboured a multiplicity of ideas among its members as to what means should be used in the "struggle". A branch of the Democratic Federation was established at Merton and later, on 14 July 1884, a Hammersmith branch was established at Kelmscott House, led by Morris.

After a demonstration in Hyde Park in August 1884, the Democratic Federation added the prefix "Social" to its title to placate the revolutionary tendency within its ranks. Differences of opinion arose within the organization over the validity of the parliamentary gradualism and the bloody revolution urged by more radical members, including Morris. Eventually, a ballot to resolve the conflict was held and Morris won 55 % of the votes, but promptly resigned.

## The Socialist League

Shortly after leaving the Social Democratic Federation, Morris formed the Socialist League with other SDF dissenters including Eleanor Marx. The "Revolutionary International Socialism" advocated by the Socialist League was the means by which class and nationhood would be eradicated and replaced by a global and democratic culture.

Made up of intellectuals, workers and foreign émigrés, the Socialist League supported a no-vote policy and its paper, *Commonweal*, aimed to supplant the SDF's publication, *Justice*, to which Morris had earlier contributed. The League's headquarters were situated in Farringdon Street and by the summer of 1886 it had 19 branches. The Hammersmith branch, was the League's spiritual heart, with meetings held in the emptied stables and coachhouse of Kelmscott House.

Earlier in the spring of 1885, the police had arrested some 50 members of the International Socialist Working Men's Club in Stepney, and now began breaking up gatherings of the Social Democratic Federation in Dod Street, a favoured place for meetings. In September 1885 this prompted a 10,000-strong protest in Dod Street in the name of freedom of speech; eight arrests took place. Morris went to the trial to stand bail for those arrested. One of them was an impoverished tailor who was sentenced to two months' hard labour for supposedly kicking a policeman. Outraged at the severity of this sentence, his comrades protested and Morris was arrested in the ensuing scuffle for allegedly hitting a policeman and breaking his helmet. Some two hours later, Morris was brought before a magistrate and when asked who he was, he famously replied: "I am an artist, and a literary man, pretty well known, I

**Walter Crane:**
Sketch of Morris addressing a May Day Rally, 1890s
Skizze von Morris bei einer Maifeier, 1890er Jahre
Esquisse de Morris prenant la parole lors d'un meeting du Premier Mai, années 1890

**Edward Burne-Jones:**
Caricature of William Morris demonstrating the art of weaving at the Arts & Crafts Exhibition, November 1888
Karikatur von William Morris, der auf der Arts and Crafts-Ausstellung im November 1888 die Kunst des Webens demonstriert
Caricature de William Morris faisant une démonstration de tissage lors de l'exposition Arts & Crafts, novembre 1888

einer Seifenkiste stehend, verbreitete er bei jedem Wetter die sozialistische Botschaft.

1883 und 1884 reiste Morris quer durch das Land, um in zahlreichen Vorträgen seine Vision einer sozialistischen und menschlicheren Zukunft darzulegen. Einer seiner ersten Vorträge, *Art under Plutocracy*, den er im November 1883 am University College in Oxford hielt, zeugt von seiner Sorge um die Umwelt: „Die Luft rein und die Flüsse sauber halten, die Wiesen und Felder so angenehm bewahren, wie es vernünftige Nutzung zuläßt …, hier und da ein Stück Ödland oder einen Berg unantastbar frei lassen."[19] Morris erklärte, daß alle Menschen in der ihnen anvertrauten Umwelt dafür verantwortlich seien, der sich ausweitenden industriellen Produktion Einhalt zu gebieten, durch die die Städte zu häßlichen Abgründen rußgeschwärzten Elends geworden seien.

In seinem Vortrag *Useful Work versus Useless Toil* Anfang 1884 im Hampstead Liberal Club wies Morris auf das Parasitentum der viktorianischen Bourgeoisie hin. Sie profitiere von der Plackerei der Arbeiterklasse. Für Morris war es die Produktion nutzloser Luxusgüter, von ihm als „Sklavenware" bezeichnet, die die Arbeiter in ewiger Knechtschaft hielt.

Morris geriet zunehmend in Konflikt mit einigen seiner Genossen in der Democratic Federation, in der – als damals einziger wirklich sozialistischer Organisation in England – unterschiedliche Meinungen über die im „Kampf" einzusetzenden Mittel vertreten wurden. Eine Ortsgruppe der Democratic Federation wurde in Merton gegründet, eine weitere am 14. Juli 1884 im Kelmscott House in Hammersmith, von Morris angeführt.

Nach einer Demonstration im Hyde Park im August 1884 fügte die Democratic Federation ihrem Namen das Präfix „Social" bei, um revolutionäre Tendenzen in ihren Reihen zu beschwichtigen. Innerhalb der Organisation gab es Meinungsverschiedenheiten darüber, ob es richtig sei, sich auf einen schrittweisen parlamentarischen Prozeß einzulassen, oder ob eine blutige Revolution erlaubt sei, wie andere, radikalere Mitglieder, darunter auch Morris, forderten. Morris gewann die Abstimmung mit 55 Prozent der Stimmen, trat aber gleich darauf zurück.

## Die Socialist League

Kurz nach seinem Austritt aus der Social Democratic Federation gründete Morris mit anderen Dissidenten der SDF, darunter Eleanor Marx, die Socialist League. Mit dem „Revolutionären Internationalen Sozialismus", den die Socialist League verfocht, sollten die Klassen und Nationen zum Verschwinden gebracht und durch eine globale und demokratische Kultur ersetzt werden.

Die Socialist League bestand aus Intellektuellen, Arbeitern und Immigranten und war gegen Wahlen. Ihre Zeitschrift *Commonweal* sollte *Justice*, das Organ

l'avancée de la production industrielle qui avait transformé les villes en terribles lieux de misère.

Dans sa conférence *Useful Work versus Useless Toil* donnée au début de 1884 au Hamstead Liberal Club, Morris soulignait la nature parasitaire de la bourgeoisie victorienne qui profitait de la besogne ingrate des classes ouvrières, contraintes de travailler énormément pour de très maigres revenus. Morris soutenait que c'était la production stupide d'objets de luxe inutiles – auxquels ils se référaient comme à « des marchandises d'esclaves » – qui perpétuait l'asservissement des ouvriers.

Si Morris considérait le socialisme comme un phénomène politique inévitable, c'est parce qu'il l'estimait juste sur le plan moral. Mais lui-même était à présent en désaccord avec quelques-uns de ses camarades de la Democratic Federation. Seule véritable organisation socialiste à cette époque dans toute l'Angleterre, cette fédération était composée d'une multiplicité de tendances, toutes censées servir la « lutte ». Une section de la Democratic Federation fut ouverte à Merton et, plus tard, le 14 juillet 1884, une Section Hammersmith conduite par Morris, fut établie à Kelmscott House.

Après une manifestation à Hyde Park en août 1884, la Democratic Federation ajouta le préfixe « Social » à son appellation afin d'apaiser la tendance révolutionnaire qui sourdait dans ses rangs. Des différences d'opinion surgirent au sein de l'organisation à propos de la validité du gradualisme parlementaire et de la révolution sanglante préconisée par d'autres membres plus radicaux, dont Morris. Finalement, un scrutin fut organisé et Morris obtint 55 % des voix, mais il se hâta cependant de démissionner.

**La ligue socialiste**

Peu après qu'il eut quitté la Social Democratic Federation, Morris forma la Ligue socialiste avec d'autres dissidents de la SDF, dont Eleanor Marx. Le « socialisme international révolutionnaire » prêché par la Ligue socialiste devait permettre d'abolir les concepts de classe et de nation et de les remplacer par une culture globale et démocratique.

Constituée d'intellectuels, d'ouvriers et d'émigrés, la Ligue socialiste soutenait une politique sans suffrage. Son organe d'expression, *Commonweal*, visait à supplanter *Justice*, la publication de la Socialist Democratic Federation, à laquelle Morris avait collaboré auparvant. Les quartiers généraux de la Ligue étaient situés dans la Farringdon Street ; à l'été 1886, elle comptait 19 sections. La Section Hammersmith était cependant son cœur spirituel : les réunions se tenaient dans les écuries et le hangar à voitures de Kelmscott House, débarrassés pour la circonstance. Le dimanche, ses membres prêchaient en plein air.

Un peu plus tôt, au printemps 1885, la police avait

**J. P. Stafford:**

*The Attitude of the Police – The Earthly Paradox,* 1885. Cartoon from *Funny Folks* magazine

*Die Haltung der Polizei – Das Weltliche Paradox.* Karikatur aus der Zeitschrift *Funny Folks*

*L'Attitude de la Police – Le Paradoxe Terrestre.* Dessin humoristique publié dans le magazine *Funny Folks*

think, throughout Europe"[20]. He denied any wrong-doing and was subsequently acquitted. Morris's social status had ensured his preferential treatment in court and the irony of this was not lost on commentators, as can be seen in J. P. Stafford's cartoon *The Attitude of the Police – The Earthly Paradox*.

During this period, Morris became associated with the nihilist Sergius Stepniak, and with the early environmentalist and Russian revolutionary Prince Peter Alexeivich, both of whom were leading anarchists. Morris's natural dislike of authority and formal leadership also allowed other extremists to infiltrate the League. With its increasingly disparate factions, the League finally became a shambles.

Despite everything, Morris continued preaching his political gospel and also spread his message through the writing of two socialist pieces, the semi-autobiographical *A Dream of John Ball* (1886–1887) and *News from Nowhere* (1889–1890). Both of these were first published in instalments in *Commonweal*.

Inspired by Thomas More's *Utopia* of 1516, *News from Nowhere* lays out Morris's personal view of Utopia (Utopia being a Greek name of More's coining, from *ou-topos* meaning "no place"). After the last instalment of *News from Nowhere* had been published, Morris was ousted as editor of *Commonweal*.

**A Return to Crafts**

Although still politically active, Morris's fervour gave way to stoicism and he returned to his old familiar creative pursuits. He was also the inspirational figurehead of the burgeoning Arts & Crafts Movement, which had been spawned by his earlier urgings for a life lived more simply. Indeed, its members were so galvanized by Morris and Ruskin's teachings that they established workshop collectives such as the Century Guild (founded by Arthur Mackmurdo in 1882) and the Art Worker's Guild (founded by Charles Ashbee in 1884) and went on to become the new vanguard of design reform.

In March 1890 Morris went into partnership with the Firm's business managers Robert and Frank Smith, retaining only a 50 % stake in the operation. Now less involved in the running of Morris & Co., he had more time to dedicate to creative work. Morris had long been a collector of fine books and he developed an interest in typography. As a result, on 12 January 1891 he rented premises at 16, Upper Mall and established the Kelmscott Press, with the intention of producing beautiful printed works for collectors and lovers of books.

Of the 66 titles published by the Kelmscott Press in small exclusive runs, 23 were written by Morris. These exquisite volumes, which included the great Kelmscott Chaucer of 1893–1894, were decorated with illustrations by Edward Burne-Jones and Morris's medieval swirling foliate borders and ci-

*"It was the essence of my undertaking to produce books which it would be a pleasure to look upon as pieces of printing and arrangement of type."*
WILLIAM MORRIS, 1895

der SDF, ersetzen, für das Morris früher geschrieben hatte. Die Ortsgruppe Hammersmith war das geistige Zentrum. Die Treffen fanden in den leergeräumten Ställen und der Remise von Kelmscott House statt. Sonntags predigten die Mitglieder im Freien.

Im Frühjahr 1885 hatte die Polizei etwa 50 Mitglieder des International Socialist Working Men's Club in Stepney verhaftet. Sie begann nun auch die Versammlungen der Social Democratic Federation in der Dod Street aufzulösen. Im September demonstrierten deshalb 10 000 Menschen an diesem bevorzugten Versammlungsort für die Redefreiheit. Es kam zu acht Festnahmen. Morris ging zur Verhandlung, um für die Festgenommenen zu bürgen. Einer von ihnen war ein verarmter Schneider, der zu zwei Monaten Zwangsarbeit verurteilt wurde, weil er angeblich einen Polizisten getreten hatte. Empört über dieses harte Urteil, protestierten seine Genossen, und Morris wurde in dem anschließenden Handgemenge verhaftet, weil er angeblich einen Polizisten geschlagen und dessen Helm beschädigt hatte. Zwei Stunden später wurde er einem Richter vorgeführt. Auf die Frage, wer er sei, gab er die berühmte Antwort: „Ich bin Künstler und Literat und, wie ich glaube, in ganz Europa wohlbekannt."[20] Er stritt jedes Vergehen ab und wurde anschließend entlassen. Sein sozialer Status war der Grund für diese Vorzugsbehandlung – eine Ironie, die auch den Kommentatoren nicht entging, wie J. P. Staffords Karikatur *Die Haltung der Polizei – Das Weltliche Paradox* zeigt.

Morris schloß sich dem Nihilisten Sergius Stepniak und dem russischen Revolutionär und früheren Vertreter der Umweltbewegung, Fürst Pjotr Aleksejewitsch, an, die beide führende Anarchisten waren. Wegen Morris' Abneigung gegen Autorität und formeller Führung konnten auch andere Extremisten die Liga infiltrieren. Diese inneren Konflikte zerstörten die Socialist League schließlich.

Dennoch predigte Morris weiter seine politische Botschaft, die er in zwei sozialistischen Erzählungen verbreitete, der stark autobiographische geprägten Geschichte *A Dream of John Ball* (1886–1887) und *News from Nowhere* (1889–1890). Beide wurden zunächst in Fortsetzungen in *Commonweal* veröffentlicht.

Letztere ist von Thomas Morus' *Utopia* von 1516 inspiriert und beschreibt Morris' persönliche Vorstellung von Utopia (ein von Morus geprägter Begriff, abgeleitet vom griechischen *outopos*). Nach der letzten Fortsetzung von *News from Nowhere* wurde Morris als Herausgeber von *Commonweal* entlassen.

**Rückkehr zum Handwerk**

Morris blieb in den 90er Jahren zwar weiterhin politisch aktiv, doch sein Eifer wich einem gewissen Gleichmut, und er wandte sich wieder seinen vertrauten schöpferischen Tätigkeiten zu. Er wurde zur Leitfigur der aufkommenden Arts-and-Crafts-Bewe-

arrêté une cinquantaine de membres de l'International Socialist Working Men's Club à Stepney, et commençait maintenant à interdire les rencontres de la Socialist Democratic Federation à Dod Street. En septembre 1885, 10.000 personnes se rassemblèrent dans la Dod Street au nom de la liberté d'expression ; huit personnes furent arrêtées. Lors du procès, Morris témoigna en leur faveur : l'une d'elles était un pauvre tailleur qui fut condamné à deux mois de travaux forcés pour avoir soi-disant donné un coup de pied à un policier. Outrés par la sévérité de la sentence, ses camarades protestèrent et Morris fut arrêté lors de l'échauffourée qui s'ensuivit, pour avoir – à ce que l'on dit – frappé un policier et cassé son casque. Environ deux heures plus tard, Morris fut amené devant un magistrat et lorsqu'on lui demanda qui il était, il répliqua : « Je suis un artiste et un homme de lettres, connu, je pense, dans toute l'Europe. »[20] Il nia avoir fait quoi que ce soit de mal et fut acquitté. Le statut social de Morris lui permit indéniablement de bénéficier d'un traitement préférentiel devant la Cour et l'ironie de la chose n'échappa pas aux commentateurs de l'époque, à en juger par exemple par la caricature *L'Attitude de la Police – Le Paradoxe Terrestre* de J. P. Stafford.

Pendant cette période, Morris s'associa avec deux figures anarchistes marquantes, le nihiliste Sergius Stepniak et le prince Piotr Alexeïvitch. L'aversion naturelle de Morris pour l'autorité et la direction formelle permit également à d'autres extrémistes d'infiltrer la Ligue. Avec ses factions de plus en plus disparates, la Ligue devint un amalgame sans nom.

Il continua malgré tout à prêcher son évangile politique et répandit aussi son message par le biais de deux pièces socialistes, *A Dream of John Ball* (1886–1887) et *News from Nowhere* (1889–1890). Ces deux œuvres furent d'abord publiées en épisodes dans le *Commonweal*.

Inspiré par *Utopia* (1516) de Thomas More, *News from Nowhere* expose la conception que Morris avait d'Utopia (« utopia » est un mot grec inventé par More, à partir de « outopos » qui signifie « pas de place »). Après la publication du dernier épisode des *News from Nowhere*, Morris fut limogé de son poste de rédacteur en chef du *Commonweal*.

## Retour au métier manuel

Il fut également l'inspirateur essentiel du tout nouveau Arts & Crafts Movement. Ce dernier était né en effet de ses désirs d'antan de mener une vie simple. Ses membres étaient tellement galvanisés par les enseignements de Morris et de Ruskin, qu'ils établirent des associations d'ateliers comme la Century Guild (fondée par Arthur Mackmurdo en 1882) et la Art Worker's Guild (fondée par Charles Ashbee en 1884), et finirent par représenter la nouvelle avant-garde de la réforme du design.

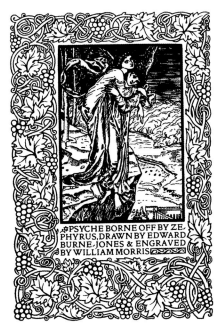
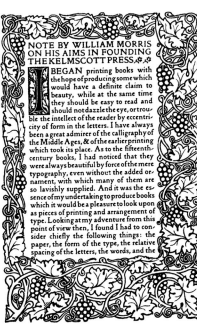

*A Note by William Morris on his aims in founding the Kelmscott Press, 1898*
Double page from the book
Buchdoppelseite
Double page du livre

William Morris's Funeral Cart
William Morris' Leichenwagen
Voiture funéraire de William Morris

phers. The Press used easy-to-read typography, including three new typefaces designed by Morris, and the books it produced helped to bring about a renaissance in art publishing.

In February 1891, Morris suffered a recurrence of gout and a kidney infection. He was very ill, and depressed about the last few years' political turmoil, in which his version of socialism had been sidelined by the Trades Union Movement.

Towards the end of his life, Morris had a political change of heart as he came to view State socialism as a necessary transitional phase along the road to the realization of his "communistic" ideal. Although unwell, Morris delivered speeches, wrote poetry and spent much time at his beloved Kelmscott Press. Eventually, in 1896, an eminent physician diagnosed him as having diabetes. On his return to England from a four-week voyage to Norway, his health continued to worsen due to the progressive nature of what had now been diagnosed as consumption. On the morning of 3 October 1896, Morris died peacefully in his bedroom at Kelmscott House at the age of 62. Reputedly, the last words he uttered were: "I want to get mumbo-jumbo out of the world"[21]. When his coffin arrived at Lechlade by train, it was placed on a traditional horse-drawn cart decorated with flowers and boughs and borne to the churchyard at Kelmscott, where he was laid silently to rest under a simple tombstone designed by Philip Webb.

**Conclusion**

For many years afterwards, Morris's influence continued to resonate not only in Great Britain but in the United States and on the Continent as well. Across America, in the late 19th century many craft communities were established, such as the Craftsman Workshops, Roycrofters and the Rose Valley Association, that aspired to his ideals of simple living and handcraft. In Continental Europe, Morris's ideas for craft-based workshops stimulated the foundation of the Darmstadt Artists' Colony, the Wiener Werkstätte, the Deutsche Werkbund and, ultimately, the Weimar Bauhaus. These artistic colonies, however, were not inspired by notions of an escape to a rural Arcadia so much as by Morris's reforming ideas: the supremacy of utility over luxury; the moral responsibility of designers and manufacturers to produce objects of quality; the use of design as a democratic tool for social change. Through the European avant-garde's espousal of these precepts, Morris must be seen as having had a fundamental impact on the early origins of the Modern Movement. But it was Morris's advocacy of a holistic approach to the design and manufacturing processes for aesthetic, social and environmental reasons that was of the most lasting relevance and will remain his greatest legacy.

*"Fellowship is heaven, and a lack of fellowship is hell: fellowship is life, and a lack of fellowship is death: and the deeds that ye do on earth, it is for fellowship's sake that ye do them."*
WILLIAM MORRIS, 1886–1887

gung, die er durch seine unermüdlichen Forderungen nach einem einfachen Leben inspiriert hatte. Die Mitglieder waren so fasziniert von Morris' und Ruskins Lehren, daß sie Werkgemeinschaften wie die Century Guild (1882 von Arthur Mackmurdo initiiert) und die Art Worker's Guild (1884 von Charles Ashbee initiiert) gründeten. Sie wurden zur neuen Avantgarde der Designreform.

Im März 1890 schloß Morris einen Partnerschaftsvertrag mit den Geschäftsführern seiner Firma, Robert und Frank Smith, und behielt nur einen Anteil von 50 Prozent. Nun, da ihn die Geschäftsführung von Morris & Co. nicht mehr so stark in Anspruch nahm, hatte er mehr Zeit für seine künstlerische Arbeit. Er hatte seit langer Zeit kostbare Bücher gesammelt und interessierte sich für Typographie. Am 12. Januar 1891 mietete er Räume an der Upper Mall 16 und gründete die Kelmscott Press, um qualitätvolle Bücher für Sammler und Liebhaber zu verlegen.

Von den 66 Titeln, die die Kelmscott Press in exklusiven Kleinauflagen veröffentlichte, stammten 23 von Morris selbst. Die prachtvollen Bände, darunter die große Chaucer-Ausgabe von 1893–1894, waren mit Illustrationen von Edward Burne-Jones und Morris' mittelalterlichen Bordüren und Ziffern aus Blattwerk geschmückt. Kelmscott Press arbeitete mit einer leicht lesbaren Typographie, darunter auch drei neue Schriften, die Morris entworfen hatte.

Im Februar 1891, einen Monat nach der Gründung der Kelmscott Press, erlitt Morris einen Gichtanfall und eine Niereninfektion. Er war sehr krank und deprimiert über die politischen Unruhen der letzten Jahre, in denen seine Version des Sozialismus durch die Gewerkschaftsbewegung in Vergessenheit geraten war.

Gegen Ende seines Lebens wandelte sich Morris' politische Einstellung. Er sah nun den Staatssozialismus als notwendige Übergangsphase auf dem Weg zur Verwirklichung seines „kommunistischen" Ideals. Trotz seiner Krankheit hielt er nach wie vor Reden, schrieb Gedichte und verbrachte viel Zeit bei seiner geliebten Kelmscott Press. 1896 diagnostizierte schließlich ein bekannter Arzt Diabetes. Nach der Rückkehr von einer vierwöchigen Reise nach Norwegen ging es ihm immer schlechter, weil seine inzwischen als Schwindsucht diagnostizierte Krankheit beständig fortschritt. Am Morgen des 3. Oktober 1896 starb Morris in seinem Schlafzimmer im Kelmscott House im Alter von 62 Jahren. Angeblich waren seine letzten Worte: „Ich möchte den faulen Zauber aus der Welt schaffen."[21] Als der Sarg mit dem Zug in Lechlade eintraf, wurde er auf eine traditionelle Pferdekutsche gestellt, die mit Blumen und Zweigen geschmückt war, und zum Friedhof in Kelmscott gefahren, wo Morris unter einem einfachen, von Philip Webb entworfenen Grabstein in aller Stille beigesetzt wurde.

Au mois de mars 1890, Morris s'associa avec les directeurs financiers de la Firme Robert & Frank Smith, ne gardant que 50 % de participation dans l'affaire. Désormais moins impliqué dans la direction de Morris & Co., il pouvait davantage se consacrer à la création. Morris avait pendant longtemps collectionné les beaux livres. Le 12 janvier 1891, il loua des locaux au 16 Upper Mall et créa la Kelmscott Press, avec l'intention de produire de très beaux livres destinés aux collectionneurs et bibliophiles.

Sur les 66 titres publiés à petits tirages exclusifs par la Kelmscott Press, 23 étaient écrits par Morris. Ces magnifiques ouvrages, parmi lesquels le célèbre Kelmscott Chaucer de 1893–1894, étaient illustrés par Edward Burne-Jones et ornés de liserés et de monogrammes de Morris, en forme de volutes florales de style médiéval. Kelmscott Press utilisait une typographie facile à lire comprenant des caractères, en partie créés par Morris.

En février 1891, un mois donc après avoir fondé la Kelmscott Press, Morris fut victime d'une crise de goutte et d'une infection rénale. L'agitation politique des dernières années, au cours desquelles sa version du socialisme avait été écartée par le mouvement syndical, l'avait gravement déprimé.

Vers la fin de sa vie, Morris connut un changement politique profond et finit par considérer le socialisme d'État comme une phase transitionnelle nécessaire sur la voie de la réalisation de son idéal « communiste ». Bien qu'il fût très malade, Morris continua de prononcer des discours et d'écrire des poèmes, et passa beaucoup de temps à la Kelmscott Press. Finalement, en 1896, un éminent médecin diagnostiqua un diabète et prescrivit un régime approprié. La croisière sembla lui redonner un temps ses esprits, mais à son retour en Angleterre après un voyage de quatre semaines en Norvège son état continua de s'aggraver : on lui trouva à présent une consomption à évolution rapide. Le matin du 3 octobre 1896, Morris s'éteignit paisiblement dans son lit, à Kelmscott House, à l'âge de 62 ans. On prétend que ses dernières paroles furent : « Je voudrais m'en aller de manière extravagante. »[21] Lorsque son cercueil arriva à Lechlade par train, il fut placé sur une charrette traditionnelle tirée par des chevaux, décorée de fleurs et de branches, et fut transporté au cimetière de la petite église de Kelmscott où il fut enterré en silence. Il repose sous une simple pierre tombale conçue par Philip Webb.

## Schlußbetrachtung

Viele Jahre später übte Morris' Werk nicht nur in Großbritannien starken Einfluß aus, sondern auch in den Vereinigten Staaten und auf dem europäischen Kontinent. Im ausgehenden 19. Jahrhundert entstanden in Amerika Handwerkskommunen und Werkstätten, wie die Craftman Workshops, die Roycrofters und die Rose Valley Association, die sein Ideal eines einfachen Lebens und einer klaren kunsthandwerklichen Gestaltung anstrebten. In Europa inspirierten Morris' Thesen die Gründung der Darmstädter Künstlerkolonie, der Wiener Werkstätte, des Deutschen Werkbunds und im Grunde auch des Weimarer Bauhauses. Diese künstlerischen Vereinigungen orientierten sich jedoch weniger an seiner Vorstellung von einer Rückkehr in ein ländliches Arkadien als an seinen Reformideen: Nützlichkeit, Einfachheit und Angemessenheit statt Luxus; moralische Verantwortung von Designern und Herstellern für die Produktion von Qualitätsware; Design als demokratisches Mittel für soziale Veränderungen. So übte Morris einen starken Einfluß auf den Beginn der Moderne aus. Von besonderer Bedeutung war dabei sein Eintreten für eine ganzheitliche, d. h. ästhetische, soziale und umweltorientierte Betrachtung des Entwurfs- und Herstellungsprozesses. Dies wird sein wichtigstes Vermächtnis bleiben.

## Conclusion

De son vivant et bien après sa mort, l'influence de Morris se fit sentir non seulement en Grande-Bretagne mais aussi aux États-Unis et sur le continent. Dans l'Amérique de la fin du XIXᵉ siècle, on vit de nombreuses communautés artisanales et d'ateliers s'établir qui aspiraient aux mêmes idéaux, la simplification de la vie et la fabrication artisanale. Parmi ces établissements, citons les « Craftsman Workshops », la communauté « Roycrofters » et la « Rose Valley Association ». En Europe, les idées de Morris furent à l'origine de la création de la colonie d'artistes de Darmstadt, des Wiener Werkstätte, du Deutscher Werkbund, mais aussi du Bauhaus de Weimar, même si ces mouvements en reprirent surtout le côté réformiste : suprématie de l'utilité, de la simplicité et de la rationalité sur le luxe, responsabilité morale des designers et des manufacturiers dans la fabrication d'objets de qualité, principe selon lequel le design pourrait et devrait être utilisé comme moyen démocratique pour transformer la société. Tous ces préceptes firent des émules et l'on peut dire que Morris eut une influence fondamentale sur les débuts du mouvement moderne, notamment parce qu'il envisageait comme un tout, esthétique et social, le design et les procédés de fabrication. Cette approche, par sa remarquable pertinence, reste son legs le plus important.

# OXFORD UNION LIBRARY, 1857

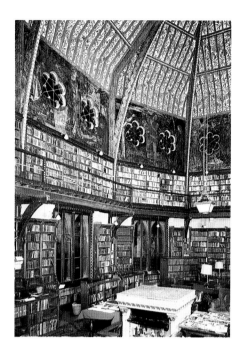

Oxford Union Library

In 1857, Rossetti managed to persuade the architect Benjamin Woodward to allow him and his followers to paint a series of "frescoes", depicting scenes from Malory's *Morte d'Arthur,* for Woodward's recently completed Oxford Union Library. Rossetti invited William Morris, Edward Burne-Jones, Val Prinsep, Arthur Hughes, Hungerford Pollen and Spencer Stanhope to join him on the project, with Morris's non-artistic friends from his Oxford days, Cormell Price, Charles Faulkner and Richard Watson Dixon acting as assistants. The Oxford Union provided them all with board and lodgings, and the atmosphere was full of good humour and camaraderie – as Val Prinsep later recalled: "What fun we had! What jokes! What roars of laughter!"[22]

For the murals, the friends modelled for each other and brought in suitable props. Although Morris never completely mastered figure painting, this project was important because the patterned ceiling decoration he executed revealed, probably for the first time, his undeniable talent for two-dimensional design. With his gruff gusto, Morris enjoyed the creative effort the murals demanded and for most of the time he was literally covered in paint. Indeed, Morris immersed himself so deeply in the project that visitors to the University mistook him for a workman. As Rossetti remarked: "He had a way of picking up dirt and annexing it."[23]

Sadly, correct preparation procedures were not followed and the newly built walls, which had not completely dried out, were only whitewashed before tempera was applied. As a result, the paint soon flaked and the colours faded, so that within six months this incomplete cycle of murals had all but disappeared. In the 1870s Morris repainted the ceiling with a lighter and more fluid design.

1857 überredete Rossetti den Architekten Benjamin Woodward, ihm und seinen Freunden zu gestatten, eine Reihe von „Fresken" mit Szenen aus Malorys *Morte d'Arthur* in Woodwards soeben fertiggestellter Oxford Union Library auszuführen. Rossetti lud William Morris, Edward Burne-Jones, Val Prinsep, Arthur Hughes, Hungerford Pollen und Spencer Stanhope zu diesem Projekt ein. Ihnen assistierten Morris' Freunde aus seinen Oxforder Tagen, Cormell Price, Charles Faulkner und Richard Watson Dixon. Die Oxford Union sorgte für Verpflegung und Unterkunft, und die Atmosphäre war fröhlich und kameradschaftlich, wie sich Val Prinsep später erinnerte: „Wieviel Spaß wir hatten! Wieviel Scherze! Wieviel Gelächter!"[22]

Für die Wandbilder standen die Freunde sich gegenseitig Modell und brachten passende Requisiten mit. Obwohl Morris die Figurenmalerei nie völlig beherrschte, war dieses Projekt für ihn wichtig, weil seine Deckendekoration vielleicht zum ersten Mal sein Talent für zweidimensionale Entwürfe deutlich machte. Morris genoß die grobe, aber kreative Tätigkeit und war meist über und über mit Farbe beschmiert. Er vertiefte sich teilweise so sehr in die Arbeit, daß Besucher der Universität ihn für einen Handwerker hielten. Rossetti sagte über seinen Freund: „Er hatte so eine Art, Schmutz aufzulesen und ihn sich anzueignen."[23]

Leider waren die Untergründe nicht richtig vorbereitet worden, und die neuen, noch nicht ganz trockenen Wände wurden vor dem Auftrag der Temperafarben nur getüncht. Deshalb blätterte die Farbe bald ab und verblaßte, so daß der unvollendete Zyklus nach sechs Monaten fast verschwunden war. In den 1870er Jahren dekorierte Morris die Decke mit einem neuen, einfacheren Gemälde.

En 1857, Rossetti réussit à persuader l'architecte Benjamin Woodward, qui venait d'achever la Oxford Union Library, de lui laisser peindre une série de « fresques » représentant des scènes de la *Morte d'Arthur* de Malory. Il invita alors William Morris, Edward Burne-Jones, Val Prinsep, Arthur Hughes, Hungerford Pollen et Spencer Stanhope à s'associer à ce projet. Se joignirent également à eux des amis de Morris datant de l'époque oxfordienne, Cormell Price, Charles Faulkner et Richard Watson Dixon, qui firent fonction d'assistants. L'atmosphère fut à la bonne humeur générale comme devait le rappeler plus tard Val Prinsep : « Qu'est ce qu'on s'amusa ! Quelles blagues ! Quels hurlements de rire ! »[22]

La peinture de personnages n'avait jamais été une discipline dans laquelle il excellait, mais ce programme de peinture était important car les motifs qu'il exécuta pour la décoration du plafond révélèrent, probablement pour la première fois, son talent indéniable pour le dessin en deux dimensions. Avec son enthousiasme résolu, Morris trouva intéressant l'effort de création que les peintures murales exigeaient de lui. La plupart du temps, il était littéralement plongé dans sa peinture[23]. Et il s'immergea en effet avec une telle intensité dans son travail que des personnes en visite à l'université le prirent à tort pour un ouvrier.

Malheureusement, on avait négligé d'observer les procédures préliminaires : avant d'appliquer la détrempe, on s'était contenté de passer à la chaux les murs qui venaient à peine d'être achevés et qui n'étaient pas encore complètement secs. Résultat : la peinture ne tarda pas à s'écailler et les couleurs fanèrent, tant et si bien qu'en l'espace de six mois, le cycle – incomplet – de ces peintures murales avait disparu. Dans les années 1870, Morris revint repeindre le plafond avec un dessin plus léger et plus fluide.

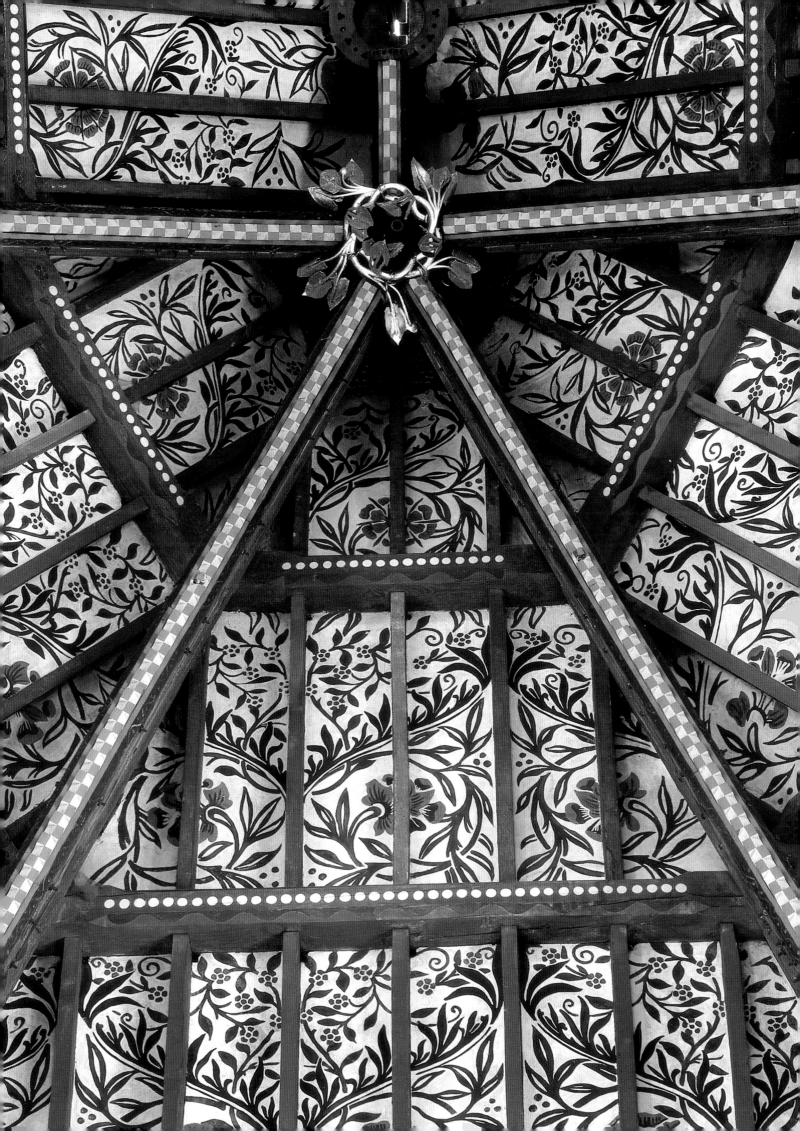

# 17, Red Lion Square, Bloomsbury, Residence from 1856 to 1859

**Edward Burne-Jones:**

Cartoon depicting one of the rooms at Red Lion Square, 1856

Karikatur einer der Räume der Wohnung am Red Lion Square

Dessin humoristique représentant l'une des pièces de Red Lion Square

When, in 1856, Morris moved into rooms at 17, Red Lion Square with Edward Burne-Jones, he could not find any furniture to his liking, so he decided to design his own. The weighty and passionately medieval pieces that resulted were probably fabricated by Henry Price, a local American-trained cabinetmaker. Included in this group of furniture was a large round table "as firm and heavy as a rock" and chairs "such as Barbarossa might have sat in"[24]. The recently rediscovered high-backed chairs were painted by Rossetti, Burne-Jones and Morris with chevron motifs and scenes of *Gwendolen in the Witch-tower* and *The Arming of a Knight* drawn from Morris's own poetry. These fanciful and highly decorated, yet quite crudely constructed chairs were the antithesis of overstuffed High Victorian seat furniture and represent early – though not the first – examples of Pre-Raphaelite influence within the decorative arts.

Als Morris 1856 mit Edward Burne-Jones zum Red Lion Square 17 zog, fand er keine passenden Möbel, und deshalb entwarf er eigene Einrichtungsgegenstände. Die schweren, stark mittelalterlich geprägten Stücke wurden wahrscheinlich von Henry Price angefertigt, einem in Amerika ausgebildeten Kunsttischler. Zu dem Ensemble gehörten ein großer, runder Tisch, „so fest und schwer wie ein Felsen", und Stühle, „in denen Barbarossa hätte sitzen können".[24] Die vor einiger Zeit wiederentdeckten hochlehnigen Stühle waren von Rossetti, Burne-Jones und Morris mit Zickzackbändern und Szenen aus *Gwendolen in the Witch-tower* und *The Arming of a Knight* nach Morris' Gedichten bemalt. Diese phantasievoll und aufwendig dekorierten, aber recht grob gezimmerten Stühle waren das Gegenteil der überladenen spätviktorianischen Sitzmöbel und zugleich frühe – wenn auch nicht die ersten – Beispiele des Präraffaelismus in der angewandten Kunst.

Lorsqu'en 1865, Morris emménagea avec Edward Burne-Jones dans le petit appartement du 17, Red Lion Square, il ne trouva aucun meuble à son goût. Il décida alors de créer son propre mobilier. Les meubles puissants et de style délibérément médiéval qui en résultèrent furent probablement fabriqués par Henri Price, un ébéniste local formé en Amérique. Cet ameublement comprenait une grande table ronde « aussi ferme et lourde qu'un rocher » et des chaises « qui devaient ressembler à celle de Barberousse »[24]. Les chaises à hauts dossiers, que l'on redécouvrait, étaient peintes par Rossetti, Burne-Jones et Morris et ornées de motifs en chevrons et de scènes de *Gwendolen in the Wich-Tower* et *The Army of a Knight*, tirées des poèmes de Morris. Ces sièges pleins de fantaisie et extrêmement ornementés, mais par ailleurs sommairement construits, étaient l'antithèse des sièges rembourrés de la haute époque victorienne, et comptent parmi les premiers exemples du préraphaélisme – sans être les tout premiers – dans les arts décoratifs.

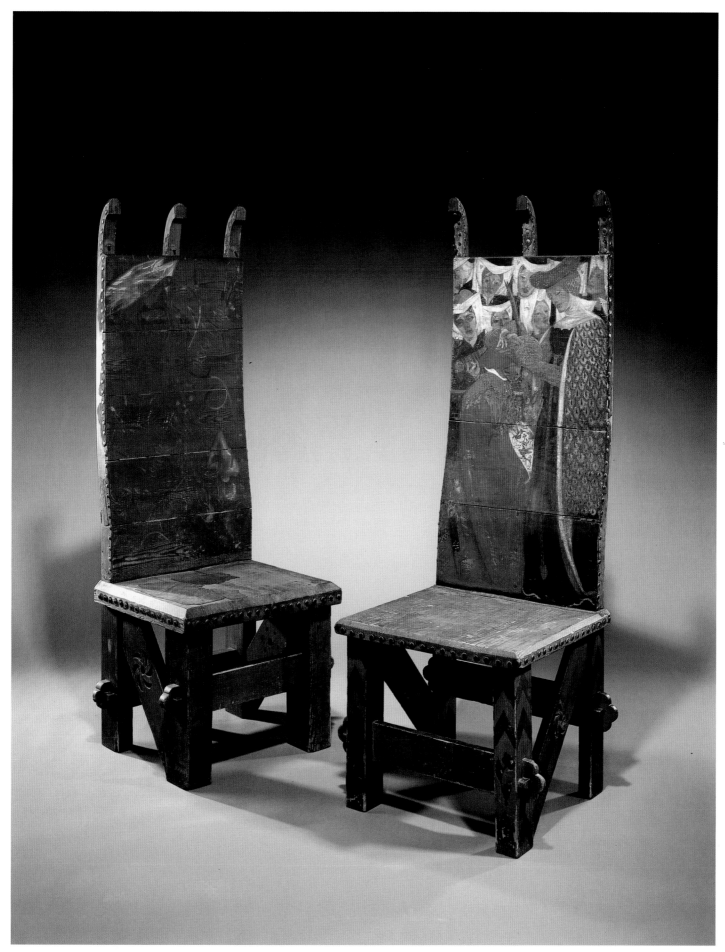

**William Morris (design/Entwurf/conception), Edward Burne-Jones & Dante Gabriel Rossetti (decoration/Dekor/décoration):**

Pair of high-backed chairs, 1856

Zwei Stühle mit hoher Rückenlehne

Deux chaises à hauts dossiers

First-floor window in the west façade
Fenster im ersten Obergeschoß der Westfassade
Fenêtre du premier étage, façade ouest

# THE RED HOUSE, BEXLEYHEATH, RESIDENCE FROM 1859 TO 1865

Morris first discussed plans for the construction of a new house for himself and his prospective wife in August 1858, while on a boat trip on the Seine with Philip Webb. Subsequently, in 1859, the Red House, Bexleyheath was designed by Webb in close collaboration with Morris. The house captured the essence of Early "muscular" Gothic architecture and was revolutionary in that its exterior, including fenestration, was determined by the interior's functional requirements. The practicality of its straightforward floor plan, which linked the rooms by means of a long L-shaped corridor, was extremely influential on a later generation of progressive architects, including Charles Voysey and Charles Rennie Mackintosh, whose revival of domestic architecture would be so acclaimed in Hermann Muthesius' critical study of 1904–1905, *Das Englische Haus* (The English House). Georgiana Burne-Jones recalled of the Red House: "It was not a large house but purpose and proportion had been so skilfully observed in its design as to arrange for all reasonable demands and leave the impression of ample space everywhere."[25]

The Red House was planned around an existing orchard so that the minimum number of trees would be felled, and its formal medieval-style garden was designed to be in complete harmony with the building. In late summer apples would even fall through the windows, much to the delight of Morris's guests. Philip Webb also designed an extension to accommodate the Burne-Jones family and the Firm's workshops; had it been built, the courtyard would have been closed on all sides to form a large quadrangle, while the internal corridor would have functioned like an enclosed cloister. The

Morris diskutierte seine Pläne zum Bau eines neuen Hauses für sich und seine künftige Frau zum ersten Mal im August 1858 bei einer Bootsfahrt auf der Seine mit Philip Webb. 1859 entwarf Webb das Red House in Bexleyheath in enger Zusammenarbeit mit Morris. Die Bauweise orientierte sich an der „muskulösen" frühgotischen Architektur und war insofern revolutionär, als das Äußere einschließlich der Fensteranordnung durch die funktionalen Erfordernisse im Inneren bestimmt wurde. Die Funktionalität des Grundrisses, der die Räume durch einen L-förmigen Korridor miteinander verband, übte einen starken Einfluß auf eine spätere Generation progressiver Architekten aus, darunter Charles Voysey und Charles Rennie Mackintosh, deren moderne Wohnhausarchitektur Hermann Muthesius in seinem Werk *Das Englische Haus* (1904–1905) überschwenglich lobte. Georgiana Burne-Jones sagte über das Red House: „Es war kein großes Haus, aber bei der Planung waren Zweck und Proportion so geschickt bedacht, daß es allen Anforderungen entsprach und den Eindruck von Weiträumigkeit erweckte."[25]

Das Red House wurde so in einen bestehenden Obstgarten integriert, daß möglichst wenige Bäume gefällt werden mußten. Der formell angelegte Garten im mittelalterlichen Stil steht in harmonischem Einklang mit dem Gebäude. Im Spätsommer fielen, zur Freude von Morris' Gästen, sogar Äpfel durch die Fenster. Philip Webb entwarf auch einen Anbau für die Familie Burne-Jones und die Werkstätten der Firma. Wäre er realisiert worden, wäre der Hof auf allen vier Seiten zu einem großen Rechteck geschlossen gewesen, und der innere Korridor hätte wie

C'est au mois d'août 1858, lors d'une excursion en bateau sur la Seine avec Philip Webb, que Morris commença à discuter des plans de sa nouvelle maison. À la suite de quoi, en 1859, Philip Webb conçut la Red House, à Bexleyheath, en étroite collaboration avec Morris. La maison avait quelque chose de la quintessence de l'architecture « musclée » du premier gothique anglais et était révolutionnaire en ce sens que son extérieur, y compris le fenêtrage, était déterminé par les exigences fonctionnelles de l'intérieur. La rationalité de son plan sur un seul niveau, les pièces étant reliées entre elles par un long couloir en forme de L, influença beaucoup la génération suivante d'architectes progressistes, parmi lesquels Charles Voysey et Charles Rennie Mackintosh. Ils remirent au goût du jour l'architecture résidentielle, une initiative pour laquelle Hermann Muthesius ne manqua pas de s'enthousiasmer dans l'étude intitulée *Das Englische Haus* (La maison anglaise), 1904–1905. Georgiana Burne-Jones évoqua la Red House en ces termes : « Ce n'était pas une grande maison mais les objectifs et les proportions avaient été si judicieusement respectés lors de sa conception, qu'elle répondait à tous les besoins rationnels, tout en donnant l'impression qu'il y avait partout beaucoup d'espace. »[25]

La construction de la Red House avait été planifiée autour d'un verger déjà existant, de sorte qu'il ne fallut pas abattre beaucoup d'arbres ; son jardin à la française, de style médiéval, fut conçu en complète harmonie avec la maison. Philip Webb dessina également une extension pour loger la famille Burne-Jones et pour accueillir les ateliers de la Firme ; si on l'avait construite, la cour aurait été fermée sur tous ses

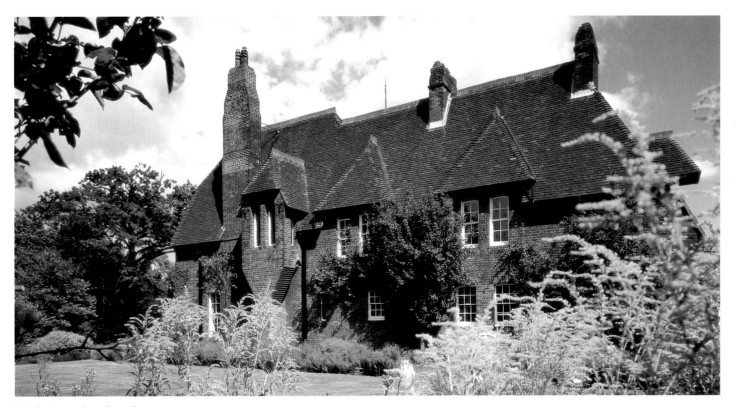

West façade seen from the garden

Westfassade vom Garten gesehen

Façade ouest vue depuis le jardin

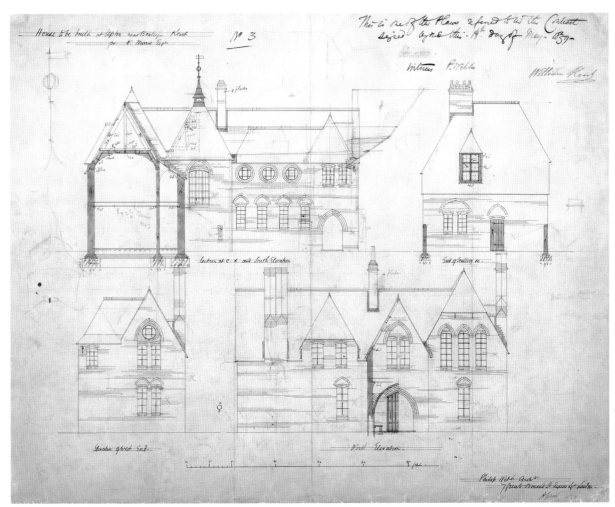

**Philip Webb:**

Drawing of the north and south elevations of the Red House, 1859

Zeichnung des Nord- und Südaufrisses des Red House

Élévations nord et sud de la Red House

PAGES 60–61 / SEITEN 60–61:

View of the east façade

Ansicht der Ostfassade

Vue de la façade est

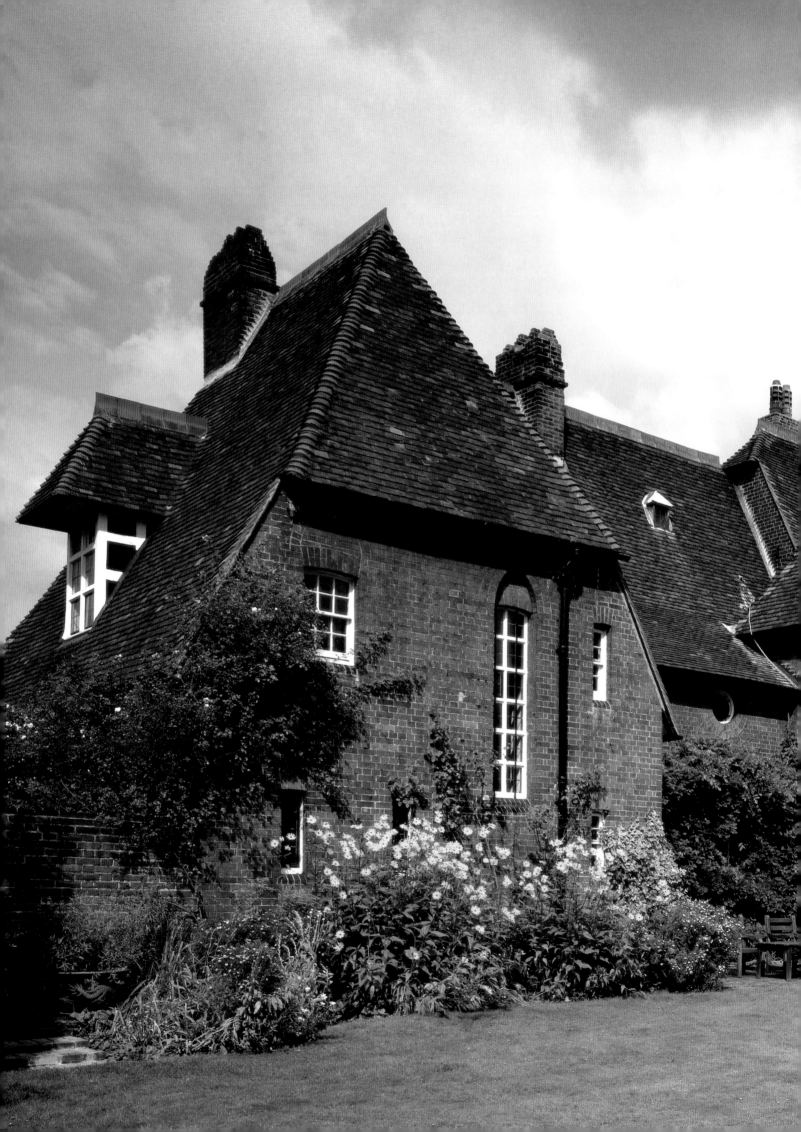

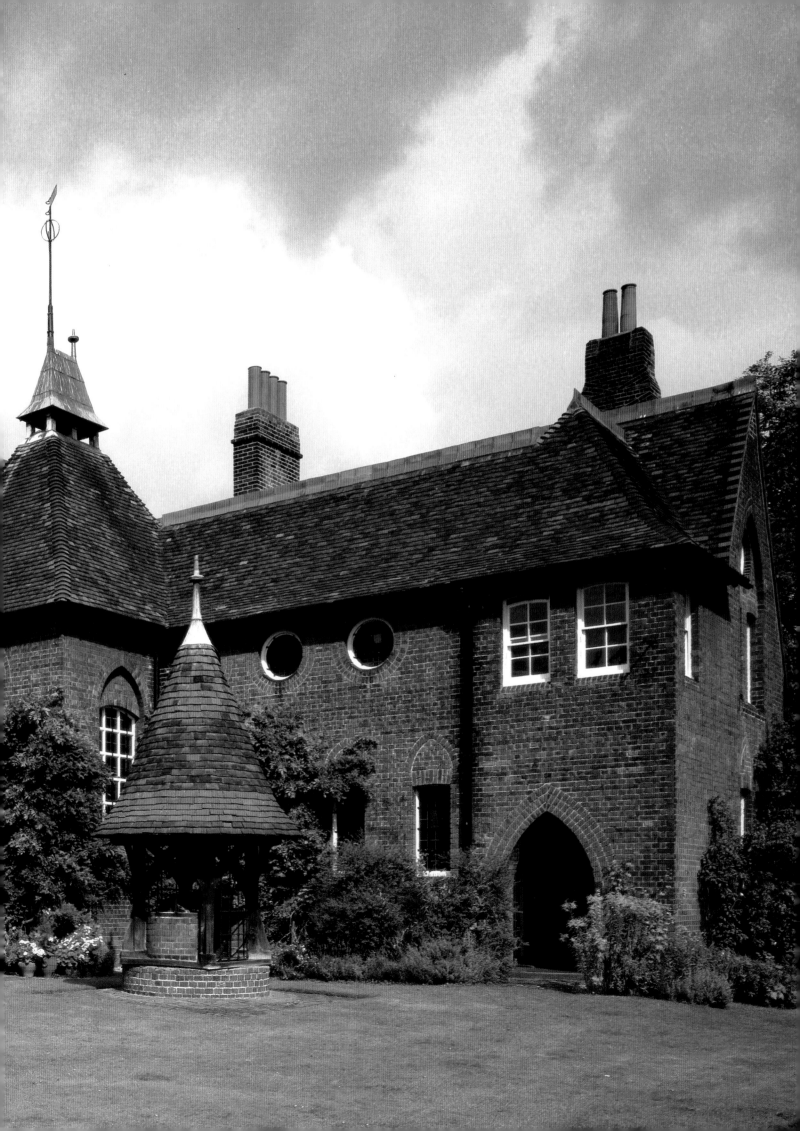

Dormer window in the south façade

Mansardenfenster in der Südfassade

Fenêtre de mansarde, façade sud

First-floor window in the west façade

Fenster im ersten Obergeschoß der Westfassade

Fenêtre du premier étage, façade ouest

Detail of chimney on the west façade

Kamindetail an der Westfassade

Détail de la cheminée, façade ouest

Detail of newel port on stairs

Detail des Treppenpfostens

Détail du pilastre de l'escalier

RIGHT PAGE: North entrance

RECHTE SEITE: Nördlicher Eingang

PAGE DE DROITE: Entrée nord

THE RED HOUSE, BEXLEYHEATH, RESIDENCE FROM 1859 TO 1865

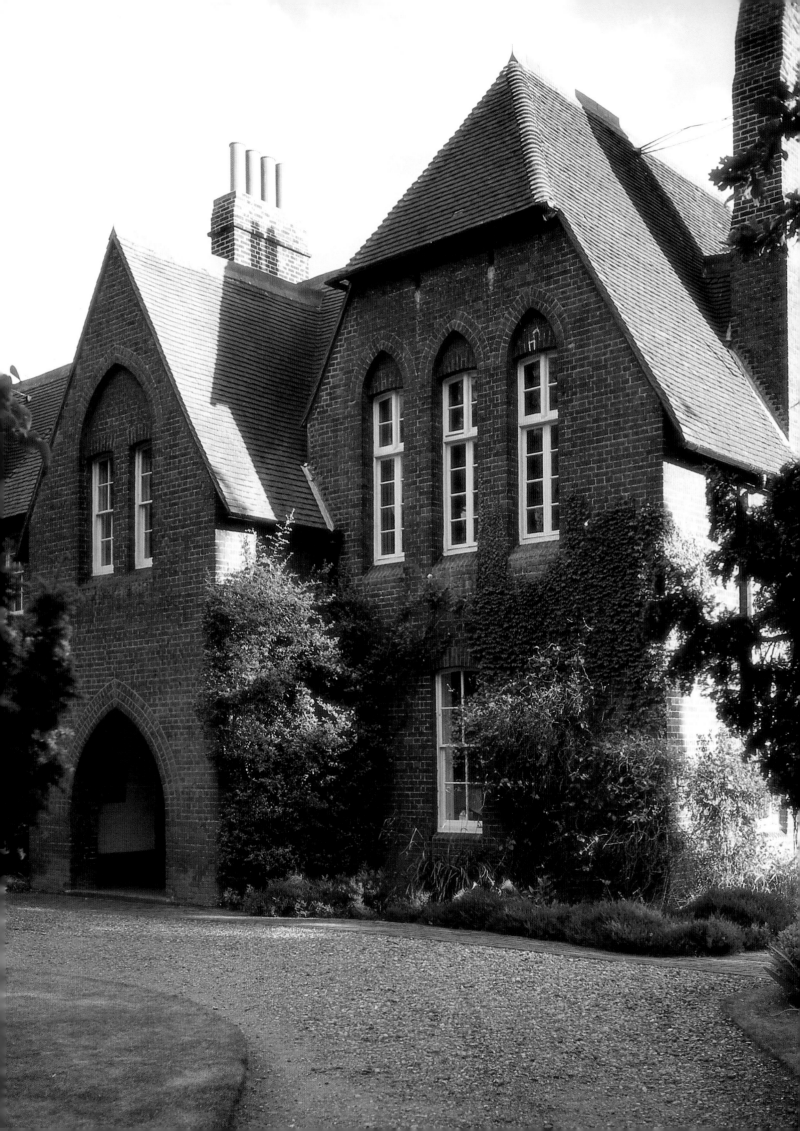

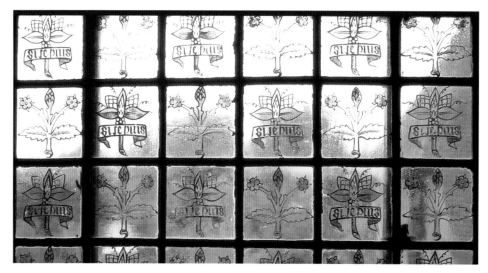

Detail of a stained-glass window in the ground-floor lobby
Detail eines farbigen Glasfensters in der Eingangshalle
Détail d'une fenêtre en verre coloré, vestibule du rez-de-chaussée

hooded well, although operative, was conceived primarily as a focal point and provided the building with a strong sense of domesticity. The unpretentious exterior of the building with its understated Gothic elements belied the richly decorated interiors within. These were adorned with murals by Rossetti and Burne-Jones, stained glass and painted medieval-style furniture, including the earlier pieces from Red Lion Square. The interior scheme, however, was perhaps too avant-garde for some. William Scott-Bell noted: "The total effect was strange and barbaric to Victorian sensibility and the adornment had a novel, not to say, startling character, but if one had been told that it was the south sea island style of thing one could have believed such to be the case, so bizarre was the execution."[26]

The Studio later described the Red House as "that wonderful red building which proved to be the prototype of all the beautiful houses of the so-called 'Queen Anne' revival; although that house, it may be said in passing, is almost entirely Gothic, with strong French influence apparent."[27] Certainly, it was one of the first domestic buildings to revive the use of unadorned brickwork and this, too, was an enormously influential feature of its design. Of greatest significance, however, was Morris's holistic approach to the project: its garden, architecture, interiors and furnishings were designed organically as a homogenous whole. As such, the Red House can be seen as an early embodiment of a *Gesamtkunstwerk* (unified work of art).

Morris never again visited the Red House after he and his family moved back to London in the autumn of 1865. Perhaps a return to his beloved "palace of art" would have been too painful an experience.

ein Kreuzgang funktioniert. Der überdachte Brunnen war zwar intakt, diente aber vor allem als optischer Mittelpunkt und verlieh dem Gebäude einen häuslichen Charakter. Das unprätentiöse Äußere mit den zurückhaltenden gotischen Architekturelementen kontrastierte mit den reich dekorierten Innenräumen. Sie waren mit Wandbildern von Rossetti und Burne-Jones, farbigen Glasfenstern und bemalten Möbeln im mittelalterlichen Stil, darunter die älteren Stücke vom Red Lion Square, ausgestattet. Manchen erschien das Innere freilich allzu avantgardistisch. William Scott-Bell notierte: „Der Gesamteindruck war befremdend und barbarisch für den viktorianischen Geschmack, und das Dekor hatte einen neuartigen, um nicht zu sagen bestürzenden Charakter, aber wenn jemand gesagt hätte, dies sei der Stil einer Südseeinsel, hätte man es geglaubt, so bizarr war die Wirkung."[26]

The Studio beschrieb das Red House später als „jenes wunderbare rote Gebäude, das sich als Prototyp all der schönen Häuser im sogenannten ‚Queen-Anne-Stil' erwies; allerdings ist dieses Haus … nahezu gänzlich gotisch mit deutlichem französischen Einfluß."[27] Zumindest war es eines der ersten Wohnhäuser, bei denen wieder undekorierter Backstein verwendet wurde. Besonders wichtig war jedoch Morris' ganzheitlicher Ansatz: Garten, Architektur, Innenräume und Möbel waren organisch als homogenes Ganzes entworfen. So läßt sich das Red House als frühes Beispiel eines „Gesamtkunstwerks" sehen.

Nachdem Morris mit seiner Familie im Herbst 1865 wieder nach London gezogen war, kehrte er niemals mehr in das Red House zurück. Vielleicht wäre ein Wiedersehen mit seinem geliebten „Kunstpalast" zu schmerzlich für ihn gewesen.

côtés pour former un vaste quadrilatère, tandis que le corridor intérieur aurait fonctionné à la manière d'un cloître. Le puits encapuchonné, fut d'abord conçu pour attirer le regard et pour donner à l'ensemble de la maison une forte empreinte de vie familiale. L'extérieur sobre des bâtiments, avec ses éléments gothiques discrets, était presque en contradiction avec les intérieurs abondamment décorés. Ces derniers étaient en effet ornés de peintures murales de Rossetti et de Burne-Jones, de vitraux et de meubles peints de style médiéval, ainsi que des premières œuvres de Red Lion Square. Le plan intérieur, toutefois, pouvait paraître trop avant-gardiste à certains. William Scott-Bell nota: «L'effet général était étrange et barbare pour une sensibilité victorienne, et la décoration intérieure avait un caractère inédit, pour ne pas dire surprenant; si on nous avait dit que c'était là le style insulaire des Mers du Sud, on aurait pu le croire, aussi bizarre que fût l'exécution.»[26]

The Studio devait plus tard décrire la Red House comme «ce magnifique bâtiment rouge qui s'avéra être le prototype de toutes ces superbes maisons issues du fameux renouveau du style ›Queen Anne‹; bien que cette maison, soit dit en passant, fût presque entièrement de style gothique, avec une forte influence française bien évidente»[27]. Ce fut certainement l'une des premières maisons à reprendre l'usage de la brique sans ornement. L'approche globale du projet était cependant très significative: son jardin, son architecture, ses intérieurs et son ameublement étaient conçus organiquement comme un tout homogène. En cela, la Red House peut être considérée comme un exemple précoce du «Gesamtkunstwerk» (œuvre d'art totale).

Après qu'il fut retourné s'installer à Londres avec sa famille, à l'automne 1865, Morris ne revint jamais plus à la Red House. Un retour dans son «palais de l'art» adoré aurait été pour lui une expérience trop douloureuse.

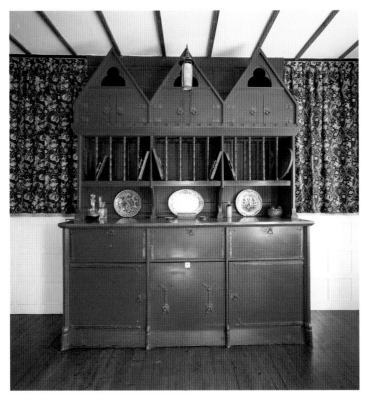

Dresser (designed by Philip Webb) in the dining room
Anrichte (Entwurf Philip Webb) im Speisezimmer
Vaisselier (conçu par Philip Webb), salle à manger

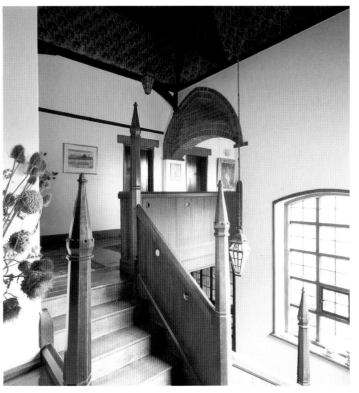

Stairs, seen from across the first-floor landing
Treppe mit erstem Geschoßabsatz
Escalier vu depuis le palier du premier étage

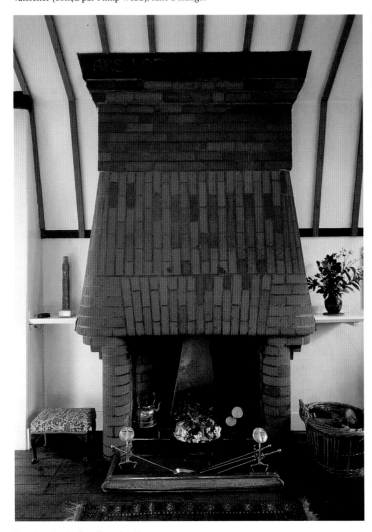

Fireplace in the first-floor drawing room
Kamin im Salon des ersten Geschosses
Cheminée, salon du premier étage

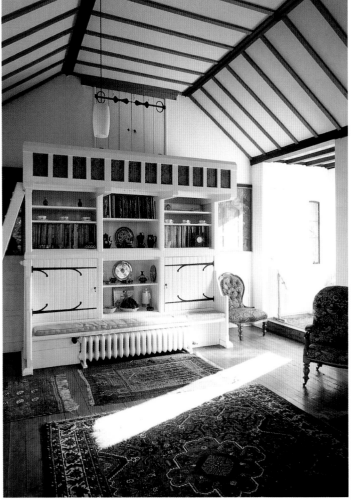

Settle in the first-floor drawing room
Umbaute Sitzbank im Salon des ersten Geschosses
Banc à haut dossier au salon du premier étage

# Kelmscott Manor,
# Kelmscott,
# Residence from 1871 to 1896

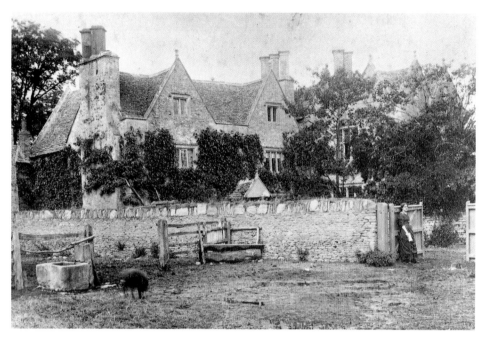

Early photograph of Kelmscott Manor with May
Morris at the gate
Frühe Photographie von Kelmscott Manor mit
Morris May am Tor
Une des premières photographies de Kelmscott
Manor, avec May Morris à la porte du jardin

RIGHT PAGE / RECHTE SEITE / PAGE DE DROITE:
East façade from the garden
Ostfassade vom Garten gesehen
Façade est vue du jardin

In May 1871, Morris and Rossetti agreed to sign
a shared lease on a country residence that had
been advertised in a London estate agent's cata-
logue. The property, Kelmscott Manor, was
a beautiful Elizabethan stone house set pic-
turesquely in a small rural hamlet on the edge
of the Cotswolds. Rented by Morris from 1871
until his death in 1896, this riverside home was
Morris's most cherished haven for over 25 years
and was the inspiration for his Utopian novel,
*News from Nowhere* (1889–1890).

In 1874, Rossetti left Kelmscott and his half of
the tenancy was taken over by Morris's publish-
er, F. S. Ellis. Eventually, in 1913, Jane purchased
Kelmscott Manor and nearly ten acres of sur-
rounding land for £4,000. May, the Morrises'
daughter, continued living there until her own
death in 1938 when, under the terms of her will,
the house and grounds were put in trust to the
University of Oxford. This bequest, however, was
later deemed invalid, and in 1962 the property
was passed over to the Society of Antiquaries,
the residuary legatee of the Morris estate, which
has in recent years painstakingly restored the
interiors to some of their former glory.

The original H-shaped building, built be-
tween 1580 and 1630, was a farmhouse that fol-
lowed a recognizable medieval plan. Although
a northeast wing was added slightly later in the

Im Mai 1871 unterzeichneten Morris und Rosset-
ti gemeinsam einen Mietvertrag für ein Land-
haus, das im Katalog eines Londoner Immobi-
lienmaklers angeboten worden war. Kelmscott
Manor war ein schönes elisabethanisches Stein-
haus in der pittoresken Umgebung eines kleinen
Weilers am Rande der Cotswolds. Dieses Haus
am Fluß, das Morris von 1871 bis zu seinem Tod
1896 gemietet hatte, war mehr als 25 Jahre lang
sein bevorzugter Zufluchtsort und inspirierte
seine utopische Erzählung *News from Nowhere*
(*Kunde von Nirgendwo*), 1889–1890.

1874 verließ Rossetti Kelmscott Manor. Seine
Hälfte des Mietvertrags wurde von Morris' Verle-
ger F. S. Ellis übernommen. 1913 kaufte schließ-
lich Jane Morris Kelmscott Manor und etwa
zehn Morgen Land für 4000 Pfund. Morris'
Tochter May lebte dort bis zu ihrem Tod 1938.
Danach wurden entsprechend ihrem Testament
Haus und Grundstück der Universität Oxford
als Treuhänder übergeben. Diese Verfügung
wurde jedoch später für ungültig erklärt, und
1962 ging der Besitz an die Society of Antiqua-
ries über, die Nachlaßverwalterin des Morris-
Erbes, die in den letzten Jahren die Innenräume
sorgfältig restauriert hat.

Das ursprüngliche H-förmige Gebäude, zwi-
schen 1580 und 1630 errichtet, war ein Bauern-
haus auf einem erkennbaren mittelalterlichen

En mai 1871, Morris et Rossetti signèrent d'un
commun accord le contrat de location d'une
maison de campagne dont une agence immobi-
lière de Londres avait fait la publicité dans une
brochure. La propriété, Kelmscott Manor, était
une superbe maison élisabéthaine en pierre,
merveilleusement située dans un petit hameau
rural, à la lisière des Costwolds. Pendant plus de
25 ans (Morris en fut locataire de 1871 à sa mort
en 1896), la maison au bord de l'eau fut son havre
préféré et inspira son roman utopique *News from
Nowhere* (*Nouvelles de nulle part*), 1889–1890.

En 1874, Rossetti quitta Kelmscott et la colo-
cation fut reprise par l'éditeur de Morris, F. S.
Ellis. Finalement, en 1913, Jane acheta Kelmscott
Manor et presque cinq hectares de terrain atte-
nant pour la somme de 4000 livres. May, la fille
des Morris, continua à y vivre jusqu'à sa mort en
1938. Selon ses dernières volontés, la maison et
les terres furent confiées à l'Université d'Oxford.
Ce legs fut toutefois déclaré non valide par la
suite, et en 1962, la propriété revint à la Société
des Antiquaires, légataire universel des biens de
Morris, et qui au cours de ces dernières années
a restauré avec soin tout l'intérieur de la demeu-
re, dans le souci de respecter sa splendeur d'au-
trefois.

Le bâtiment d'origine en forme de H, cons-
truit entre 1580 et 1630, était une maison de

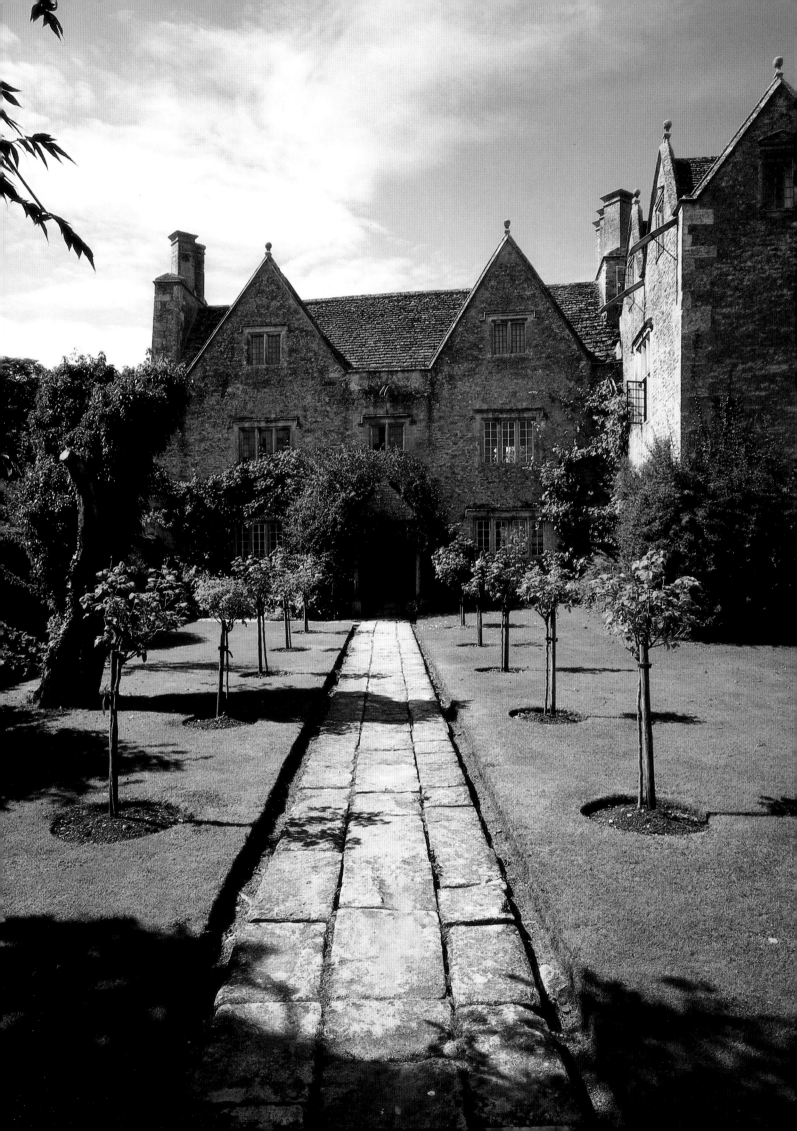

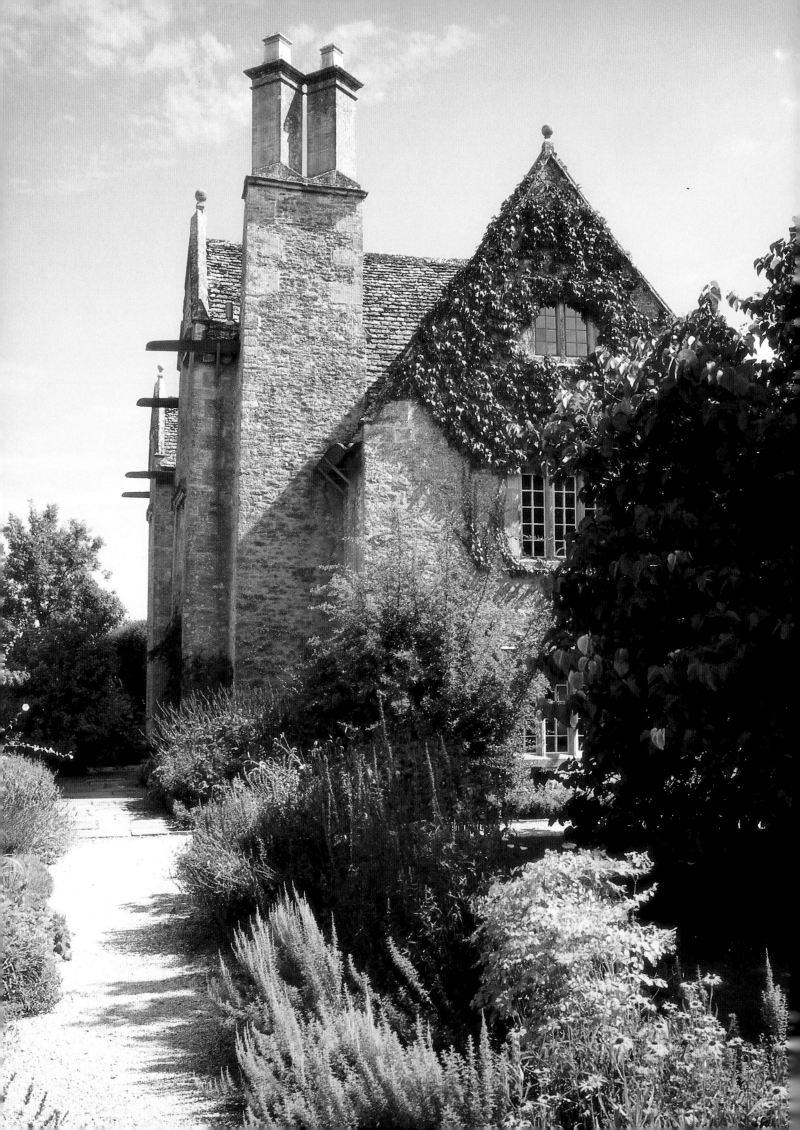

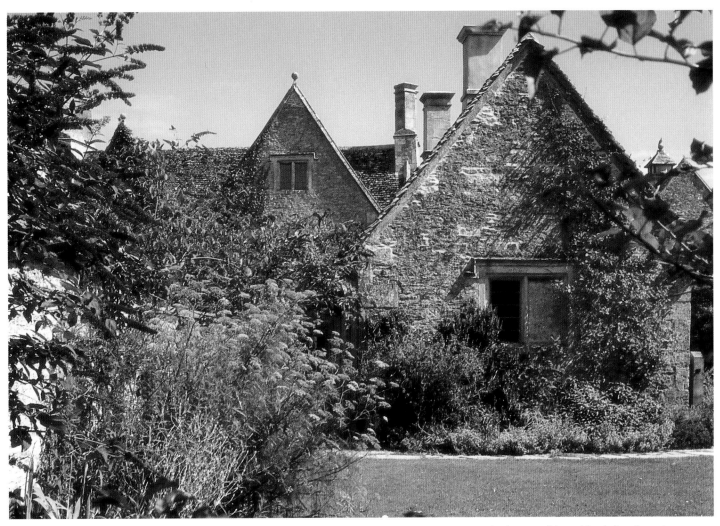

South corner of the west façade from the garden
Südliche Ecke der Westfassade vom Garten gesehen
Coin sud de la façade ouest vue du jardin

Centre of the west façade from the garden
Mittlerer Teil der Westfassade vom Garten gesehen
Centre de la façade ouest vue du jardin

LEFT PAGE / LINKE SEITE / PAGE DE GAUCHE:
North corner of the west façade from the garden
Nördliche Ecke der Westfassade vom Garten gesehen
Coin nord de la façade ouest vue du jardin

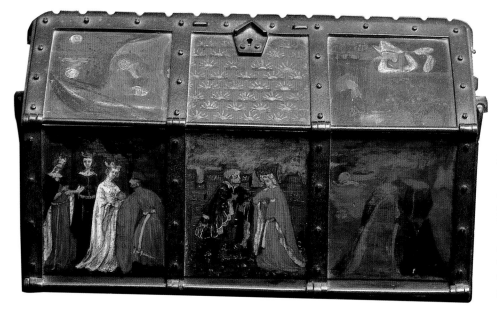

Jane Morris's jewel casket, probably designed by Philip Webb and painted by Lizzie Siddal and Dante Gabriel Rossetti

Jane Morris' Schmuckkasten, wahrscheinlich von Philip Webb entworfen und von Lizzie Siddal und Dante Gabriel Rossetti bemalt

Coffret à bijoux de Jane Morris, probablement dessiné par Philip Webb et peint par Lizzie Siddal et Dante Gabriel Rossetti

RIGHT PAGE / RECHTE SEITE / PAGE DE DROITE:

William Morris's bedroom

William Morris' Schlafzimmer

Chambre à coucher de William Morris

17th century, providing more spacious accommodation, the house was little altered over the succeeding years. Morris used Kelmscott Manor primarily as a holiday home, and as its tenant made few changes to the fabric of the building. He did, however, decorate it with sympathetic furnishings, many of which were sadly displaced after his death. The interiors that exist today were reconstructed using furniture left over from his tenancy as well as additional items gathered from his various London residences. A number of the more exotic objets d'art that decorate the Manor belonged to Rossetti.

The Green Room, a sitting room on the ground floor, exemplifies Morris's approach to interior design. Here, the simple and uncluttered space is decorated with an eclectic mix of period objects and other items produced by the Firm, together with Morris's early medieval-style *If I Can* embroidered hanging. The Tapestry Room on the first floor was and still is hung with four 17th-century tapestries depicting the life of Samson. Initially used by Rossetti as a studio, this long room was originally furnished with a gate-leg table and Sussex chairs. The main bedroom used by Morris, however, has been little altered and retains its 17th-century carved oak four-poster bed adorned with hangings embroidered by May Morris. The embroidered pelmet of the bed was worked with a verse specially composed by Morris that reveals his deep affection for Kelmscott Manor.

In the attics at the top of the Manor, amongst the great roof timbers, small garret rooms were used as bedrooms by Jenny and May. These were furnished with simple utilitarian green-painted furniture that was designed in the early years of

Grundriß. Im späten 17. Jahrhundert wurde zwar ein Nordost-Flügel angebaut, doch sonst wurde an dem Haus wenig verändert. Morris nutzte Kelmscott vorwiegend als Ferienhaus und nahm als Mieter wenig Änderungen an seiner Struktur vor. Allerdings stattete er es mit passenden Möbeln aus, von denen nach seinem Tod leider viele verschwanden. Die heutigen Innenräume wurden mit den erhaltenen Möbeln aus seiner Mieterzeit und Objekten aus seinen verschiedenen Londoner Wohnungen eingerichtet. Die exotischeren Kunstgegenstände im Haus stammen überwiegend aus Rossettis Besitz.

Das Grüne Zimmer, ein Wohnraum im Erdgeschoß, ist charakteristisch für Morris' Innengestaltung. Der einfache, offene Raum ist mit einer eklektischen Mischung aus zeitgenössischen Objekten und anderen Produkten der Firma dekoriert, unter anderem mit Morris' besticktem Wandbehang *If I Can* im frühmittelalterlichen Stil. Im Tapisseriezimmer im ersten Stock hängen bis heute vier Tapisserien aus dem 17. Jahrhundert, auf denen das Leben Samsons dargestellt ist. Dieser lange Raum, den Rossetti als Atelier benutzte, war ursprünglich mit einem Klapptisch und Sussex-Stühlen ausgestattet. Das von Morris bewohnte große Schlafzimmer ist wenig verändert und enthält noch immer das aus Eiche geschnitzte Himmelbett aus dem 17. Jahrhundert, das mit bestickten Vorhängen von May Morris geschmückt ist. Den bestickten Querbehang des Bettes zierte ein Vers von Morris, der seine tiefe Zuneigung zu Kelmscott Manor offenbart.

Im Dachgeschoß zwischen den großen Holzbalken dienten kleine Mansardenräume als Schlafzimmer für Jenny und May. Sie waren mit

ferme qui suivait un plan médiéval aisément reconnaissable. Bien qu'une aile nord-est ait été ajoutée au XVII$^e$ siècle, offrant ainsi plus d'espace habitable, la maison fut peu modifiée au cours des années qui suivirent. Morris utilisa Kelmscott Manor essentiellement comme résidence de vacances et procéda à quelques modifications de la structure du bâtiment. Il la décora avec de très beaux meubles, dont la plupart furent malheureusement ôtés après sa mort. Les intérieurs actuels ont été refaits et meublés avec ce qu'il restait ainsi qu'avec des pièces supplémentaires récupérées dans ses différentes résidences londoniennes. Un certain nombre des objets d'art exotiques qui décorent le Manoir appartenaient à Rossetti.

La Chambre Verte, un salon du rez-de-chaussée, est un exemple de la manière dont Morris concevait les arts décoratifs. Ici, l'espace simple et ordonné est agrémenté d'un mélange éclectique d'objets curieux et autres pièces réalisées par la Firme, ainsi que de la tenture de Morris *If I Can*, brodée dans un style médiéval primitif. Au premier étage, la Chambre de la Tapisserie était (et est encore) décorée de quatre tapisseries datant du XVII$^e$ siècle et décrivant la vie de Samson. Initialement utilisée par Rossetti comme atelier, cette longue pièce était à l'origine meublée avec une table anglaise et des chaises Sussex. La chambre principale occupée par Morris, en revanche, a été peu transformée. Elle a conservé le lit à baldaquins en chêne sculpté datant du XVII$^e$ siècle et paré de rideaux brodés par May Morris. Le lambrequin, également brodé, était ouvragé d'un poème spécialement composé par Morris et dans lequel il disait sa profonde affection pour Kelmscott Manor.

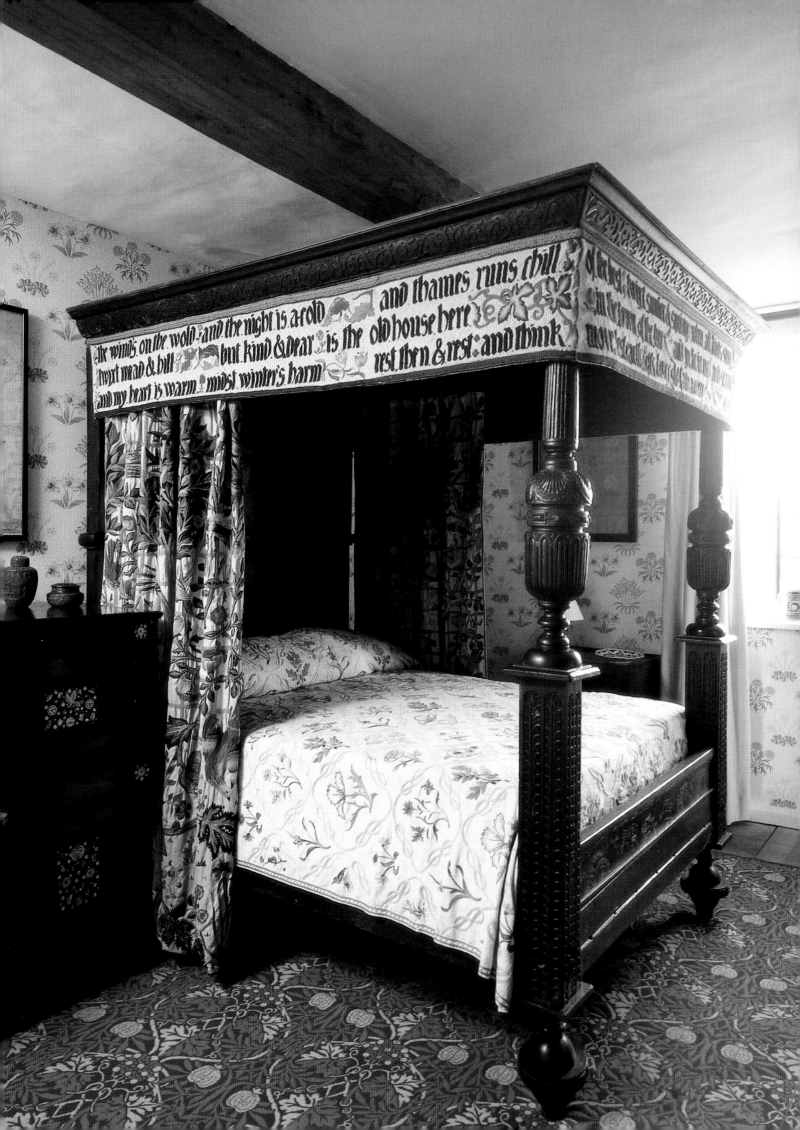

the winds on the wold and the night is a-cold
and thames runs chill
twixt mead & hill
but kind & dear is the old house here
and my heart is warm 'midst winter's harm
rest then & rest: and think

Settle and *Daisy* hanging on the ground floor
Sitzbank und Wandbehang *Gänseblume* im Erdgeschoß
Banc à haut dossier et tenture *Pâquerette*, rez-de-chaussée

Attic bedroom with Morris & Co.'s rustic "green" furniture designed by Ford Madox Brown
Dachzimmer mit dem rustikalen „grünen" Mobiliar von Morris & Co., entworfen von Ford Madox Brown
Mansarde garnie du mobilier rustique «vert» de Morris & Co., conçu par Ford Madox Brown

Morris, Marshall, Faulkner & Co. by Ford Madox Brown. Just as these and the other unpretentious interiors at Kelmscott Manor were completely in tune with the rural character of the building, so too was the semi-formal front garden. With its avenue of roses, this garden is important in its own right as an early example of first-phase Arts & Crafts garden design.

einfachen, grün gestrichenen Möbeln ausgestattet, die Ford Madox Brown in den Anfangsjahren von Morris, Marshall, Faulkner & Co. entworfen hatte. Diese und andere bescheidene Innenräume von Kelmscott Manor entsprachen dem rustikalen Charakter des Gebäudes, ebenso wie der etwas formelle Garten an der Vorderseite. Der Garten mit seiner Rosenallee ist ein wichtiges Beispiel für die frühe Gartengestaltung im Arts-and-Crafts-Stil.

Dans les combles, tout en haut du Manoir, parmi les poutres du grand toit, de petites pièces mansardées servaient de chambres à Jenny et à May. Elles étaient équipées de meubles simples et utilitaires peints en vert, qui avaient été conçus par Ford Madox Brown dans les premières années de Morris, Marshall, Faulkner & Co. Tous les intérieurs de Kelmscott Manor étaient en parfaite harmonie avec le caractère rural du bâtiment, tout comme le jardin de devant. Avec ses allées de rosiers, ce jardin est un des premiers exemples des jardins Arts & Crafts.

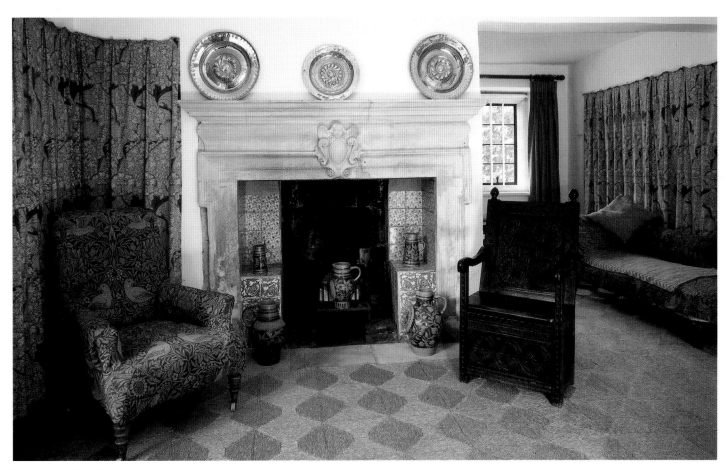

Fireplace in the Green Room

Kamin im Grünen Zimmer

Cheminée dans la Chambre Verte

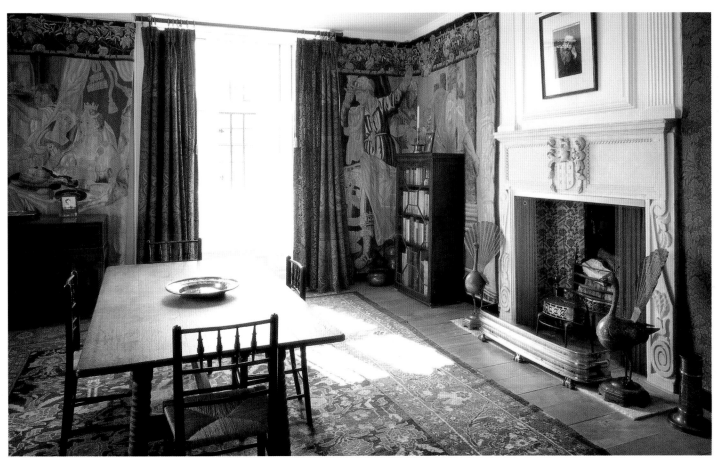

The Tapestry Room – view to the south

Das Tapisseriezimmer – Blick nach Süden

La Chambre de la Tapisserie – vue vers le sud

# KELMSCOTT HOUSE, HAMMERSMITH, RESIDENCE FROM 1878 TO 1896

William Morris's study, 1896
William Morris' Arbeitszimmer
Bureau de William Morris

This Georgian property at 26, Upper Mall, Hammersmith was originally known as The Retreat, but Morris renamed it Kelmscott House in tribute to his other riverside home. Overlooking the Thames, the property was rented from the children's author and poet Dr. George Macdonald, whose family of eleven children had previously occupied it. After the Morris family moved in, a carpet factory was set up in the stables and coach-house, and later, when this workshop moved to Merton Abbey, the space was used for Morris's political meetings.

Having spent nearly £1,000 on the redecoration of the property, the Morris family moved into Kelmscott House in November 1878. The interiors had either woven textile hangings or swirling floral wallpapers, with only a few pictures adorning the walls. The furniture ranged from heavy medieval-style pieces such as the *Prioress's Tale* wardrobe and Webb's settle, both of which were positioned in the first-floor drawing room, to more commercial Morris & Co. designs such as Webb's adjustable Morris chair and Sussex chair. The richness of these interiors was achieved by the addition of lustre plates, Persian carpets, eastern brassware and Morris & Co. rugs. While the overall effect was distinctly masculine and conveyed a sense of connoisseurship rather than luxury, the light and relatively restrained aesthetic of the rooms was quite a departure from the mainstream Victorian taste for cluttered interiors with quantities of trinkets and heavy layers of dark curtaining. Although still used as a private residence, the basement of Kelmscott House is now the home of the William Morris Society.

Dieses georgianische Haus an der Upper Mall 26 in Hammersmith mit Blick auf die Themse trug ursprünglich den Namen „The Retreat", doch Morris nannte es in Erinnerung an sein anderes Haus am Fluß Kelmscott House. Er mietete es von dem Kinderbuchautor und Dichter Dr. George Macdonald, der mit seinen elf Kindern dort gewohnt hatte. Als die Familie Morris einzog, richtete man in den Ställen und der Remise eine Teppichmanufaktur ein. Diese Werkstatt wurde später nach Merton Abbey umgesiedelt, und Morris nutzte die Räume für politische Versammlungen.

Nachdem die Familie Morris fast 1000 Pfund für die Renovierung ausgegeben hatte, zog sie im November 1878 in das Haus ein. Das Innere war mit gewebten Textilbehängen und floral gemusterten Tapeten ausgestattet. Nur wenige Bilder schmückten die Wände. Die Möblierung umfaßte schwere, mittelalterlich inspirierte Stücke wie den Schrank *Die Geschichte der Priorin* und Webbs Sitzbank, beide im Salon des ersten Obergeschosses, ebenso wie kommerziellere Entwürfe von Morris & Co. wie Webbs verstellbaren Morris- und Sussex-Stuhl. Zum Reichtum der Innenausstattung trugen Lüsterteller, persische Teppiche, asiatische Messingobjekte und Brücken von Morris & Co. bei. Der Gesamteindruck war maskulin und sprach eher von Kunstgeschmack als von Luxus. Die relativ zurückhaltende Ästhetik dieser Räume stand in deutlichem Kontrast zu der modischen viktorianischen Vorliebe für überladene Interieurs mit unzähligen Ausstattungsstücken und schweren Schichten dunkler Vorhänge. Das Haus wird bis heute privat genutzt, doch im Untergeschoß ist die William Morris Society untergebracht.

La propriété géorgienne du 26, Upper Mall, à Hammersmith, était à l'origine connue sous le nom de « The Retreat », mais Morris la rebaptisa Kelmscott House en hommage à son autre résidence riveraine. Surplombant la Tamise, la propriété appartenait à l'écrivain et poète George Macdonald, dont la famille de onze enfants avait auparavant occupé les lieux. Après l'emménagement de la famille Morris, on installa un atelier de tapis dans les étables et le hangar à voitures ; lorsque cette entreprise fut transférée à Merton Abbey, l'espace ainsi libéré devait servir aux réunions politiques de Morris.

Après avoir dépensé presque mille livres dans la redécoration de la propriété, la famille Morris vint s'installer à Kelmscott House en novembre 1878. Les intérieurs étaient garnis soit de tentures en étoffe tissée soit de papiers peints à volutes florales ; quelques rares tableaux ornaient les murs. L'ameublement allait des pièces en lourd style médiéval, comme la garde-robe *L'histoire de la prieure* et le banc à haut dossier de Webb, qui se trouvaient dans le salon du premier étage, à des œuvres plus commerciales Morris & Co., comme la chaise Morris et la chaise Sussex réglables. L'opulence de ces intérieurs était parachevée par l'addition d'une argenterie étincelante, de tapis persans, de cuivres orientaux et de petits tapis Morris & Co. Alors que l'effet d'ensemble était profondément viril, dégageant une impression d'intérieur décoré avec compétence plutôt qu'avec luxe, l'esthétique discrète et relativement réduite de ces pièces constituait une entorse au goût victorien en vogue pour les intérieurs encombrés par des quantités de bibelots et plusieurs épaisseurs de tentures sombres. Encore utilisé comme logement privé, le sous-sol de Kelmscott House abrite désormais la Société William Morris.

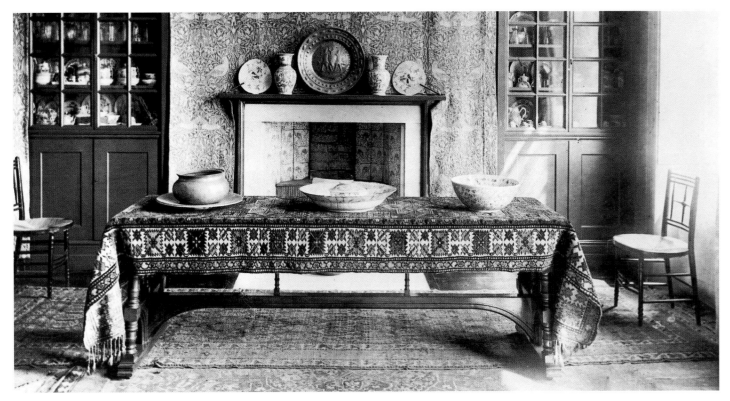

The drawing room – east view, 1896
Der Salon – Ansicht von Osten
Le salon – vue est

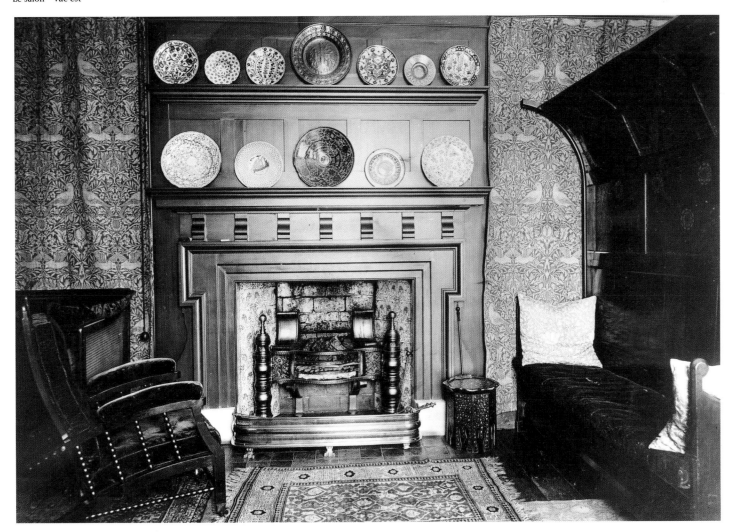

North wall of the drawing room, 1896
Nordwand des Salons
Mur nord du salon

# STANDEN

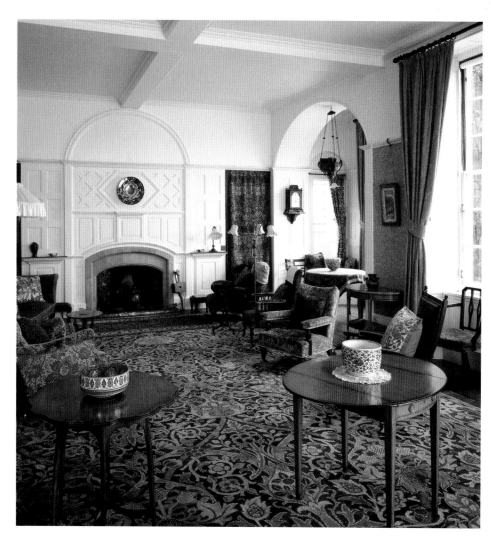

The drawing room, seen from the hall
Der Salon, von der Halle gesehen
Le salon vu de l'entrée

RIGHT PAGE / RECHTE SEITE / PAGE DE DROITE:
South façade
Südfassade
Façade sud

J. S. Beale, a successful solicitor and friend of the Ionides family, commissioned Philip Webb to design a house for him near East Grinstead, Sussex, in 1891. The unostentatious Standen, like the Red House, was inspired by vernacular building types and was built to a similar L-shaped plan. Many of its rooms were papered with Morris & Co. designs, while the dining room was decorated with woven Morris & Co. curtains and the drawing room furniture was covered with Morris & Co. chintzes. Standen can be considered a quintessential Arts & Crafts house and is one of the best surviving examples of the Domestic Revival – a style of architecture that was pioneered by Morris and Webb at the Red House.

J. S. Beale, ein erfolgreicher Anwalt und Freund der Familie Ionides, gab Philip Webb 1891 den Auftrag, für sein Grundstück bei East Grinstead in Sussex ein Haus zu entwerfen. Das bescheidene Standen war wie das Red House von lokalen Bautypen inspiriert und auf einem ähnlichen L-förmigen Grundriß errichtet. Viele Räume waren mit Tapeten von Morris & Co. ausgestattet. Das Speisezimmer war mit gewebten Vorhängen der Firma dekoriert, und die Möbel im Salon wurden mit Morris-Chintz bezogen. Standen ist ein typisches Arts-and-Crafts-Haus und eines der schönsten erhaltenen Beispiele für das „Domestic Revival" – eines Architekturstils, den Morris und Webb mit dem Red House einführten.

En 1891, J. S. Beale, avocat prospère et ami de la famille Ionides, commanda à Philip Webb la conception de sa nouvelle maison près de East Grinstead, dans le Sussex. Comme la Red House, la discrète résidence de Standen était inspirée des constructions traditionnelles et bâtie suivant un plan analogue en forme de L. Beaucoup de ses pièces étaient tapissées de papiers peints Morris & Co., tandis que la salle à manger était ornée de rideaux tissés provenant de chez Morris & Co. Le mobilier du salon était également recouvert des chintz de la Firme. Standen peut être considérée comme la quintessence d'une maison Arts & Crafts et reste l'un des meilleurs exemples du Domestic Revival – style architectural dont Morris et Webb furent les pionniers avec la Red House.

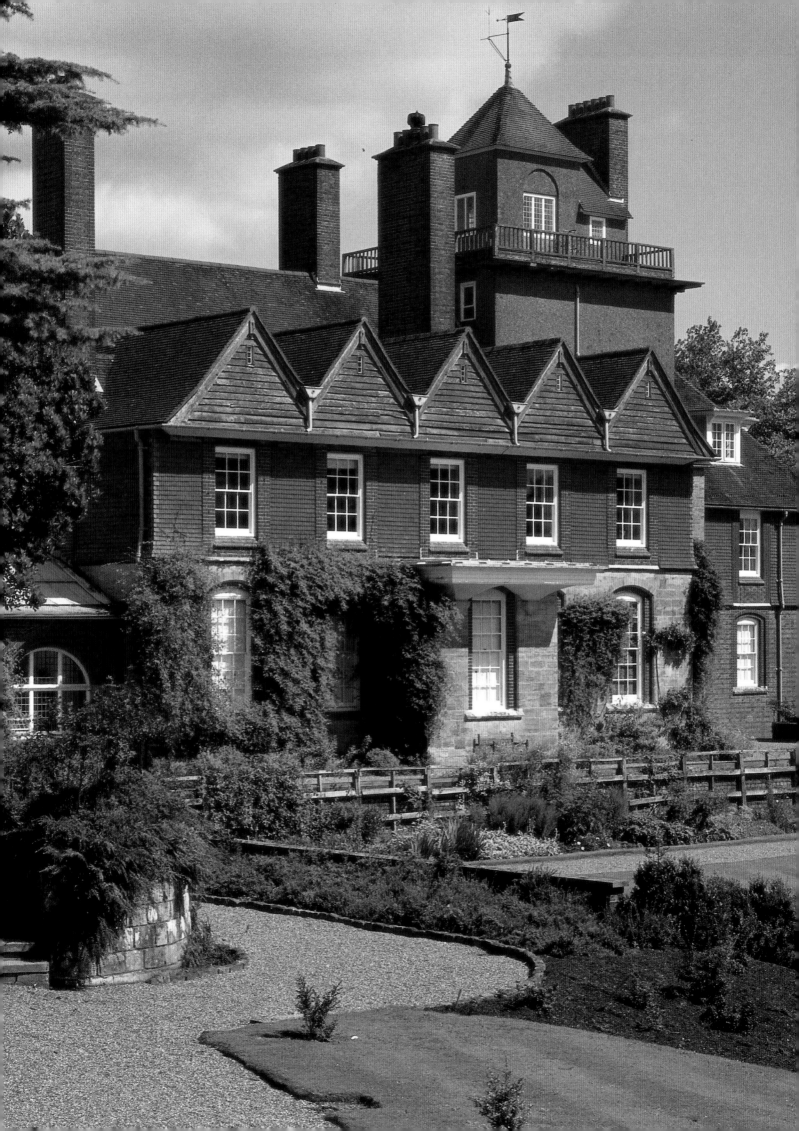

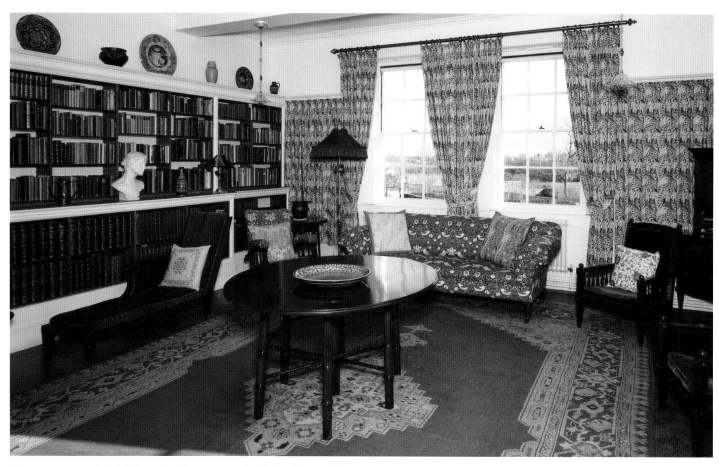

The morning room with *daffodil* chintz by William Morris and a table by Philipp Webb

Das Morgenzimmer mit Chintz *Narzisse* von William Morris und einem Tisch von Philip Webb

La salle du matin avec le chintz *Jonquille* de William Morris et une table de Philip Webb

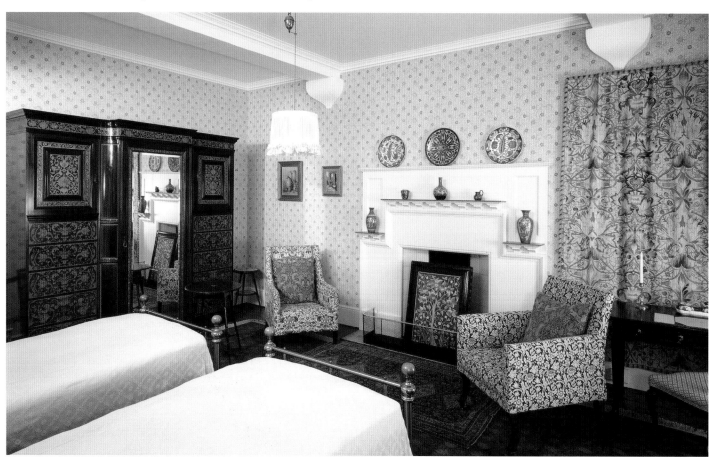

The north bedroom

Das nördliche Schlafzimmer

La chambre nord

RIGHT PAGE / RECHTE SEITE / PAGE DE DROITE: The staircase

Die Treppe

L'escalier

STANDEN

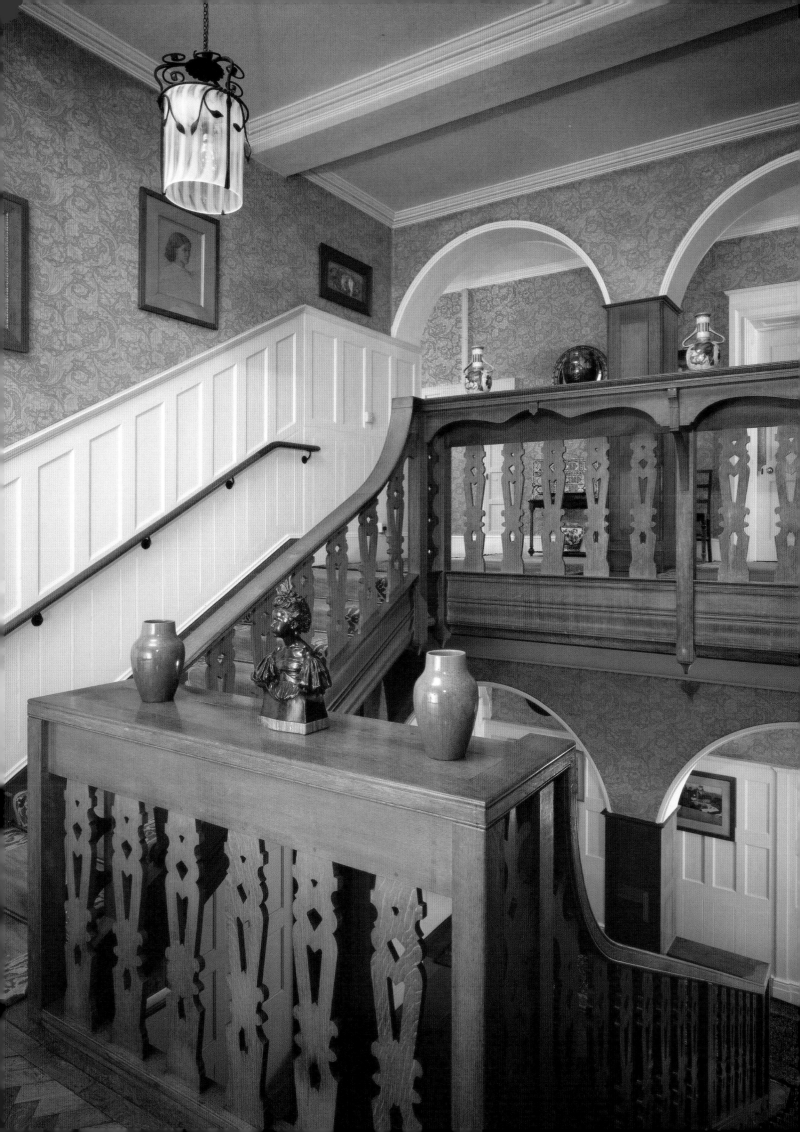

# Wightwick Manor

The Pomegranate Passage with a tapestry panel designed by Edward Burne-Jones and a Sussex settle

Granatapfel-Durchgang mit einer Tapisserie von Edward Burne-Jones und Sussex-Sitzbank

Le Passage des Grenades : tapisserie dessinée par Edward Burne-Jones et banc à haut dossier Sussex

In 1887 Theodore Mander, a wealthy paint manufacturer, purchased a property three miles from his native town of Wolverhampton and shortly afterwards commissioned the architect Edward Ould to design a new house for the site. The resulting building, which was extended in 1893, was half-timbered and in the Tudor Revival style. A profusion of upholstery textiles, hangings, embroideries and tiles by Morris & Co. was used throughout the Manor's interior. In addition to this, the hall was decorated with stained-glass panels inspired by characters from Morris's *Earthly Paradise*, albeit designed by the Gothic Revivalist C. E. Kempe. The decorative arrangement of the richly masculine Great Parlour combined the baronial with the homely, while the other interiors at the Manor imparted a sense of comfort and quality rather than luxury. Over a period of 40 years, the Firm continued to supply an array of designs for the house, ranging from tapestries to light fixtures, and its interior scheme may thus be considered truly representative of the Morris & Co. aesthetic.

1887 kaufte Theodore Mander, ein wohlhabender Farbenfabrikant, drei Meilen von seiner Geburtsstadt Wolverhampton entfernt ein Grundstück. Kurze Zeit später beauftragte er den Architekten Edward Ould, ein neues Haus zu bauen. Das Gebäude im Stil des Tudor Revival, das 1893 erweitert wurde, war zur Hälfte mit Holz verkleidet. Das Innere war aufwendig mit Polsterbezügen, Wandbehängen, Stickereien und Fliesen von Morris & Co. ausgestattet. Die farbigen Glasfenster der Halle zeigten Motive aus Morris' *Earthly Paradise* (*Das irdische Paradies*), obwohl sie von dem Neogotiker C. E. Kempe stammten. Der maskuline große Empfangsraum verband herrschaftliche mit häuslichen Elementen, während die anderen Innenräume weniger von Luxus als von Komfort und Qualität geprägt waren. Morris & Co. lieferte 40 Jahre lang Entwürfe für das Haus, von Tapisserien bis zu Leuchtkörpern. So ist die Inneneinrichtung außergewöhnlich repräsentativ für die Ästhetik der Firma.

En 1887, Theodore Mander, riche fabricant de peinture, acheta une propriété à environ cinq kilomètres de sa ville natale de Wolverhampton et chargea peu après l'architecte Edward Ould de concevoir une nouvelle maison sur ce site. La bâtisse qui en résulta, et qui fut agrandie en 1893, était à moitié en bois et de style Tudor Revival. Une énorme quantité de tissus d'ameublement, de tentures, de broderies et de carreaux de chez Morris & Co. furent utilisés dans tout le manoir. Le vestibule était orné de panneaux de vitrail inspirés des personnages du *Earthly Paradise* (*Paradis terrestre*) de Morris, encore que conçus par le revivaliste gothique C. E. Kempe. Le programme de décoration intérieure du Grand Salon combinait l'aspect seigneurial et l'aspect familial, alors que les autres intérieurs du Manoir donnaient une sensation de confort et de qualité plutôt que d'opulence. Pendant une quarantaine d'années, la Firme continua à fournir un ensemble impressionnant d'éléments de décoration pour cette maison, allant des tapisseries aux lampes. Le concept de décoration intérieure est en ce sens l'un des plus représentatifs de l'esthétique Morris & Co.

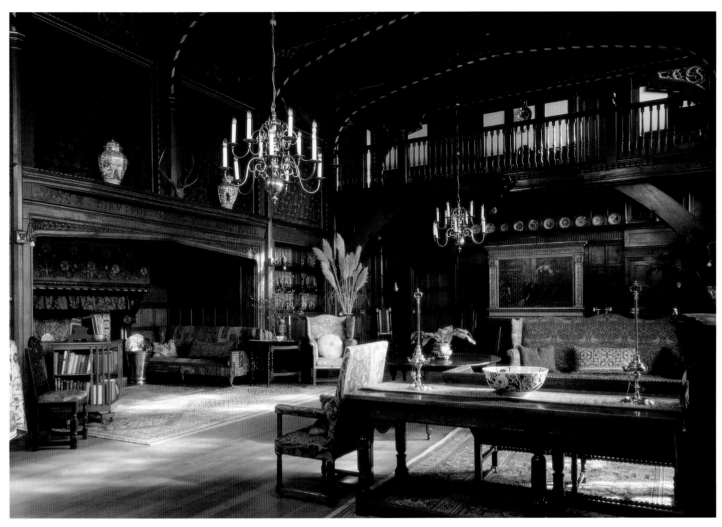

The Great Parlour
Das Große Empfangszimmer
Le Grand Salon

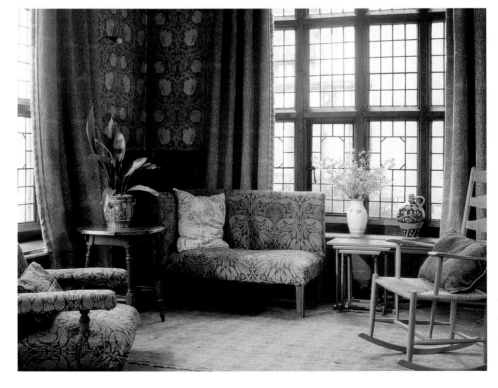

The billiard room, with *Bird* tapestry weave curtains, *Pimpernel* wallpaper and *Lily* Kidderminster carpet

Das Billardzimmer mit gewirkten Vorhängen *Vogel*, Tapete *Pimpernelle* und Kidderminster-Teppich *Lilie*

La salle de billard garnie des rideaux tissés en tapisserie *Oiseau*, du papier peint *Mouron* et du tapis Kidderminster *Lis*

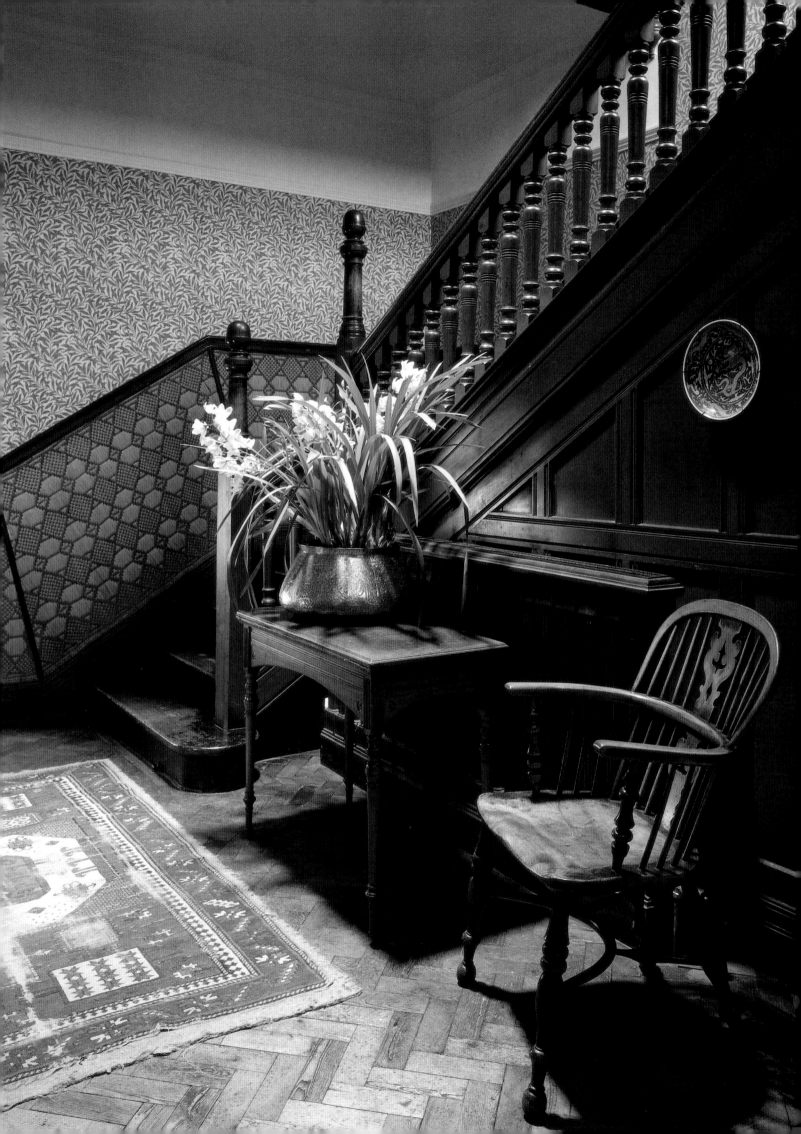

RIGHT / RECHTS / À DROITE:

Carpet in the Oak Room, designed by either William Morris or J. H. Dearle

Teppich im Eichenzimmer, entworfen von William Morris oder J. H. Dearle

Tapis de la Chambre du Chêne, conçu par William Morris ou J. H. Dearle

LEFT PAGE / LINKE SEITE / PAGE DE GAUCHE:

The visitor's staircase, with *Willow Bough* wallpaper and woven rush dado

Besuchertreppe mit Tapete *Weidenzweig* und gewebtem Binsensockel

L'escalier des invités, recouvert du papier peint *Branche de Saule* avec une plinthe en jonc tressé

BOTTOM / UNTEN / CI-DESSUS:

The Oak Room

Das Eichenzimmer

La Chambre en Bois de Chêne

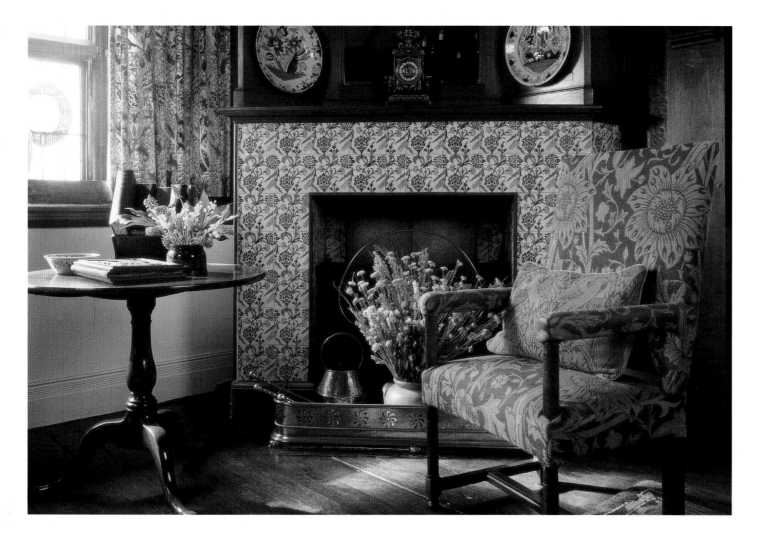

# Queen's College Hall, Cambridge, 1863–1864

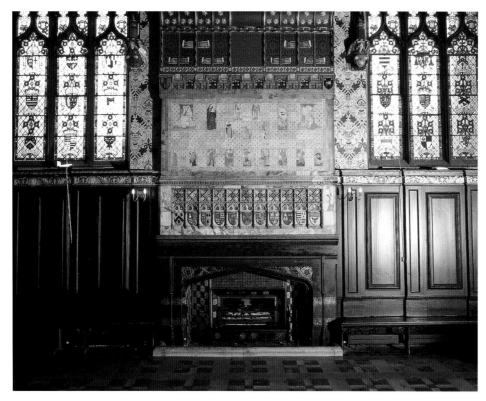

Fireplace
Kamin
Cheminée

From 1863 to 1864, the Gothic Revivalist architect G. F. Bodley undertook the restoration of The Old Hall at Queen's College, Cambridge. This work included the installation of a new tiled floor and a fireplace, the mantle of which was embellished with a panel of tin-glazed earthenware tiles specially commissioned from Morris & Co. The tiles, depicting the Virgin Mary, Saint Bernard and Saint Margaret as well as the months of the year, were hand-painted by Burne-Jones, Rossetti, Ford Madox Brown and Morris and were bordered with *Swan* tiles – a repeating pattern designed by Morris in 1862. Akin to an ancient Book of Hours, the panel was suitably Gothic in style, as too were the later wall and ceiling decorations carried out by Bodley in 1875. Other decorative commissions in Cambridge undertaken by Morris & Co. included those for Jesus College Chapel (c. 1866) and the Combination Room at Peterhouse College (c. 1874).

Von 1863 bis 1864 restaurierte der Neogotiker G. F. Bodley die Old Hall am Queen's College in Cambridge. Diese Arbeiten umfaßten auch die Verlegung eines neuen Fliesenbodens und die Installation eines Kamins, dessen Ummantelung mit glasierten, von Morris & Co. speziell hergestellten Steingutfliesen dekoriert war. Die Fliesen mit Darstellungen der Jungfrau Maria, des hl. Bernhard, der hl. Margareta und der Monate des Jahres waren von Burne-Jones, Rossetti, Ford Madox Brown und Morris handbemalt und mit *Schwan*-Bordüren eingefaßt – ein Muster, das Morris seit 1862 immer wieder verwendete. Das Fliesenpaneel erinnerte an ein altes Stundenbuch und war im gotischen Stil gehalten, ebenso wie die späteren Wand- und Deckendekorationen, die Bodley 1875 ausführte. Weitere Dekorationsarbeiten in Cambridge führte Morris & Co. an der Jesus College Kapelle (um 1866) und im Gemeinschaftsraum des Peterhouse College (um 1874) aus.

De 1863 à 1864, l'architecte « Gothic Revivaliste » G. F. Bodley entreprit la restauration du Old Hall de Queen's College, à Cambridge. Ce travail comprenait l'installation d'un nouveau sol carrelé et d'une cheminée, dont le manteau était ornementé d'un panneau de céramiques en étain émaillé réalisé sur commande spéciale par Morris & Co. Les carreaux, qui montraient la vierge Marie, saint Bernard, sainte Marguerite ainsi que les mois de l'année, étaient peints à la main par Burne-Jones, Rossetti, Ford Madox Brown et Morris, et bordés de carreaux *Cyne* – un motif répétitif conçu par Morris en 1862. Apparenté à un ancien livre d'heures, le panneau était, comme il se doit, de style gothique, comme l'étaient aussi les décorations du mur et du plafond exécutées par Bodley en 1875. D'autres programmes de décorations furent entrepris à Cambridge par Morris & Co., dont ceux de la Jesus College Chapel (vers 1874) et de la Combination Room du Peterhouse College (vers 1874).

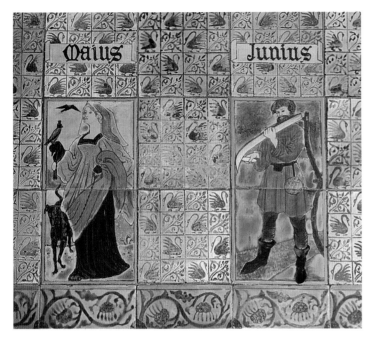

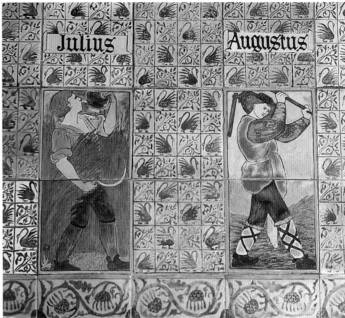

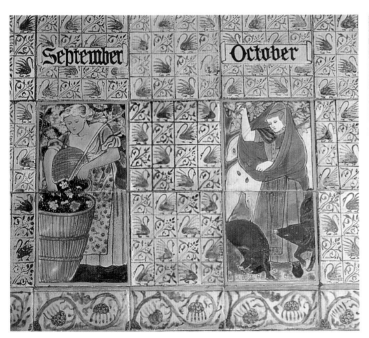

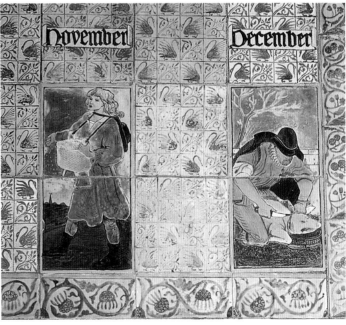

Details of tiled panels, May to December

Details des Fliesenbildes, Mai bis Dezember

Détails des carreaux en céramique, mois de mai à décembre

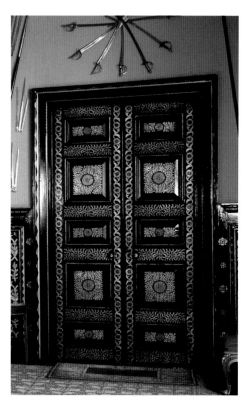

# THE ARMOURY & TAPESTRY ROOM, ST JAMES'S PALACE, 1866–1867

The door
Die Tür
La porte

The interior design of the adjoining Armoury and Tapestry Room at St James's Palace was overseen by Philip Webb on behalf of Morris, Marshall, Faulkner & Co., while the execution of the work was subcontracted to S & S Dunn. The myriad complementary patterns used in these two interiors produced an intensely Gothic effect, and this was augmented by the use of decorative motifs that bore a similarity to the engraved niello ornamentation of historic weaponry. The Armoury's dark lacquered panelling with its green and gold detailing complemented the weapons above, while the rich mustard yellow colour of the walls provided an enhancing background for the display. The overall effect of the scheme, though dark, was lifted by a few slightly eccentric elements, including colossal fireplaces with boldly striped decoration reminiscent of medieval jousting tents. With its incised black and gold decoration, the Armoury can be seen as more Aesthetic in style than other interiors undertaken by the Firm. This prestigious, State-funded royal commission helped to establish Morris, Marshall, Faulkner & Co.'s reputation and was one of the first to earn it much needed profits. Ironically, Morris despised the institution of monarchy and openly questioned the morality of its existence in society, even though Queen Victoria was now his most important client. Such was Morris's lack of regard of the monarch that he mockingly referred to her as the "Widow Guelph" or "Empress Brown".

Die Innendekoration des nebeneinanderliegenden Waffensaals und Tapisserienzimmers wurde von Philip Webb im Auftrag von Morris, Marshall, Faulkner & Co. beaufsichtigt, während man die Ausführung S & S Dunn übertrug. Die unzähligen einander ergänzenden Muster in diesen beiden Räumen schufen einen deutlich gotischen Effekt. Dazu trugen auch die Motive bei, die an die Niellogravuren historischer Waffen erinnern. Die dunkel lackierte Täfelung des Waffensaals mit ihren grünen und goldenen Details paßte zu den darüber befindlichen Waffen, während die senfgelbe Farbe der Wände die Form der Objekte betonte. Die Räume wirkten zwar dunkel, wurden aber durch einige exzentrische Elemente belebt, etwa kolossale Kamine mit kühn gestreiftem Dekor, die an mittelalterliche Turnierzelte erinnern. Dieser prestigeträchtige Auftrag vom Hof förderte das Ansehen von Morris, Marshall, Faulkner & Co. und war einer der ersten, die den so sehr benötigten finanziellen Gewinn einbrachten. Ironischerweise verachtete Morris die Monarchie und stellte den Sinn dieser Institution offen in Frage, obwohl Königin Viktoria nun seine wichtigste Kundin war. Er hatte so wenig Respekt vor der Monarchin, daß er sie scherzhaft als „Welfenwitwe" oder „Kaiserin Brown" bezeichnete.

Le décor intérieur de la Salle d'Armes et de la Salle des Tapisseries de St James's Palace fut supervisé par Philip Webb pour le compte de Morris, Marshall, Faulkner & Co. L'exécution du travail fut confiée à S & S Dunn. La myriade de motifs complémentaires utilisés dans ces deux intérieurs produisait un effet très gothique, encore renforcé par le recours à des éléments décoratifs assez semblables aux niellures ornementant les armes anciennes. Les sombres boiseries laquées de la Salle d'Armes, avec leurs détails vert et or, s'harmonisaient aux armes exposées au-dessus, tandis qu'à l'arrière-plan, les murs jaune moutarde mettaient le tout bien en valeur. L'effet d'ensemble de ce projet, quoique un peu sombre, était rehaussé d'éléments légèrement excentriques, comme des cheminées colossales décorées de rayures audacieuses rappelant les tentes des joutes médiévales. Avec ses incrustations décoratives noires et dorées, la Salle d'Armes est plus de style « esthétique » que tous les autres intérieurs réalisés par la Compagnie. Cette commande royale prestigieuse, financée par l'État, contribua à établir la réputation de Morris, Marshall, Faulkner & Co. et fut l'une des premières à rapporter un bénéfice dont la Compagnie avait énormément besoin. Ironie du sort, Morris continuait à mépriser l'institution monarchique et posait ouvertement la question de la moralité de son existence dans la société, alors que la reine Victoria était sa plus importante cliente. L'irrespect de Morris à l'égard de la reine était tel qu'il la qualifiait de « Veuve Guelf » ou d'« Impératrice Brown ».

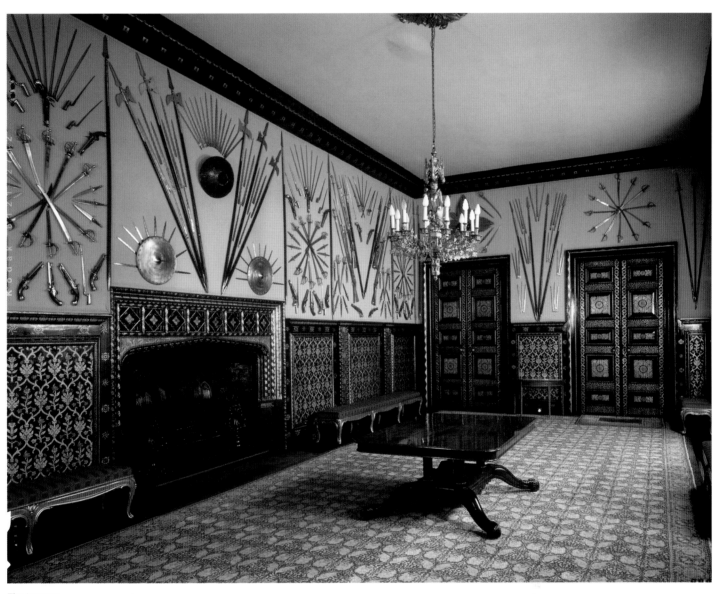

The Armoury
Der Waffensaal
La Salle d'Armes

# THE GREEN DINING ROOM, SOUTH KENSINGTON MUSEUM, 1866–1867

**Philip Webb:**

Design for wall and cornice decoration, 1866

Entwurf für Wand- und Gesimsdekor

Motif pour la décoration d'un mur et d'une corniche

The Green Dining Room was one of three re-freshment areas on the ground floor of the newly built South Kensington Museum. Although the other dining rooms – the Renaissance Revival Gamble Room and the Aesthetic-style Poynter Room – exemplified progressive trends in Victorian interior design, their influence on contemporary taste was not as pervasive as Morris, Marshall, Faulkner & Co.'s scheme for the Green Dining Room. Frequented by James McNeil Whistler and George du Maurier, the Green Dining Room formed the prototype for many similar establishments, in which Victorian aesthetes would gather for refreshments – a practice lampooned by W. S. Gilbert and A. S. Sullivan in their comic opera *Patience* (1881).

The interior was designed by Philip Webb with Morris's assistance and the execution of the work was subcontracted to S & S Dunn. Like the Firm's decorations at St James's Palace, the Green Dining Room was a jewel-like space in-corporating a plethora of complementary pat-terns. It differed from the royal interiors, how-ever, in that its overall effect was both lighter and brighter. The stone-blue painted panelling and sage green wallpaper used in the scheme were enriched by painted and gilded panels to-gether with a sumptuous frieze. Incorporated in the patterned ceiling were sunburst motifs which were very much Aesthetic in style. While the interior exhibits a Regency-like opulence, its intricate detailing stands in testimony to the Firm's virtuoso handling of different media.

Das Grüne Speisezimmer war einer der drei Erfrischungsräume im Erdgeschoß des neuer-bauten South Kensington Museum. Auch die anderen Speiseräume – das Spielzimmer im Neorenaissance-Stil und das Poynter Zimmer im Ästhetischen Stil – zeigten progressive Tenden-zen in der viktorianischen Innendekoration, übten aber keinen so starken Einfluß aus wie der Entwurf von Morris, Marshall, Faulkner & Co. für das Grüne Speisezimmer. James McNeil Whistler und George du Maurier waren hier zu Gast, und das Speisezimmer wurde zum Prototyp für viele ähnliche Räume, in denen sich vikto-rianische Ästheten zu einen Imbiß versammel-ten – eine Praxis, über die sich W. S. Gilbert und A. S. Sullivan in ihrer komischen Oper *Patience* (1881) lustig machten.

Die Innenausstattung entwarf Philip Webb in Zusammenarbeit mit Morris, die Ausführung wurde S & S Dunn übertragen. Ähnlich wie die Räume im St. James's Palace war das Grüne Speisezimmer eine Art Schatzkammer, mit üppi-gen Mustern dekoriert. Anders als die königli-chen Innenräume wirkte es jedoch heller und freundlicher. Die kobaltblau gestrichenen Ver-täfelungen und die salbeigrünen Tapeten wur-den durch bemalte und vergoldete Paneele und einen üppigen Fries betont. Die Ausgestaltung erinnert an die Opulenz des Regency-Stils, doch die raffinierten Details zeugen von dem virtuo-sen Umgang der Firma mit unterschiedlichen künstlerischen Techniken.

La Green Dining Room était une des trois salles de repos au rez-de-chaussée du tout nouveau South Kensington Museum (aujourd'hui Victoria and Albert Museum). Bien que les autres salles à manger – la salle de jeu Renaissance Revival et la Poynter Room de style « esthétique » – fussent un exemple de tendances progressistes dans la conception des intérieurs victoriens, elles n'in-fluencèrent pas autant le goût de l'époque que le programme de décoration intérieure de Morris, Marshall, Faulkner & Co. choisi pour la Green Dining Room. Fréquentée par James McNeil Whistler et George du Maurier, la Green Dining Room constituait le prototype de nom-breuses salles similaires, dans lesquelles des es-thètes victoriens se retrouvaient pour se délas-ser et boire un verre – usage tourné en dérision par W. S. Gilbert et A. S. Sullivan dans leur opéra-comique *Patience* (1881).

La décoration intérieure de cette salle fut conçue par Philip Webb assisté de Morris, et l'exécution du travail confiée à S & S Dunn. La Green Dining Room était un espace semblable à un joyau, qui comprenait pléthore de motifs complémentaires. Les boiseries bleu ardoise et le papier peint vert tilleul, utilisés dans le projet de décoration, étaient enrichis de panneaux peints et dorés assortis d'une frise somptueuse. Incorporés dans le plafond orné de motifs, des dessins de style « esthétique » évoquaient des échappées de soleil. Tandis que l'intérieur dé-ployait une opulence de style Régence, ses dé-tails complexes témoignaient de la virtuosité avec laquelle la Firme maîtrisait les différentes techniques artistiques.

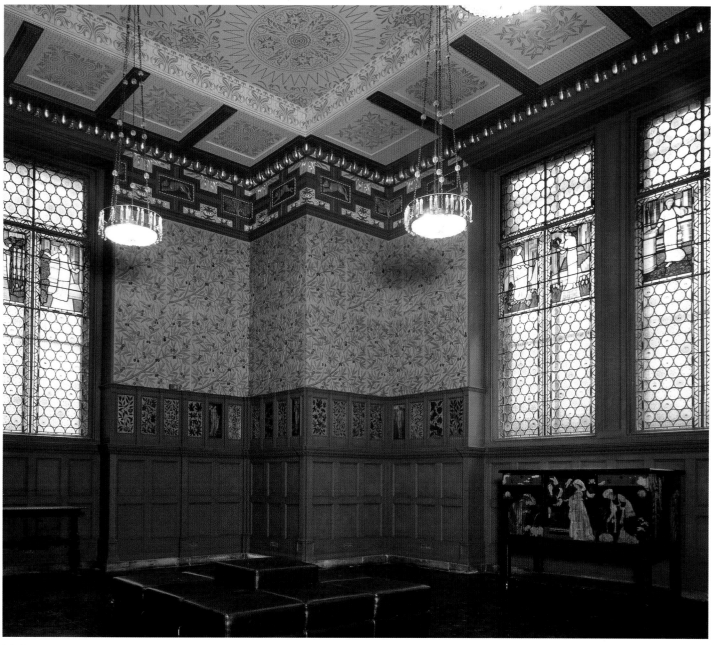

Interior
Innenansicht
Intérieur

**Philip Webb & William Morris:**
Two designs for the ceiling decoration, 1866/1867
Zwei Entwürfe für die Deckendekoration
Deux motifs pour la décoration du plafond

# STAINED GLASS

**Philip Webb:**

Stained-glass panel possibly designed for the nursery at the Red House, c. 1859–1860

Farbiges Glasfenster, wahrscheinlich für das Kinderzimmer des Red House entworfen, ca. 1859–1860

Panneau en verre coloré probablement conçu pour la chambre d'enfants de la Red House, vers 1859–1860

Shortly after Morris, Marshall, Faulkner & Co. was founded in 1861, a kiln for firing glass was installed in its premises at 8, Red Lion Square. A professional glass painter and an experienced glazier were engaged and young assistants were recruited from the Industrial Home for Destitute Boys. By 1862 there was a team of twelve workers producing designs for stained glass, and it was in this area that the Firm received the majority of its earliest commissions. Morris, Marshall, Faulkner & Co. showed several stained-glass panels at the 1862 International Exhibition held at South Kensington, and so well did these capture the spirit of ancient archetypes that some of the Firm's competitors accused it of exhibiting original medieval work!

Unlike the majority of manufacturers, who produced panels that were the equivalent of stained-glass paintings and which relied heavily on shading, the Firm's windows, like those of the Middle Ages, accentuated the mosaic-like qualities of the medium. Excelling as a colourist, Morris juxtaposed different subtly toned and patterned pieces to create exquisite panels of immense richness. Although stylistically inspired by Pre-Renaissance work, the Firm's designs should be regarded as essentially Pre-Raphaelite and not as Gothic reproductions. Many of the stained-glass panels were collectively designed, with Burne-Jones being responsible for the execution of the figures and either Morris or Webb creating the backgrounds. For Morris, the function of stained glass was to "tell stories in a simple direct manner"[28]. Religious subjects in the Firm's designs, in particular the saints, were not charged with the piety so often found in mainstream Victorian stained glass.

Kurz nach der Gründung von Morris, Marshall, Faulkner & Co. 1861 wurde in deren Werkstatt, Red Lion Square 8, ein Brennofen für Glasschmelze installiert. Ein professioneller Glasmaler und ein erfahrener Glaser wurden engagiert, jugendliche Helfer kamen aus dem Heim für mittellose Jungen. 1862 realisierte ein Team von zwölf Arbeitern Entwürfe für farbige Glasfenster, eine Sparte, in der die Firma die meisten ihrer frühen Aufträge erhielt. Morris, Marshall, Faulkner & Co. zeigten auf der Weltausstellung von 1862 in South Kensington mehrere Buntglaspaneele. Sie spiegelten den Geist älterer Archetypen so überzeugend, daß einige Konkurrenten die Firma beschuldigten, sie stelle mittelalterliche Originalwerke aus!

Anders als die meisten Manufakturen, deren Arbeiten ähnlich wie die Glasmalerei stark von Farbschattierungen abhingen, betonten die Fenster von Morris' Firma wie die des Mittelalters den mosaikartigen Charakter des Mediums. Morris, ein exzellenter Kolorist, stellte unterschiedlich gefärbte und gemusterte Elemente nebeneinander, um außergewöhnlich farbenfrohe, exquisite Glasflächen zu schaffen. Obwohl stilistisch vom Mittelalter inspiriert, sind die Entwürfe der Firma eher als Manifestationen des Präraffaelismus zu sehen denn als Nachahmungen der Gotik. Viele der farbigen Fenster wurden gemeinsam signiert, wobei Burne-Jones für die Figuren zuständig war und entweder Morris oder Webb den Hintergrund schufen. Für Morris hatten farbige Glasfenster die Funktion, „Geschichten in einfacher, direkter Form zu erzählen".[28] Religiöse Themen, vor allem die Heiligen, wurden in den Entwürfen der Firma nicht mit der Frömmigkeit befrachtet, die sich

Peu après la fondation en 1861 de Morris, Marshall, Faulkner & Co., un four pour la cuisson du verre fut installé au 8, Red Lion Square. Un peintre sur verre professionnel et un verrier expérimenté furent embauchés et de jeunes assistants furent recrutés chez Industrial Home for Destitute Boys. En 1862, une équipe de douze ouvriers produisait des dessins pour des vitraux. C'est dans ce domaine que la Firme enregistra la plus grande partie de ses premières commandes. Morris, Marshall, Faulkner & Co. exposèrent plusieurs vitraux à l'Exposition internationale de South Kensington.

À la différence de la majorité des fabricants qui produisaient des panneaux équivalant à des peintures en verre coloré s'appuyant énormément sur les procédés d'ombres, les vitraux de la Firme, comme ceux du Moyen Âge, accentuaient les effets de mosaïque du matériau. Coloriste hors pair, Morris juxtaposait différentes pièces subtilement harmonisées et décorées pour créer de ravissants panneaux d'une immense richesse. Quoique stylistiquement inspirées par les œuvres du Moyen Âge, les décorations de la Firme doivent être davantage considérées comme des expressions du préraphaélisme que comme des reproductions gothiques. La plupart de ces vitraux furent conçus collectivement : Burne-Jones était responsable de l'exécution des personnages tandis que Morris ou Webb créait les arrière-plans. Pour Morris, la fonction des vitraux était de « raconter des histoires d'une manière simple et directe »[28]. Les sujets religieux utilisés dans les décorations de la Firme, en particulier les saints, n'étaient pas chargés de la piété que l'on observe si souvent dans le vitrail victorien. La Firme préféra opter pour une ap-

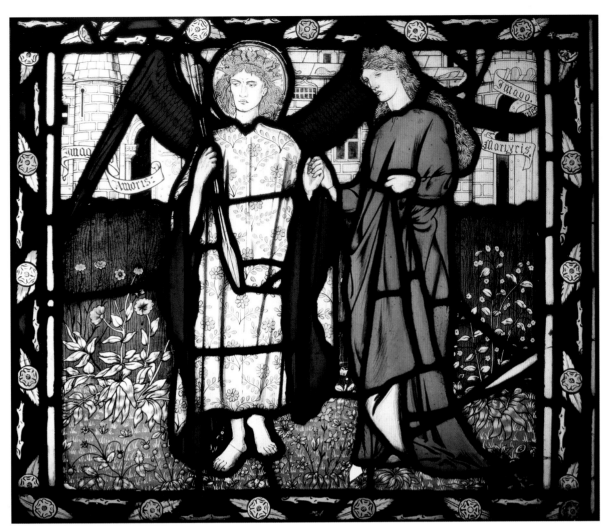

**Edward Burne-Jones:**

*Amor & Alcestis* (scene from Chaucer's *Legend of Goode Wimen*), stained-glass panel, 1864

*Amor & Alkestis* (Szene aus Chaucers *Legende von den guten Frauen*), farbiges Glas

*Amor & Alcestis* (scène tirée de la *Légende des femmes exemplaires* de Chaucer), vitrail

BOTTOM / UNTEN / CI-DESSUS:

**Ford Madox Brown:**

*Architecture* and *Music* (two scenes from *King René's Honeymoon*), stained-glass panels, c. 1863

*Architektur* und *Musik* (zwei Szenen aus *König René's Hochzeitsreise*), farbiges Glasfenster, ca. 1863

*Architecture et Musique* (deux scènes tirées de *La Lune de Miel du Roi René*), vitraux, vers 1863

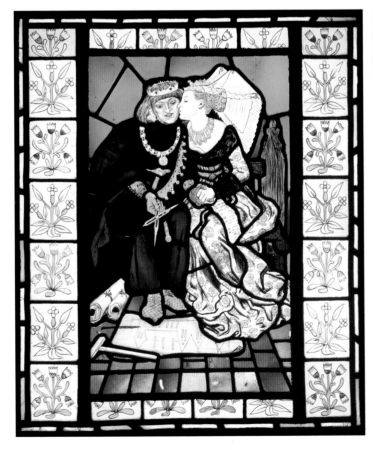
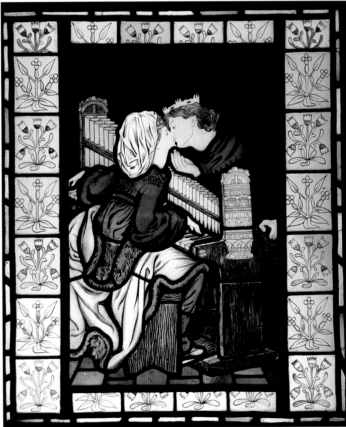

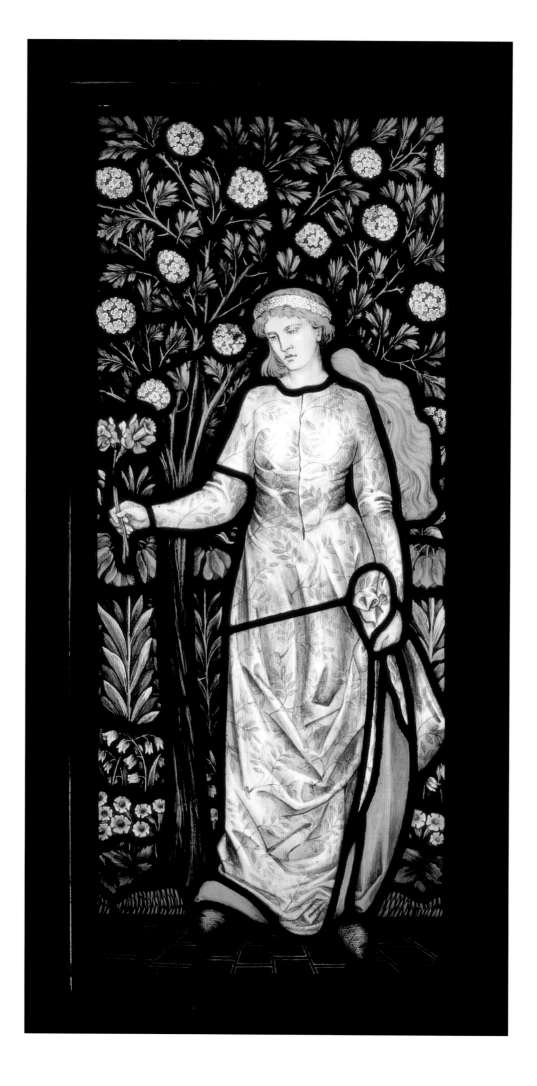

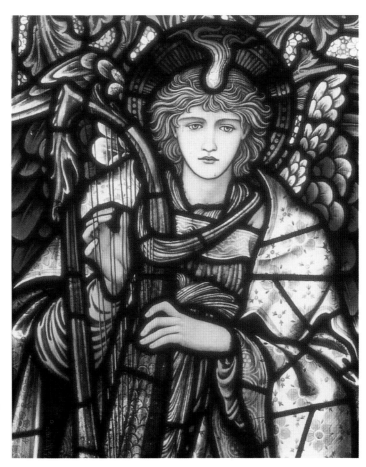

Instead, the Firm took a straightforward narrative approach and produced designs that conveyed that sense of humanity that is so characteristic of Pre-Raphaelite painting.

The 1860s was a period of intensive church building, which brought Morris, Marshall, Faulkner & Co. numerous commissions for stained glass, from Gothic Revival architects such as George Edmund Street and George Frederick Bodley. The first such commission was for Bodley's All Saints' Church in Selsey in 1861. The Firm also designed stained-glass windows and panels both for Gothic Revivalist restorations of old churches, and as memorials, which Morris later referred to as "grave stones"[29].

After founding the Society for the Protection of Ancient Buildings in 1877, Morris refused to supply stained glass to any medieval building undergoing restoration – a line of business that had previously accounted for a third of the Firm's stained glass work. After this, many incorrectly believed that Morris & Co. had entirely abandoned the manufacture of stained glass, and the volume of commissions fell to such an extent that Morris had to place advertisements in various journals to set the record straight. During the 1880s and 1890s, the Firm's designs for stained glass became more pictorial and less medieval in style. Importantly, Morris & Co. revived stained glass art and craftsmanship and in so doing inspired a renaissance of the medium that was perpetuated by the Arts & Crafts Movement.

so häufig in viktorianischen Fenstern findet. Statt dessen bevorzugte man narrative Mythen und übermittelte damit jene Menschlichkeit, die so charakteristisch für die präraffaelitische Malerei ist.

Die 60er Jahre des 19. Jahrhunderts waren eine Zeit intensiven Kirchenbaus, so daß Morris, Marshall, Faulkner & Co. von Neugotikern wie George Edmund Street und George Frederick Bodley zahlreiche Aufträge für Glasfenster erhielten. Die erste Arbeit entstand 1861 für Bodleys All Saints' Church in Selsey. Die Firma entwarf auch farbige Fenster und Paneele für neogotische Restaurierungen alter Kirchen und für Gedenkstätten, die Morris später als „Grabsteine"[29] bezeichnete.

Nachdem er 1877 die Society for the Protection of Ancient Buildings gegründet hatte, weigerte sich Morris, Glasfenster für die Restaurierung mittelalterlicher Bauten anzufertigen – ein Geschäftszweig, der der Firma zuvor ein Drittel ihrer Aufträge für Buntglas gesichert hatte. Danach meinten viele Kunden fälschlicherweise, Morris & Co. habe die Herstellung von farbigem Glas eingestellt, und Morris mußte Anzeigen in verschiedenen Zeitungen veröffentlichen, um den Sachverhalt richtigzustellen. In den 1880er und 90er Jahren wurden die Glasentwürfe der Firma bildhafter und waren weniger vom Mittelalter geprägt. Insgesamt trug Morris & Co. zur Wiederbelebung der Buntglasproduktion bei und inspirierte damit auch die Arts-and-Crafts-Bewegung.

proche narrative directe et créa des décorations qui conféraient le même sentiment d'humanité que l'on retrouve, de manière si caractéristique, dans la peinture préraphaélite.

Les années 1860 correspondirent à une période de construction intense d'églises, ce qui procura à Morris, Marshall, Faulkner & Co., de nombreuses commandes de vitraux de la part d'architectes « Gothic Revival » comme George Edmund Street et George Frederick Bodley. La première de ces commandes fut pour l'église All Saints de Sesley, (1861). La Firme conçut également des vitraux et des boiseries, à la fois pour les restaurations Gothic Revival de vieilles églises et pour des mémoriaux, que Morris qualifia plus tard de « pierres tombales »[29].

Après avoir fondé en 1877 la Society for the Protection of Ancient Buildings, Morris refusa de fournir des vitraux à tout bâtiment médiéval en restauration – un créneau commercial qui avait jusque-là représenté un tiers de la production de vitraux de la Firme. À partir de ce moment, beaucoup crurent à tort que Morris & Co. avaient complètement abandonné la fabrication de vitrail, et le volume de commandes s'écroula à tel point que Morris dut faire paraître des publicités dans divers journaux pour mettre les choses au clair et dissiper toute confusion. Pendant les années 1880 et 1890, les réalisations de vitraux devinrent plus imagées et moins médiévales de style. Morris & Co. renouvelèrent l'art du vitrail et ce faisant, inspirèrent un renouveau de cet art, perpétué par le mouvement Arts & Crafts.

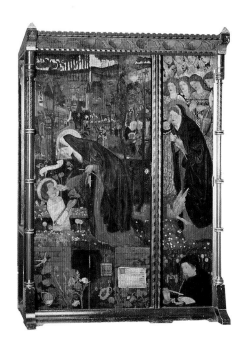

# FURNITURE

**Edward Burne-Jones:**
*The Prioress's Tale* wardrobe, 1858
Schrank *Die Geschichte der Priorin*
La garde-robe *L'histoire de la prieure*

Morris's earliest-known furniture designs are those he produced in late 1856/early 1857 for the three-roomed bachelor accommodation he shared with Edward Burne-Jones at 17, Red Lion Square. This solidly constructed and medievally inspired furniture, which was built for Morris by a local cabinetmaker, included two high-backed chairs and a large round table (now in the Cheltenham Art Gallery & Museum). The chairs were painted by Rossetti, Burne-Jones and Morris with chevron motifs and scenes from Morris's *Sir Galahad: A Christmas Mystery*, a poem that glorifies an Arcadia inhabited by chivalrous knights and fair damsels. The Weaving chair designed by Morris, with rustic painted decoration and a crude plank construction, most probably dates from this period as well. The Red Lion Square furniture also included an enormous settle which Morris reputedly carved partially himself, and a "throne" chair that was topped with a box-like element that Rossetti suggested would be perfect for keeping owls in.

When Morris and his young wife, Jane, moved into the Red House in June 1860, some pieces of furniture were specially produced for the interior. Most of these were designed by Webb and included a dresser, a settle that incorporated cupboards, and two trestle tables, one of which served as a prototype for a later design manufactured by Morris & Co. The Red House was also furnished with rush-seated chairs which were probably early examples of Sussex chairs, and with Edward Burne-Jones' wedding gift to the Morrises, the *Prioress's Tale* wardrobe which was a forerunner of the painted furniture designs exhibited by the Firm in 1862. Morris's experience in overseeing the interior design of the Red House and the furniture produced for it was a prime motivating factor in his formation of Morris, Marshall, Faulkner & Co. in 1861.

Although the Firm was established with the

Morris' früheste bekannte Möbelentwürfe entstanden gegen Ende des Jahres 1856 bzw. Anfang 1857, als er mit Edward Burne-Jones eine 3-Zimmer-Junggesellenwohnung am Red Lion Square 17 bezog. Zu den solide gebauten, mittelalterlich inspirierten Möbeln, die ein Kunsttischler für Morris herstellte, zählten zwei hochlehnige Stühle und ein runder Tisch (heute in Cheltenham Art Gallery & Museum). Die Stühle waren von Rossetti, Burne-Jones und Morris mit Zickzackbändern und Szenen aus Morris' *Sir Galahad: A Christmas Mystery* bemalt, einem Gedicht, das ein Arkadien mit galanten Rittern und schönen Damen besingt. Morris' Webstuhl mit seinem rustikalen gemalten Dekor und der rohen Bretterkonstruktion ist wahrscheinlich ebenfalls aus dieser Zeit. Zum Mobiliar des Red Lion Square gehörten auch eine riesige Sitzbank, die Morris angeblich teilweise selbst schnitzte, und ein „Thronsessel", von einem kastenartigen Element bekrönt, das Rossetti für die Haltung von Eulen empfahl.

Als Morris und seine junge Frau Jane 1860 in das Red House zogen, wurden einige Möbel speziell für die Innenräume hergestellt. Die meisten hat Webb entworfen, darunter eine Anrichte, eine Sitzbank mit Schrankumbau und zwei Zeichentische, von denen einer als Prototyp für ein späteres Modell der Firma Morris & Co. diente. Im Red House gab es auch Binsenstühle, vielleicht frühe Exemplare der Sussex-Stühle, sowie Edward Burne-Jones' Hochzeitsgeschenk an das Ehepaar Morris, den Schrank *Die Geschichte der Priorin*, einen Vorläufer der bemalten Möbel, die die Firma 1862 vorstellte. Morris' Erfahrungen bei der Innenausstattung des Red House und der Herstellung der Möbel spielten eine wichtige Rolle bei seiner Gründung von Morris, Marshall, Faulkner & Co. im Jahr 1861.

Die Firma hatte zwar das Ziel, Waren von hoher künstlerischer Qualität zu entwerfen, herzustel-

Les premiers meubles connus créés par Morris sont ceux qu'il réalisa à la fin de l'année 1856 et au début de 1857, pour le logement de trois pièces que Burne-Jones et lui partageaient en célibataires au 17, Red Square Lion. Ce mobilier massif et d'inspiration médiévale, fabriqué pour Morris par un ébéniste local, comprenait deux chaises à haut dossier et une grande table ronde (aujourd'hui au Cheltenham Art Gallery & Museum). Les chaises étaient peintes par Rossetti, Burne-Jones et Morris avec des motifs de chevrons et des scènes de *Sir Galahad: A Christmas Mystery*, poème glorifiant une Arcadie habitée par des cavaliers chevaleresques et des damoiselles vertueuses. La chaise à bascule conçue par Morris, avec son ornementation rustique peinte et sa construction rudimentaire en planches, date très probablement de cette période également. Le mobilier du Red Lion Square comprend aussi un énorme banc à haut dossier que Morris aurait en partie sculpté lui-même, et une chaise « trône » surmontée d'un élément semblable à une boîte, « parfait pour abriter des hiboux » selon Rossetti.

Lorsque Morris et sa femme Jane s'installèrent dans la Red House en juin 1860, certains meubles furent spécialement fabriqués pour l'intérieur de la maison. La plupart furent conçus par Webb et comprenaient un vaisselier, un banc à haut dossier également équipé de placards, et deux tables à tréteaux ; l'une d'entre elles servit par la suite de modèle pour une pièce de mobilier manufacturée par Morris & Co. La Red House était meublée de chaises à dossier un peu sommaires, probablement des exemples précoces des chaises Sussex, et du cadeau de mariage d'Edward Burne-Jones, la garde-robe *L'histoire de la prieure*, un précurseur du style de meubles peints exposés par la Firme en 1862. L'expérience que fit Morris en supervisant la décoration intérieure de la Red

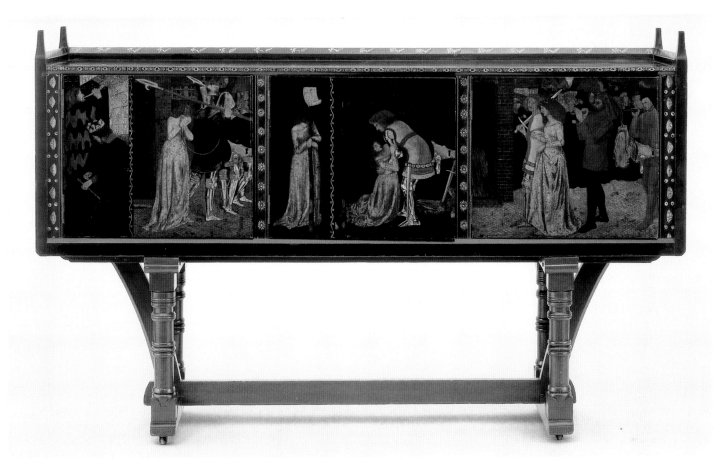

**Philip Webb (design/Entwurf/conception) & William Morris (decoration/Dekor/décoration):**

*Legend of St George* cabinet, 1861–1862

Schrank *Legende von St. Georg*

Cabinet *Légende de St-George*

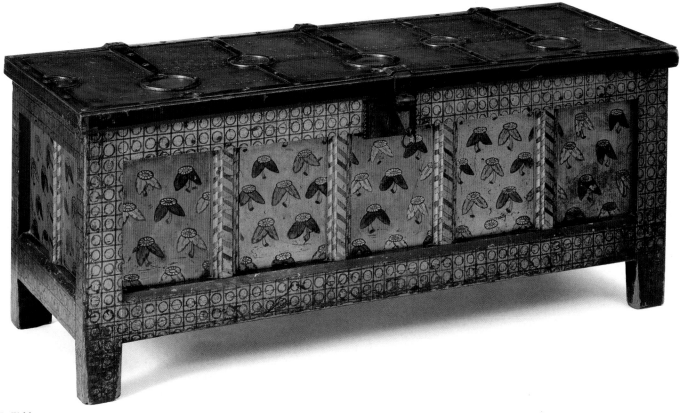

**Philip Webb:**

Chest, 1862

Truhe

Coffre

objective of designing, manufacturing and retailing high quality artistic goods, its partners from the outset intended that its products should be non-elitist and wide-ranging in their appeal. Rossetti wrote in January 1861 that the aim of the Firm was to "give real good taste at the price as far as possible of ordinary furniture"[30]. The furniture exhibited by Morris, Marshall, Faulkner & Co. in the Medieval Court at the 1862 International Exhibition in South Kensington was, however, far from ordinary in style or cost. The richly decorated *Legend of St George* cabinet, for example, was very expensively priced at 50 guineas and far beyond the means of all but the wealthiest.

From the mid-1860s, alongside their sumptuously painted and carved furniture, the Firm began to produce simpler and more affordable designs, such as the Rossetti armchair. During these early years, Webb designed the majority of the Firm's case furniture and tables and in 1867 he was formally appointed Morris, Marshall, Faulkner & Co.'s furniture manager. His Reformed Gothic furniture designs were a response to George Edmund Street's appeal for pieces of furniture that were "really simple, with no more material consumed in their construction than was necessary for their solidity"[31]. Much of this early furniture was manufactured

len und zu verkaufen, doch die Partner wollten von Anfang an auch ein bürgerliches breites Publikum erreichen. Rossetti schrieb im Januar 1861, die Firma wolle „wirklich guten Geschmack so weit möglich zum Preis normaler Möbel" [30] verbreiten. Die Möbel, die Morris, Marshall, Faulkner & Co. 1862 im Mittelalter-Saal der Weltausstellung in South Kensington präsentierten, waren allerdings im Hinblick auf Stil und Kosten alles andere als normal. So sollte der aufwendig dekorierte Kabinettschrank *Legende von St. Georg* den stolzen Preis von 50 Guineas kosten, was ihn nur für wirklich wohlhabende Kunden erschwinglich machte.

Ab der Mitte der 60er Jahre begann die Firma neben ihren üppig bemalten und geschnitzten Möbeln auch einfachere und preiswertere Stücke wie den Armlehnstuhl von Rossetti herzustellen. In diesen frühen Jahren entwarf Webb die meisten Möbel und Tische für das Unternehmen. 1867 wurde er zum Leiter der Möbelabteilung von Morris, Marshall, Faulkner & Co. ernannt. Seine neugotischen Entwürfe waren eine Reaktion auf George Edmund Streets Forderung nach Möbeln, „die wirklich einfach waren und für deren Konstruktion nicht mehr Material verbraucht wurde, als für ihre Solidität notwendig war".[31] Viele dieser frühen Stücke wurden in den firmeneigenen Werkstätten im Great Or-

House ainsi que le mobilier réalisé à cet effet, fut déterminante et l'incita à fonder, en 1861, l'association Morris, Marshall, Faulkner & Co.

Bien que la Firme ait été créée dans le but de concevoir, de fabriquer et de distribuer des marchandises de haute qualité, ses partenaires décidèrent dès le début que les produits devraient être non élitistes et variés. Rossetti écrivit en janvier 1861 que l'objectif de la Firme était d'« offrir des choses de bon goût, autant que possible au prix de meubles ordinaires ».[30] Les meubles exposés par Morris, Marshall, Faulkner & Co. dans la Medieval Court, lors de l'Exposition internationale de South Kensington, en 1862, étaient toutefois bien loin, par leur prix et leur style, de l'ordinaire. Le cabinet richement décoré *Légende de St-George* par exemple, était extrêmement cher, au prix de 50 guinées, une somme qui n'était pas à la portée de toutes les bourses.

À partir de la moitié des années 1860, la Firme se mit à fabriquer, outre son mobilier somptueusement peint et sculpté, des œuvres plus simples et plus abordables, comme le fauteuil de Rossetti. Durant ces premières années, Webb conçut la majorité du mobilier de rangement et des tables, et en 1867, il fut officiellement nommé directeur de l'ameublement chez Morris, Marshall, Faulkner & Co. Ses créations de style Gothique Réformé se voulaient une réponse au goût de

**Philip Webb:**
Sideboard, c. 1862
Anrichte, ca. 1862
Buffet, vers 1862

PAGE 99 / SEITE 99:
**Ford Madox Brown (attr./zugeschr.):**
Sussex chair, c. 1864–1865
Sussex-Stuhl, ca. 1864–1865
Chaise Sussex, vers 1864–1865

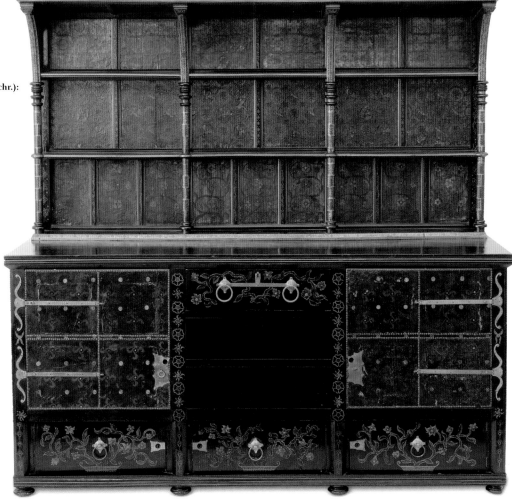

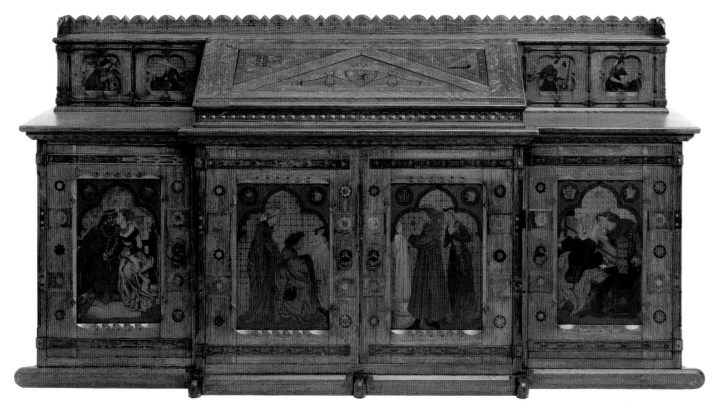

**John Pollard Seddon:**

*King René's Honeymoon* cabinet, decorated with panels executed by Morris, Marshall, Faulkner & Co., 1861–1862

Truhe *König Renés Hochzeitsreise*, dekoriert mit von Morris, Marshall, Faulkner & Co. ausgeführten Tafelbildern

Cabinet *La Lune de Miel du Roi René*, décoré de panneaux exécutés par Morris, Marshall, Faulkner & Co.

in the Firm's own workshops in Great Ormond Yard, while from 1881 furniture production was undertaken at Merton Abbey.

The Firm's most commercially successful furniture was the Sussex range of chairs. These are generally attributed to Ford Madox Brown, who reputedly discovered their antique archetype in a shop in Sussex. Produced from around 1865 until the closure of the Firm in 1940, the Sussex chairs were competitively priced at a modest 9/- around 1912. The success of this type of lower cost vernacular furniture, which Morris described in 1882 as "good citizen's furniture" and "necessary work-a-day furniture, which should be of course both well made and well proportioned"[32], contributed to the birth of the Arts & Crafts Movement.

The introduction of more accessible "cottage" furniture to the Firm's product range coincided with George Warington Taylor's appointment as business manager and his re-organization of the company. Indeed, Warington Taylor believed that "it is hellish wickedness to spend more than 15/- in a chair, when the poor are starving in the streets"[33]. The Firm nevertheless also continued to produce more expensive and elaborate furniture that revelled in traditional craft techniques, such as carving, inlaying and painting. Morris believed in the validity of this exclusive high-style "state-furniture", because he saw it not only as a means of promoting the handicrafts but also as a medium through which skilled workers could be meaningfully employed. This type of

mond Yard hergestellt. 1881 verlegte man die Produktion nach Merton Abbey.

Besonderen Erfolg hatte die Firma mit den sogenannten Sussex-Stühlen. Sie werden allgemein Ford Madox Brown zugeschrieben, der angeblich ein antikes Vorbild in einem Laden in Sussex entdeckt hatte. Die Stühle wurden von etwa 1865 bis zur Schließung der Firma 1940 hergestellt und kosteten um 1912 den bescheidenen Preis von 9 Shilling. Der Erfolg dieser preiswerten einheimischen Arbeiten, die Morris 1882 als „gutbürgerliche Möbel" bezeichnete und als „notwendige Alltagsmöbel, die natürlich sowohl gut gemacht wie gut proportioniert sein sollten"[32], trug zur Entstehung der Arts-and-Crafts-Bewegung bei.

Die Einführung populärer „Cottage"-Möbel in das Firmenprogramm traf mit der Ernennung George Warington Taylors zum Geschäftsführer und der Reorganisation der Gesellschaft zusammen. Warington Taylor hielt es für eine „höllische Grausamkeit, mehr als 15 Shilling für einen Stuhl auszugeben, wenn die Armen auf den Straßen verhungern".[33] Dennoch produzierte die Firma auch weiterhin kostspieligere Stücke, die auf traditionelle Handwerkstechniken wie Schnitzen, Einlegearbeit und Bemalung zurückgriffen. Morris sah in diesen exklusiven prestigeträchtigen Möbeln eine Möglichkeit, nicht nur das Kunsthandwerk zu fördern, sondern auch den Fachkräften selbst zu sinnvoller Arbeit zu verhelfen. Diese aufwendig dekorierten Möbel produzierte die Firma „ebenso um der Schön-

George Edmund Street pour des meubles « vraiment simples, sans plus de matériau utilisé dans leur construction qu'il n'était nécessaire à leur solidité »[31]. Beaucoup de ces premiers meubles furent fabriqués dans les propres ateliers de la Firme, à Great Ormond Yard, et par la suite, à partir de 1881, à Merton Abbey, où la production du mobilier fut transférée.

Les meubles qui rencontrèrent le plus gros succès commercial furent la série des chaises Sussex. Ces dernières sont généralement attribuées à Ford Madox Brown, qui, à ce que l'on dit, aurait découvert leur modèle antique dans une boutique du Sussex. Fabriquées dès 1865 environ jusqu'à la fermeture de la Firme en 1940, les chaises Sussex coûtaient le prix modeste et concurrentiel de 9 livres vers 1912. Le succès de ce type de meubles vernaculaires à bas prix, que Morris décrivait en 1882 comme « des meubles pour honnêtes citoyens » et « des meubles utiles pour tous les jours qui devaient être bien sûr à la fois bien faits et bien proportionnés »[32], contribuèrent à la naissance du Arts & Crafts Movement.

L'introduction de meubles « cottage » (rustiques) plus accessibles dans l'assortiment des articles de la Firme, devait coïncider avec la nomination de George Warington Taylor au poste de directeur financier et avec la restructuration de la compagnie entreprise par ce dernier. En effet, Warington Taylor croyait qu'« il est diaboliquement cruel de dépenser plus de 15 livres pour une chaise, quand les pauvres meurent de faim

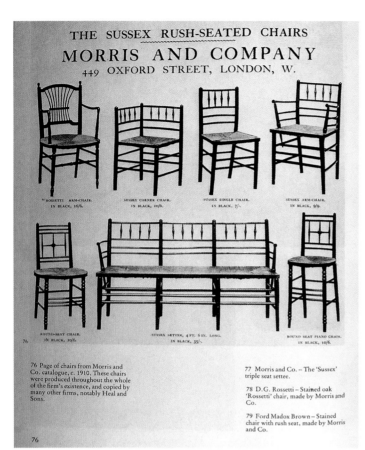

76 Page of chairs from Morris and Co. catalogue, c. 1910. These chairs were produced throughout the whole of the firm's existence, and copied by many other firms, notably Heal and Sons.

77 Morris and Co. – The 'Sussex' triple seat settee.

78 D.G. Rossetti – Stained oak 'Rossetti' chair, made by Morris and Co.

79 Ford Madox Brown – Stained chair with rush seat, made by Morris and Co.

76

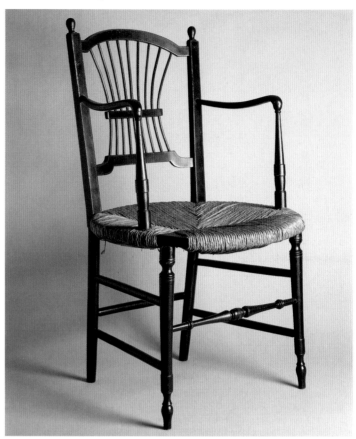

The Sussex range, illustrated in the Morris & Co. catalogue, c. 1915

Das Sussex-Programm im Katalog von Morris & Co., ca. 1915

La collection Sussex, illustration du catalogue de Morris & Co., vers 1915

**Dante Gabriel Rossetti:**

Rossetti armchair, c. 1864–1865

Rossetti-Armlehnstuhl, ca. 1864–1865

Fauteuil Rossetti, vers 1864–1865

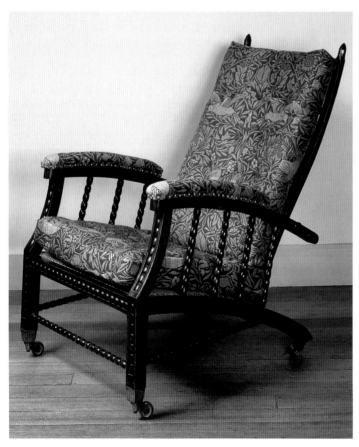

**Philip Webb:**

Adjustable Morris & Co. chair, upholstered with *Bird* textile, produced c. 1866

Verstellbarer Morris & Co.-Stuhl, gepolstert mit Stoff *Vogel*, produziert ca. 1886

Chaise Morris & Co. réglable, recouverte du tissu *Oiseau*, vers 1866

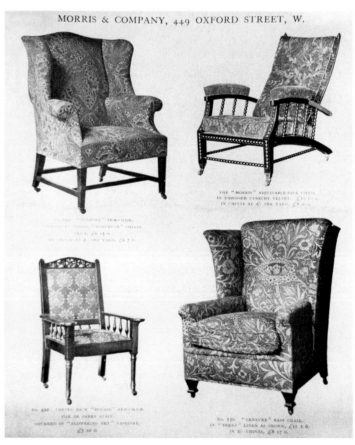

Chairs, illustrated in the Morris & Co. catalogue, c. 1915

Stühle im Katalog von Morris & Co., ca. 1915

Chaises, illustration du catalogue Morris & Co., vers 1915

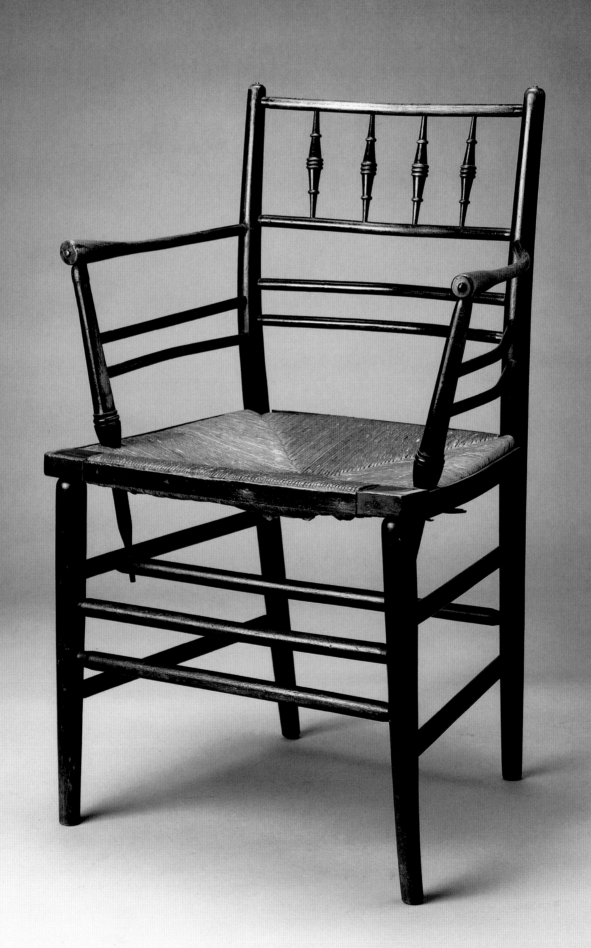

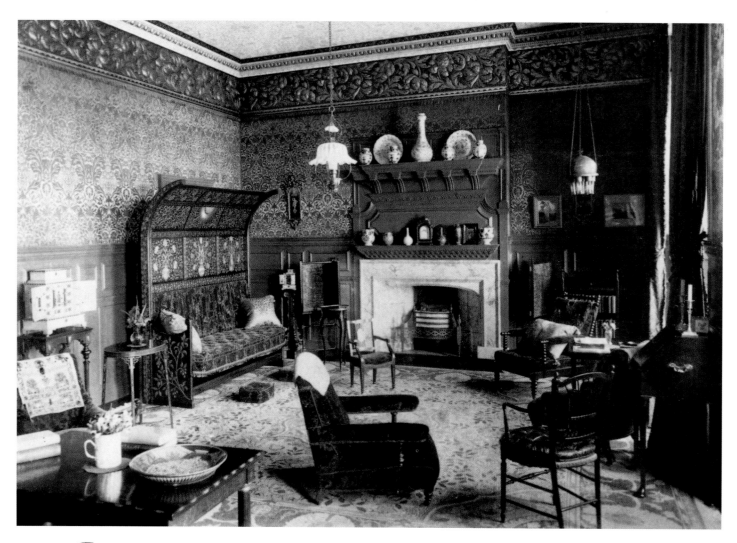

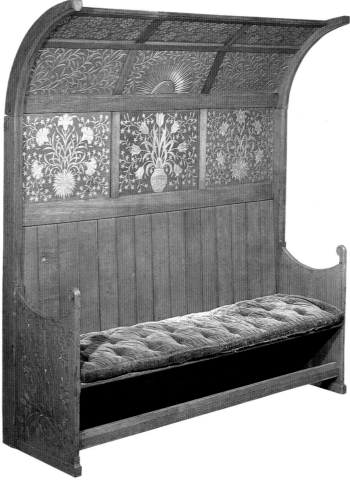

TOP / OBEN / CI-DESSUS:

The drawing room at Old Swan House, London, c. 1890

Der Salon im Old Swan House, London, ca. 1890

Le salon de Old Swan House, Londres, vers 1890

LEFT / LINKS / À GAUCHE:

**Philip Webb:**

Settle, c. 1860

Sitzbank, ca. 1860

Banc à haut dossier, vers 1860

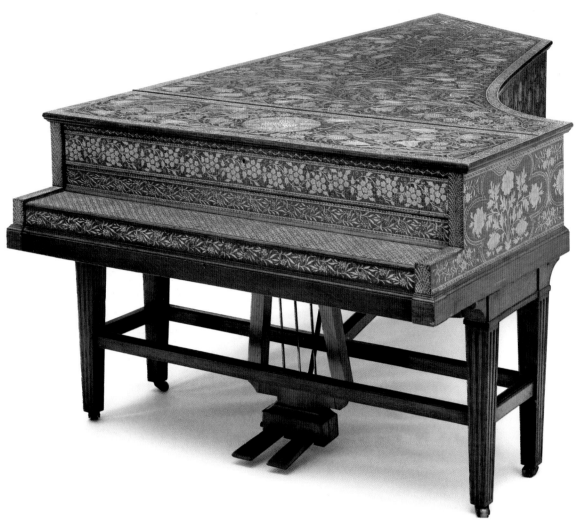

TOP / OBEN / CI-DESSUS:

**Edward Burne-Jones (design/Entwurf/dessin) & Kate Faulkner (decoration/Dekor/décoration):**

Grand Piano for 1, Holland Park, 1884–1885

Flügel für Holland Park 1

Piano à queue pour le 1, Holland Park

RIGHT / RECHTS / À DROITE:

**George Jack:**

Armchair, c. 1893

Sessel, ca. 1893

Bergère, vers 1893

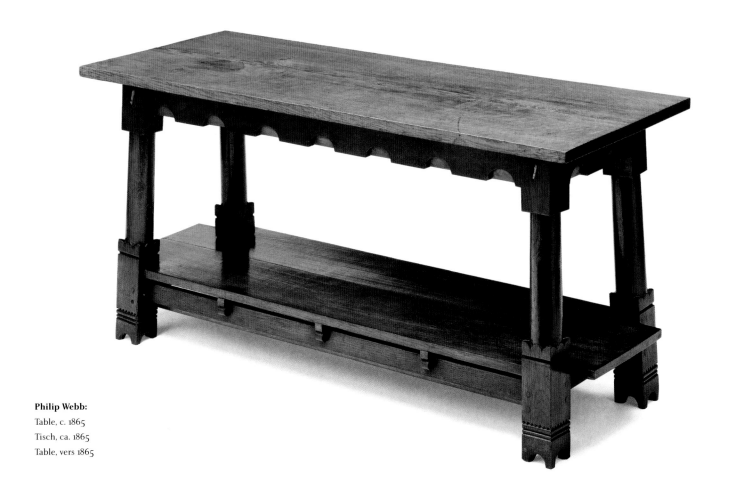

**Philip Webb:**
Table, c. 1865
Tisch, ca. 1865
Table, vers 1865

highly ornamented furniture was produced by
the Firm "as much for beauty's sake as for use",
and was regarded by Morris as "the blossoms of
the art of furniture"[34].

In 1890 the Firm acquired a furniture factory
from Holland & Son. Situated in Pimlico, it was
subsequently managed by George Jack, who
took over from Philip Webb as Morris & Co.'s
chief furniture designer. Jack's tenure marked a
stylistic departure for the Firm's furniture range,
as he instigated a return to more traditional
cabinetmaking methods and produced designs
that were more suited to contemporary bour-
geois taste. This furniture was inspired by the
Regency style and was often decorated with
marquetry. Unlike Webb, who favoured oak,
Jack's preferred material was mahogany, which
he used to great effect in furniture designs such
as his Saville chair of c. 1890.

heit wie des Nutzens willen". Für Morris waren
sie „die Blüten der Möbelkunst".[34]

1890 erwarb die Firma von Holland & Son
eine Möbelfabrik in Pimlico. Sie wurde an-
schließend von George Jack geführt, der von
Philip Webb als Chefmöbelentwerfer zu Morris
& Co. wechselte. Jack führte einen stilistischen
Wechsel im Möbelprogramm der Firma herbei,
denn er kehrte zu traditionelleren Handwerks-
techniken zurück und schuf Entwürfe, die dem
zeitgenössischen bürgerlichen Geschmack eher
entsprachen. Diese Möbel waren vom Regency-
Stil beeinflußt und häufig mit Intarsien deko-
riert. Anders als Webb, der Eiche favorisierte,
bevorzugte Jack Mahagoni, das er höchst wir-
kungsvoll bei Entwürfen wie seinem Saville-
Stuhl aus der Zeit um 1890 verwendete.

dans les rues »[33]. La Firme continua cependant à
produire des meubles plus chers et plus raffinés,
qui faisaient volontiers appel aux techniques ar-
tisanales traditionnelles comme la sculpture, la
marqueterie et la peinture. Morris croyait en la
valeur de ce « mobilier de choix » exclusif, au style
sophistiqué, parce qu'il le considérait non seule-
ment comme un moyen de promouvoir les mé-
tiers de l'artisanat, mais aussi comme une possi-
bilité d'employer à bon escient des ouvriers
habiles. Ce genre de mobilier extrêmement orne-
menté était produit par la Firme « autant pour
l'amour de la beauté que pour l'usage qui en
était fait », et était considéré par Morris comme
« la fine fleur de l'ameublement »[34].

En 1890, la Firme fit l'acquisition d'une fa-
brique de meubles appartenant à Holland &
Son. Située à Pimlico, elle fut dirigée par la suite
par George Jack, qui succéda à Philip Webb
comme décorateur en chef du mobilier chez
Morris & Co. La prise de fonction de Jack mar-
qua un nouveau départ stylistique pour l'assor-
timent du mobilier de la Firme. Il amorça en
effet un retour à des techniques d'ébénisterie
plus traditionnelles et créa des œuvres qui con-
venaient mieux au goût bourgeois de l'époque.
Ce mobilier s'inspirait du style Régence et était
souvent orné de marqueterie. Contrairement à
Webb, qui affectionnait le chêne, le matériau
préféré de Jack était l'acajou, qu'il utilisait avec
bonheur dans des modèles de meubles comme
la chaise Saville (vers 1890).

**Ford Madox Brown:**

Mirror, c. 1860

Spiegel, ca. 1860

Miroir, vers 1860

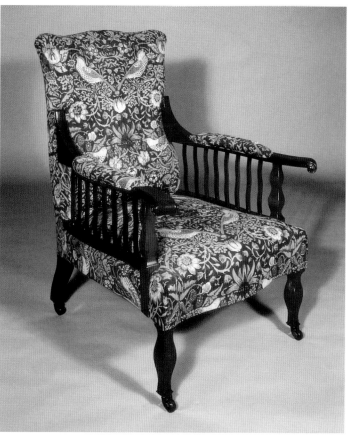

**George Jack:**

Saville chair, c. 1890

Saville-Stuhl, ca. 1890

Chaise Saville, vers 1890

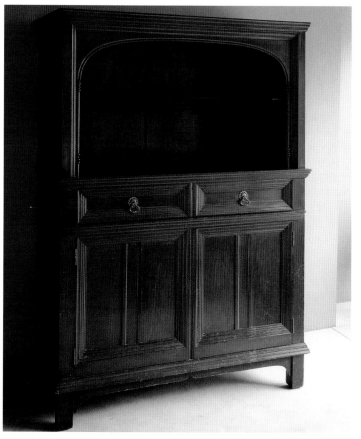

**Philip Webb:**

Sideboard, 1860s

Anrichte, 1860er Jahre

Buffet, années 1860

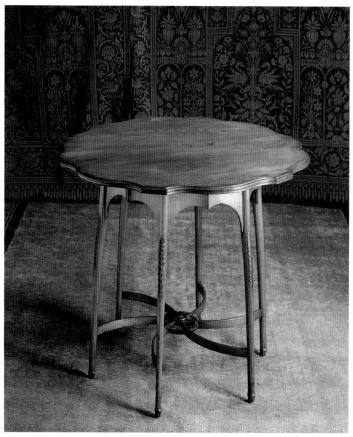

**George Jack:**

Occasional table, c. 1888

Beistelltisch, ca. 1888

Guéridon, vers 1888

# TILES

**Edward Burne-Jones:**
*St Cecilia* tile, c. 1863
Fliese *St. Cäcilia*, ca.1863
Carreau *St-Cecilia*, vers 1863

One of the Firm's earliest technical and commercial successes was with its decorated tin-glazed earthenware tiles. From c. 1862, Morris, Burne-Jones, Rossetti and Ford Madox Brown produced designs for tile panels depicting scenes from ancient legends, fairy tales or months of the year. These designs were subsequently hand-painted with enamel paints onto blank white tiles, imported from Holland, by associates of the Firm, such as George Campfield, Lucy Faulkner, Kate Faulkner, and on occasions Georgiana Burne-Jones and even Morris himself. Once the tiles had been painted they were re-fired, initially in a kiln set up in the basement of Morris, Marshall, Faulkner & Co.'s premises in Red Lion Square. The tiles, which were intended for both interior and exterior use, were most frequently arranged as panels and used on the walls of entrance porches, fireplace surrounds and mantels. The figurative imagery depicted in these panels revived the narrative tradition in Renaissance maiolica ware.

Other tiles, many of which were designed by Morris and Webb, were conceived as repeating patterns and were inspired by 18th-century Delft tiles. In the mid-1870s, probably for technical reasons, the production of some of these highly popular repeating pattern tiles was transferred to Dutch manufacturers, such as Ravesteijn in Utrecht. It seems that the Firm had difficulty in achieving good results from the enamels commercially obtainable in the 1860s. This was due in all likelihood to the enamels having too high a borax content. Around 1870, however, improved colours came onto the market and were supplied by William De Morgan, who produced designs for the Firm from 1863.

Ihre ersten technischen und kommerziellen Erfolge erzielte die Firma mit ihren dekorierten zinnglasierten Steingutfliesen. Ab etwa 1862 entwarfen Morris, Burne-Jones, Rossetti und Ford Madox Brown Fliesenbilder mit Szenen aus alten Legenden, Märchen oder Monatsbildern. Diese Entwürfe wurden anschließend mit Emailfarbe von Hand auf weiße, aus Holland importierte Fliesen gemalt, meist von Mitarbeitern der Firma wie George Campfield, Lucy Faulkner, Kate Faulkner und gelegentlich von Georgiana Burne-Jones oder sogar Morris selbst. Nach der Bemalung wurden die Fliesen erneut in einem Ofen im Keller von Morris, Marshall, Faulkner & Co. am Red Lion Square gebrannt. Sie waren für Innen- und Außenflächen geeignet und wurden meist als Bildfelder im Eingangsbereich oder an Kaminen angebracht. Ihre figürlichen Darstellungen griffen auf die narrative Bildwelt von Renaissance-Majoliken zurück.

Andere Fliesen, häufig von Morris und Webb entworfen, waren als Rapportmuster konzipiert und von den Delfter Fliesen des 18. Jahrhunderts inspiriert. Mitte der 70er Jahre des 19. Jahrhunderts wurde die Produktion dieser überaus populären Fliesen, wahrscheinlich aus technischen Gründen, auf holländische Hersteller wie Ravesteijn in Utrecht übertragen. Offenbar hatte die Firma Probleme, mit den in den 1860er Jahren verfügbaren Emailfarben gute Resultate zu erzielen – möglicherweise, weil diese einen zu hohen Boraxgehalt halten. Um 1870 kamen jedoch verbesserte Farben auf den Markt, die William De Morgan lieferte, der ab 1863 Entwürfe für die Firma ausführte.

Verwirrenderweise entwarf De Morgan Fliesen, die von Morris' Firma hergestellt wurden,

L'un des premiers succès techniques et commerciaux de la Firme fut ses carreaux décorés en faïence émaillée d'étain. À partir de 1862 environ, Morris, Burne-Jones, Rossetti et Ford Madox Brown produisirent des dessins pour des panneaux de carreaux représentant les mois de l'année ou des scènes tirées de légendes anciennes et de contes de fée. Ces dessins furent par la suite peints à la main au moyen de peintures laquées sur des carreaux absolument blancs, importés de Hollande par des associés de la Firme comme George Campfield, Lucy Faulkner, Kate Faulkner, et à l'occasion par Georgiana Burne-Jones et même Morris lui-même. Une fois les carreaux peints, ils étaient recuits, initialement dans un four installé dans le sous-sol des ateliers de Morris, Marshall, Faulkner & Co., à Red Lion Square. Les carrelages, prévus aussi bien pour l'intérieur que l'extérieur, étaient le plus fréquemment présentés en panneaux et utilisés sur les murs des porches d'entrée, ainsi que pour les bordures et les manteaux de cheminées. L'imagerie figurative de ces panneaux reprenait les thèmes décoratifs des majoliques de la Renaissance.

D'autres carreaux, dont beaucoup furent dessinés par Morris et Webb, étaient conçus comme des motifs en série et s'inspiraient des faïences de Delft du XVIIIe siècle. Au milieu des années 1870, probablement pour des raisons techniques, la production de certains de ces carreaux aux motifs répétitifs, extrêmement populaires, fut transférée et confiée à des fabricants hollandais, comme Ravesteijn à Utrecht. Il semblerait que la Firme ait eu quelques difficultés à atteindre les bons résultats commerciaux escomptés avec les émaux dans les années 1860.

**Edward Burne-Jones:**

Four tile panels depicting *Hypermnes, Philomelae, Thisbes* and *Didonis*, c. 1863

Vierfliesenbild mit *Hypermnes, Philomela, Thisbe und Dido*, ca. 1863

Panneaux de quatre carreaux représentant *Hypermnes, Philomelae, Thisbes* et *Didonis*, vers 1863

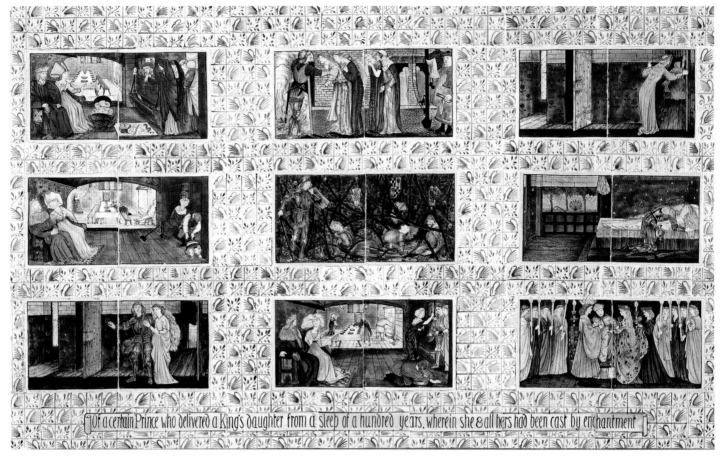

Of a certain Prince who delivered a King's daughter from a sleep of a hundred years, wherein she & all hers had been cast by enchantment

**Edward Burne-Jones & William Morris:**
*Sleeping Beauty* panel of tiles, 1862–1863
Fliesenbild *Dornröschen*
Panneau de carreaux *La Belle au bois dormant*

Confusingly, De Morgan designed tiles that were manufactured by the Firm, while at the same time producing tiles designed by members of the Firm at his own pottery in Chelsea. From the early 1880s, De Morgan's new pottery, which was sited adjacent to Morris's own works at Merton Abbey, manufactured the majority of tiles designed by the Firm. Many of De Morgan's own tiles, most of which were decorated with either strange mythical creatures, exotic intertwining flora or galleons on stormy seas, were retailed by Morris & Co.

während er gleichzeitig Fliesen von Mitarbeitern von Morris & Co. in seiner eigenen Keramikfabrik in Chelsea produzierte. Ab den frühen 1880er Jahren führte De Morgans neue Keramikwerkstatt, die direkt neben Morris' eigenem Unternehmen in Merton Abbey lag, die meisten Fliesenentwürfe der Firma aus. Viele von De Morgans eigenen Entwürfen, die entweder mit seltsamen mythischen Geschöpfen, exotischen Schlingpflanzen oder Galeonen auf stürmischer See dekoriert waren, wurden von Morris & Co. vertrieben.

Ceci était probablement dû au fait que ces derniers contenaient trop de borax. Autour de 1870, toutefois, des couleurs améliorées apparurent sur le marché et furent distribuées par William De Morgan, qui concevait des projets pour la Firme depuis 1863.

C'est ainsi que De Morgan dessinait des carreaux qui étaient manufacturés par la Firme, alors qu'au même moment, il fabriquait des carreaux conçus par les membres de la Firme, dans sa propre poterie, à Chelsea. Dès le début des années 1880, la nouvelle poterie de De Morgan, qui était située près des ateliers de Morris à Merton Abbey, manufacturait la majorité des carreaux créés par la Firme. De nombreuses œuvres de De Morgan même, dont la plupart étaient décorées soit d'étranges créatures mystiques et exotiques entrelacées de fleurs, soit de galions fendant les flots de mers déchaînées par la tempête, étaient vendues par Morris & Co.

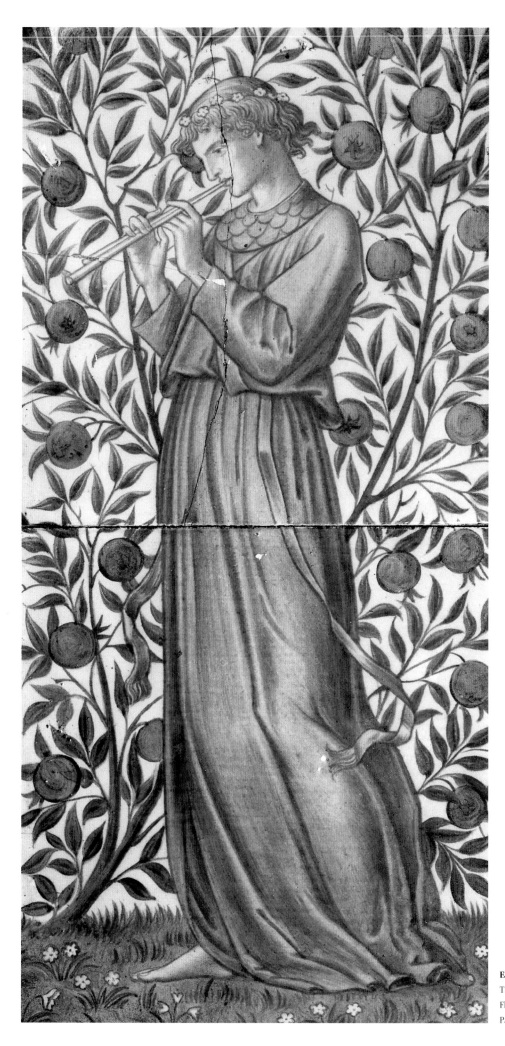

**Edward Burne-Jones (attr./zugeschr.):**
Tile panel depicting a minstrel, c. 1870
Fliesenbild mit Musikant, ca. 1870
Panneau de carreaux représentant un ménestrel, vers 1870

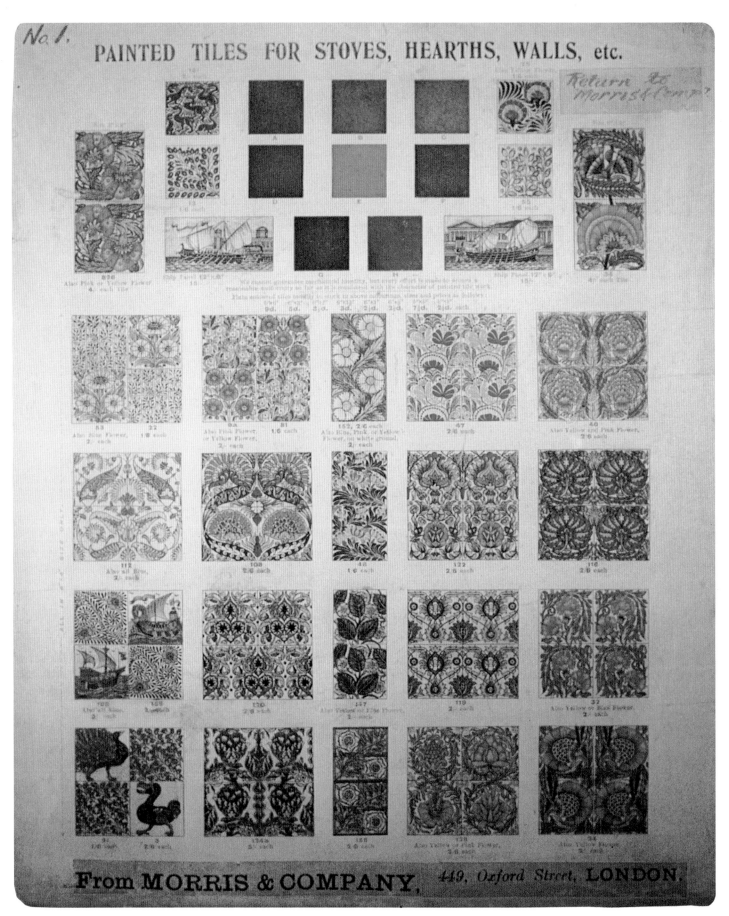

**Morris & Co.:**

Broadsheet showing the range of De Morgan tiles retailed by the Firm, undated

Plakat mit dem Fliesenprogramm von De Morgan, das von der Firma vertrieben wurde, undatiert

Affiche montrant la collection des carreaux de De Morgan vendus par la Firme, non daté

**William Morris (attr./zugeschr.):**
*Pink & Hawthorn* tiles, 1887
Fliesen *Nelke und Weißdorn*
Carreaux *Œillet et Aubépine*

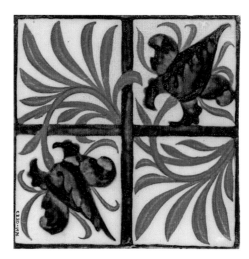

**William Morris:**
*Tulip & Trellis* tile, 1870
Fliese *Tulpe und Spalier*
Carreau *Tulipe et Treillage*

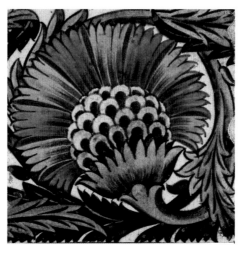

**William De Morgan:**
*BBB* tile from the Chelsea period, c. 1875
Fliese *BBB* aus der Chelsea-Periode, ca. 1875
Carreau *BBB* de la période Chelsea, vers 1875

# WALLPAPERS

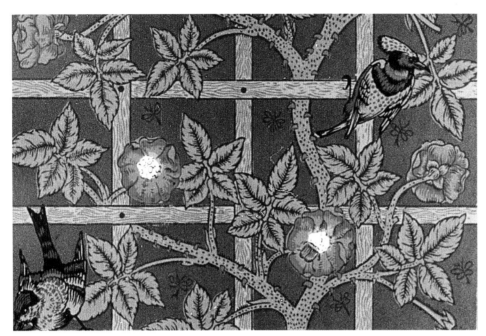

Morris designed his first three wallpapers – *Daisy, Fruit* and *Trellis* – between 1864 and 1867 and initially intended to produce them with zinc plates. Finding this process too time-consuming, he eventually turned to Barrett of Bethnal Green, a firm of block cutters, to cut traditional blocks out of pear wood for their production. Morris's early designs countered the mainstream Victorian taste for the florid "French" style of the early 1850s and the "Reformist" style popularized by A. W. N. Pugin and Owen Jones from the mid-1850s. The latter style of wallpaper patterning was characterized by a geometric uniformity that emphasized the two-dimensionality of the medium. While Morris's designs were non-illusionistic – thus remaining true to their materials – his naturalistic patterned repeats flowed freely and seamlessly into one another to create rhythmic and balanced overall patterns. The block printing of these early and relatively straightforward wallpaper designs was subcontracted to a technical specialist, Messrs Jeffrey & Co. of Islington, who would also execute the later more complex Morris & Co. designs.

In the late 1860s, the Firm retailed another quite different group of wallpapers, including *Indian*, that were inspired by 18th-century precedents. These used only two colours which made them less expensive to produce. Although Morris did not favour the Victorian practice of using different patterned papers together, he bowed to commercial pressure and around 1868 designed *Diaper*, a two-toned, non-directional

Morris entwarf seine ersten drei Tapeten – *Gänseblümchen, Frucht* und *Spalier* – zwischen 1864 und 1867 und wollte sie ursprünglich mit Zinkplatten drucken lassen. Da sich dieses Verfahren als zu zeitraubend erwies, wandte er sich an Barrett in Bethnal Green, eine Firma von Holzschneidern, die traditionelle Platten aus Birnenholz für die Herstellung fertigen sollte. Morris' frühe Entwürfe entsprachen weder der viktorianischen Vorliebe für den floralen „französischen" Stil der frühen 1850er Jahre noch dem „reformistischen" Stil, den A. W. N. Pugin und Owen Jones seit Mitte der 1850er Jahre populär gemacht hatten und der sich durch eine geometrische Einheitlichkeit auszeichnete, die den zweidimensionalen Charakter der Tapeten betonte. Morris' Entwürfe waren nicht illusionistisch und blieben damit dem Material treu, doch seine naturalistischen Rapportmuster gingen frei fließend ineinander über und schufen rhythmische Gesamtbilder. Der Druck dieser frühen, relativ einfachen Entwürfe wurde einem Spezialisten übertragen, Jeffrey & Co. aus Islington, der auch die späteren komplizierteren Vorlagen umsetzte.

In den späten 1860er Jahren vertrieb die Firma eine ganz andere Art von Tapeten, einschließlich *Indian*, die von Vorbildern des 18. Jahrhunderts inspiriert waren. Ihre Produktion war preiswerter, weil nur zwei Farben verwendet wurden. Morris schätzte zwar die viktorianische Praxis nicht, verschieden gemusterte Tapeten nebeneinander zu verkleben, doch er beugte

Morris créa ses trois premiers papiers peints – *Pâquerette, Fruit* et *Treillage* – entre 1864 et 1867. Il avait d'abord tenté de les produire en utilisant des plaques de zinc à l'eau-forte. Trouvant le procédé trop coûteux, il finit par se tourner vers Barrett de Bethnal Green, une entreprise de tailleurs de blocs, afin qu'ils coupent des tampons dans du bois de poirier selon la méthode traditionnelle. Les premiers dessins de Morris rejoignaient le goût victorien du moment pour le style tarabiscoté « français » du début des années 1850 et le style « réformiste » popularisé par A. W. N. Pugin et Owen Jones à partir du milieu des années 1850. Ce dernier style de motifs pour papiers peints se caractérisait par une uniformité géométrique qui renforçait le caractère bidimensionnel du médium. Alors que les œuvres de Morris ne produisaient pas d'illusions – restant fidèles aux matériaux – ses motifs naturalistes en série s'enchaînaient librement et sans interruption pour créer des motifs d'ensemble rythmiques et équilibrés. Le tampon qui servait à imprimer ces premiers dessins, relativement simples, de papiers peints fut commandé à un spécialiste technique, MM Jeffrey & Co. de Islington, qui allait également exécuter par la suite les dessins plus complexes de Morris & Co.

À la fin des années 1860, la Firme se mit à vendre une autre catégorie de papiers peints complètement différents, comme *Indian*, inspirés de modèles du XVIIIe siècle. Comme ils n'utilisaient que deux couleurs, ils étaient moins chers à fabriquer. Bien que Morris n'appréciât

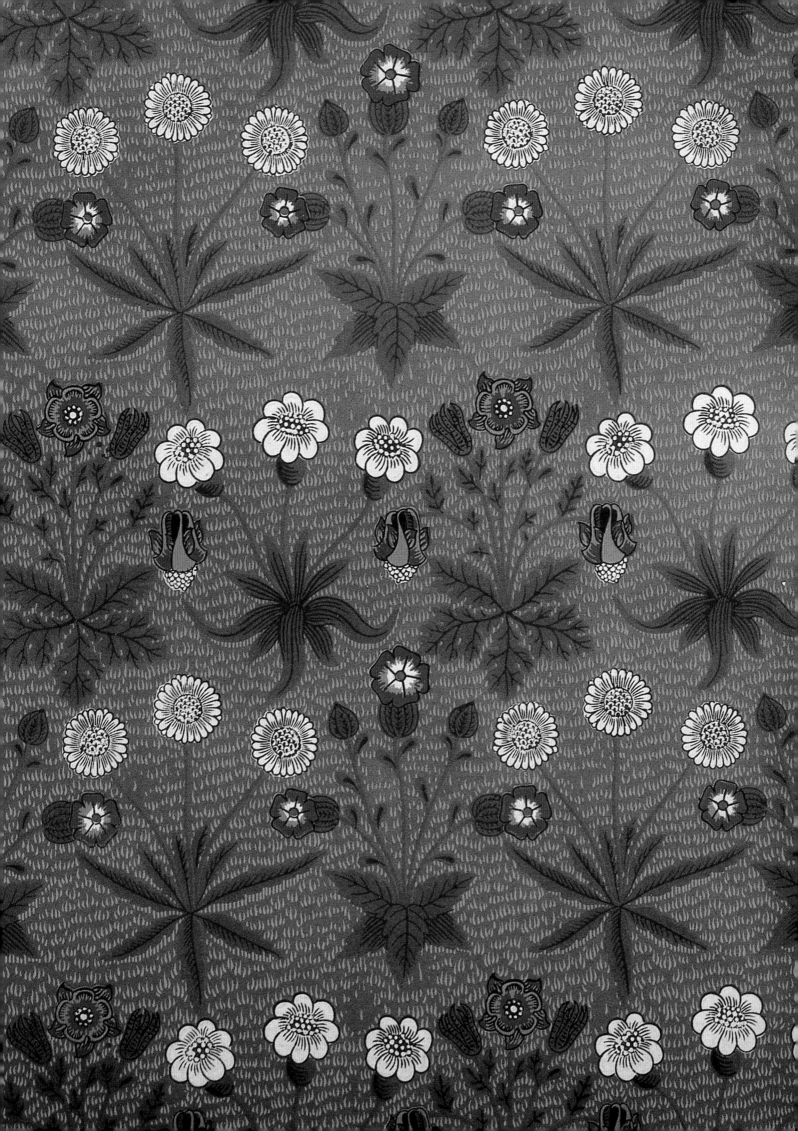

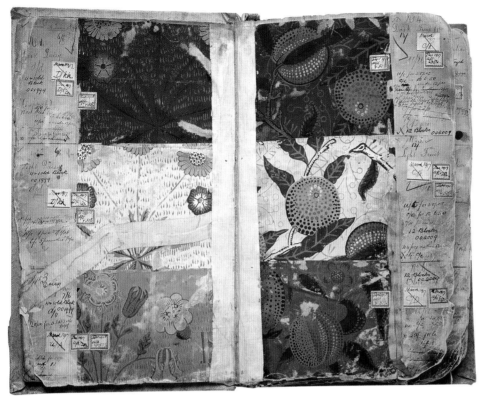

Morris & Co. log book, maintained by Jeffrey & Co., c. 1865–1893, showing *Fruit* and *Daisy*

Musterlogbuch von Morris & Co., von Jeffrey & Co. geführt, ca. 1865–1893, mit *Früchte* und *Gänseblümchen*

Registre de Morris & Co., conservé par Jeffrey & Co., vers 1865–1893, présentant *Fruit* et *Pâquerette*

RIGHT PAGE / RECHTE SEITE / PAGE DE DROITE:
**William Morris:**

*Fruit* or *Pomegranate* wallpaper, issued c. 1866

Tapete *Früchte* oder *Granatapfel*, herausgegeben ca. 1866

Papier peint *Fruit* ou *Grenade*, émis vers 1866

paper specifically for use on ceilings as a complement to the Firm's other wallpapers. Between 1872 and 1876 Morris executed a series of wallpapers that were different again, and which included *Larkspur, Jasmine, Acanthus, Pimpernel, Vine* and *Willow*. These more closely patterned designs convey a strong sense of organic growth through the density of their scrolling foliage, and reveal a maturity of handling. The swirling organicism found in such patterns was stylized by a later generation of designers in the 1890s, and the more linear and sinuous forms that evolved became one of the most distinctive decorative features of Art Nouveau.

Morris executed the majority of his designs for printed textiles and wallpapers between 1876 and 1882. During these prolific years he designed 16 wallpapers, including *Acorn*, all of which possessed a more formal pattern structure and appeared flatter than his earlier designs. This measured approach, in which the repeats were easily identified, may well have been inspired by his preoccupation, at that time, with weaving. Morris returned, however, to more naturalistic motifs for his later wallpapers, producing designs such as *Horn Poppy* (1885), which through the bold outlining of their patterns display a remarkable sense of rhythm.

During the 1890s, John Henry Dearle designed many wallpapers for Morris & Co. in the Firm's house style. His designs, such as *Compton* and *Golden Lily*, with their swirling tendrils, re-

sich dem kommerziellen Druck und entwarf um 1868 *Diaper*, eine zweifarbige Tapete für die Decke als Ergänzung zu den anderen Firmenentwürfen. Zwischen 1872 und 1876 entwarf Morris eine weitere Serie von Tapeten, zu denen *Rittersporn, Jasmin, Akanthus, Pimpernelle, Weinranke* und *Weide* gehörten. Diese dichteren Muster erinnern mit ihrem gerollten Blattwerk an organisches Wachstum. Ihr üppiges Pflanzendekor wurde von einer späteren Designergeneration in den 1890er Jahren stilisiert. Die stärker linearen, geschwungenen Formen, die sich daraus entwickelten, wurden zu einem der wichtigsten Dekorationselemente der Art nouveau.

Morris' Entwürfe für bedruckte Textilien und Tapeten entstanden überwiegend zwischen 1876 und 1882. In diesen fruchtbaren Jahren entwarf er 16 Tapeten, einschließlich *Eichel*, die alle formeller und flächiger wirkten als seine älteren Arbeiten. Diese klarere Struktur, in der sich die Wiederholungen einfach identifizieren ließen, geht vielleicht auf seine gleichzeitige Beschäftigung mit der Webkunst zurück. Bei seinen späteren Tapeten kehrte Morris jedoch zu naturalistischeren Mustern zurück, die, wie *Hornmohn* (1885), mit ihren kühnen Linienführung einen bemerkenswerten Sinn für Rhythmus offenbaren.

In den 90er Jahren entwarf John Henry Dearle viele Tapeten für Morris & Co. im typischen Stil der Firma. Seine Arbeiten, wie etwa *Compton* und *Goldene Lilie* mit ihren gebogenen Ranken,

pas la pratique victorienne qui consistait à juxtaposer des papiers peints de motifs différents, il se plia à la pression commerciale, et vers 1868 dessina *Diaper*, un papier en deux tons, sans trame, spécialement employé pour tapisser les plafonds en complément avec d'autres papiers peints de la Firme. Entre 1872 et 1876, Morris exécuta une série de papiers peints encore différents : *Pied d'alouette, Jasmin, Acanthe, Mouron, Vigne* et *Saule*. Ces dessins, ornés de motifs plus rapprochés, donnent une forte impression de croissance organique par la densité de leurs volutes, et révèlent une maîtrise technique achevée. Ces motifs organiques en volutes furent stylisés dans les années 1890 par la génération suivante d'artistes décorateurs. Les formes linéaires et sinueuses qui en découlèrent devinrent l'une des caractéristiques les plus distinctives de l'Art Nouveau.

Morris exécuta la majorité de ses dessins pour les textiles et les papiers peints imprimés entre 1876 environ et 1882. Durant ces années prolifiques il conçut 16 papiers peints, dont *Gland*. Tous possédaient une structure à motifs plus régulière et semblaient plus anodins que les premières créations. Cette approche mesurée, dans laquelle on pouvait aisément identifier les reprises, a bien pu être inspirée par sa préoccupation du moment, qui était le tissage. Morris revint cependant à des motifs plus naturalistes pour ses derniers papiers peints, créant des œuvres – comme *Coquelicot* (1885) – met-

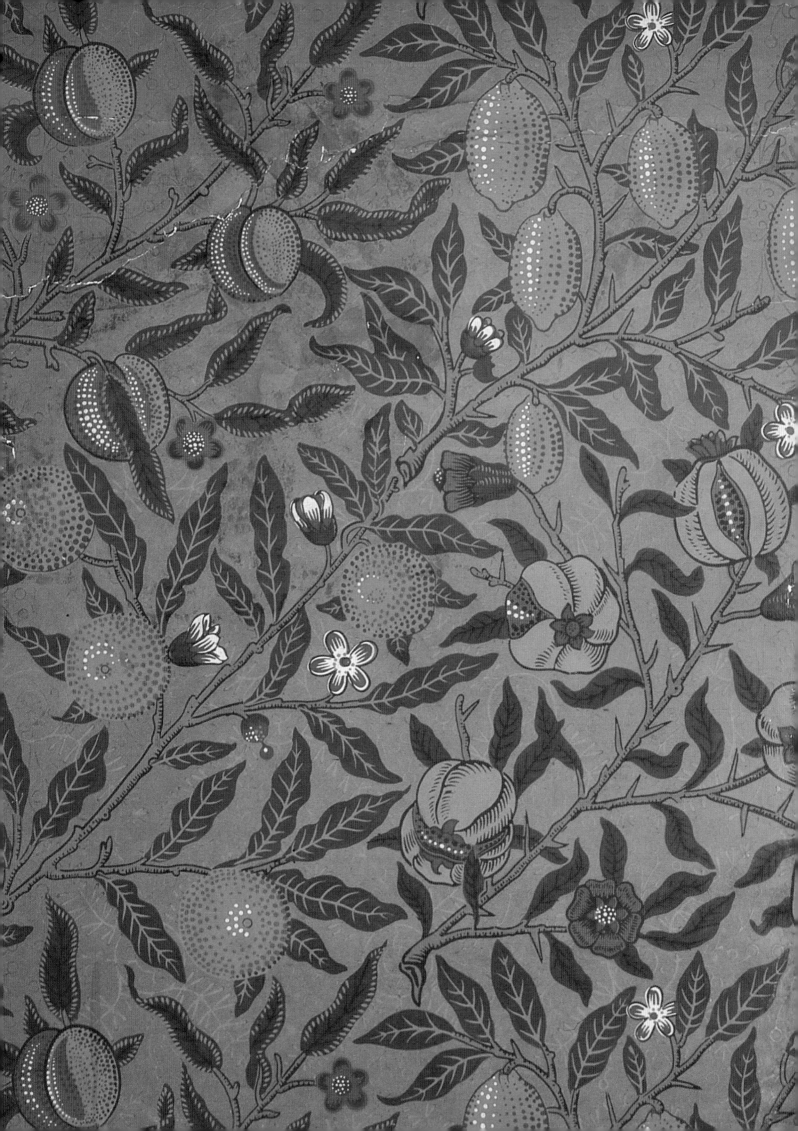

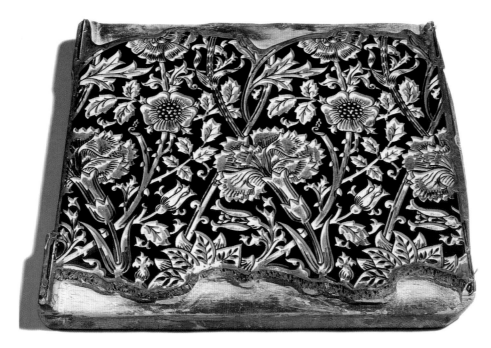

Printing block for *Pink & Rose* ceiling paper, designed by
William Morris in 1890

Druckplatte für Deckentapete *Nelke & Rose*, 1890 von
William Morris entworfen

Tampon pour le papier peint *Œillet & Rose*, dessiné par
William Morris en 1890

captured the spirit of Morris's earlier work from
the mid-1870s. Towards the turn of the century,
however, Dearle developed a somewhat sweeter
style, as evidenced by his *Orchard* wallpaper,
which was more in tune with the design currents
emanating from the Arts & Crafts Movement.

All of Morris & Co.'s wallpapers were original-
ly printed by hand using woodblocks – a pro-
cess that was painfully time-consuming. Many
of the Firm's designs required up to 20 different
blocks, while *St James* (1881) used a staggering
68. In 1925, Arthur Sanderson & Sons took over
the manufacture of the wallpapers from Jeffrey
& Co., and since the 1950s the company has
continuously produced Morris & Co. wallpaper
designs using both hand and mechanized pro-
duction methods.

erinnerten an Morris' frühere Arbeit aus der
Mitte der 70er Jahre. Gegen Ende des Jahrhun-
derts entwickelte Dearle einen gefälligeren Stil,
am Beispiel der Tapete *Obstgarten* erkennbar,
der den Tendenzen der Arts-und-Crafts-Bewe-
gung näher kam.

Alle Tapeten der Firma wurden ursprünglich
im Handdruck mit Holzplatten hergestellt – ein
äußerst zeitaufwendiger Prozeß. Viele Entwürfe
benötigten bis zu 20 verschiedene Blöcke, *St.
James* von 1881 sogar 68. 1925 übernahmen Ar-
thur Sanderson & Sons die Herstellung der Ta-
peten von Jeffrey & Co. Seit den 50er Jahren un-
seres Jahrhunderts stellen sie die Tapeten von
Morris & Co. weiterhin sowohl als Handdrucke
wie auch in mechanischer Produktion her.

taient en évidence un sens du rythme remar-
quable.

Pendant les années 1890, John Henry Dearle
conçut de nombreux papiers peints pour Morris
& Co. dans le style caractéristique de la Firme.
Ses créations, comme *Compton* et *Lis d'Or*, avec
leurs vrilles en spirales, reprenaient l'esprit des
premiers travaux de Morris au milieu des années
1870. Vers le tournant du siècle, toutefois,
Dearle développa un style un peu plus harmo-
nieux, que l'on retrouve dans son papier peint
*Verger* et qui s'accordait mieux avec les courants
décoratifs issus du mouvement Arts & Crafts.

Tous les papiers peints de chez Morris & Co.
étaient à l'origine imprimés à la main au moyen
de tampons en bois – procédé qui nécessitait
énormément de temps. La plupart des ornemen-
tations de la Firme exigeaient jusqu'à vingt tam-
pons différents, et le modèle *St James* (1881) né-
cessita le nombre stupéfiant de 68 ! En 1925,
Arthur Sanderson & Fils reprirent la manufactu-
re de papiers peints de Jeffrey & Co., et depuis
1950, la compagnie continue à produire des
papiers peints Morris & Co., utilisant des mé-
thodes de production à la fois manuelles et mé-
canisées.

RIGHT PAGE / RECHTE SEITE / PAGE DE DROITE:
**William Morris:**

*Diaper* ceiling paper, issued 1868–1870

Deckentapete *Diaper*, herausgegeben 1868–1870

Papier peint *Diaper*, émis en 1868–1870

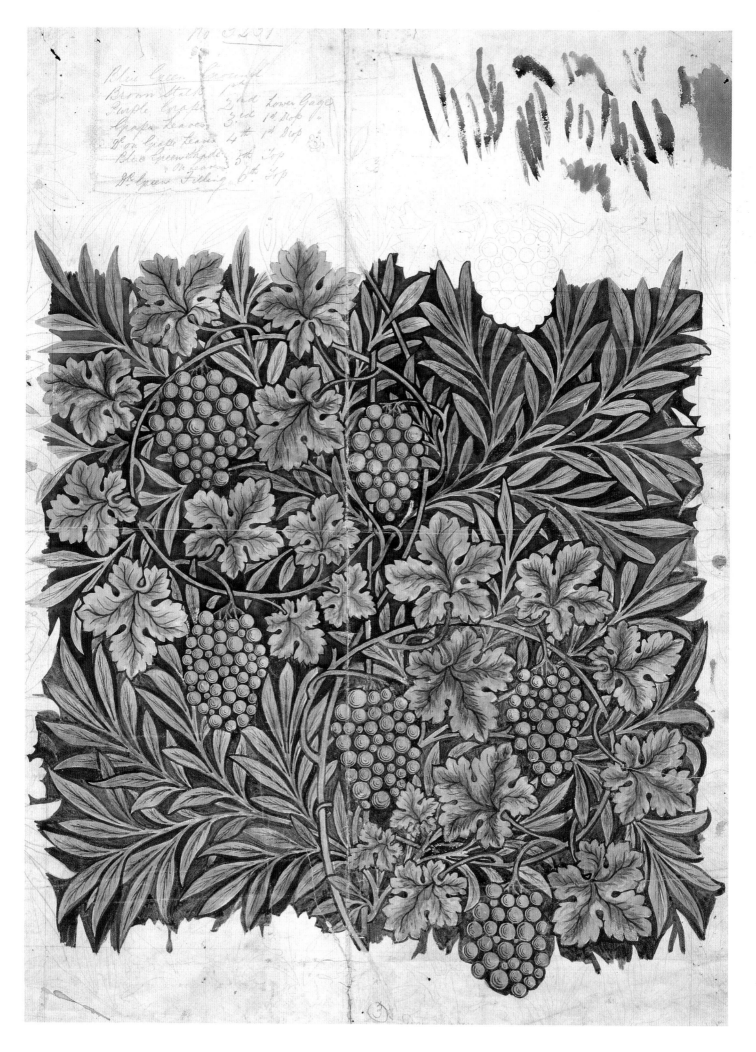

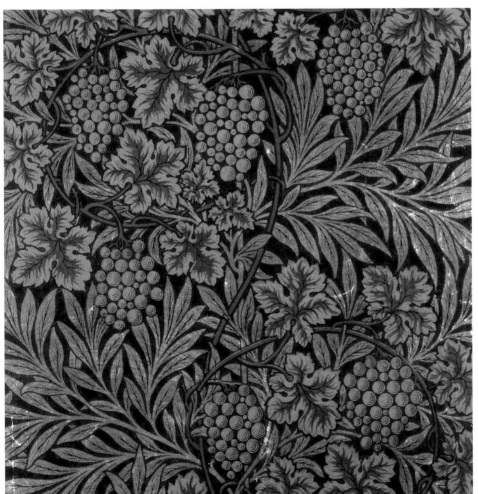

TOP / OBEN / CI-DESSUS:

Morris & Co. log book, maintained by Jeffrey & Co., c. 1865–1893

Musterlogbuch von Morris & Co., von Jeffrey & Co. geführt, ca.1865–1893

Registre de Morris & Co., conservé par Jeffrey & Co., vers 1865–1893

LEFT / LINKS / À GAUCHE:

**William Morris:**

*Vine* wallpaper, designed 1874

Tapete *Weinranke*, entworfen 1874

Papier peint *Vigne*, dessiné en 1874

LEFT PAGE / LINKE SEITE / PAGE DE GAUCHE:

**William Morris:**

Design for *Vine* wallpaper, c. 1873

Entwurf für Tapete *Weinranke*, ca. 1873

Motif pour le papier peint *Vigne*, vers 1873

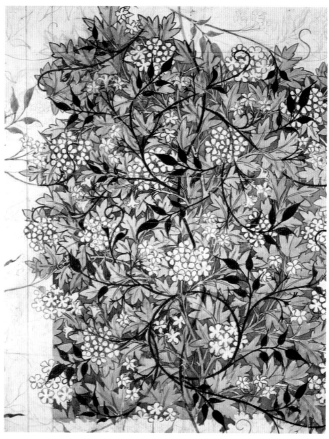

**William Morris:**

Design for *Jasmine* wallpaper, c. 1872

Entwurf für Tapete *Jasmin*, ca. 1872

Motif pour le papier peint *Jasmin*, vers 1872

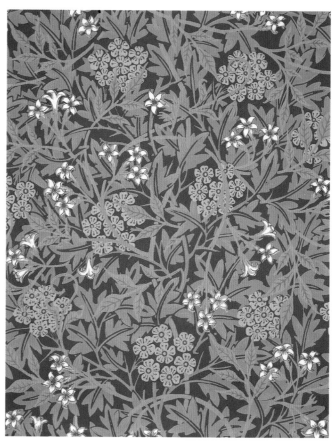

**William Morris:**

*Jasmine* wallpaper, designed c. 1872, issued 1872

Tapete *Jasmin*, entworfen ca. 1872, herausgegeben 1872

Papier peint *Jasmin*, dessiné vers 1872, émis en 1872

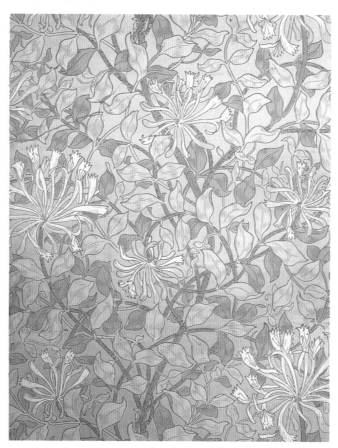

**William Morris:**

*Honeysuckle* wallpaper, registered 1883

Tapete *Geißblatt*, registriert 1883

Papier peint *Chèvrefeuille*, enregistré en 1883

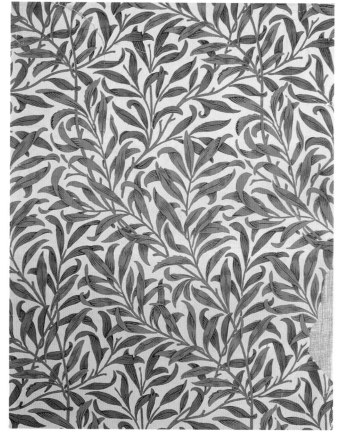

**William Morris:**

*Willow Bough* wallpaper, issued 1887

Tapete *Weidenzweig*, herausgegeben 1887

Papier peint *Branche de Saule*, émis en 1887

WALLPAPERS

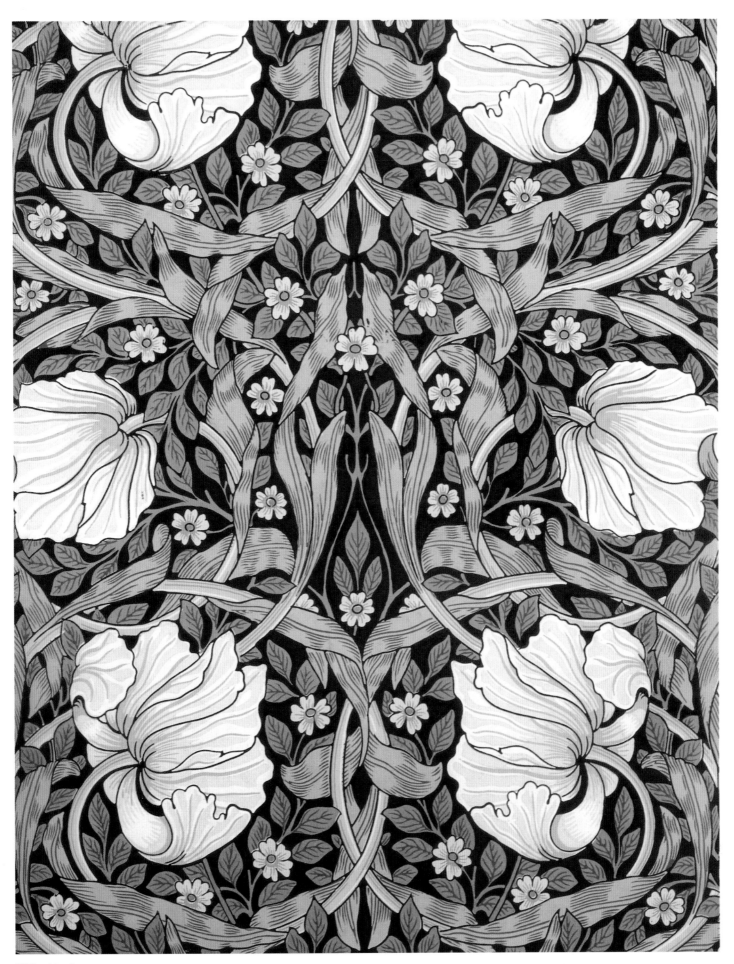

**William Morris:**

*Pimpernel* wallpaper, registered 1876

Tapete *Pimpernelle*, registriert 1876

Papier peint *Mouron*, enregistré en 1876

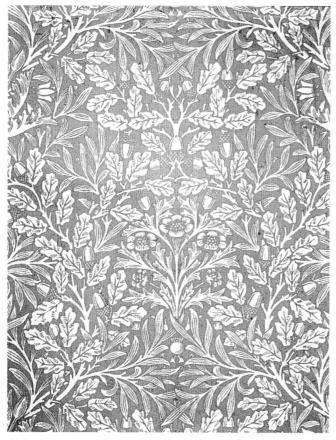

**William Morris:**

*Acorn* wallpaper, registered 1879

Tapete *Eichel*, registriert 1879

Papier peint *Gland*, enregistré en 1879

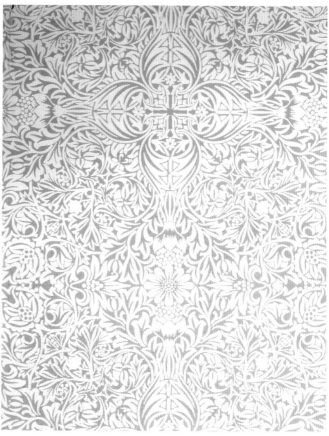

**William Morris:**

*Ceiling 101* wallpaper, registered 1877

Tapete *Decke 101*, registriert 1877

Papier peint *Plafond 101*, enregistré en 1877

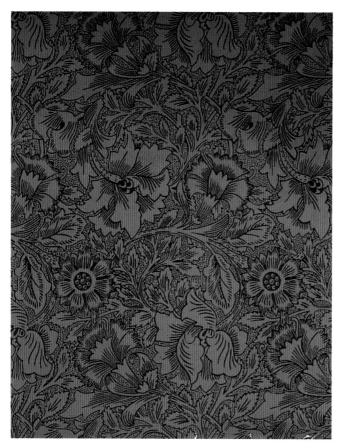

**William Morris:**

*Poppy & Pink* wallpaper, designed 1880

Tapete *Mohn & Nelke*, entworfen 1880

Papier peint *Pavot & Œillet*, dessiné en 1880

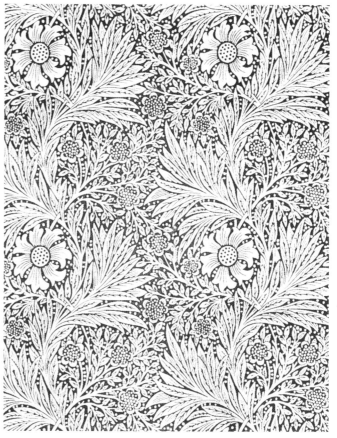

**William Morris:**

*Marigold* wallpaper, designed 1875

Tapete *Ringelblume*, entworfen 1875

Papier peint *Souci*, dessiné en 1875

Page from Morris & Co. wallpaper catalogue

Seite aus dem Tapetenkatalog von Morris & Co.

Page du catalogue de papiers peints de Morris & Co.

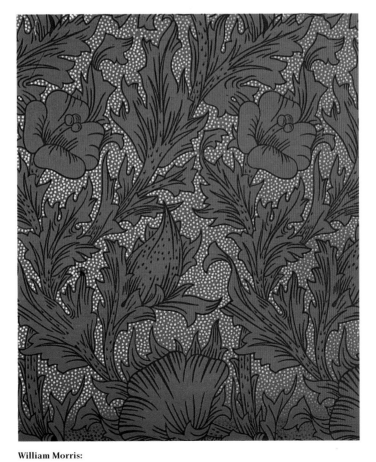

**William Morris:**

*Horn Poppy* wallpaper, registered 1885

Tapete *Hornmohn*, registriert 1885

Papier peint *Coquelicot*, déposé en 1885

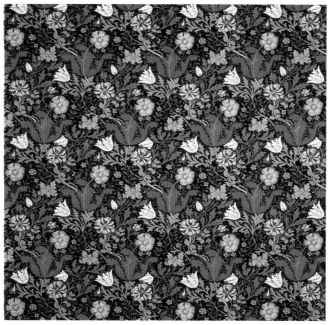

**J. H. Dearle:**

*Compton* wallpaper, designed 1895

Tapete *Compton*, entworfen 1895

Papier peint *Compton*, dessiné en 1895

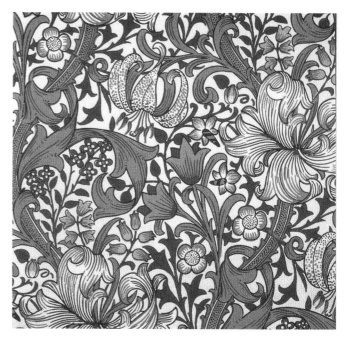

**J. H. Dearle:**

*Golden Lily* wallpaper, designed c. 1899

Tapete *Goldene Lilie*, entworfen ca. 1899

Papier peint *Lis d'Or*, dessiné vers 1899

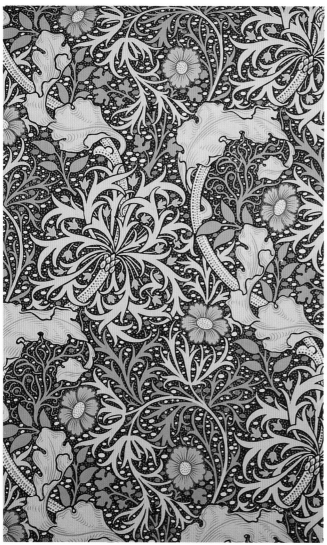

**J. H. Dearle:**

*Seaweed* wallpaper, designed 1901

Tapete *Seetang*, entworfen 1901

Papier peint *Varech*, dessiné en 1901

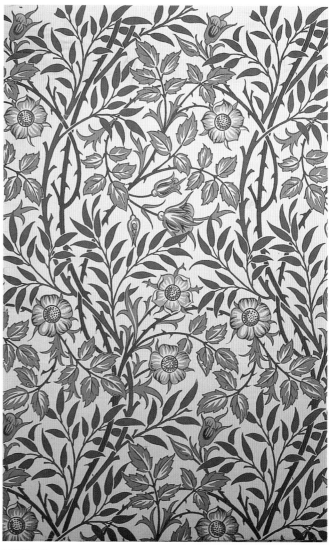

**J. H. Dearle:**

*Sweet Briar* wallpaper, designed 1912

Tapete *Heckenrose*, entworfen 1912

Papier peint *Églantier*, dessiné en 1912

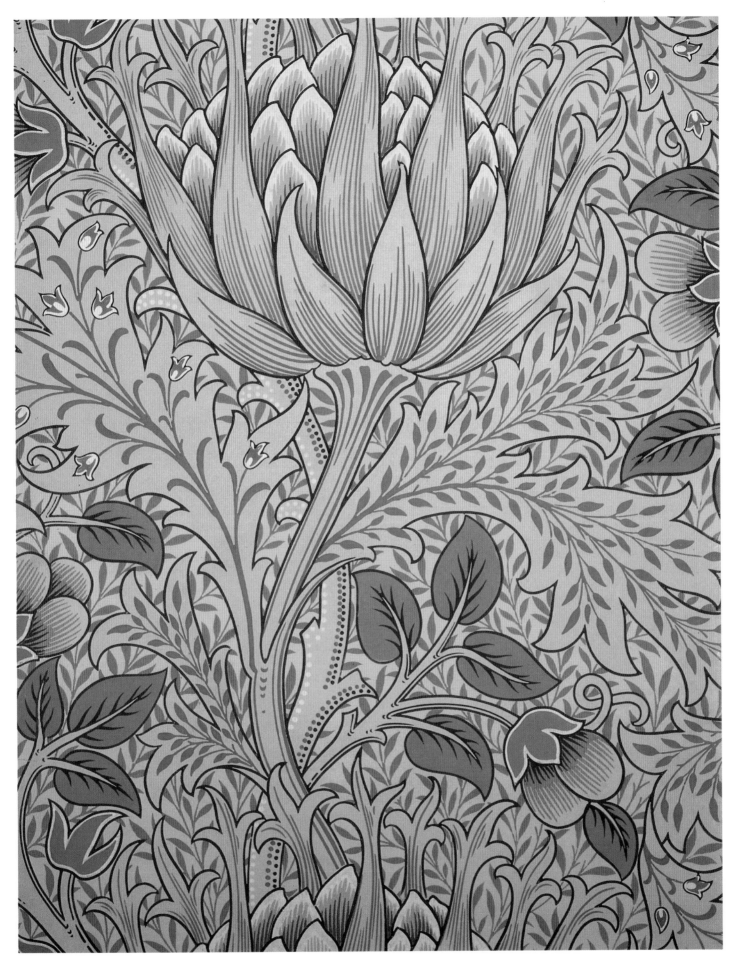

**J. H. Dearle:**

*Artichoke* wallpaper, designed 1898–1899

Tapete *Artischocke,* entworfen 1898–1899

Papier peint *Artichaut,* dessiné en 1898–1899

# EMBROIDERY

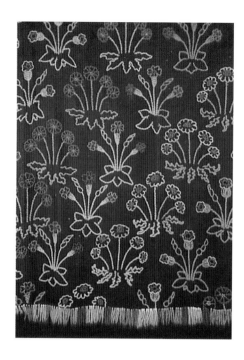

**William Morris:**
*Daisy* hanging, 1860
Vorhang *Gänseblümchen*
Tenture *Pâquerette*

RIGHT PAGE / RECHTE SEITE / PAGE DE DROITE:
**William Morris:**
*Qui bien aime, tard oublie* hanging, early 1860s
Vorhang *Qui bien aime, tard oublie*, frühe 1860er Jahre
Tenture *Qui bien aime, tard oublie*, début des années 1860

RIGHT PAGE FAR RIGHT / RECHTE SEITE AUSSEN /
PAGE DE DROITE CI-CONTRE:
**William Morris:**
*If I Can* hanging, 1856–1857
Vorhang *If I Can*
Tenture *If I Can*

During the second half of the 19th century, the Anglo-Catholic Movement's campaign for a greater use of ritual within the Church of England led to an increased demand for ecclesiastical embroideries, such as altar cloths. Morris was introduced to this specialized craft while articled to the Gothic Revivalist architect George Edmund Street, who was involved in much church building and restoration. Street had already co-written, with Agnes Blencowe, an influential book entitled *Ecclesiastical Embroidery*, published in 1848. In this, he stated his opposition to the contemporary trend of cross-stitch work for church use and urged for more creative forms of needlework, such as embroidery. But whereas Street favoured using silks, which gave his embroideries a relative flatness, Morris initially preferred the use of wool yarns and backing which, though harder to work with, produced a greater three-dimensional effect. This in turn brought his embroideries closer in spirit to the medieval archetypes he so admired.

While Morris was living at 17, Red Lion Square, he had an embroidery frame made, based on an antique model. Using woollen yarns which he also had specially dyed for him, and with time-consuming diligence, Morris set about mastering the techniques of embroidery, including his preferred method of "laying and couching". He subsequently instructed his housekeeper, "Red Lion" Mary, on how to embroider his designs, and she became the first of many women during Morris's lifetime who painstakingly executed this type of work for him. The first known embroidery by Morris himself is a hanging dating from 1857, in which he employed a relatively crude method of working and aniline dyed wool. With its simple stylized tree and bird forms, this early design possesses a charming naïvety. Its "If I Can" motto makes reference to the 15th-century artist Jan Van Eyck's

In der zweiten Hälfte des 19. Jahrhunderts führte die Forderung der Anglokatholischen Bewegung nach einer stärkeren Ritualisierung innerhalb der Englischen Staatskirche zu einer größeren Nachfrage nach sakralen Stickarbeiten wie Altartüchern. Morris entdeckte diesen kunsthandwerklichen Bereich, als er bei dem neugotischen Architekten George Edmund Street lernte, der intensiv mit Kirchenbau- und Restaurationsprojekten beschäftigt war. Street hatte mit Agnes Blencowe bereits ein einflußreiches Buch mit dem Titel *Ecclesiastical Embroidery* (1848) veröffentlicht. Darin wandte er sich gegen den aktuellen Trend zu Kreuzsticharbeiten für die Kirche und setzte sich für kreativere Formen der Stickereien ein. Doch während Street Seide bevorzugte, die seine Stickereien flächig wirken ließ, favorisierte Morris zunächst Wollgarne und Ausfütterungen, die zwar schwieriger zu handhaben waren, jedoch einen dreidimensionalen Effekt hervorriefen. Dadurch kamen seine Stickarbeiten den mittelalterlichen Vorbildern näher, die er so sehr bewunderte.

Als Morris am Red Lion Square 17 wohnte, ließ er sich einen Stickrahmen nach antikem Vorbild anfertigen. Mit Wollgarnen, die speziell für ihn eingefärbt wurden, und mit ausdauerndem Fleiß eignete sich Morris die Technik des Stickens einschließlich des Plattstichs an. Anschließend lehrte er seine Haushälterin „Red Lion" Mary, seine Entwürfe zu sticken. Sie war die erste von vielen Frauen in Morris' Leben, die diese Arbeit sorgfältig für ihn ausführten. Die älteste bekannte Stickerei von Morris selbst ist ein Wandbehang von 1857, eine relativ einfache Arbeit mit anilingefärbter Wolle. Mit seinen stilisierten Baum- und Vogelmotiven zeigt die Darstellung eine bezaubernde Naivität. Das Motto „If I Can" spielt auf das berühmte Wortspiel des Malers Jan van Eyck aus dem 15. Jahrhundert an: „Als Ich Kan" („Wie Ich Kann" oder „Wie Eyck Kann").

Durant la première moitié du XIXᵉ siècle, la campagne du mouvement anglo-catholique en faveur d'un plus grand usage du rituel à l'intérieur de l'Église d'Angleterre conduisit à une demande croissante de broderies ecclésiastiques, comme les nappes d'autels. Morris fut initié à ce domaine de l'artisanat alors qu'il était en apprentissage chez l'architecte revivaliste George Edmund Street. Ce dernier était engagé dans de nombreux projets de constructions et de restaurations d'églises. Street avait déjà écrit en collaboration avec Agnes Blencowe un livre intitulé *Ecclesiastical Embroidery* (1848), qui rencontra un vif succès. Il y exprimait son opposition à la mode contemporaine des ouvrages au point de croix pour l'usage ecclésiastique, et prônait les formes plus créatives de travaux à l'aiguille, comme la broderie. Mais tandis que Street préconisait l'utilisation des fils de soie, ce qui donnait à ses broderies un aspect relativement plat, Morris préféra dès le début des filés et des supports de laine qui, même s'ils étaient plus difficiles à travailler, rendaient un meilleur effet tridimensionnel qui rapprochait ses broderies de l'esprit des modèles médiévaux qu'il admirait tant.

Morris habitait au 17, Red Square Lion, lorsqu'il fit fabriquer un métier à broder qui était la copie d'un modèle antique. Utilisant des filés de laine qu'il avait lui-même teints, Morris consacra beaucoup d'efforts et de temps pour parvenir à maîtriser les techniques de broderies, y compris sa méthode préférée de broderie en « point plat ». Il instruisit par la suite sa gouvernante, Mary « Red Lion », de la manière de broder ses dessins. Elle devint la première des nombreuses femmes qui, du vivant de Morris, exécutèrent pour lui ce type de travail minutieux. La première broderie connue, brodée par Morris lui-même, est une tenture de 1857, pour laquelle il recourut à une méthode de travail assez rudimentaire et employa de la laine teinte à l'aniline.

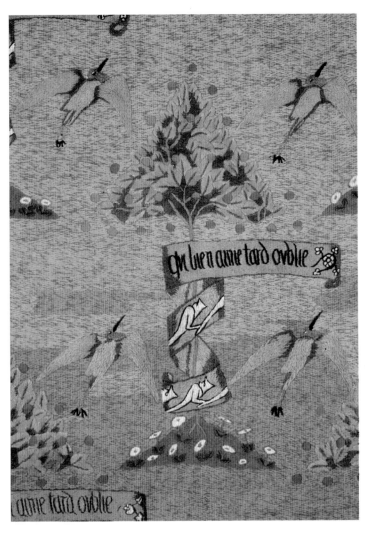
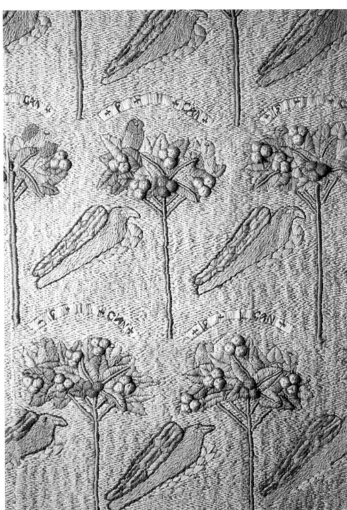

famous pun, "Als Ich Kan" ("As I Can" or "As Eyck Can").

Another early hanging, which was embroidered specifically for the Red House in 1860, used indigo-dyed woollen serge for its backing, while its laid and couched daisy motif was inspired by a 15th-century Froissart manuscript in the British Museum. The *Daisy* hanging, with its simple repeating motif and honest expression of the medium, embodies many of Morris's design principles. Indeed, the rustic vernacularism of this curtain must have seemed startlingly radical in its day. Between 1860 and 1865, Morris also designed a series of figurative panels for the Red House that depicted, among others, St Catherine, Penelope and Queen Guinevere.

When Morris, Marshall, Faulkner & Co.'s first prospectus was issued in April 1861, it stated that the co-operative would be producing and undertaking commissions for embroideries. In 1862 the Firm exhibited embroidered designs at the International Exhibition in South Kensington. Although not to everyone's taste, *The Clerical Journal* at least described them as "quaintly pleasing", even if it inaccurately referred to them as "reproductions"[35]. After the exhibition, the Firm began to receive commissions for ecclesiastical embroideries from Gothic Revivalist architects, such as G. F. Bodley.

Bei einem 1860 speziell für das Red House gestickten Vorhang bestand die Fütterung aus indigogefärbtem Wollserge. Das Gänseblümchenmotiv war von einem Manuskript Froissarts im British Museum inspiriert. Dieser Vorhang *Gänseblümchen* mit seinem einfachen Rapportmotiv verkörpert viele von Morris' Designprinzipien und muß in seiner Radikalität damals als geradezu revolutionär erschienen sein. Zwischen 1860 und 1865 entwarf Morris für das Red House auch eine Reihe figürlicher Darstellungen, die unter anderem die hl. Katharina, Penelope und Königin Guenevere zeigten.

Als im April 1861 der erste Prospekt von Morris, Marshall, Faulkner & Co. erschien, wurde dort angekündigt, daß die Firma Aufträge für Stickarbeiten übernehme. 1862 stellte sie auf der Weltausstellung in South Kensington Stickereien aus, die allerdings nicht allen Besuchern gefielen. Dennoch beschrieb zumindest *The Clerical Journal* sie als „seltsam gefällig" und nannte sie „Reproduktionen".[35] Nach der Ausstellung erhielt die Firma Aufträge für Kirchen von neogotischen Architekten wie G. F. Bodley. Diese stilistisch einfachen Arbeiten wurden von Morris und Webb gemeinsam entworfen und von den Freunden und Verwandten der Partner realisiert, etwa Jane Morris, Georgiana Burne-Jones und Lucy und Kate Faulkner.

Avec son arbre et ses oiseaux stylisés, il émane de cette œuvre précoce une naïveté charmante. La formule emblématique « If I can » fait référence au célèbre jeu de mot de l'artiste du XVe siècle, Jan van Eyck – « Als Ich Kan » (« As I Can » ou « As Eyck Can »).

Une des premières tentures de Morris, spécialement brodée pour la Red House en 1860, utilisait de la serge de laine teintée à l'indigo pour le support, tandis que le motif de marguerite brodé à point plat était inspiré d'un manuscrit de Froissart datant du XVe siècle et se trouvant au British Museum. La tenture *Pâquerette*, avec son motif répétitif tout simple exécuté de manière sobre, concrétisait de nombreux principes de Morris en matière d'art décoratif. La rusticité vernaculaire de ce rideau dut énormément choquer à l'époque. Entre 1860 et 1865, Morris réalisa également pour la Red House une série de panneaux figuratifs qui représentaient, entre autres, sainte Catherine, Pénélope et la reine Guenièvre.

Le premier prospectus de Morris, Marshall, Faulkner & Co., publié en avril 1861, annonçait que la coopérative produisait et sous-traitait des commandes de broderies. Et de fait, en 1862, la Firme exposa des ouvrages brodés à l'Exposition internationale de South Kensington. Bien qu'ils ne fussent pas du goût de chacun, *The Clerical Journal* les décrivit du moins comme des œuvres

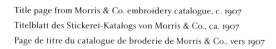

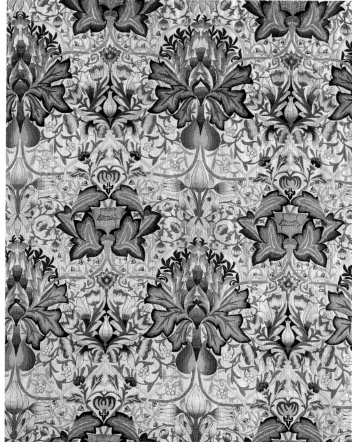

Title page from Morris & Co. embroidery catalogue, c. 1907
Titelblatt des Stickerei-Katalogs von Morris & Co., ca. 1907
Page de titre du catalogue de broderie de Morris & Co., vers 1907

**William Morris:**
*Artichoke* hanging, 1877
Vorhang *Artischocke*
Tenture *Artichaut*

These early and stylistically simple embroideries were co-designed by Morris and Webb and worked by the partners' friends and relatives, including Jane Morris, Georgiana Burne-Jones, and Lucy and Kate Faulkner.

When Morris eventually gained sole control of the Firm in 1875, the urgency of attaining financial viability became even more pressing. For Morris & Co. to survive, he realized that the range of designs it offered would have to become more commercially appealing. Around this time, Morris and Webb began designing flatter embroideries that were less medieval in style yet still required a traditional method of execution. During the 1870s, many site-specific commissions for domestic hangings and panels were obtained from secular clients, such as the industrialist Sir Isaac Lowthian Bell. In response to the increasing popularity of their embroideries, the Firm began retailing "kit" designs for cushion covers and fire-screen panels. With these, Morris's intention was to grant the embroiderer greater creative freedom by leaving open the choice of stitch and colour of yarn. Morris was also closely associated with the Royal School of Needlework, which was established in 1872 for the promotion of ornamental needlework as an art form, and with Burne-Jones executed three designs for the institution.

Als Morris 1875 alleiniger Inhaber der Firma wurde, wurde der finanzielle Druck noch stärker. Damit Morris & Co. überleben konnte, mußte er seine Produktpalette kommerziell attraktiver gestalten. In dieser Zeit begannen Morris und Webb flächigere Stickereien zu entwerfen, die stilistisch weniger an das Mittelalter erinnerten, aber immer noch traditionell ausgeführt werden mußten. In den 1870er Jahren gingen auch viele Aufträge für Vorhänge und Paneele von Privatkunden wie dem Industriellen Sir Isaac Lowthian Bell ein. Da ihre Stickereien immer populärer wurden, vertrieb die Firma bald „Entwurfssätze" für Kissenbezüge und Ofenschirme. Damit wollte Morris den Stickern größere kreative Freiheit gewähren, die nun Stichart oder Garnfarbe selbst wählen konnten. Morris war auch eng mit der School of Needlework verbunden, die 1872 zur Förderung ornamentaler Nadelarbeit als Kunstform gegründet wurde. Mit Burne-Jones führte er drei Entwürfe für diese Institution aus.

Morris' üppige Vorhänge und Wandbehänge aus den späten 1870er und 1880er Jahren wie *Artischocke* und *Akanthus* hatten kompliziertere Muster als seine frühen Entwürfe und zeugen von seinem wachsenden Interesse an Teppichen. May Morris, eine erfahrene Stickerin, die schon sehr früh für ihren Vater gearbeitet hatte, über-

« bizarrement plaisantes », qu'il nommait cependant improprement « reproductions »[35]. Après l'Exposition, la Firme commença à recevoir des commandes d'architectes comme G. F. Bodley. Ces premières broderies furent conçues par Morris et Webb et exécutées par les amis et les parents des partenaires de la Compagnie, y compris Jane Morris, Georgiana Burne-Jones et Lucy et Kate Faulkner.

Lorsque Morris finit par prendre seul le contrôle de la Firme, en 1875, l'urgence d'atteindre une viabilité financière se fit encore plus pressante. Morris se rendit compte que l'assortiment d'œuvres proposées par l'entreprise devait devenir plus attrayant d'un point de vue commercial. C'est alors que Morris et Webb se mirent à créer des broderies plus anodines, moins médiévales de style, mais qui exigeaient cependant d'être exécutées selon une technique traditionnelle. En réponse à la popularité croissante des broderies qu'elle réalisait, la Firme commença à détailler en « kit » des motifs ornementaux pour des enveloppes de coussins et des pare-étincelles. Morris voulait en fait concéder une plus grande liberté créatrice à l'art de la broderie en permettant à sa clientèle de choisir le point ou la couleur du filé. Il travaillait également en étroite association avec la Royal School of Needlework (École royale des Travaux à

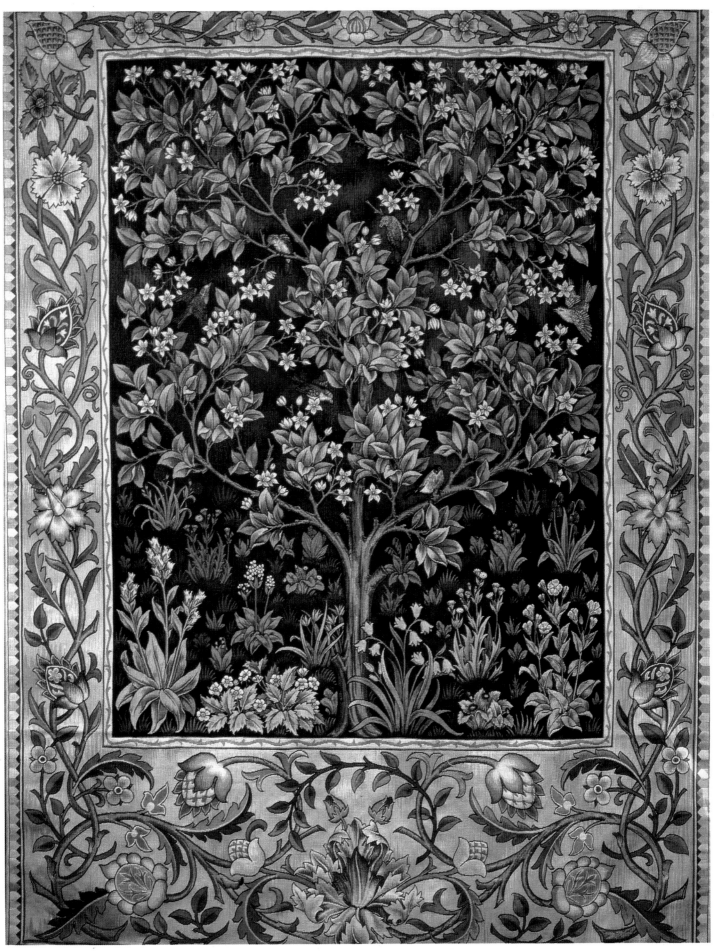

**J. H. Dearle:**

Hanging, c. 1890

Vorhang, ca. 1890

Tenture, vers 1890

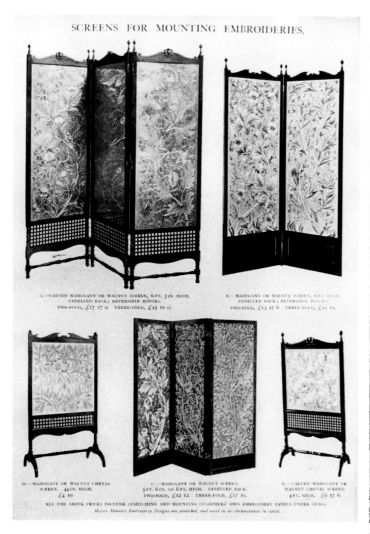

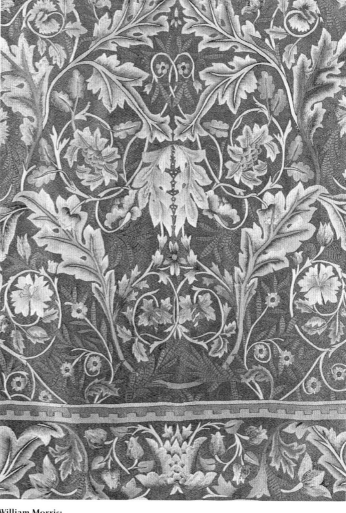

Screens, illustrated in the Morris & Co. catalogue
Wandschirme im Katalog von Morris & Co.
Paravents, illustration d'une page du catalogue Morris & Co.

**William Morris:**
*Acanthus* sample hanging, c. 1880
Mustervorhang *Akanthus*, ca. 1880
Exemple de tenture *Acanthe*, vers 1880

Morris's sumptuous hangings of the late 1870s and 1880s, such as *Artichoke* and *Acanthus*, were more complex and intricate in their patterning than his earlier designs and can be seen as a reflection of his growing interest in carpet-making. May Morris, who was a skilled needlewoman, having worked her father's designs from a very young age, took over Morris & Co.'s embroidery workshop in 1885. She and John Henry Dearle, who became the Firm's artistic director in 1896, subsequently designed all new Morris & Co. embroideries. Dearle's designs for portières, such as *Owl and Pigeon*, though stylistically similar to Morris's designs of the 1880s, lack their vitality. After her father's death, May Morris wrote several articles on embroidery, showed her own designs at various Arts & Crafts exhibitions and lectured widely on the subject in Britain and America.

nahm die Stickereiwerkstatt von Morris & Co. 1885. Sie und John Henry Dearle, ab 1896 künstlerischer Direktor der Firma, entwarfen später alle neuen Stickereien. Dearles Entwürfe für Portieren wie *Eule und Taube* ähneln zwar Morris' Arbeiten aus den 1880er Jahren, besitzen aber nicht deren Vitalität. Nach dem Tod ihres Vaters schrieb May Morris mehrere Artikel über Stickerei, zeigte ihre Entwürfe auf verschiedenen Arts-and-Crafts-Ausstellungen und hielt in England und Amerika Vorträge über dieses Thema.

l'Aiguille), fondée en 1872 pour la promotion artistique des ouvrages à l'aiguille ornementaux, et pour laquelle il exécuta trois œuvres en collaboration avec Burne-Jones.

Les superbes tentures de Morris datant de la fin des années 1870 et 1880, comme *Artichaut* et *Acanthe*, étaient plus complexes et subtiles dans le traitement des motifs que ces premières œuvres, et reflétaient son intérêt croissant pour la fabrication des tapis. May Morris prit la direction de l'atelier de broderie de Morris & Co. en 1885. Avec John Henry Dearle, qui devait devenir le directeur artistique de la Firme en 1896, elle conçut par la suite toutes les nouvelles broderies de Morris & Co. Les créations de Dearle pour portières, comme les modèles *Hibou et Pigeon*, pourtant semblables dans le style aux dessins de Morris des années 1880, n'ont pas la vitalité de ces derniers. Après la mort de son père, May Morris écrivit plusieurs articles sur la broderie, présenta ses propres œuvres dans diverses expositions Arts & Crafts et donna de nombreuses conférences sur ce thème en Grande-Bretagne et aux États-Unis.

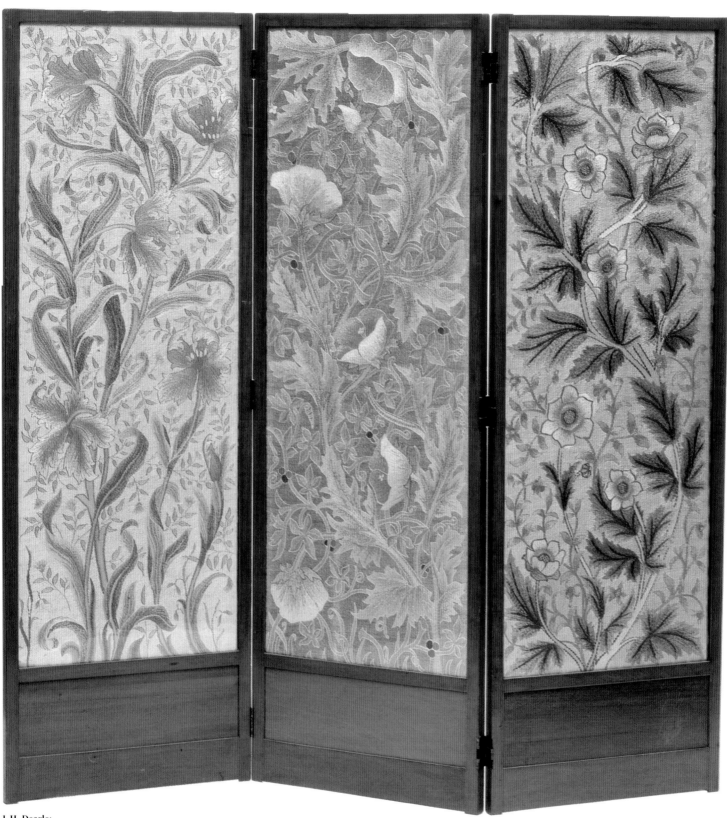

**J. H. Dearle:**
Three-fold screen, c. 1885–1890
Dreiteiliger Wandschirm, ca. 1885–1890
Paravent à trois panneaux, vers 1885–1890

# PRINTED TEXTILES

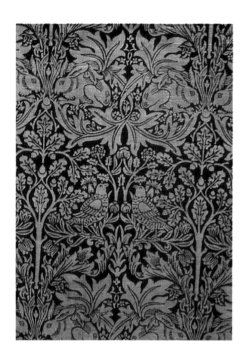

**William Morris:**

*Brother Rabbit* printed textile, designed 1880–1881, registered 1882

Bedruckter Stoff *Bruder Kaninchen*, entworfen 1880–1881, registriert 1882

Tissu imprimé *Frère Lapin*, dessiné en 1880–1881, déposé en 1882

RIGHT PAGE / RECHTE SEITE / PAGE DE DROITE:

**William Morris:**

*Tulip & Willow* printed textile, designed 1873

Bedruckter Stoff *Tulpe & Weide*, entworfen 1873

Tissu imprimé *Tulipe & Saule*, dessiné en 1873

The first printed textiles retailed by Morris, Marshall, Faulkner & Co. from about 1868 were reissues of earlier floral designs from the 1830s, and were reproduced for the Firm by Thomas Clarkson of Bannister Hall, near Preston in Lancashire. Clarkson's soon afterwards printed Morris's first original design, *Jasmine Trellis* (c. 1868–1870), using synthetic dyes. This was followed by *Tulip & Willow*, which Morris designed in 1873. When he saw the printed product, however, Morris was extremely disappointed with the quality of the colours. This was due to the aniline dyes, which he later stated had "terribly injured the art of dyeing"[36]. Accordingly, Morris began researching ancient recipes for traditional natural dyes, consulting books such as Giovanni Ventura Roseto's *Plictho de l'arte de tentori* of 1540 and John Gerard's *Herball or Generall Historie of Plants* of 1597.

When more space became available at Queen Square due to the Morris family's move to Turnham Green in 1872, Morris – with the help of John Smith (an assistant from the stained glass workshop) – began his own dyeing experiments using age-old formulas. Quickly realizing that there was still insufficient space for a commercial operation, Morris approached Thomas Wardle, the brother of his business manager, who had recently established his own silk dyeing and printing firm in Leek, Staffordshire. Wardle was sympathetic to Morris's desire to use natural dyes, although he employed modern aniline dyes himself. In the summer of 1875 Morris began large-scale dyeing experiments at Wardle's Hencroft Dye Works, the results of which led to alternating bouts of despair, anger and elation.

Morris's attempts at indigo discharge printing were beset with problems. This process, in which areas of colour were effectively bleached out, was applied to the printing of designs such

Die ersten bedruckten Stoffe, die Morris, Marshall, Faulkner & Co. ab etwa 1868 vertrieben, waren Neuauflagen floraler Entwürfe aus den 1830er Jahren und wurden von Thomas Clarkson von Bannister Hall bei Preston in Lancashire für die Firma hergestellt. Kurze Zeit später druckte Clarkson Morris' ersten Originalentwurf, *Jasmin Spalier* (um 1868–1870), mit synthetischen Farben. Danach folgte *Tulpe & Weide*, ein Morris-Entwurf von 1873. Als er den fertigen Druck sah, war Morris jedoch sehr enttäuscht über die Qualität der Farben. Dies lag an den Anilinfarben, die, wie er später erklärte, „der Kunst des Färbens schrecklich geschadet"[36] hatten. Deshalb suchte Morris selbst nach alten Rezepten für traditionelle Naturfarben. Er konsultierte dabei Bücher wie Giovanni Ventura Rosetos *Plictho de l'arte de tentori* von 1540 und John Gerards *Herball or Generall Historie of Plants* von 1597.

Als am Queen Square durch den Umzug der Familie nach Turnham Green 1872 Räume frei wurde, begann Morris – mit Hilfe von John Smith, einem Assistenten aus der Glaswerkstatt – seine eigenen Färbexperimente nach traditionellen Rezepten. Er erkannte bald, daß hier noch keine Möglichkeiten für eine kommerzielle Nutzung bestanden, und wandte sich an Thomas Wardle, den Bruder seines Managers, der gerade seine eigene Seidenfärberei und Seidendruck-Firma in Leek, Staffordshire, gegründet hatte. Wardle verstand Morris' Wunsch nach Naturfarben, obwohl er selbst Anilin verwendete. Im Sommer 1875 begann Morris in Wardles Hencroft Dye Works mit größeren Färbexperimenten – deren Resultate abwechselnd Verzweiflung, Zorn und Begeisterung hervorriefen.

Morris' Versuche mit dem Indigo-Bleichdruck erwiesen sich als problematisch. Diese Technik, bei der Farbfelder gebleicht werden, wurde beim Druck von Entwürfen wie *Tulpe & Weide* an-

Les premiers tissus imprimés vendus par Morris, Marshall, Faulkner & Co. à partir de 1868 étaient des rééditions de motifs floraux datant des années 1830, et furent reproduits pour la Firme par Thomas Clarkson de Bannister Hall, près de Preston, dans le Lancashire. Clarkson imprima peu après le premier exemplaire original de Morris, *Treillage de Jasmin* (vers 1868–1870), en se servant de teintures synthétiques. Ce modèle fut suivi de *Tulipe & Saule*, conçu par Morris en 1873. Mais lorsqu'il vit le résultat de l'impression, Morris fut extrêmement déçu de la qualité des couleurs. Les colorants à l'aniline, au sujet desquels il devait déclarer qu'ils étaient « une terrible injure à l'art de la teinture »[36], étaient responsables de la piètre qualité du produit fini. Morris se mit donc à rechercher de vieilles recettes de teintures naturelles, allant jusqu'à consulter des ouvrages anciens comme *Plictho de l'arte de tentori* de Giovanni Ventura Roseto (1540) et *Herball or Generall Historie of Plants* de John Gerard (1597).

À la suite du déménagement de la famille Morris à Turnham Green, en 1872, Morris disposa d'un espace plus grand à Queen Square et put se lancer, avec l'aide de John Smith (un assistant de l'atelier de vitraux), dans ses propres expérimentations dans le domaine de la teinture, en recourant à des formules traditionnelles. Morris se rendit cependant rapidement compte que les locaux restaient insuffisants pour une exploitation commerciale, et il se rapprocha alors de Thomas Wardle, le frère de son directeur financier, qui venait de fonder sa propre manufacture de teinture et d'impression sur soie à Leek, dans le Staffordshire. Wardle était d'accord avec Morris pour utiliser des teintures naturelles, bien qu'il employât lui-même des colorants modernes à l'aniline. À l'été 1875, Morris se mit à entreprendre des expériences de teinture de grande envergure dans les ateliers de tein-

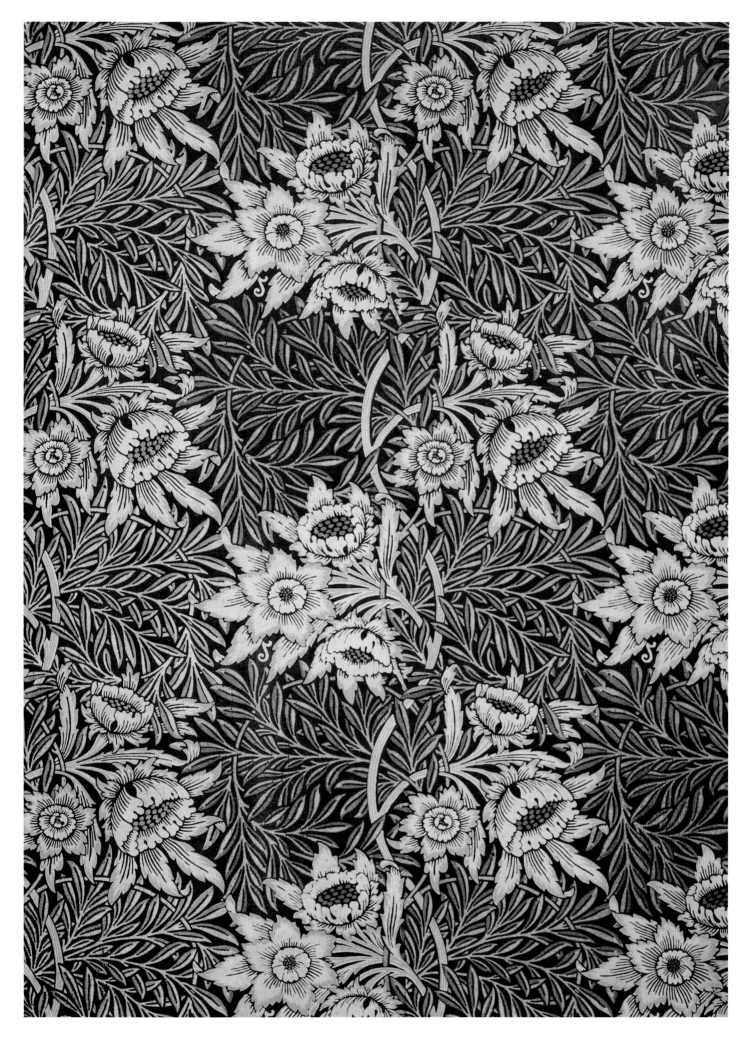

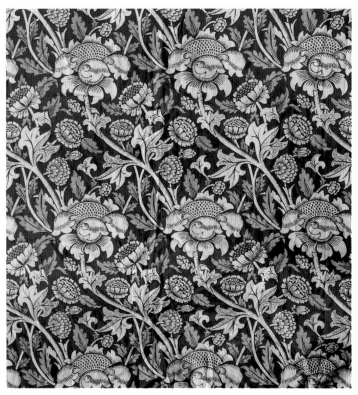 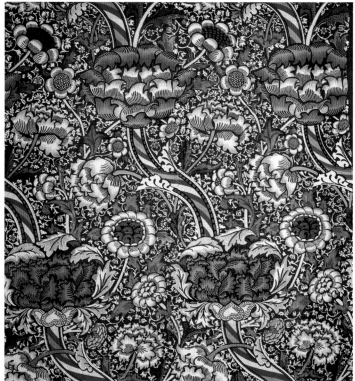

**William Morris:**
*Wey* printed textile, designed 1883
Bedruckter Stoff *Wey*, entworfen 1883
Tissu imprimé *Wey*, dessiné vers 1883

**William Morris:**
*Wandle* printed textile, registered 1884
Bedruckter Stoff *Wandle*, registriert 1884
Tissu imprimé *Wandle*, enregistré en 1884

as *Tulip & Willow*, although it was not truly perfected until 1882. Nevertheless, in or around 1876 a further 14 designs by Morris, including *Snakeshead, African Marigold* and *Honeysuckle* were successfully block-printed by Wardle using a restricted list of acceptable dyes and modern chemical dye-setting compounds. Despite this, Morris became increasingly concerned with quality control and Wardle's apparent failure to supervise his workers. By 1881, Wardle's standards of production had degenerated to such an extent that the Firm's clients were returning poorly printed textiles. Morris realized that the only way to achieve the high standards he desired would be to undertake the manufacturing himself, and so he began searching for suitable premises.

The printing of textiles was moved that same year to Morris & Co.'s new works at Merton Abbey. But even given the closer supervision there, it took many frustrating months of trial runs before any successful results were achieved. After the move to Merton, all the necessary block-cutting for Morris & Co. printed textiles was undertaken by Alfred Barrett of Bethnal Green, and later by his son, James Barrett. First a tracing was made of the original design drawing, and then this transfer was rubbed onto the uncut pear wood block. Once the outlines of the design had been laboriously cut, it was "inked up" on a dye-pad before being carefully laid on the prepared cloth, which was supported on a blanketed table. When in posi-

gewendet, aber erst 1882 perfektioniert. Dennoch wurden um 1876 vierzehn weitere Entwürfe von Morris, darunter *Schlangenkopf, Tagetes* und *Geißblatt*, erfolgreich gedruckt. Wardle benutzte hierbei eine beschränkte Anzahl ansprechender Farben und moderne chemische Färbezusätze. Um 1881 hatte sich allerdings, auch wegen der ungenügenden Kontrolle der Arbeiter, Wardles Produktionsstandard so sehr verschlechtert, daß die Kunden der Firma fehlerhaft gedruckte Textilien zurückgaben. Morris erkannte, daß er eine hohe Qualität nur erreichen konnte, wenn er selbst die Herstellung übernahm. So begann er nach geeigneten Räumen zu suchen.

Im selben Jahr wurde die neue Farbdruckerei von Morris & Co. in Merton Abbey eröffnet. Doch trotz der strengeren Kontrolle waren monatelange Versuche notwendig, bis sich Erfolge zeigten. Nach dem Umzug nach Merton wurden die Platten für die Textildrucke der Firma von Alfred Barrett aus Bethnal Green und später von dessen Sohn James Barrett geschnitten. Zunächst wurde eine Pause der ursprünglichen Entwurfszeichnung angefertigt, dann wurde diese auf den unbearbeiteten Birnenholzblock aufgerieben. Waren die Umrisse des Entwurfs sorgfältig ausgeschnitten, wurden sie mit einem Farbballen eingerieben und auf den vorbereiteten Stoff gelegt. Die Platte wurde mit einem Holzhammer aufgeschlagen und vorsichtig wieder abgehoben, dann wiederholte man den Vorgang. Waren mehrere Farben vorgesehen, wurden verschiedene Platten mit anderen Tönen

ture de Wardle's Hencroft, dont les résultats le plongeaient dans tous les états possibles du désespoir, de la colère ou de l'allégresse.

Les diverses tentatives de Morris d'imprimer à l'indigo furent hérissées de difficultés. Ce procédé, qui consiste à décolorer des zones de couleur et qui ne fut véritablement maîtrisé qu'à partir de 1882, fut appliqué à des modèles comme *Tulipe & Saule*. Néanmoins, vers 1876, quatorze autres motifs de Morris, y compris *Tête de serpent, Tagète* et *Chèvrefeuille* furent imprimés avec bonheur à l'aide de tampons en bois, en utilisant une liste réduite de teintures adéquates et de composés modernes de colorants chimiques. Morris continuait cependant à se préoccuper de plus en plus du contrôle de la qualité et du manque évident de surveillance des ouvriers chez Wardle. Vers 1881, les standards de production de cette entreprise avaient dégénéré à un tel point que les clients de la Firme ramenaient des étoffes mal imprimées. Morris comprit que le seul moyen d'atteindre le haut niveau qu'il ciblait était d'entreprendre lui-même la fabrication ; il se mit donc à la recherche de locaux mieux adaptés.

L'impression des étoffes fut transférée cette même année dans les nouveaux ateliers de Morris & Co. à Merton Abbey. Mais même en resserrant le contrôle de toutes les étapes de la production, il fallut plusieurs mois d'essais frustrants avant d'obtenir un résultat pleinement satisfaisant. Après l'installation à Merton, toute la taille des tampons nécessaires à l'impression des

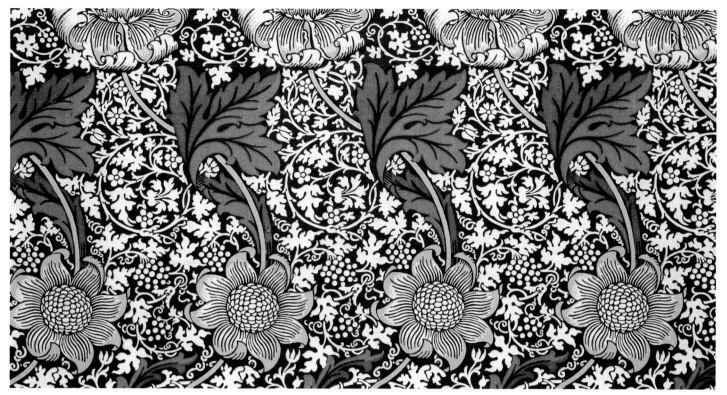

**William Morris:**

*Kennet* printed textile, registered 1883

Bedruckter Stoff *Kennet*, registriert 1883

Tissu imprimé *Kennet*, enregistré en 1883

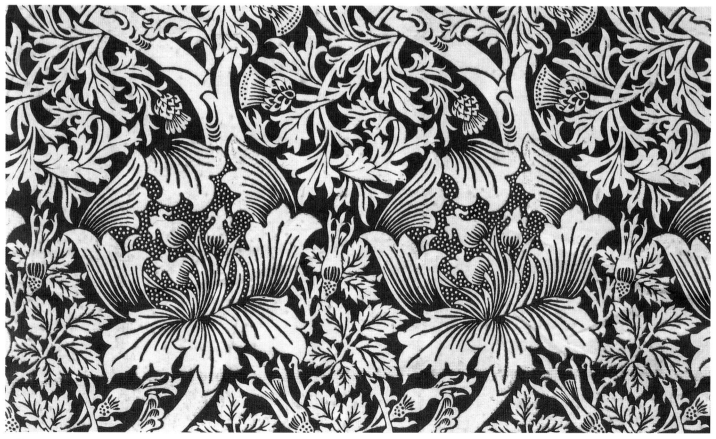

**William Morris:**

*Rose & Thistle* printed textile, designed c. 1881

Bedruckter Stoff *Rose & Distel*, entworfen ca. 1881

Tissu imprimé *Rose & Chardon*, dessiné vers 1881

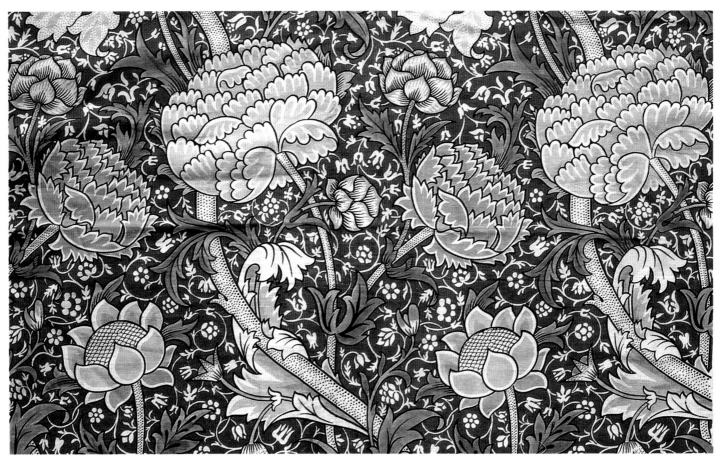

**William Morris:**

*Cray* printed textile, designed 1884

Bedruckter Stoff *Cray*, entworfen 1884

Tissu imprimé *Cray,* dessiné en 1884

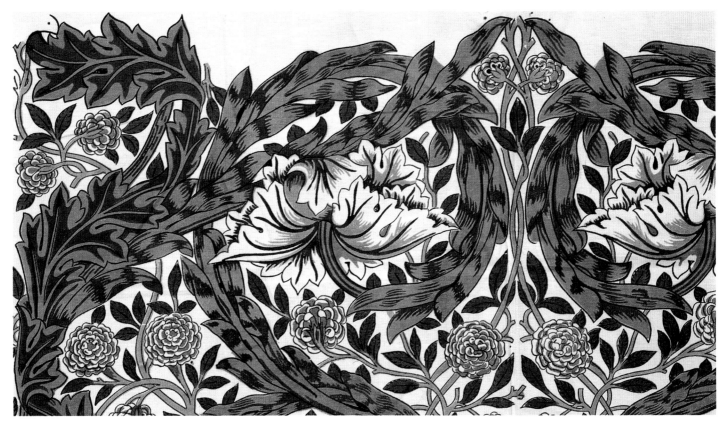

**William Morris:**

*African Marigold* printed textile, registered 1876

Bedruckter Stoff *Tagetes,* registriert 1876

Tissu imprimé *Tagète,* enregistré en 1876

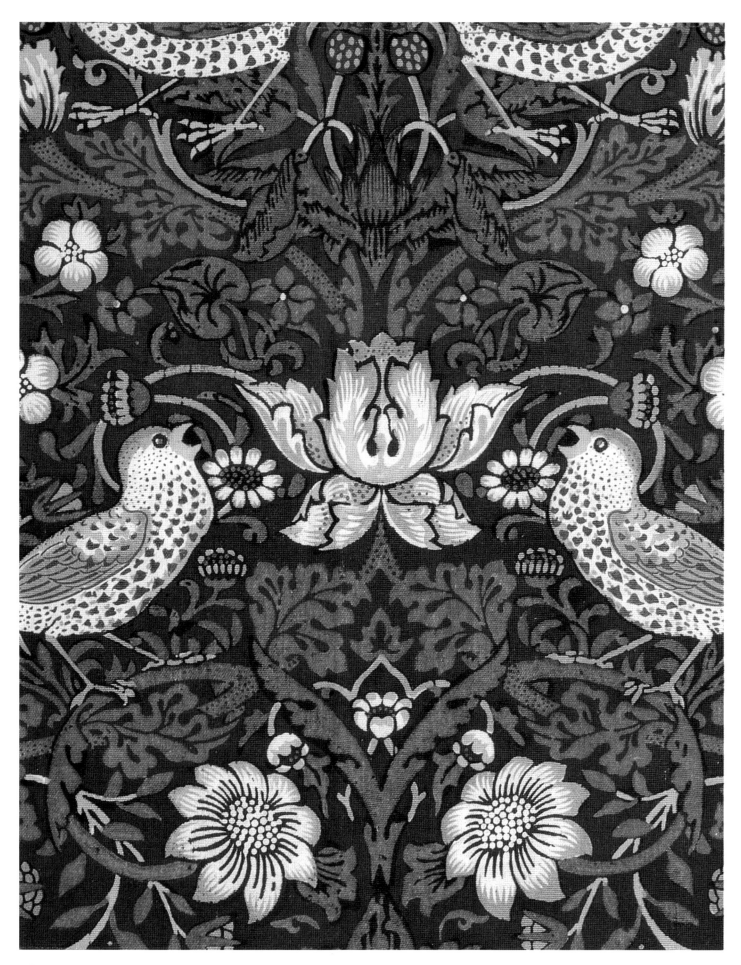

**William Morris:**
*Strawberry Thief* printed textile, registered 1883
Bedruckter Stoff *Erdbeerdieb*, registriert 1883
Tissu imprimé *Voleur de fraises*, enregistré en 1883

**William Morris:**

Design for *Rose* printed textile, 1883

Entwurf für bedruckten Stoff *Rose*, 1883

Motif pour le tissu imprimé *Rose*, 1883

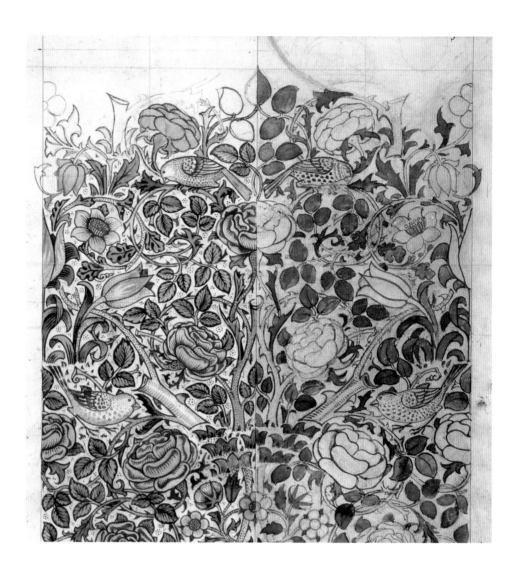

tion, the block would be struck with a mallet and cautiously lifted, then the process would be repeated. If the design called for more than one colour, different blocks with other colours would be printed once the preceding dye or dyes had dried. When the printing and fixing processes had been completed, the cloth was washed up to five times in the nearby River Wandle and laid out to dry in the meadows surrounding the Merton Abbey works. This exacting process ensured not only superlative quality but also higher costs, which had to be passed onto the client – even though the Firm's profit margins were a lot narrower than those of its competitors. A considerable number of Morris's own two-dimensional designs were used for both printed textiles and wallpapers.

aufgedruckt, sobald die vorhergehende Farbe getrocknet war. Sobald Druck und Fixierung beendet waren, wurde der Stoff bis zu fünfmal im nahen Fluß Wandle gewaschen und auf den Wiesen rund um die Werkstatt in Merton Abbey getrocknet. Dieser zeitaufwendige Prozeß führte nicht nur zu einer hervorragenden Qualität, sondern auch zu höheren Kosten, die an den Kunden weitergegeben werden mußten – obwohl die Firma eine viel geringere Gewinnspanne hatte als ihre Konkurrenten. Viele von Morris' eigenen Entwürfen wurden sowohl für Textilien als auch für Tapeten genutzt.

étoffes Morris & Co. fut confiée à Alfred Barrett de Bethnal Green, et plus tard à son fils James Barrett. On faisait d'abord un tracé du dessin original, et on gravait ensuite ce transfert sur le bloc de poirier non taillé. Une fois les contours du motif coupés, le tampon était « encré » sur un buvard de teinture avant d'être posé sur l'étoffe apprêtée, qui attendait sur une table recouverte d'une couverture. Une fois en place, le tampon était frappé à l'aide d'un maillet, et soulevé avec précaution, puis le procédé était répété. Si le motif exigeait plus d'une couleur, différents blocs d'autres couleurs étaient appliqués une fois que la ou les couleurs précédentes avaient séché. Les processus d'impression et de fixation terminés, l'étoffe était lavée jusqu'à cinq fois dans la rivière River Wandle toute proche et étendue pour sécher sur les prairies entourant les ateliers de Merton Abbey. Cette technique astreignante garantissait une qualité parfaite mais impliquait des coûts plus élevés, qu'il fallait ensuite répercuter sur le client. Malgré cela, les marges bénéficiaires de la Firme restaient largement au-dessous de celles de leurs concurrents. Un nombre impressionnant de dessins bidimensionnels réalisés par Morris servait à la fois pour les tissus imprimés et pour les papiers peints.

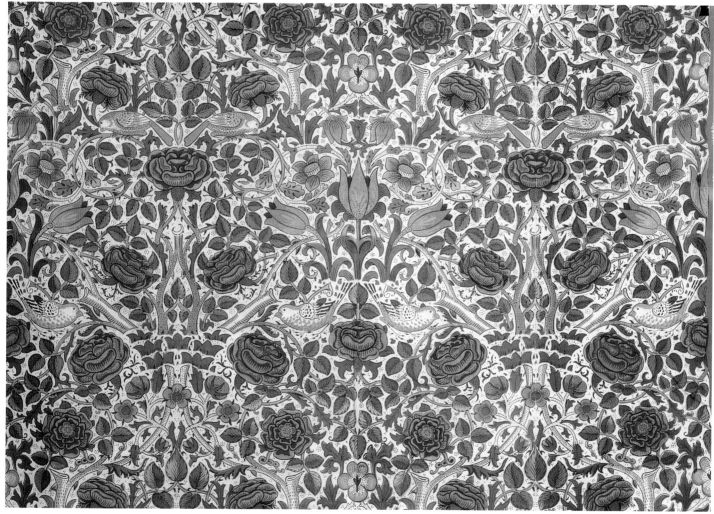

**William Morris:**
*Rose* printed textile, 1883
Bedruckter Stoff *Rose,* 1883
Tissu imprimé *Rose,* 1883

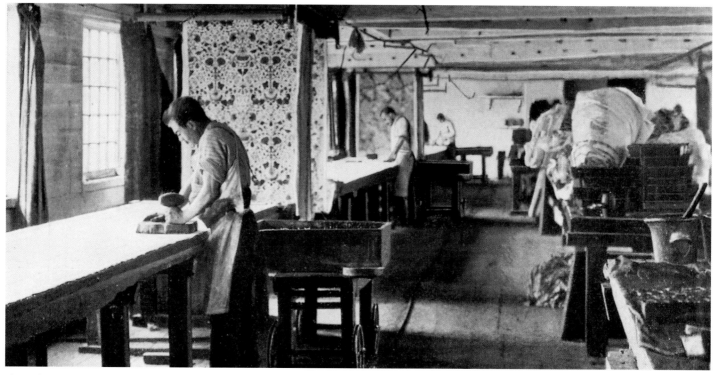

The textile printing workshop at Merton Abbey
Die Werkstatt für Textildruck in Merton Abbey
L'atelier d'impression des tissus à Merton Abbey

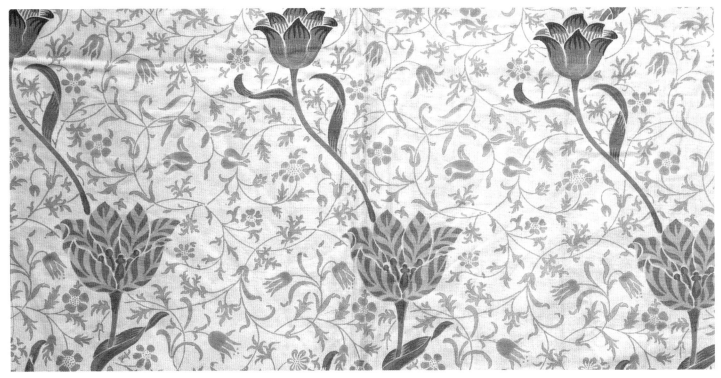

**William Morris:**

*Medway* printed textile (white background), registered 1885

Bedruckter Stoff *Medway* (weißer Hintergrund), registriert 1885

Tissu imprimé *Medway* (fond blanc), enregistré en 1885

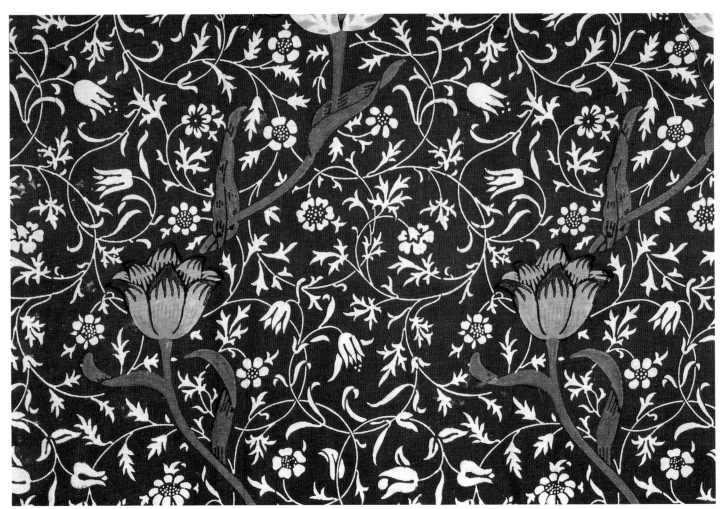

**William Morris:**

*Medway* printed textile (blue background), registered 1885

Bedruckter Stoff *Medway* (blauer Hintergrund), registriert 1885

Tissu imprimé *Medway* (fond bleu), enregistré en 1885

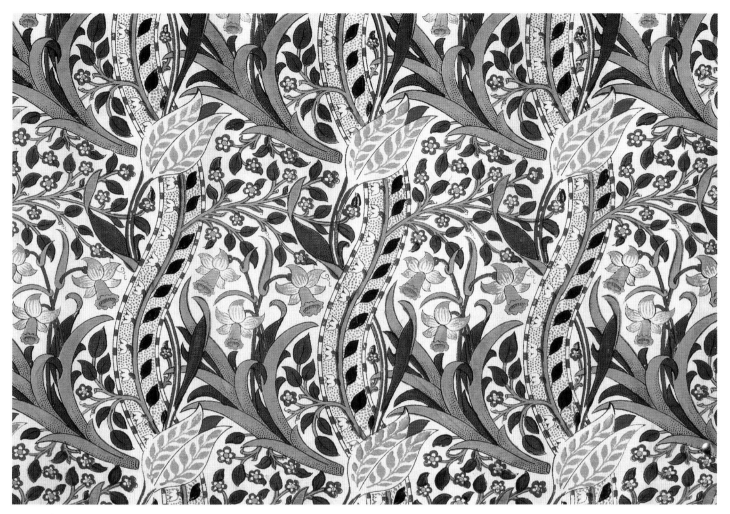

**J. H. Dearle:**
*Daffodil* printed textile (white background), designed c. 1891
Bedruckter Stoff *Narzisse* (weißer Hintergrund), entworfen ca. 1891
Tissu imprimé *Jonquille* (fond blanc), enregistré en 1891

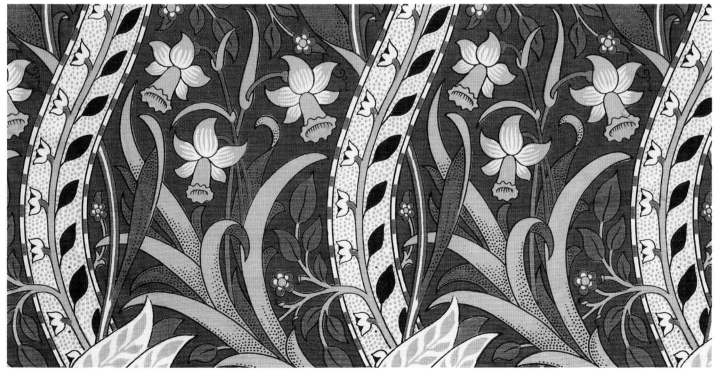

**J. H. Dearle:**
*Daffodil* printed textile (blue background), designed c. 1891
Bedruckter Stoff *Narzisse* (blauer Hintergrund), entworfen ca. 1891
Tissu imprimé *Jonquille* (fond bleu), enregistré en 1891

# WOVEN TEXTILES

Hand-activated jaquard looms in the fabric-weaving sheds at Merton Abbey

Handbetriebene Jacquard-Webstühle in der Weberei von Merton Abbey

Métiers à tisser manuels Jacquard dans la remise de la fabrique de tissage, à Merton Abbey

RIGHT PAGE / RECHTE SEITE / PAGE DE DROITE:
**William Morris:**
*Bird* woven textile, designed 1878
Gewebter Stoff *Vogel*, entworfen 1878
Étoffe tissée *Oiseau*, dessinée en 1878

Over many years, Morris studied antique textiles at the South Kensington Museum and amassed his own private collection of historical specimens, which served as technical and aesthetic points of reference for his own designs. His first woven textile design, which Morris & Co. confusingly referred to as "tapestry", was registered in 1876. Initially, the production of this and other early designs was subcontracted to established weavers, such as the Heckmondwike Manufacturing Company in Yorkshire. By early 1877, however, Morris decided to establish his own weaving workshop. To this end, Thomas Wardle helped Morris recruit Louis Bazin, a professional silk weaver from Lyons. In September 1877, a suitable workspace was found in Great Ormond Yard and Bazin set to work. It took a few frustrating weeks, nevertheless, to perfect the production of the Firm's woollen brocades. These textiles, such as *Bird* (1877–1878), were woven on a Jacquard loom that Bazin had brought over with him from France. Although this was a hand-loom that used a mechanical system of punched cards to create the required pattern, Morris accepted this form of mechanization as it provided significantly better quality than traditional production methods. The Firm also produced many patterned textiles on Jacquard power-looms, and in the late 1870s and

Viele Jahre lang studierte Morris im South Kensington Museum antike Textilien und er legte eine Sammlung historischer Stücke an, die ihm als technische und ästhetische Vorbilder für eigene Entwürfe dienten. Sein erster Webtextilentwurf, den Morris & Co. verwirrenderweise als „Tapisserie" bezeichnete, entstand 1876. Zunächst wurde die Ausführung der Entwürfe etablierten Webereien wie der Heckmondwike Manufacturing Company in Yorkshire überlassen. Doch Anfang 1877 beschloß Morris, eine eigene Weberei einzurichten. Thomas Wardle half Morris, Louis Bazin zu gewinnen, einen erfahrenen Seidenweber aus Lyon. Im September 1877 wurde im Great Ormond Yard eine passende Werkstatt gefunden, und Bazin ging an die Arbeit. Doch es dauerte einige Wochen, bis die Herstellung der Wollbrokate zufriedenstellende Ergebnisse zeitigte. Diese Stoffe, zum Beispiel *Vogel* (1877–1878) wurden auf einem Jacquard-Rahmen gewebt, den Bazin aus Frankreich mitgebracht hatte. Obwohl bei diesem Handwebstuhl ein mechanisches System von Lochkarten das gewünschte Muster erzeugte, akzeptierte Morris eine solche Form der Mechanisierung, weil die Qualität besser war als beim traditionellen Verfahren. Die Firma stellte auch viele gemusterte Textilien auf mechanischen Jacquard-Webstühlen her. In den späten 1870er und in

Pendant de nombreuses années, Morris étudia les étoffes anciennes au South Kensington Museum (l'actuel Victoria and Albert Museum), et constitua sa propre collection privée de spécimens rares, qui lui servaient de points de référence techniques et esthétiques dans son travail de décorateur. Sa première création d'étoffe tissée, que Morris & Co. référença curieusement sous le terme inexact de « tapisserie », fut enregistrée en 1876. Jusque-là, la production de ce type d'œuvres était sous-traitée par des tisserands établis, comme la Heckmondwike Manufacturing Company à Yorkshire. Au début de l'année 1877, Morris décida toutefois de créer son propre atelier de tissage. Thomas Wardle lui suggéra alors de recruter Louis Bazin, un tisseur de soie professionnel de Lyon. En septembre 1877, on trouva un lieu de travail adéquat à Great Ormond Yard et Bazin put se mettre au travail. Il fallut cependant quelques semaines pénibles pour perfectionner la production de brocarts en laine de la Firme. Ces étoffes, comme *Oiseau* (1877–1878), étaient confectionnées sur un métier Jacquard que Bazin avait apporté de France. Bien qu'il s'agît d'un métier manuel utilisant un système mécanique de cartes perforées pour réaliser le motif désiré, Morris accepta ce type de mécanisation car il donnait de façon évidente un meilleur résultat

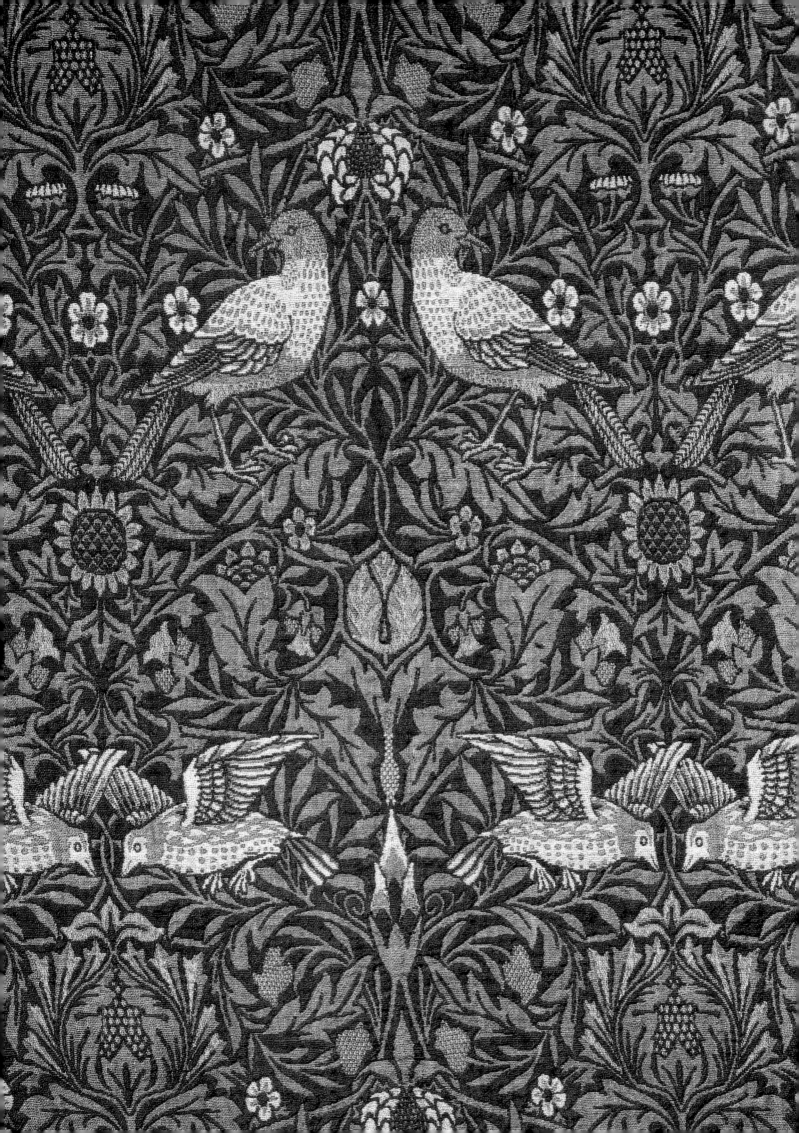

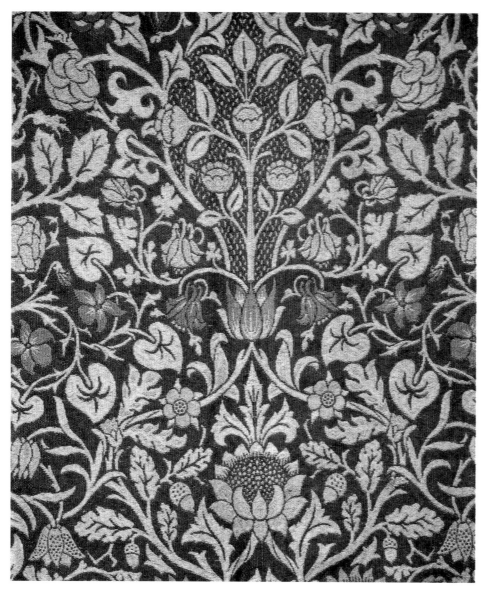

**William Morris:**
*Violet & Columbine* woven textile, registered 1883
Gewebter Stoff *Veilchen & Akelei*, registriert 1883
Étoffe tissée *Violette & Ancolie*, enregistrée en 1883

1880s Morris & Co. manufactured exquisite silk brocades and damasks as well as fine *broché* dress silks. In 1881, the weaving workshop was moved from London to Merton Abbey, and from the late 1880s J. H. Dearle designed the majority of woven textiles retailed by Morris & Co.

den 8oer Jahren entstanden exquisite Seidenbrokate und Damaststoffe sowie feine kleingemusterte Kleiderseiden. 1881 wurde die Weberei von London nach Merton Abbey verlegt. Seit den späten 1880er Jahren entwarf J. H. Dearle die meisten Webtextilien von Morris & Co.

que les méthodes de production traditionnelles. La Firme réalisa aussi un certain nombre d'étoffes à motifs sur des métiers mécaniques Jacquard, et à la fin des années 1870 et 1880, Morris & Co. manufacturait de magnifiques brocarts et damas de soie ainsi que des soies finement brochées pour la confection. En 1881, les ateliers de tissage quittèrent Londres pour Merton Abbey, et à partir de la fin des années 1880, c'est J. H. Dearle qui conçut la majorité des étoffes tissées vendues par Morris & Co.

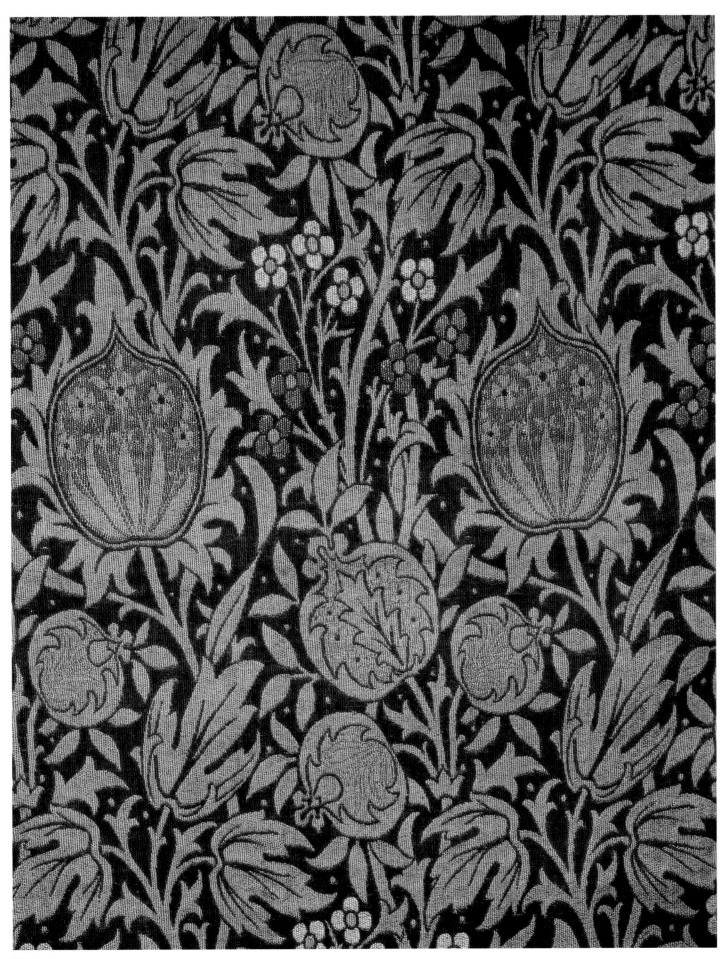

**J. H. Dearle:**

*Elmcote* woven textile, designed c. 1900

Gewebter Stoff *Elmcote*, entworfen ca. 1900

Étoffe tissée *Ormeau*, dessinée vers 1900

# TAPESTRY

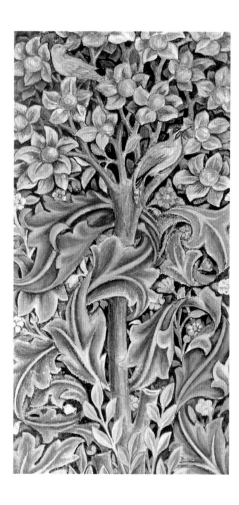

**William Morris:**

Design for *The Woodpecker* tapestry, c. 1885
Entwurf für die Tapisserie *Specht*, ca. 1885
Motif pour la tapisserie *Le Pic*, vers 1885

It is not surprising that, as a consummate story-teller, Morris regarded tapestry as the highest form of textile design. Like stained glass, woven tapestries could retell tales of long ago with an immediacy and accessibility that is difficult to comprehend in our own era. In 1877, Thomas Wardle attempted to persuade Morris to set up a "non-artistic manufactory"[37] for the commercial production of tapestries, but Morris rejected the idea: the mechanized method of production available at that time was, he felt, creatively too limiting. Instead, Morris turned his attention to traditional methods of high-warp tapestry weaving, and in 1878 began fervently experimenting with a loom that he set up in his bedroom at Kelmscott House. Once he had mastered the techniques of tapestry weaving, Morris founded a workshop at Queen Square that was headed by J. H. Dearle.

Morris believed that to create successful tapestry designs it was essential to be a good colourist and draughtsman, to have a feeling for art in general, and to possess a sound understanding of the techniques and technologies involved – attributes he certainly possessed. Many of the Morris & Co. tapestries were collaboratively designed by Morris, Edward Burne-Jones (who usually executed the figures), Philip Webb (who drew animals and birds) and J. H. Dearle. The design process would very often begin with Burne-Jones producing a preliminary design for the figures, which was then translated into a coloured drawing by Morris or Dearle. Following

Es überrascht nicht, daß Morris als begnadeter Geschichtenerzähler in der Tapisserie die höchste Form der Textilgestaltung sah. Wie bunte Glasfenster konnten gewirkte Tapisserien Geschichten aus alter Zeit mit großer Direktheit und Verständlichkeit erzählen. 1877 versuchte Thomas Wardle Morris zur Einrichtung einer „nichtkünstlerischen Manufaktur"[37] für die kommerzielle Herstellung von Tapisserien zu überreden, doch Morris lehnte die Idee ab: Die damals verfügbaren mechanisierten Produktionsmethoden schränkten seiner Meinung nach die Kreativität ein. Statt dessen wandte sich Morris den traditionellen Methoden des Teppichwirkens zu. 1878 begann er intensiv mit einem Webstuhl zu experimentieren, den er in seinem Schlafzimmer im Kelmscott House aufgestellt hatte. Sobald er die Technik beherrschte, richtete er am Queen Square eine Werkstatt unter Leitung von J. H. Dearle ein.

Morris glaubte, ein erfolgreicher Entwerfer von Tapisserien müsse ein guter Kolorist und Zeichner sein, Kunstverständnis im allgemeinen haben und die entsprechenden Techniken beherrschen – Fähigkeiten, die er selbst sicherlich besaß. Viele Tapisserien von Morris & Co. wurden gemeinsam von Morris, Edward Burne-Jones (Figuren), Philip Webb (Tiere und Vögel) und J. H. Dearle entworfen. Der Entwurfsprozeß begann häufig mit einer Vorzeichnung von Burne-Jones für die Figuren, die dann von Morris oder Dearle in eine farbige Zeichnung übertragen wurde. Dann wurde photographisch ein Karton

Il n'est pas surprenant que Morris, en conteur accompli, ait considéré la tapisserie comme la plus haute forme de création textile. Comme le vitrail, les tapisseries tissées pouvaient raconter des histoires d'autrefois avec une immédiateté et une accessibilité qu'il est difficile de comprendre aujourd'hui. En 1877, Thomas Wardle tenta de persuader Morris de fonder une « manufacture non artistique »[37] pour la production commerciale de tapisseries, mais Morris rejeta cette idée : la méthode mécanisée de production utilisable à l'époque était, lui semblait-il, trop limitative sur le plan de la créativité. Morris préféra tourner son attention vers des méthodes traditionnelles de tissage de tapisseries de haute lisse et en 1878, il se lança avec ferveur dans toute une série d'expérimentations sur un métier qu'il installa dans sa chambre, à Kelmscott House. Une fois qu'il eut maîtrisé les techniques du tissage des tapisseries, Morris créa un atelier à Queen Square, dont il confia la direction à J. H. Dearle.

Morris était persuadé que pour réussir des tapisseries, il était essentiel d'être à la fois un bon coloriste et un bon dessinateur, d'avoir le sens de l'art en général et de bien maîtriser les techniques et les technologies concernées. Il remplissait à lui seul tous ces critères. Beaucoup des tapisseries de Morris & Co. étaient conçues en collaboration par Morris, Edward Burne-Jones (qui exécutait habituellement les personnages), Philip Webb (qui dessinait les animaux et les oiseaux) et par J. H. Dearle. Le processus de créa-

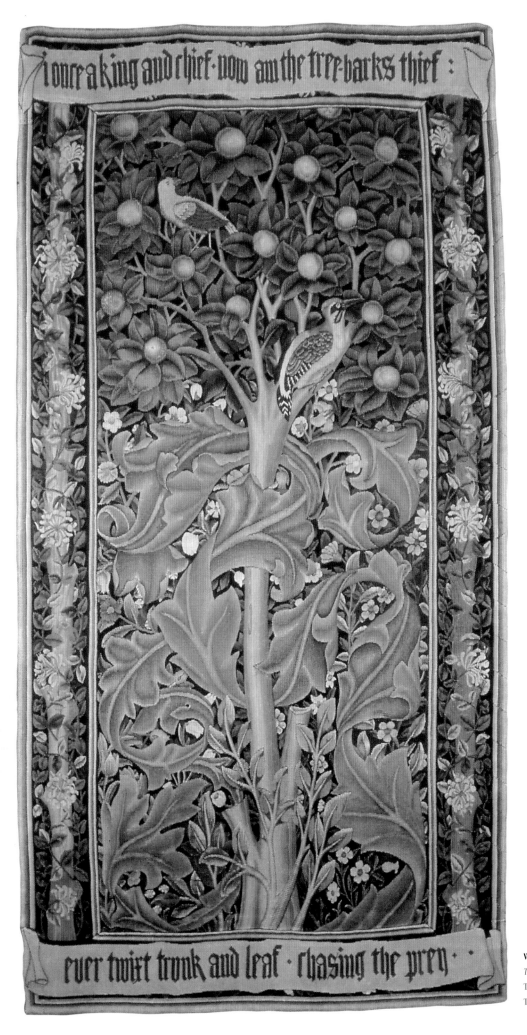

**William Morris:**

*The Woodpecker* tapestry, c. 1885

Tapisserie *Specht*, ca. 1885

Tapisserie *Le Pic*, vers 1885

· angeli · laudantes ·

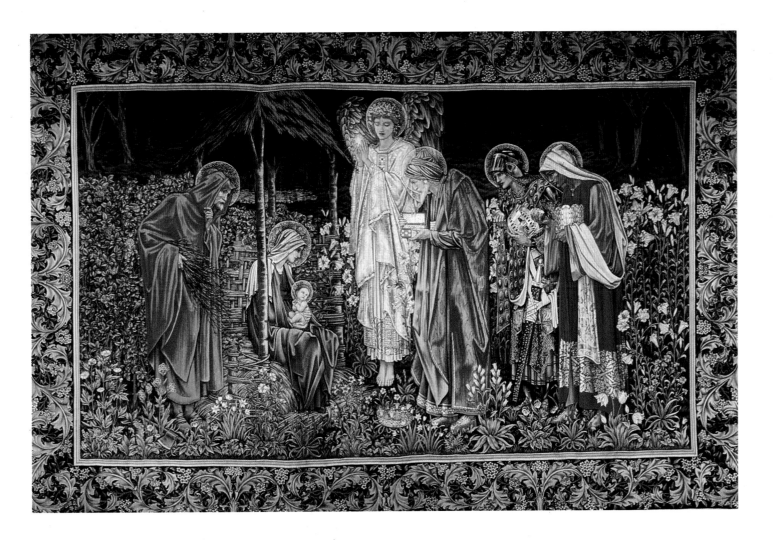

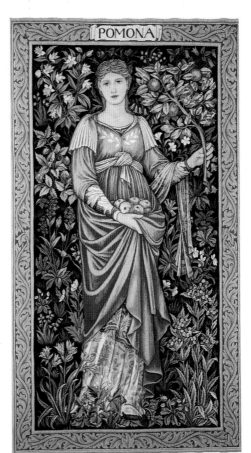

TOP / OBEN / CI-DESSUS:
**Edward Burne-Jones:**

*The Adoration of the Magi* tapestry, 1906

Tapisserie *Die Anbetung der Könige*, 1906

Tapisserie *L'Adoration des Rois Mages*, 1906

PAGES 148–149 / SEITEN 148–149:
**Edward Burne-Jones:**

*The Arming and Departure of the Knights of the Round Table on the Quest for the Holy Grail* tapestry by Morris & Co., 1890

Tapisserie *Bewaffnung und Aufbruch der Ritter der Tafelrunde auf der Suche nach dem Heiligen Gral* von Morris & Co.

Tapisserie *L'Armement et le Départ des chevaliers de la Table Ronde dans la Quête du Saint-Graal*, exécutée par Morris & Co.

LEFT / LINKS / À GAUCHE:
**Edward Burne-Jones & J. H. Dearle:**

*Pomona* tapestry, c. 1900

Tapisserie *Pomona*, ca. 1900

Tapisserie *Pomone*, vers 1900

LEFT PAGE / LINKE SEITE / PAGE DE GAUCHE:
**Edward Burne-Jones & J. H. Dearle:**

*Angeli Laudantes* tapestry, 1894

Tapisserie *Angeli Laudantes*

Tapisserie *Angeli Laudantes*

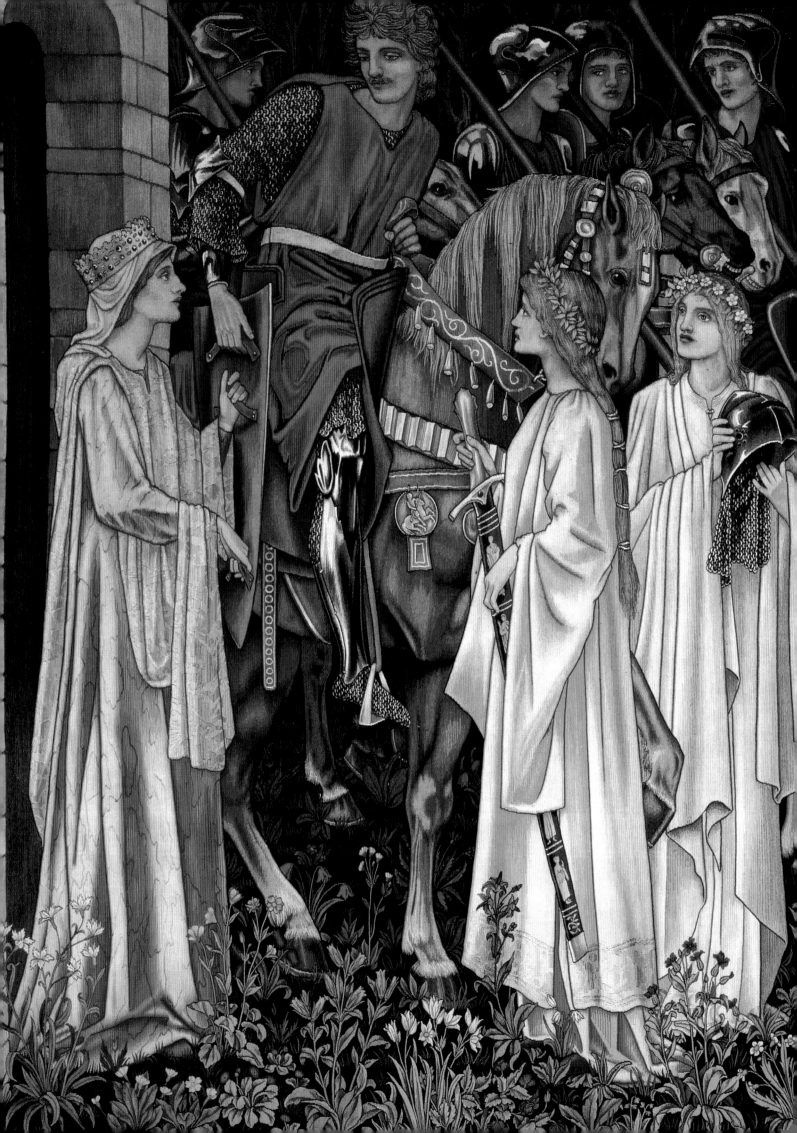

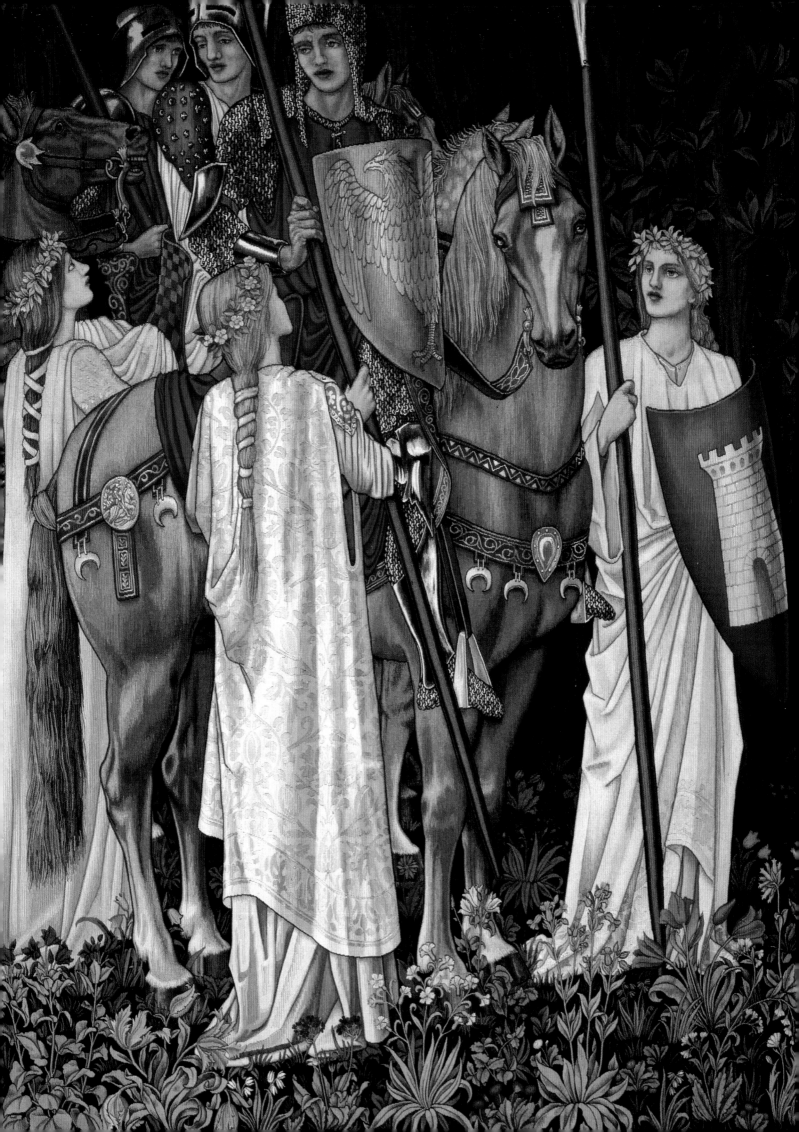

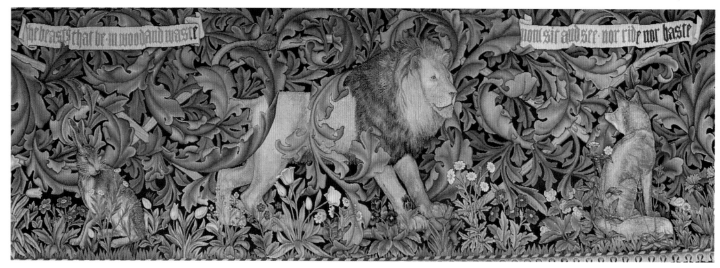

**William Morris, Philip Webb & J. H. Dearle:**
*The Forest* tapestry, 1887
Tapisserie *Der Wald*
Tapisserie *La Forêt*

this, a cartoon of the drawing would be made by photographic means. Morris or Dearle would then add the decorative borders and fill in the background and foreground by tracing over the cartoon with their own designs of flowers and trees. This first tracing and the photographic cartoon were subsequently taken by the weaver and retraced together. The resulting complete design on this second tracing was then transferred onto the warp by rubbing with a small piece of ivory.

Once the Firm had moved its weaving workshops into sheds at Merton Abbey in 1881, it was able to undertake large-scale production of tapestries. At Merton, the weaving of tapestries on vertical looms was, for the most part, done by boys of 13 or 14 years old, who were provided with board and lodgings as well as a weekly wage. Although the Firm retailed smaller-scale designs for cushion covers and furniture upholstery panels, the majority of its tapestry designs such as *The Woodpecker* (1885), were conceived as decorative hangings. These tapestries were either secular or sacred in theme, depending on whether they were destined for a private home or a church. Particular designs were repeated over and over again. Ten versions of the *Adoration* tapestry, for example, were woven between 1890 and 1907, although each differed somewhat, with its own border design. The largest tapestry project undertaken by the Firm was the *Holy Grail* series of 1890, which comprised five narrative panels with life-sized figures and six smaller foliate panels. The subject-matter of this woven cycle, which was commissioned by William Knox D'Arcy for Stanmore Hall, was described by Morris as "the most beautiful and complete episode of the legends"[38].

der Zeichnung hergestellt. Morris oder Dearle fügten dekorative Randleisten hinzu und füllten auf einer Pause über dem Karton Vorder- und Hintergrund mit Blumen und Bäumen aus. Diese erste Pause und der photographische Karton wurden dann vom Weber in eine Vorlage zusammengeführt. Der vollständige Entwurf auf dieser zweiten Pause wurde dann durch Reiben mit einem Elfenbeinstück auf die Kettfäden übertragen.

Als die Firma 1881 in die neue Weberei in Merton Abbey zog, konnte sie die Großproduktion von Tapisserien aufnehmen. An den Hochrahmen arbeiteten überwiegend 13- bis 14jährige Jungen, die Kost und Logis und einen wöchentlichen Lohn erhielten. Die Firma produzierte auch kleinere Artikel wie Kissenbezüge und Möbelpolster, doch die meisten Tapisserieentwürfe waren als dekorative Wandbehänge konzipiert, etwa *Der Specht* (1885). Sie hatten je nach ihrer Bestimmung säkuläre oder sakrale Themen. Manche Motive finden sich immer wieder. So wurden von der Tapisserie *Anbetung* zwischen 1890 und 1907 zehn Versionen gewirkt, bei denen nur die Randleisten differierten. Das größte Projekt der Firma war die Serie *Heiliger Gral* von 1890, die fünf narrative Bildfelder mit lebensgroßen Figuren und sechs kleinere Paneele mit Blattornamenten umfaßte. Das Thema dieses Zyklus, den William Knox D'Arcy für Stanmore Hall in Auftrag gegeben hatte, war laut Morris „die schönste und vollständigste Episode der Legende".[38]

tion commençait très souvent avec Burne-Jones qui ébauchait un dessin préliminaire pour les personnages, ensuite transformé en dessin en couleur par Morris ou Dearle. Après quoi, on réalisait un carton photographique de ce dessin. Morris ou Dearle ajoutait les bordures décoratives et remplissaient l'arrière ou l'avant-plan en traçant par-dessus le carton leurs propres motifs de fleurs et d'arbres. Le premier tracé et le carton photographique étaient confiés par la suite au tisserand, puis retracés. Enfin, le dessin complet résultant de ce second tracé était transféré sur la chaîne du tissu, par simple frottement, à l'aide d'une petite pièce d'ivoire.

Lorsque la Firme installa ses ateliers de tissage dans les locaux de Merton Abbey, en 1881, elle était capable d'entreprendre des productions de tapisseries à grande échelle. À Merton, le tissage des tapisseries sur des métiers de haute lisse était, pour la plus grande part, confié à des enfants de 13 ou 14 ans, à qui l'on assurait le gîte et le couvert, ainsi qu'un salaire hebdomadaire. Bien que la Firme vendît des œuvres plus petites destinées à des housses de coussins et à des panneaux de meubles rembourrés, la majorité de ces dessins de tapisserie étaient conçus pour des tentures décoratives, comme *Le Pic* (1885). Certaines œuvres étaient reprises maintes fois. Dix versions de la tapisserie *L'Adoration* par exemple, furent tissées entre 1890 et 1907, chacune différant quelque peu par le dessin de sa bordure. La plus grande tapisserie réalisée par la Firme fut la série datant de 1890, *Saint-Graal*, qui comprenait cinq panneaux narratifs avec des personnages grandeur nature et six panneaux plus petits à motifs de feuillages. Le thème de ce cycle de tissage – une commande de William Knox D'Arcy pour Stanmore Hall – fut décrit par Morris comme « le plus complet et le plus bel épisode des légendes »[38].

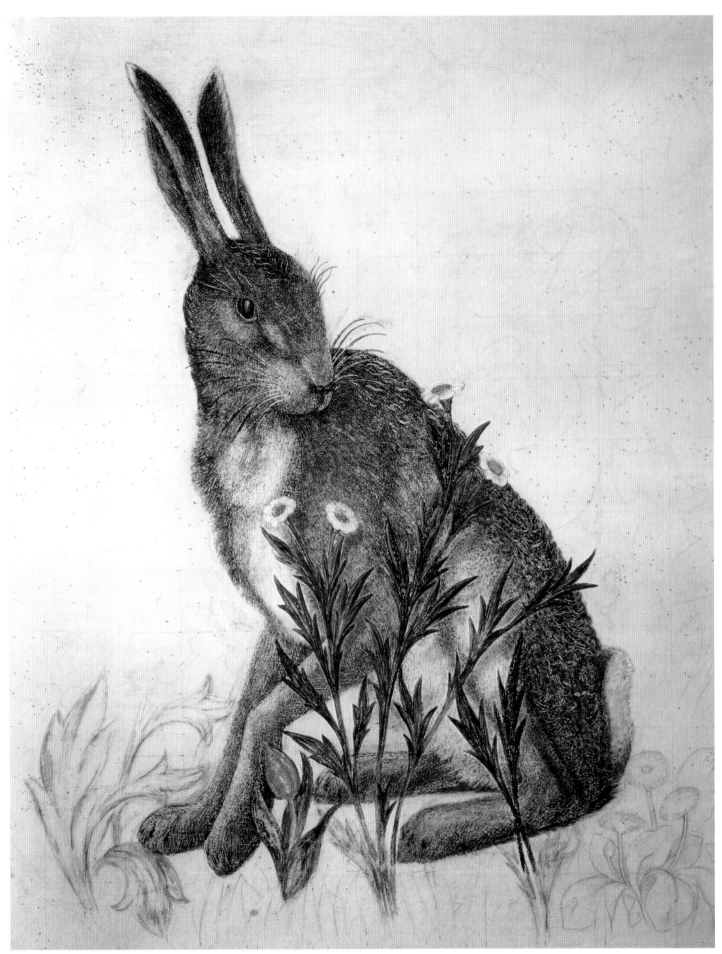

**Philip Webb:**

Drawing of a hare for *The Forest*, c. 1887

Zeichnung eines Hasen für *Der Wald*, ca. 1887

Dessin d'un lièvre pour *La Forêt*, vers 1887

# CARPETS

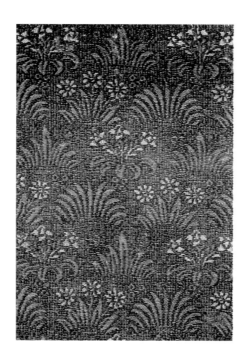

**William Morris:**

*Daisy* Kidderminster carpet, c. 1875 (manufactured by Heckmondwike)

Kidderminster-Teppich *Gänseblümchen*, ca. 1875 (hergestellt von Heckmondwike)

Tapis Kidderminster *Pâquerette*, vers 1875 (manufacturé par Heckmondwike)

In March 1875 Morris became sole proprietor of the Firm, and almost at once began diversifying its product range in an effort to boost sales and achieve financial stability. Within three months, he registered a design for a linoleum floor-covering by the name of "Corticine floor cloth", and in December of the same year he registered two designs for machine-woven Wilton carpets. By the 1880s, the Firm was retailing a large range of machine-made Axminster, Wilton and Kidderminster carpets that Morris had begun designing in the mid-1870s. The production of these commercial carpets was subcontracted to the Wilton Royal Carpet Factory Co. and the Heckmondwike Manufacturing Company in Yorkshire. Stylistically, the machine-made designs differed significantly from the Firm's Hammersmith range of hand-knotted carpets and rugs – the Kidderminster carpeting was actually technically and aesthetically closer to Morris & Co. woven textiles, while the Axminster and Wilton carpets had tighter and more geometric in-fill patterns within their borders. With these designs, Morris made a rare concession to industrialization. He did this largely for commercial reasons, no doubt believing that if the Firm did not produce and retail good quality, affordable and aesthetically pleasing machine-made carpets, one of its competitors eventually would.

Despite his acquiescence to industrial production, Morris most wanted "to make England independent of the East for the supply of hand-made carpets which may claim to be considered works of art"[39]. While living at Queen Square, he therefore began investigating first hand the techniques of carpet weaving, and executed several trial samples. As an acknowledged authority on Eastern carpets whose expert opinion was frequently sought by the keepers of the South Kensington Museum for purposes of attribution,

Im März 1874 wurde Morris Alleineigentümer von Morris & Co. Er begann sofort, die Produktpalette zu erweitern, um den Verkauf zu fördern und finanzielle Stabilität zu erreichen. Nach drei Monaten ließ er einen Bodenbelag aus Linoleum unter dem Namen „Corticine floor cloth" registrieren und im Dezember desselben Jahres zwei Entwürfe für maschinengewebte Wilton-Teppiche. In den 80er Jahren verkaufte die Firma zahlreiche maschinell hergestellte Axminster-, Wilton- und Kidderminster-Teppiche, die Morris seit der Mitte der 70er Jahre entworfen hatte. Mit der Herstellung waren die Wilton Royal Carpet Factory Co. und die Heckmondwike Manufacturing Company in Yorkshire beauftragt. Stilistisch unterschieden sich die maschinell hergestellten Teppiche deutlich von den handgeknüpften Hammersmith-Teppichen. Die Kidderminster-Entwürfe ähnelten technisch und ästhetisch eher den Webtextilien von Morris & Co., während die Axminster- und Wilton-Teppiche dichtere geometrische Muster an den Rändern aufwiesen. Mit diesen Entwürfen machte Morris eine seltene Konzession an die Industrialisierung. Er tat dies vor allem aus kommerziellen Gründen, denn er glaubte, wenn die Firma keine guten, erschwinglichen und ästhetisch ansprechenden maschinell gefertigten Teppiche produziere, werde es einer seiner Konkurrenten tun.

Obwohl Morris sich der Industrieproduktion fügte, wollte er vor allem „England in der Versorgung manuell hergestellter Teppiche, die als Kunstwerke gelten können, vom Osten unabhängig machen".[39] Deshalb begann er am Queen Square, sich intensiv mit der Technik des Teppichwebens zu beschäftigen und führte mehrere Versuchsstücke aus. Da er ein anerkannter Experte für Teppiche aus dem Osten war, überrascht es nicht, daß seine eigenen Entwürfe vom Orient inspiriert waren. Doch erst nach seinem

En mars 1875, Morris devint le propriétaire unique de la Firme, et entreprit presque immédiatement de diversifier l'assortiment des articles avec l'intention de faire grimper les ventes en flèche et d'arriver à une certaine stabilité financière. En l'espace de trois mois, il fit enregistrer un motif ornemental pour un revêtement de sol en linoléum sous le nom de « Corticine floor cloth », et en décembre de la même année, il déposa deux dessins pour des tapis Wilton tissés à la machine. Dans les années 1880, la Firme vendait un large choix de tapis Axminster, Wilton et Kidderminster faits à la machine, que Morris avait commencé à concevoir au milieu des années 1870. La production de ces tapis commerciaux fut confiée en sous-traitance à Wilton Royal Carpet Factory Co. et à Heckmondwike Manufacturing Company dans le Yorkshire. Stylistiquement, les œuvres réalisées à la machine différaient de manière significative de l'ensemble des tapis et des carpettes noués à la main de chez Hammersmith. Les tapis Kidderminster étaient en fait techniquement et esthétiquement plus proches des étoffes tissées Morris & Co., tandis que les tapis Axminster et Wilton comportaient des motifs plus serrés et plus géométriques à l'intérieur de leurs bordures. Ce fut là une des rares concessions que Morris fit à l'industrialisation. Il s'y résolut surtout pour des raisons commerciales, conscient du fait que si la Firme ne se mettait pas à produire et à vendre des tapis faits machine de bonne qualité, à prix abordables et agréables à l'œil, un de ses concurrents finirait par le faire.

Malgré ce consentement à la production industrielle, Morris voulait surtout « rendre l'Angleterre indépendante de l'Orient pour l'approvisionnement de tapis faits main pouvant prétendre au statut d'œuvres d'art »[39]. Alors qu'il vivait à Queen Square, il se mit donc à étudier les techniques de tissage de tapis et exécuta

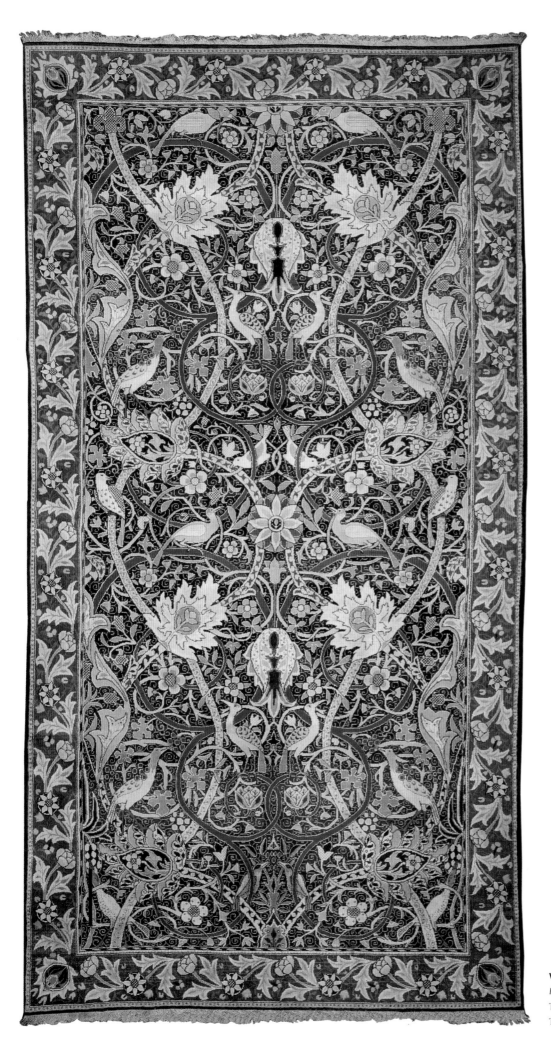

**William Morris & J. H. Dearle:**
*Bullerswood* carpet, 1889
Teppich *Bullerswood*
Tapis *Bullerswood*

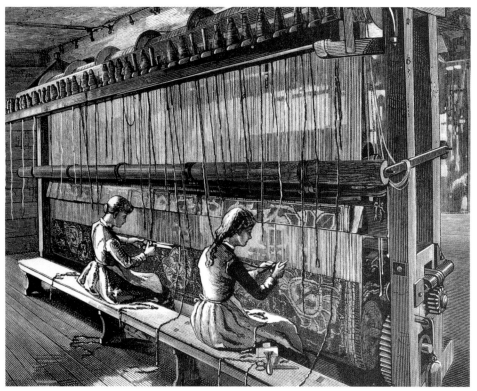

Girls working on a carpet loom at Merton Abbey, *Art Journal*, 1883
Mädchen an einem Teppichwebstuhl in Merton Abbey
Jeunes filles tissant un tapis à Merton Abbey

it is not surprising that Morris's own designs were inspired by those of the Orient. It was not until his move to Kelmscott House in 1879, however, that Morris was able to set up a carpet workshop and begin realizing his objectives. The carpet "factory" was situated in the stables and coach house of his home and employed a mainly female workforce. Although the Hammersmith hand-knotted rugs and carpets produced there did not match their Oriental antecedents in terms of technical quality, they did possess a charming lack of sophistication. In 1881 Morris & Co.'s carpet-making activities were transferred to Merton Abbey, where much larger designs, such as *Clouds* and *Bullerswood*, were produced. These enormous, specially commissioned carpets were freer in style and more English in their inspiration than the earlier Hammersmith work. With their homely appeal, Morris & Co. hand-knotted carpets had a marked influence on the later Arts & Crafts revival of carpet making.

Umzug in das Kelmscott House 1879 konnte Morris eine Teppichwerkstatt einrichten und seine Pläne verwirklichen. Die Teppich-„Fabrik" war in den Ställen und der Remise seines Hauses untergebracht und beschäftigte hauptsächlich Frauen. Obwohl die dort hergestellten handgeknüpften Hammersmith-Teppiche die Qualität ihrer orientalischen Vorbilder nicht erreichten, bestachen sie gerade durch ihre Einfachheit. 1881 wurde die Teppichweberei nach Merton Abbey verlegt, wo sehr viel größere Entwürfe wie *Wolken* und *Bullerswood* realisiert wurden. Diese riesigen, im Kundenauftrag angefertigten Teppiche waren stilistisch freier und britischer in ihrer Anmutung als die älteren Hammersmith-Arbeiten. Die handgeknüpften Teppiche von Morris & Co. übten einen starken Einfluß auf die spätere Wiederbelebung der Teppichwebkunst in der Arts-and-Crafts-Bewegung aus.

plusieurs modèles d'essais. Considéré comme une autorité confirmée en matière de tapis d'Orient, Morris était souvent consulté pour des expertises par les conservateurs du South Kensington Museum. Il n'est donc pas surprenant que ses propres créations aient été inspirées par les modèles orientaux. Ce n'est toutefois qu'à partir de son installation à Kelmscott House, en 1879, que Morris put établir un atelier de tapis et commencer à réaliser ses objectifs. « L'usine » de tapis était située dans les étables et le hangar à voitures de la maison, et employait une main-d'œuvre essentiellement féminine. La qualité technique des carpettes et des tapis Hammersmith noués à la main et produits à Kelmscott House n'égalait pas celle de leurs modèles orientaux, mais ils possédaient un manque de sophistication qui faisait précisément leur charme. En 1881, la fabrication des tapis Morris & Co. fut transférée à Merton Abbey, où des motifs beaucoup plus grands, comme *Nuages* et *Bullerswood*, étaient reproduits. Ces tapis immenses, réalisés sur commande, étaient de style plus libre et d'inspiration plus anglaise que les premiers travaux de Hammersmith. Avec leur simplicité attrayante, les tapis noués main de Morris & Co. eurent une très grande influence sur le renouveau de la fabrication des tapis amorcé par le mouvement Arts & Crafts.

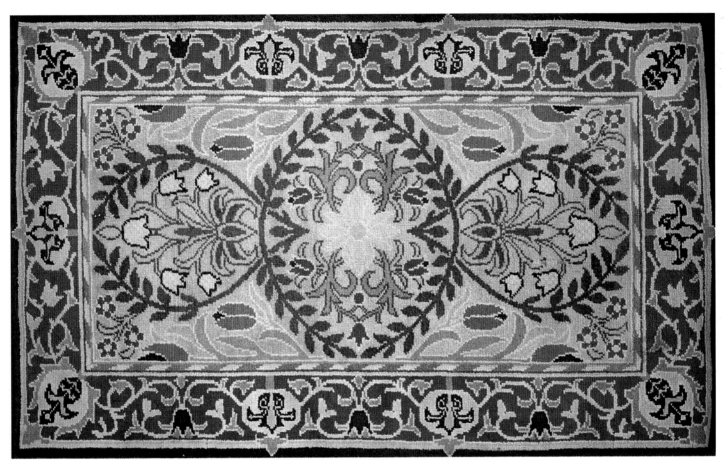

**Morris & Co.:**

Hammersmith rug, 1890

Hammersmith-Brücke

Carpette Hammersmith

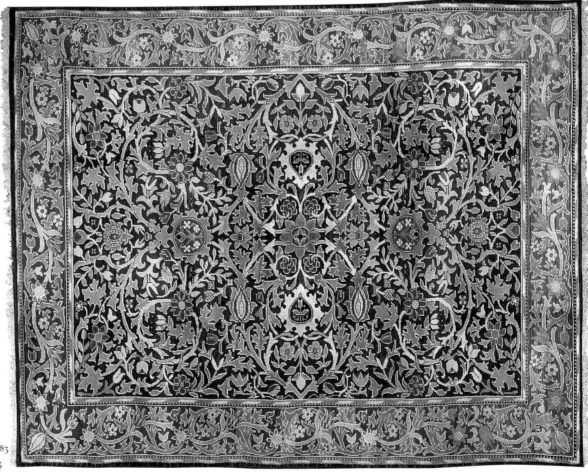

**William Morris:**

Hammersmith carpet, c. 1883

Hammersmith-Teppich, ca. 1883

Tapis Hammersmith, vers 1883

# CALLIGRAPHY

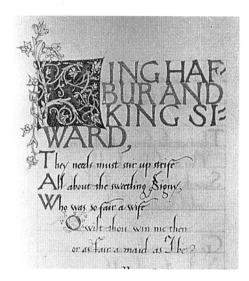

**William Morris:**
*King Hafbur and King Siward, 1873 &*
*The Story of Hen-Thorir, 1874*
Illustrated pages
Illustrierte Seiten
Pages illustrées

RIGHT PAGE / RECHTE SEITE / PAGE DE DROITE:
**William Morris, Edward Burne-Jones, Charles Fairfax Murray & George Wardle:**
*A Book of Verse, 1870*
Front page
Titelblatt
Page de titre

Morris began to develop expert knowledge of and a connoisseur's eye for French and English medieval illuminated manuscripts as a result of his studies at the Bodleian Library in Oxford and the British Museum in London. He was dedicated to the idea of rekindling this ancient art form from as early as 1857, and while living at Red Lion Square he made a number of abortive attempts at manuscript illumination and calligraphy. These earlier trials led Morris, from around 1869, to begin teaching himself the skills required. He had in his possession four 16th-century Italian writing manuals, which must have been invaluable to him in his painstaking attempts to master both Roman and italic scripts. Morris also attempted to perfect the difficult technique of gilding letters, which involved laying gold leaf onto a gesso ground and then burnishing it. Over the next five years, he found time in his busy schedule to execute over 1,500 illuminated manuscript pages on both paper and vellum. In this large body of work, which included two completed books, a score of unfinished book projects and a great number of trial pages and fragments, Morris did not so much replicate medieval manuscript techniques as revive and revitalize the arts of illumination and calligraphy in a contemporary manner. His

Nach seinen Studien in der Bodleian Library in Oxford und im British Museum in London entwickelte sich Morris zum Kenner für französische und englische Buchmalerei. Seit 1857 war er fasziniert von der Idee, diese alte Kunstform wiederzubeleben. Während seiner Zeit am Red Lion Square unternahm er eine Reihe mißlungener Versuche in Buchillustration und Kalligraphie. Seit etwa 1869 begann er sich dann selbst die notwendigen Kenntnisse anzueignen. Er besaß vier italienische Handbücher über die Schrift aus dem 16. Jahrundert, die für ihn offenbar von unschätzbarem Wert waren. Morris versuchte sich auch in der schwierigen Technik, Lettern zu vergolden. Hierbei bringt man Blattgold auf einen Kreidegrund auf und poliert es dann. In den nächsten fünf Jahren fand er trotz intensiver Arbeit die Zeit, mehr als 1500 illuminierte Manuskriptseiten auf Papier oder Pergament herzustellen. Bei diesem großen Unternehmen, das zwei komplette Bücher, viele unvollendete Buchprojekte und zahlreiche Versuchsseiten und Fragmente umfaßte, ahmte Morris nicht so sehr die mittelalterlichen Techniken nach, sondern erfüllte die Kunst der Kalligraphie in moderner Manier mit neuem Leben. Nach ersten gefälligen Versuchen wie in *A Book of Verse* (1870) entwickelte er einen reifen, siche-

C'est à la suite de ses études à la Bodleian Library d'Oxford et au British Museum de Londres que Morris commença à développer une compétence d'expert et un œil de connaisseur pour les manuscrits médiévaux enluminés français et anglais. Dès 1857, il s'était efforcé de ranimer cette ancienne forme d'art, et pendant qu'il vivait à Red Lion Square, il s'essaya sans succès à des travaux de calligraphie et d'enluminure de manuscrits. Ces premières tentatives l'amenèrent, à partir de 1869 environ, à acquérir lui-même les compétences requises pour ces disciplines. Il possédait quatre manuels italiens de calligraphie datant du XVIᵉ siècle, qui durent lui être précieux dans ses tentatives laborieuses de maîtriser les caractères romains et italiques. Morris tenta également de se perfectionner dans la difficile technique de la dorure des lettres, qui consistait à poser une feuille d'or sur un support enduit de plâtre et à la polir. Pendant les cinq années qui suivirent, il trouva le loisir, dans un emploi du temps pourtant chargé, d'exécuter plus de 1500 pages d'enluminures de manuscrits sur papier et sur vélin. Dans ce vaste champ de création, qui comptait deux livres complets, quantité de projets de livres inachevés et un grand nombre de pages et de fragments d'essais, Morris s'appliqua moins à reproduire les tech-

UT BELLI SIGNUM LAUREN
TI TURNUS AB ARCE EXTU
LIT, ET RAUCO STREPUE
RUNT CORNUA CANTU;
UTQUE ACRES CONCUSSIT
EQUOS, UTQUE IMPULIT
ARMA: EXTEMPLO TUR
BATI ANIMI, SIMUL OM
NE TUMULTU CONIU
RAT TREPIDO LATIUM,
SAEVITQUE IUVENTUS

**William Morris, Edward Burne-Jones & Charles Fairfax Murray:**
*The Aeneids of Virgil, 1874–1875*
Illustrated page
Illustrierte Seite
Page illustrée

RIGHT PAGE / RECHTE SEITE / PAGE DE DROITE:
**William Morris, Edward Burne-Jones & Charles Fairfax Murray:**
*Odes of Horace, 1874*
Illustrated page
Illustrierte Seite
Page illustrée

approach developed from a rather sweet and tentative style, as illustrated by *A Book of Verse* (1870), to the mature and confident work in his two last major calligraphic projects, *Odes of Horace* and *The Aeneids of Virgil* (both 1874) with their exquisite jewel-like borders and ciphers. Morris's illuminated manuscripts must be seen on one hand as highly private expressions of his personal creativity and on the other as an important steps towards his founding of the Kelmscott Press.

ren Stil mit exquisiten Bordüren und Ziffern, etwa bei seinen letzten großen kalligraphischen Arbeiten *Odes of Horace* (*Oden des Horaz*) und *The Aeneids of Virgil* (*Aeneis des Vergil*) (beide 1874). Morris' Buchmalerei war einerseits ein höchst privater Ausdruck seiner Kreativität, andererseits aber auch ein wichtiger Impuls für die Gründung der Kelmscott Press.

niques médiévales manuscrites qu'à faire revivre les arts de l'enluminure et de la calligraphie d'une façon contemporaine. Son approche alla d'un style plutôt charmant et expérimental, comme celui des illustrations de *A Book of Verse* (1870), à un style plus mûr et plus sûr de lui avec de magnifiques bordures et des initiales travaillées avec un art d'orfèvre, comme dans ses deux derniers projets d'envergure, *Odes of Horace* (*Les Odes de Horace*) et *The Aeneids of Virgil* (*L'Énéide de Virgile*), tous deux parus en 1874. Les manuscrits enluminés de Morris doivent être considérés comme l'expressions la plus intime de sa créativité personnelle, mais aussi comme une expérience décisive pour la fondation de la Kelmscott Press.

OTUMEX
METELLO
CONSULE
CIVICUM
BELLIQUE
CAUSASETVITIA
ET MODOS

ludumque fortunae gravesque
Principum amicitias et arma
Nondum expiatis uncta cruoribus,
periculosae plenum opus aleae,
tractas, et incedis per ignes
suppositos cineri doloso
Paullum sevaerae Musa tragediae
desit theatris: mox ubi publicas
res ordinaris, grande munus
Cecropio repetes cothurno
Insigne maestis praesidium reis

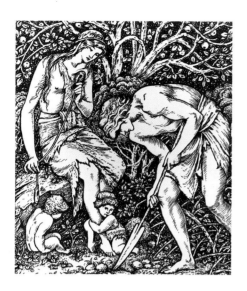

# KELMSCOTT PRESS

**Kelmscott Press:**

*When Adam delved and Eve span, Who was then the gentleman*
Frontispiece of *The Dream of John Ball*, 1886, reprinted in the 1890s
Frontispiz von *Ein Traum von John Ball*, in den 1890er Jahren nachgedruckt
Frontispice de *Un rêve de John Ball*, puis réimprimé dans les années 1890

RIGHT PAGE / RECHTE SEITE / PAGE DE DROITE:
**Kelmscott Press:**
*News from Nowhere*, 1892
Frontispiece
Frontispiz
Page de titre

Morris had a profound interest in fine books, having been an avid collector for many decades and having himself produced two exquisite illuminated manuscript books during the 1870s. He also had practical publishing experience as a result of his editorship of both *The Oxford & Cambridge Magazine* and *Commonweal*. After attending a lecture in 1888 given by his friend Emery Walker, who had a process-engraving business, Morris was determined to design a new typeface and to have it cast. This interest in typography also led him to select the typeface and oversee the lay-out for his book *The House of the Wolfings*. Although somewhat disappointed with the resulting volume, which was published by the Chiswick Press in 1888, he was enraptured by the typography and binding of *The Roots of the Mountains* – his second book, printed by the Chiswick Press in 1889. During the 1890s, Morris's time was relatively free from political activities and the day-to-day running of Morris & Co., and this enabled him to pursue his own artistic and creative interests. It is not at all surprising that he eventually immersed himself fully in fine art publishing, for he believed that a beautiful book came second only to a beautiful house. As with his other craft interests, Morris undertook preliminary research into the techniques and materials, such as handmade papers and inks, required for this venture. He also consulted Emery Walker, T. J. Cobden-Sanderson, who ran Doves Bindery at 15, Upper Mall, and the art publisher C. T. Jacobi, who founded the Chiswick Press.

In January 1891 Morris rented suitable premises at 16, Upper Mall – a small cottage close to his Hammersmith home – and established the Kelmscott Press. Shortly afterwards, the newly formed publishing house printed the first edition of Morris's *The Story of the Glittering Plain* using a single Albion press. The initial run of 200 books was intended for book lovers and collectors and sold out immediately. From the outset, the Kelmscott Press was a critical and financial success. As a result of this, they had to move to larger premises at 14, Upper Mall and pur-

Morris war sehr interessiert an bibliophilen Büchern, die er jahrzehntelang sammelte. Er selbst hatte in den 1870er Jahren zwei exquisite Manuskripte mit Buchmalerei geschaffen und besaß außerdem praktische Erfahrung als Herausgeber von *The Oxford & Cambridge Magazine* und *Commonweal*. 1888, nach einem Vortrag seines Freundes Emery Walker, der eine Photogravuranstalt betrieb, beschloß er, eine neue Schrifttype zu entwerfen und gießen zu lassen. Sein Interesse an der Typographie führte auch dazu, daß er die Schrift für sein Buch *The House of the Wolfings* selbst auswählte und das Layout überwachte. Als das Buch 1888 bei der Chiswick Press erschien, war er ein wenig enttäuscht. Doch begeistert war er von Typographie und Einband von *The Roots of the Mountains*, seinem zweiten Buch, das von der Chiswick Press 1889 gedruckt wurde. In den 1890er Jahren war Morris relativ wenig von seinen politischen Aktivitäten und dem Tagesbetrieb bei Morris & Co. beansprucht und konnte deshalb seine eigenen künstlerischen Interessen verfolgen. Für ihn war ein schönes Buch fast so wichtig wie ein schönes Gebäude, und deshalb überrascht es nicht, daß er sich schließlich mit Leib und Seele der Druckkunst verschrieb. Wie immer studierte er zunächst die Techniken und Materialien, etwa handgeschöpftes Papier und Tinten, die für den Druck notwendig waren. Er konsultierte auch Emery Walker, T. J. Cobden-Sanderson, der an der Upper Mall 15 die Doves Bindery führte, und den Kunstverleger C. T. Jacobi, den Gründer der Chiswick Press.

Im Januar 1891 mietete Morris Räume an der Upper Mall 16 – nahe seinem Wohnsitz in Hammersmith – und gründete die Kelmscott Press. Bald danach druckte der neue Verlag die erste Auflage von Morris' *The Story of the Glittering Plain* auf einer einzigen Albion-Presse. Die Erstauflage von 200 Exemplaren entstand für Büchersammler und war sofort vergriffen. Von Anfang an hatte die Kelmscott Press bei der Kritik und beim Verkauf Erfolg. Schließlich mußte sie in größere Räume an der Upper Mall 14 umziehen und eine zweite Albion-Presse anschaf-

Morris portait un très grand intérêt aux ouvrages de bibliophilie. Pendant plusieurs décennies, il avait été un collectionneur passionné et il avait lui-même réalisé pendant les années 1870 deux magnifiques livres manuscrits enluminés. Il possédait également une expérience pratique de l'édition qu'il avait acquise lors de la publication de *The Oxford & Cambridge Magazine* et de *Commonweal*. C'est après avoir assisté à la conférence de son ami imprimeur-graveur Emery Walker, en 1888, que Morris se décida à créer un nouveau caractère d'imprimerie et à le faire fondre. Cet intérêt pour la typographie l'amena également à choisir le caractère et à superviser la mise en page de son ouvrage *The House of the Wolfings*. Il fut quelque peu déçu par le livre qui en résulta, publié en 1888 par Chiswick Press, mais en contrepartie il se montra ravi de la typographie et de la reliure de *The Roots of the Mountains*, le second livre paru en 1889, toujours chez Chiswick Press. Au cours des années 1890, Morris se trouva relativement dégagé de ses activités politiques et de l'administration quotidienne de Morris & Co, ce qui lui permit de s'adonner à loisir à ses activités de création artistique. On ne s'étonnera donc pas qu'il se soit finalement complètement adonné à l'édition de livres d'art, lui pour qui un beau livre venait immédiatement après une belle maison. Il prit conseil auprès d'Emery Walker, de T. J. Cobden-Sanderson, qui dirigeait les ateliers de reliure Doves Bindery au 15, Upper Mall, et auprès de l'éditeur d'art C. T. Jacobi, fondateur de Chiswick Press.

En janvier 1891, Morris loua des locaux appropriés au 16, Upper Mall – une petite maison proche de son domicile de Hammersmith – et y établit la Kelmscott Press. Peu de temps après, la maison d'édition nouvellement créée imprimait la première édition de *The Story of the Glittering Plain* de Morris, sur une simple presse Albion. Le tirage initial de 200 exemplaires était destiné aux amateurs de beaux livres et aux collectionneurs, et fut immédiatement épuisé. Dès le début, la Kelmscott Press remporta un succès décisif et fut une réussite financière. Il fallut

THIS IS THE PICTURE OF THE OLD HOUSE BY THE THAMES TO WHICH THE PEOPLE OF THIS STORY WENT. HEREAFTER FOLLOWS THE BOOK IT. SELF WHICH IS CALLED NEWS FROM NOWHERE OR AN EPOCH OF REST & IS WRITTEN BY WILLIAM MORRIS.

**William Morris:**

The first colophone for the Kelmscott Press, 1890

Das erste Kolophon der Kelmscott Press

Le premier colophon (achevé d'imprimer) de la Kelmscott Press

chase a second Albion press to speed up production. Morris's employees at the press were better paid than some, but unlike their colleagues at Merton Abbey, had working conditions that differed little from other printing works.

The excellence of the work produced by the Kelmscott Press ranks very highly in the history of printing. Over its eight years of operation, it produced 53 titles on either fine handmade papers or, in special cases, vellum, and printed a total of 18,234 volumes. With their splendid woodcut illustrations designed by Edward Burne-Jones, Walter Crane and C. M. Gere, and their swirling medieval-style borders and ciphers by Morris, these editions were designed to be beautiful. They were also intended to be easily read and this concern for clearly decipherable typography prompted Morris to design three new typefaces: *Golden* (based on a 15th-century Venetian Roman type), *Troy* (a gothic type) and *Chaucer* (a reduced version of *Troy*). The designs for the types were reduced, photographically transferred and cut into steel punches so as to be able to be cast into metal founts, that were sufficiently strong to bear the pressure produced by the Albion hand-press. The nature of the texts that were printed ranged considerably – 23 were written by Morris, 22 were of medieval origin, 13 were of contempo-

fen. Morris' Angestellte erhielten mehr Lohn als allgemein üblich, doch anders als bei ihren Kollegen in Merton Abbey unterschieden sich ihre Arbeitsbedingungen wenig von denen in anderen Druckereien.

Die exzellente Arbeit der Kelmscott Press nimmt in der Geschichte des Buchdrucks einen hohen Rang ein. In den acht Jahren ihres Bestehens produzierte sie 53 Titel, entweder auf handgeschöpftem Papier oder in besonderen Fällen auf Pergament, und druckte insgesamt 18 234 Bände. Mit ihren prachtvollen Holz-schnitten von Edward Burne-Jones und Morris' Bordüren und Ziffern im mittelalterlichen Stil waren sie für Bibliophile gedacht. Außerdem sollten sie leicht lesbar sein, deshalb entwarf Morris drei neue Schrifttypen: *Golden* (nach einer venezianischen Type des 15. Jahrhunderts), *Troy* (eine gotische Type) und *Chaucer* (eine reduzierte Version von *Troy*). Die Entwürfe für die Buchstaben wurden verkleinert, photographisch übertragen und in Stahlstanzen geschnitten, mit deren Hilfe Metalltypen gegossen werden konnten, die stabil genug waren, um den Druck einer Albion-Handpresse auszuhalten. Die Texte waren sehr unterschiedlich – 23 stammten von Morris selbst, 22 hatten einen mittelalterlichen Ursprung, 13 waren zeitgenössische Lyrik. Darüber hinaus entstand der Nachdruck eines

donc déménager dans des locaux plus grands, au 14, Upper Mall, et acheter une seconde presse Albion pour accélérer la production.

L'excellence du travail effectué par la Kelmscott Press la hissa à un niveau très élevé dans l'histoire de l'imprimerie. Au cours de ses huit années d'existence, elle produisit 53 titres soit sur de beaux papiers faits mains, soit, dans certains cas particuliers, sur du vélin, et imprima 18 234 volumes au total. Avec leurs superbes illustrations de gravures sur bois dessinées par Edward Burne-Jones, Walter Crane et C. M. Gere, et leurs bordures et monogrammes en volutes réalisés dans le style médiéval par Morris, ces éditions étaient conçues pour être de superbes ouvrages. Ces derniers devaient également pouvoir se lire facilement et ce souci d'une typographie aisément déchiffrable incita Morris à créer trois nouveaux caractères typographiques : le *Golden* (inspiré du type romain vénitien du XVe siècle), le *Troy* (un caractère gothique) et le *Chaucer* (une version réduite du *Troy*). La nature des textes imprimés variait considérablement – 23 étaient écrits par Morris, 22 étaient d'origine médiévale, 13 étaient de la poésie contemporaine, et le dernier, intitulé *On the Nature of Gothic*, comprenait une réimpression d'un chapitre des *Stones of Venice* (*Pierres de Venises*) de John Ruskin.

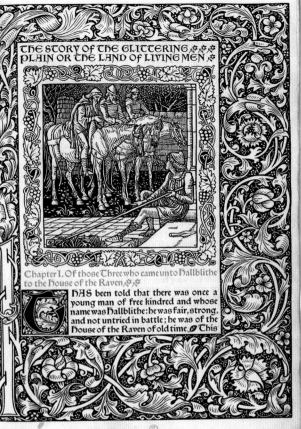

**Kelmscott Press:**

*The Story of the Glittering Plain,* published/erschienen/publié en 1891

## LXV.

### TO ONE WHO SPOKE ILL OF HIM.

HAT is your quarrel
with me, in Love's
name,
Fair queen of wrath?
What evil have I
done,
What treason to the
thought of our dear
shame
Subscribed or plotted?
Is my heart less one
In its obedience to your stern decrees
Than on the day when first you said, "I please,"
And with your lips ordained our union?
Am I not now, as then, upon my knees?
You bade me love you, and the deed was done,
And when you cried, "Enough," I stopped, and
when
You bade me go I went, and when you said
"Forget me" I forgot. Alas, what wrong
Would you avenge upon a loyal head,
Which ever bowed to you in joy and pain,
That you thus scourge me with your pitiless
tongue?

## LXVI.

### TO ONE WHO HAD LEFT HER CONVENT TO MARRY.

YEAR ago you gave
yourself to God.
It was a noble gift and
nobly given,
And we who watched
you as you fearless
trod,
Like one inspired,
your pilgrimage to
Heaven,
Rejoiced, poor sinners, there was still this leaven
For a bad world, this bud on Aaron's rod,
This virgin still at watch with the wise seven,
And envying you we almost envied God.
A year ago! Another service now
Moves your delight, another noble whim,
Another bride-groom and another vow.
Again we envy you and envy him,
First God's, then Man's! Your love all ranks
would level.
Who knows? Next year may add a third, the
Devil.

**Kelmscott Press:**

*The Love Lyrics and Songs of Proteus* by/von/par Wilfred Scawen Blunt, published/erschienen/publié en 1892

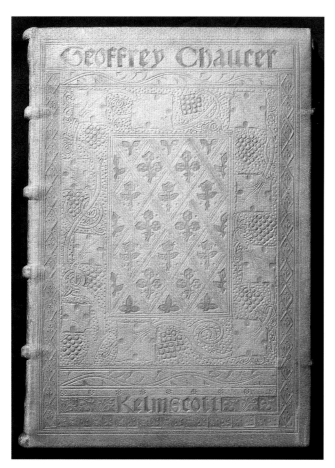

**Kelmscott Press:**

*The Works of Geoffrey Chaucer*, published/erschienen/publié en 1896
Stamped pigskin binding designed by William Morris
Geprägter Schweinsledereinband von William Morris
Reliure en cuir repoussé, conçue par William Morris

The Press Room of the Kelmscott Press
Druckerei der Kelmscott Press
L'imprimerie de la Kelmscott Press

rary poetry, while the remainder included the reprint of a chapter from John Ruskin's *Stones of Venice* entitled *On the Nature of Gothic*.

The most important project undertaken by the Kelmscott Press was the publication of *The Works of Geoffrey Chaucer* (1891–1896), which took five years to complete. Known as the Kelmscott Chaucer, this magnificent volume of 556 pages serves as a vast lexicon of decorative motifs, with 86 illustrations by Burne-Jones and 664 different designs by Morris for initial monograms, borders, title-pages and so forth. Morris commented: "It was only natural that I, a decorator by profession, should attempt to ornament my books suitably; about this matter I will only say that I have always tried to keep in mind the necessity for making my decorations a part of the page type."[40] The Kelmscott Chaucer was heavily over-subscribed, even though it was extremely expensive: the version printed on handmade paper, of which 425 copies were produced, cost £20, while the version printed on finest vellum, of which just 13 copies were printed, cost £120. Issued only a few months before his death, the Kelmscott Chaucer can be seen as a glorious culmination of Morris's highly illustrious career, and as a fitting epitaph to one of the most talented, driven and enlightened design entrepreneurs of the 19th century.

Kapitels aus John Ruskins *Stones of Venice* (*Die Steine von Venedig*) mit dem Titel *On the Nature of Gothic*.

Das wichtigste Projekt der Kelmscott Press war die Publikation von *The Works of Geoffrey Chaucer* (1891–1896), die fünf Jahre in Anspruch nahm. Dieser prächtige Band mit 556 Seiten, als „Kelmscott Chaucer" bekannt, ist ein gewaltiges Lexikon von Dekorationsmotiven mit 86 Illustrationen von Burne-Jones und 664 Entwürfen von Morris für Initialen, Bordüren, Titelseiten usw. Morris erklärte: „Es war nur natürlich, daß ich als professioneller Dekorateur meine Bücher angemessen schmücken mußte; ich möchte dazu nur sagen, daß ich immer versucht habe, meinen Dekor als Bestandteil der gesamten Buchseite zu gestalten."[40] Der „Kelmscott Chaucer" war stark überzeichnet, trotz seines hohen Preises: Die Version auf handgeschöpftem Papier, von der 425 Exemplare gedruckt wurden, kostete 20 Pfund, während die 13 Exemplare auf feinstem Pergament 120 Pfund kosteten. Der „Kelmscott Chaucer", der nur wenige Monate vor seinem Tod erschien, war ein strahlender Höhepunkt in Morris' Laufbahn und ein passendes Epitaph für einen der talentiertesten und aufgeklärtesten Designunternehmer des 19. Jahrhunderts.

Le projet le plus important entrepris par la Kelmscott Press fut la publication des œuvres complètes de Geoffrey Chaucer, *The Works of Geoffrey Chaucer*, qui s'étala sur cinq ans (1891–1896). Connu sous le nom de « Kelmscott Chaucer », ce magnifique ouvrage de 556 pages consiste en un grand dictionnaire de motifs décoratifs, comptant 86 illustrations de Burne-Jones et 664 dessins différents de Morris pour des monogrammes d'initiales, des bordures, des pages de titre, etc. Morris fit le commentaire suivant : « Il était tout naturel que le décorateur de profession que je suis essaie d'ornementer mes livres convenablement ; à ce propos, je dirai simplement que je me suis toujours efforcé d'intégrer la décoration la page imprimée. »[40] Les ventes du *Kelmscott Chaucer* par souscription dépassèrent toute espérance, malgré son prix très élevé : l'édition imprimée sur papier fait main, qui fut tirée à 425 exemplaires, coûtait 20 livres, tandis que la version sur vélin fin, dont on ne tira que 13 exemplaires, coûtait 120 livres. Publié quelques mois à peine avant la mort de Morris, le *Kelmscott Chaucer* peut être considéré comme l'apogée de la carrière prestigieuse de Morris, et comme le meilleur éloge posthume de celui qui fut le décorateur le plus talentueux, le plus inspiré et le plus entreprenant du XIXe siècle.

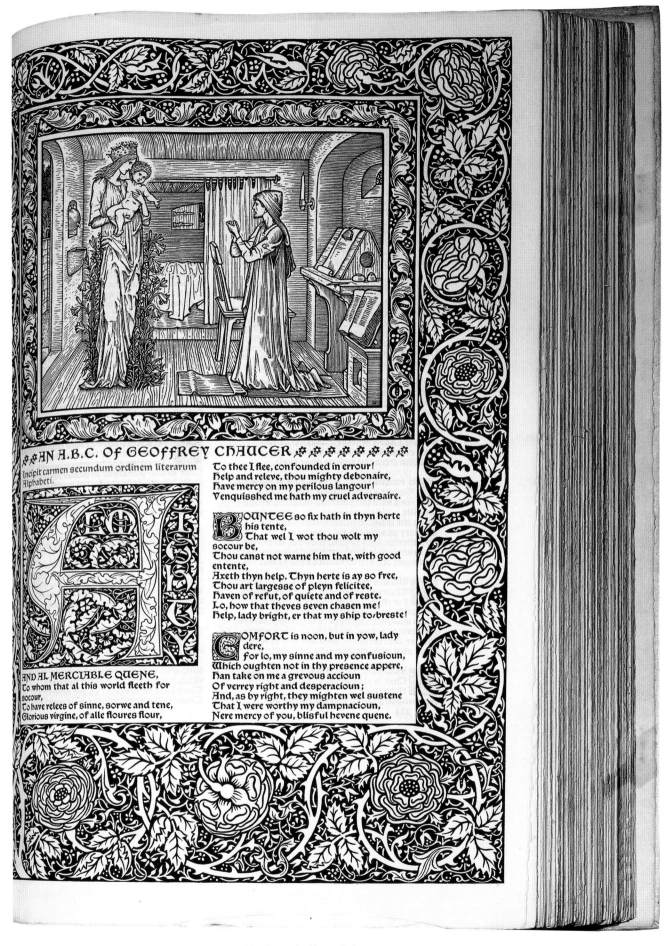

**Kelmscott Press:** The Works of Geoffrey Chaucer, published/erschienen/publié en 1896

Illustrated page

Illustrierte Seite

Page illustrée

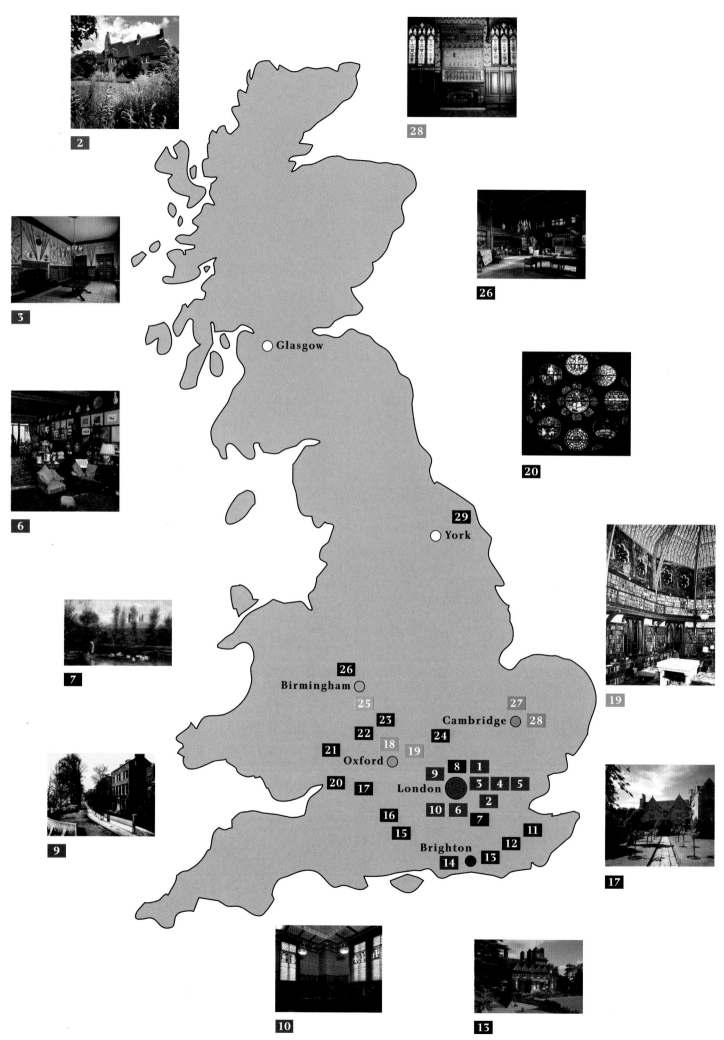

**2**

**28**

**26**

**3**

**20**

○ Glasgow

**6**

**29**

○ York

**7**

**19**

**26**
Birmingham ○

**25**

**23**

**27**
Cambridge ○ **28**

**22**

**24**

**21**

**18**

**19**

Oxford ○

**20**

**17**

**9** **8** **1**

London ●

**3** **4** **5**

**2**

**10** **6**

**7**

**16**

**11**

**9**

**15**

**12**

Brighton

**13**

**14** **13** ●

**17**

**10**

**13**

WILLIAM MORRIS − PLACES OF INTEREST

# WILLIAM MORRIS – PLACES OF INTEREST

**1** William Morris Gallery
(Morris's boyhood home, now a museum
with a permanent collection)
Water House, Lloyd Park
Forest Road
London E17 4PP
Tues–Sat 10.00–1.00 and 2.00 to 5.00, 1st
Sunday each month 10.00–12.00

**2** Red House (Morris's home 1859–1865)
Red House Lane
Bexleyheath, Kent DA6 8JF
Open only by prior arrangement
Feb-Dec 1st Sat and Sun each month.
Please write to (enclose a stamped-
addressed envelope) Mr. and Mrs.
Hollamby.

**3** St. James's Palace (The Armour & Tapestry
Room 1866–1867)
The Mall
London SW1
Not open to the public

**4** Tate Gallery (Pre-Raphaelite art)
Millbank
London SW1P 4RG
Mon – Sat 10.00 –6.00, Sun 2.00 – 6.00

**5** St. Giles Church
(Stained-glass windows by Morris & Co)
Camberwell
London

**6** Linley Sambourne House (Victorian town-
house with Morris wallpapers)
18 Stafford Terrace
Kensington
London W8
Mar to Nov, Wed 10.00 – 4.00,
Sun 2.00 – 5.00

**7** Merton Abbey works
(Morris & Co workshop 1881–1940)
Merton High Street
Merton, Surrey

**8** Christ Church
(Stained-glass windows by Morris & Co.)
Southgate, Middlesex

**9** Kelmscott House
(Morris's home 1878–1896)
William Morris Society
26 Upper Mall
Hammersmith
London W6 9TA
Private house, not open to the public.
Basement and coach house
(headquarters of the William Morris
Society):
Thurs and Sat 2.00–5.00

**10** Victoria and Albert Museum
(The Green Dining Room, Morris wall-
paper designs)
Cromwell Road
South Kensington
London SW7 2RL
Mon–Sat 10.00–5.50, Sun 2.30–5.50

**11** St. Mary the Virgin
(Stained-glass windows by Morris & Co)
Speldhurst near Royal Tunbridge Wells
Kent

**12** All Saints Church
(Stained-glass windows by Morris & Co.)
Langton Green near Speldhurst
Kent

**13** Standen (Victorian house designed in
1891 by P. Webb extensively decorated
with Morris designs)
East Grinstead
West Sussex RH19 4NE
Apr–Oct, Wed–Sun and Bank Holiday
Mons 1.30–5.30

**14** St. Michael & All Angels
(Stained-glass windows by Morris & Co)
Brighton
East Sussex

**15** St. Michael & St. Mary Magdalene
(Stained-glass windows by Morris & Co.)
Easthampstead near Bracknell
Berkshire

**16** St. Michael's Church
(Stained-glass windows by Morris & Co.)
Tilehurst near Reading
Berkshire

**17** Kelmscott Manor (Morris's holiday home
1871–1896) Kelmscott near Lechlade
Oxfordshire
Apr to Sept, Weds 11.00–1.00 and
2.00–5.00,
3rd Sat each month 2.00–5.00

**18** Christ Church Cathedral (Stained-glass
windows by W. Morris and E. Burne-Jones)
Oxford
Mon–Sat 9.00–5.00, Sun 1.00–5.00

**19** Oxford Union Library (Ceiling and mural
decoration by W. Morris and friends, 1857)
Frewin Court, St. Michael's Street
Oxford OX1 3JD

**20** All Saints Church
(Stained-glass windows by Morris & Co.)
Selsley near Stroud
Gloucestershire

**21** Cheltenham Art Gallery and Museum (Per-
manent exhibition of furniture by W. Mor-
ris and other Arts & Crafts designers)
Clarence Street
Cheltenham, Gloucestershire GL 50 3JT
Mon–Sat 10.00–5.30

**22** St. Mary's Church
(Stained-glass windows by Morris & Co.)
Bloxham near Banbury
Oxfordshire

**23** All Saints Church
(Stained-glass windows by Morris & Co)
Middle Cheney near Banbury
Oxfordshire

**24** St. Mary's Church
(Stained-glass windows by Morris & Co.)
King's Walden near Luton
Hertfordshire

**25** Birmingham City Museum and Art Gallery
(Pre-Raphaelite art, Morris & Co works)
Chamberlain Square
Birmingham B3 3DH
Mon–Sat 10.00–5.30, Sun 12.30–5.00

**26** Wightwick Manor
(Victorian house designed in 1887 for T.
Mander extensively decorated with Morris
designs)
Wightwick Bank
Wolverhampton
West Midlands WV6 8EE
Mar–Dec, Thurs and Sat 2.30 to 5.30

**27** Jesus College Chapel
(Stained-glass windows and ceiling pain-
ting by Morris & Co., c. 1866)
Jesus College
Jesus Lane
Cambridge CB5 8BL

**28** Queen's College Hall
(Tiled floor and fireplace by Morris & Co
1843–1864)
Queen's College
Queen's Lane
Cambridge

**29** St. Martin-on-the-hill
(Stained-glass windows by Morris & Co)
Scarborough
Yorkshire

# CHRONOLOGY

1834   William Morris is born on 24 March in
Walthamstow.

1843   Attends Misses Arundel's academy for young gentle-
men.

1845   The Devonshire Great Consolidated Copper Mining
Company (Devon Great Consols) is officially regis-
tered.

1847   William Morris Snr. dies.

1848   Attends Marlborough College.
Pre-Raphaelite Brotherhood founded by William
Holman Hunt, John Everett Millais and Dante
Gabriel Rossetti.

1852   Placed under the tutelage of Rev. Frederick Guy.
Sits matriculation exam for Exeter College, Oxford.
Meets Edward Burne-Jones.

1853   Attends Exeter College, Oxford.

1855   Makes second journey to France, with Edward
Burne-Jones and William Fulford.
Abandons theology for "a life of art".

1856   Enters the architectural office of George Edmund
Street.
First number of the *Oxford and Cambridge Magazine*
is published.
Introduced to Dante Gabriel Rossetti by Edward
Burne-Jones.
Abandons architecture for painting on the recom-
mendation of Dante Gabriel Rossetti.
Shares apartment with Edward Burne-Jones at 17,
Red Lion Square, London.

1857   Paints murals at the Oxford Union Library with,
among others, Dante Gabriel Rossetti and Edward
Burne-Jones.
Meets and falls in love with Jane Burden.

1858   Becomes officially engaged to Jane Burden in the
spring.
Publishes, at his own expense, *The Defence of
Guinevere and Other Poems*.

1859   Marries Jane Burden on 26 April in Oxford.
The Red House designed by Philip Webb.

1860   The Red House is completed and the Morrises move
in.

1861   Jane Alice Morris (Jenny) is born on 18 January.
Founds Morris, Marshall, Faulkner & Co. with six
other partners.

1862   Morris, Marshall, Faulkner & Co. exhibit in the
Medieval Court at the International Exhibition,
South Kensington.
Mary Morris (May) is born on 25 March.

1864   Designs first wallpapers.

1865   Morris family move to 26, Queen Square, London.
George Warington Taylor appointed business man-
ager of Morris, Marshall, Faulkner & Co.
Begins composing *The Earthly Paradise*.

1866   The Firm receives its first major public commissions
for the decoration of the Armoury and Tapestry
Room at St James's Palace and the Green Dining
Room at the South Kensington Museum.

1867   Philip Webb appointed furniture manager of Morris, Marshall, Faulkner & Co.
       *The Death of Jason* is published.

1868   First volume of *The Earthly Paradise* is published.

1869   William and Jane Morris stay at Bad Ems for six weeks.
       Meets the Icelandic translator Eiríkr Magnússon.
       Translation of *The Story of Grettir the Strong* is published.

1870   Executes an illuminated manuscript book entitled *A Book of Verse*.
       Translation of *The Story of the Volsungs and Niblungs* is published.

1871   Signs joint lease on Kelmscott Manor with Dante Gabriel Rossetti.
       Travels to Iceland.

1872   Morris family moves to Horrington House, Turnham Green.
       Begins dyeing experiments.

1873   Travels to Iceland.
       *Love is Enough* is published.

1874   Dante Gabriel Rossetti relinquishes his share of the lease on Kelmscott Manor.
       Morris takes sole control of The Firm and renames it Morris & Co.

1875   Undertakes large-scale dyeing experiments at Hencroft Dye Works, Leek.

1876   Translation of *The Aeneids of Virgil* is published.

1877   Establishes the Society for the Protection of Ancient Buildings (nicknamed "Anti-Scrape").
       Delivers *The Lesser Arts* lecture to the Trades Guild in Oxford.
       Opens a Morris & Co. showroom in Oxford Street to retail the Firm's designs.
       Establishes workshop to produce woven textiles.

1878   Morris family moves to The Retreat, Hammersmith, and renames property Kelmscott House.

1879   Becomes treasurer of the National Liberal League.
       Sets up carpet factory in the stables and coach-house of Kelmscott House.

1881   Signs lease for works at Merton Abbey.

1882   Dante Gabriel Rossetti dies.
       Reads Karl Marx's *Das Kapital*.

1883   Joins the Democratic Federation.
       Morris & Co. exhibits at the Foreign Fair at Franklin Hall in Boston.
       Delivers *Art under Plutocracy* lecture at University College, Oxford.

1884   Delivers *Useful Work and Useless Toil* lecture at the Hampstead Liberal Club.
       Establishes Hammersmith branch of the Democratic Federation.
       Resigns from the Democratic Federation and forms the Socialist League.

1885   Arrested for allegedly hitting a policeman.
       *Chants for Socialists* published by the Socialist League.

1886   Serialization of *A Dream of John Ball* commences in *Commonweal*.

1888   *The House of the Wolfings* is published.
       The first Arts & Crafts Society Exhibition is held.

1889   Serialization of *News from Nowhere* commences in *Commonweal*.
       *The Roots of the Mountains* published.

1890   Hammersmith branch of the Socialist League leaves the organization and is renamed the Hammersmith Socialist League.
       Robert and Frank Smith become partners in Morris & Co.
       The Firm acquires furniture factory in Pimlico.

1891   Establishes the Kelmscott Press at 16, Upper Mall, Hammersmith.
       Kelmscott Press publishes first book, *The Story of the Glittering Plain*.

1893   Drafts *The Manifesto of The English Socialists* with H. M. Hyndman and George Bernard Shaw.

1896   Travels to Norway.
       Kelmscott Press publishes *The Works of Geoffrey Chaucer*.
       John Henry Dearle becomes artistic director of Morris & Co.
       William Morris dies at Kelmscott House on 3rd October.

1898   Edward Burne-Jones dies.

1914   Jane Morris dies.

1934   Memorial Hall designed by Ernest Gimson is opened at Kelmscott.

1935   Jenny Morris dies.

1938   May Morris dies.

# CHRONOLOGIE

1834   William Morris wird am 24. März in Walthamstow geboren.

1843   Besuch der Akademie für junge Gentlemen der Damen Arundel.

1845   Die Devonshire Great Consolidated Copper Mining Company (Devon Great Consols) wird offiziell registriert.

1847   William Morris sen. stirbt.

1848   Besuch des Marlborough College. Die Präraffaelitische Bruderschaft wird von William Holman Hunt, John Everett Millais und Dante Gabriel Rossetti gegründet.

1852   Morris wird unter die Vormundschaft von Rev. Federick Guy gestellt. Immatrikulationsexamen für das Exeter College, Oxford. Er lernt Edward Burne-Jones kennen.

1853   Besuch des Exeter College, Oxford.

1855   Zweite Reise nach Frankreich mit Edward Burne-Jones und William Fulford. Morris gibt die Theologie zugunsten eines „Lebens für die Kunst" auf.

1856   Eintritt in das Architekturbüro von George Edmund Street. Die erste Ausgabe des *Oxford and Cambridge Magazine* erscheint. Morris lernt durch Edward Burne-Jones Dante Gabriel Rossetti kennen. Er gibt auf den Rat von Rossetti die Architektur zugunsten der Malerei auf. Gemeinsame Wohnung mit Edward Burne-Jones am Red Lion Square 17, London.

1857   Morris malt Fresken in der Oxford Union Library mit u. a. Dante Gabriel Rossetti und Edward Burne-Jones. Er begegnet Jane Burden und verliebt sich in sie.

1858   Im Frühjahr offizielle Verlobung mit Jane Burden. Morris publiziert auf eigene Kosten *The Defence of Guinevere and Other Poems.* (*Die Verteidigung der Guenevere und andere Gedichte*)

1859   Hochzeit mit Jane Burden am 26. April in Oxford. Das Red House wird von Philip Webb entworfen.

1860   Fertigstellung des Red House und Einzug des Ehepaar Morris.

1861   Jane Alice Morris (Jenny) wird am 18. Januar geboren. Gründung von Morris, Marshall, Faulkner & Co. mit sechs anderen Partnern.

1862   Morris, Marshall, Faulkner & Co. stellt im Mittelalter-Saal der Weltausstellung in South Kensington aus. Mary Morris (May) wird am 25. März geboren.

1864   Morris entwirft die ersten Tapeten.

1865   Die Familie zieht zum Queen Square 26, London. George Warington Taylor wird Geschäftsführer von Morris, Marshall, Faulkner & Co. Beginn der Arbeit an *The Earthly Paradise* (*Das irdische Paradies*).

1866 Die Firma erhält ihre ersten größeren öffentlichen Aufträge für die Dekoration des Armoury und Tapestry Room im St. James's Palace und des Grünen Speisezimmers im South Kensington Museum.

1867 Philip Webb wird verantwortlich für die Möbelproduktion von Morris, Marshall, Faulkner & Co. *The Death of Jason* wird publiziert.

1868 Der erste Band von *The Earthly Paradise* erscheint.

1869 Sechswöchiger Kuraufenthalt von William und Jane Morris in Bad Ems.
Morris begegnet dem isländischen Übersetzer Eiríkr Magnússon.
Die Übersetzung von *The Story of Grettir the Strong* wird veröffentlicht.

1870 Herausgabe einer illustrierten Manuskriptausgabe von *A Book of Verse*.
Die Übersetzung von *The Story of the Volsungs and Niblungs* erscheint.

1871 Morris unterzeichnet mit Dante Gabriel Rossetti einen gemeinsamen Mietvertrag für Kelmscott Manor.
Reise nach Island.

1872 Die Familie Morris zieht in das Horrington House, Turnham Green.
Beginn der Färbexperimente.

1873 Reise nach Island.
Veröffentlichung von *Love is Enough*.

1874 Dante Gabriel Rossetti gibt seinen Anteil am Mietvertrag für Kelmscott Manor auf.
Morris wird Alleininhaber der Firma und nennt sie Morris & Co.

1875 Er unternimmt groß angelegte Färbeversuche in den Hencroft Dye Works, Leek.

1876 Die Übersetzung von *The Aeneids of Virgil* (Aeneis des Vergil) erscheint.

1877 Gründung der Society for the Protection of Ancient Buildings.
Vortrag *The Lesser Arts* vor der Trades Guild, Oxford.
Eröffnung eines Ausstellungs- und Verkaufsraums von Morris & Co. in der Oxford Street.
Die Werkstatt für Webtextilien wird eingerichtet.

1878 Die Familie Morris zieht in das Haus The Retreat, Hammersmith, und nennt es Kelmscott House.

1879 Morris wird Schatzmeister der National Liberal League.
Er richtet eine Teppichfabrik in den Ställen und der Remise von Kelmscott House ein.

1881 Unterzeichnung eines Mietvertrags für Werkstätten in Merton Abbey.

1882 Dante Gabriel Rossetti stirbt.
Morris liest *Das Kapital* von Karl Marx.

1883 Er schließt sich der Democratic Federation an.
Morris & Co. stellt auf der Foreign Fair in Boston aus.
Vortrag *Art under Plutocracy* am University College, Oxford.

1884 Vortrag *Useful Work and Useless Toil* im Hampstead Liberal Club.
Gründung der Zweigstelle Hammersmith der Democratic Federation.
Morris tritt aus der Democratic Federation aus und gründet die Socialist League.

1885 Verhaftung wegen angeblicher Verletzung eines Polizisten.
*Chants for Socialists* wird von der Socialist League veröffentlicht.

1886 *A Dream of John Ball* (Ein Traum von John Ball) erscheint in Fortsetzungen in *Commonweal*.

1888 *The House of Wolfings* wird veröffentlicht.
Erste Ausstellung der Arts & Crafts Society.

1889 *News from Nowhere* (Kunde von Nirgendwo) erscheint in Fortsetzungen in *Commonweal*.
*The Roots of the Mountains* wird veröffentlicht.

1890 Die Filiale Hammersmith der Socialist League verläßt die Organisation und nennt sich nun Hammersmith Socialist League.
Robert und Frank Smith werden Partner bei Morris & Co.
Die Firma erwirbt eine Möbelfabrik in Pimlico.

1891 Morris gründet die Kelmscott Press an der Upper Mall 16, Hammersmith.
Kelmscott Press publiziert das erste Buch, *The Story of the Glittering Plain*.

1893 Entwirft *The Manifesto of The English Socialists* mit H. M. Hyndman und George Bernard Shaw.

1896 Reise nach Norwegen.
Die Kelmscott Press veröffentlicht *The Works of Geoffrey Chaucer*.
John Henry Dearle wird künstlerischer Direktor von Morris & Co.
William Morris stirbt am 3. Oktober im Kelmscott House.

1898 Edward Burne-Jones stirbt.

1914 Jane Morris stirbt.

1934 Die von Ernest Gimson entworfene Memorial Hall wird in Kelmscott eröffnet.

1935 Jenny Morris stirbt.

1938 May Morris stirbt.

# CHRONOLOGIE

**1834** Naissance de William Morris le 24 mars à Walthamstow.

**1843** Fréquente la Misses Arundel's Academy, institution pour jeunes garçons.

**1845** Enregistrement officiel de la Devonshire Great Consolidated Copper Mining Company (Devon Great Consols).

**1847** Mort du père de William Morris.

**1848** Élève au Marlborough College.
Fondation de la Fraternité Préraphaélite par William Holman Hunt, John Everett Millais et Dante Gabriel Rossetti.

**1852** Confié à la tutelle du Révérend Frederick Guy. Passe l'examen d'entrée à l'Exeter College d'Oxford. Rencontre Edward Burne-Jones.

**1853** Élève à l'Exeter College, à Oxford.

**1855** Deuxième voyage en France, en compagnie d'Edward Burne-Jones et William Fulford. Abandonne la théologie pour « une vie consacrée à l'art ».

**1856** Apprentissage dans l'étude d'architecte de George Edmund Street.
Publication du premier numéro du *Oxford and Cambridge Magazine.*
Edward Burne-Jones le présente à Dante Gabriel Rossetti.
Sur les conseils de Rossetti, abandonne l'architecture pour la peinture.
Partage avec Edward Burne-Jones un logement au 17, Red Lion Square, à Londres.

**1857** Réalisation des peintures murales de la Oxford Union Library avec, entre autres, Dante Gabriel Rossetti et Edward Burne-Jones.
Rencontre Jane Burden et en tombe amoureux.

**1858** Au printemps, fiançailles officielles avec Jane Burden.
Publication à compte d'auteur de *The Defence of Guinevere and Other Poems* (*La Défense de Guenièvre et autres poèmes*).

**1859** Mariage avec Jane Burden le 26 avril à Oxford.
Philip Webb conçoit la Red House.

**1860** Achèvement de la Red House et emménagement des Morris.

**1861** Naissance de Jane Alice Morris (Jenny) le 18 janvier.
Avec six autres partenaires, fonde la Morris, Marshall, Faulkner & Co.

**1862** Morris, Marshall, Faulkner & Co. expose à la Medieval Court lors de l'Exposition internationale, à South Kensington.

**1864** Création de motifs pour papiers peints muraux.

**1865** La famille Morris s'installe au 26, Queen Square, à Londres.
George Warington Taylor est nommé directeur financier de la Compagnie.
Entreprend la rédaction du *The Earthly Paradise* (*Le Paradis terrestre*).

**1866** La Firme reçoit ses premières commandes publiques

importantes pour la décoration intérieure de l'Armoury and Tapestry Room de St James's Palace et de la Green Dining Room du South Kensington Museum.

1867 Philip Webb est nommé directeur de l'ameublement de la Compagnie.
Parution de *The Death of Jason*.

1868 Publication du premier tome de *The Earthly Paradise*.

1869 Séjour de William et de Jane Morris à Bad Ems.
Rencontre avec le traducteur islandais Eiríkr Magnússon.
Parution de la traduction *The Story of Grettir the Strong*.

1870 Exécute un ouvrage manuscrit enluminé, *A Book of Verse*.
Publication de la traduction *The Story of the Volsungs and Niblungs*.

1871 Signe un contrat de colocation de Kelmscott Manor avec Dante Gabriel Rossetti.
Voyage en Islande.

1872 La famille Morris s'installe à Horrington House, Turnham Green.
Premières expériences de teinture.

1874 Rossetti renonce à sa part de bail à Kelmscott Manor.
Morris prend seul le contrôle de la Firme qu'il re-baptise Morris & Co.

1875 Expériences intensives de teinture aux ateliers Hencroft Dye Works, à Leek.

1876 Publication de la traduction *The Aeneids of Virgil* (*L'Énéide de Virgile*).

1877 Fondation de la Society for the Protection of Ancient Buildings.
Conférence *The Lesser Arts* devant la Guilde des Commerçants à Oxford.
Ouverture du magasin d'exposition de Morris & Co. dans l'Oxford Street, afin de vendre au détail les créations de la Firme.
Création des ateliers de tissage.

1878 La famille Morris s'installe à La Retraite, à Hammersmith, et rebaptise la maison Kelmscott House.

1879 Trésorier de la National Liberal League.
Installation de la manufacture de tapis dans les étables et le hangar à voitures de Kelmscott House.

1881 Signature du bail pour l'installation d'une entreprise à Merton Abbey.

1882 Mort de Dante Gabriel Rossetti.
Lecture du *Capital* de Marx.

1883 Adhésion à la Democratic Federation.
Morris & Co. expose à la Foreign Fair, au Franklin Hall, à Boston.
Conférence *Art under Plutocracy* à l'University College d'Oxford.

1884 Conférence *Useful Work and Useless Toil* au Liberal Club de Hampstead.
Création de la section Hammersmith de la Democratic Federation.

Demissionne de la Democratic Federation et forme la Socialist League.

1885 Arrêté pour avoir prétendument frappé un policier.
*Chants for Socialists* publiés par la Socialist League.

1886 *A Dream of John Ball* (*Un rêve de Jahn Ball*) commence à paraître en feuilletons dans *Commonweal*.

1888 Publication de *The House of the Wolfings*.
Première exposition Arts & Crafts.

1889 Parution en feuilletons dans *Commonweal* de *News from Nowhere* (*Nouvelles de nulle part*).
Publication de *The Roots of the Mountains*.

1890 La section Hammersmith de la Socialist League rompt avec l'organisation centrale et devient la Hammersmith Socialist League.
Robert et Frank Smith deviennent partenaires de Morris & Co.
La Firme se dote d'une usine de meubles à Pimlico.

1891 Établissement de la Kelmscott Press au 16, Upper Mall, à Hammersmith.
Publication du premier livre de la Kelmscott Press, *The Story of the Glittering Plain*.

1893 Rédaction de *The Manifesto of The English Socialists* en collaboration avec H. M. Hyndman et George Bernard Shaw.

1896 Voyage en Norvège.
Kelmscott Press publie *The Works of Geoffrey Chaucer*.
John Henry Dearle devient directeur artistique de Morris & Co.
Mort de William Morris à Kelmscott House, le 3 octobre.

1898 Mort d'Edward Burne-Jones.

1914 Mort de Jane Morris.

1934 Inauguration à Kelmscott du Memorial Hall conçu par Ernest Gimson.

1935 Mort de Jenny Morris.

1938 Mort de May Morris.

# Notes
## Anmerkungen

1   William Morris: *How I became a Socialist*, in: *Justice*, 1894, in: Fiona MacCarthy: *William Morris, A Life for our Time*, p. 263.

2   William Gaunt: *The Pre-Raphaelite Dream*, p. 165.

3   MacCarthy, p. 3.

4   Charles Harvey & Jon Press: *William Morris, Design and Enterprise in Victorian Britain*, p. 10.

5   David Rodgers: *William Morris at Home*, p. 23.

6   MacCarthy, p. 34.

7   Mackail, vol. 1, p. 29.

8   Mackail, vol. 1, p. 35.

9   Edward Burne-Jones, letter to Cormell Price, May 1853, in: MacCarthy, p. 67.

10  Ibid., p. 74.

11  Edward Burne-Jones, in: MacCarthy, p. 95.

12  Thompson, p. 44.

13  Ibid., p. 139.

14  Aymer Vallance: *The Life and Works of William Morris*, p. 438.

15  Ernest Rhys, introduction to the 1911 edition of *The Life and Death of Jason* published by J. M. Dent, p. ix.

16  Mackail, vol. 1, p. 318.

17  MacCarthy, p. 210.

18  William Morris, "Beauty of Life" lecture, in: Rodgers, p. 109.

19  Morton, p. 63.

20  Mackail, vol. 2, p. 147.

21  David Benedictus: "The Man who Banned Mumbo Jumbo", *Evening Standard*, 27 April 1979.

22  Stephen Coote: *William Morris, His Life and Work*, p. 33.

23  MacCarthy, p. 131.

24  Mackail, vol. 1, p. 113.

25  Georgiana Burne-Jones: *Memorials of Edward Burne-Jones*, vol. 1, p. 208.

26  Linda Parry: *William Morris Textiles*, p. 13.

27  Vallance, p. 44.

28  MacCarthy, p. 178.

29  Linda Parry (ed.): *William Morris*, ex. cat., p. 107.

30  Ibid., p. 158.

31  Harvey & Press, p. 43.

32  Annette Carruthers & Mary Greensted: *Good Citizen's Furniture, The Arts & Crafts Collection at Cheltenham*, p. 9.

33  E. P. Thompson: *The Work of William Morris*, pp. 83, 85.

34  Carruthers & Greensted, p. 9.

35  *The Clerical Journal*, vol. X, 8 May 1862, p. 241.

36  William Morris, "Of Dyeing as an Art", lecture, 1889.

37  Mackail, vol. 1, p. 363.

38  Parry (ed.), ex. cat., p. 294.

39  MacCarthy, p. 403.

40  Fridolf Johnson: *William Morris, Ornamentation and Illustrations from the Kelmscott Chaucer*, Introduction, p. xi.

# Bibliography
## Bibliographie

Barringer, Tim: *Die Präraffaeliten. Wie sie malten, wie sie dachten, wie sie lebten*, Köln, 1998.

Bassus, Jean-Marie: *William Morris poète*, Atelier reproduction des thèses Universitè de Lille III, 1980.

Breuer, Gerda: *Ästhetik der schönen Genügsamkeit oder Arts & Crafts als Lebensform*, Braunschweig/Wiesbaden 1998.

Carruthers, Annette & Mary Greensted: *Good Citizen's Furniture, The Arts & Crafts Collection at Cheltenham*, Cheltenham 1994.

Cooper, Jeremy: *Victorian & Edwardian Furniture & Interiors*, London 1987.

Coote, Stephen: *William Morris, His Life and Work*, Godalming 1995.

Davey, Peter: *Arts & Crafts Architecture*, London 1985 (*Arts-and-Crafts-Architektur*, Stuttgart 1996).

Gaunt, William: *The Pre-Raphaelite Dream*, London 1943.

Gillow, Norah: *William Morris*, Paris, 1988.

Giroud, Mark: *The Victorian Country House*, London & New Haven 1979.

Goldzamt, Edmund: *William Morris und die sozialen Ursprünge der modernen Architektur*, Dresden 1976.

Greensted, Mary: *The Arts & Crafts Movement in the Cotswolds*, Stroud 1993.

Haslam, Malcolm: *Arts & Crafts Carpets*, London 1991.

Harvey, Charles & Jon Press: *William Morris, Design and Enterprise in Victorian Britain*, Manchester 1991.

Hobsbawm, E. J.: *The Age of Capital, 1848–1875*, London 1975.

Jill Duchess of Hamilton, Penny Hart & John Simmons: *The Gardens of William Morris*, London 1998.

Kelvin, Norman: *The Collected Letters of William Morris*, London 1896.

Kirsch, Hans-Christian: *William Morris, ein Mann gegen die Zeit*, Munich 1996.

Louis, Paul: *Cent cinquante ans de pensée socialiste*, Paris 1953.

MacCarthy, Fiona: *William Morris, A Life for Our Time*, London 1994.

Mackail, J. W.: *The Life of William Morris*, London 1899.

Morris, May (ed.): *The Collected Works of William Morris*, London 1910–1915.

Morton, A. L. (ed.): *Political Writings of William Morris*, London 1973.

Myers, Richard & Hilary: *William Morris Tiles, The Tile Designs of Morris & His Fellow-Workers*, Somerset 1996.

Naylor, Gillian: *The Arts and Crafts Movement*, London 1971.

Parry, Linda: *William Morris Textiles*, London 1983.

Parry, Linda (ed.): *William Morris, Art & Kelmscott*, Woodbridge 1996.

Pevsner, Nikolaus: *Pioneers of Modern Design: From William Morris to Gropius*, London 1960.

Poulson, Christine: *William Morris*, London 1989.

Rodgers, David: *William Morris at Home*, London 1996.

Sambrook, James (ed.): *Pre-Raphaelitism, A Collection of Critical Essays*, Chicago 1974.

Shannon, Richard: *The Crisis of Imperialism, 1865–1915*, London 1974.

Stansky, Peter: *Redesigning the World: William Morris, the 1880s, and the Arts and Crafts*, Princeton 1985.

Steegman, John: *Victorian Taste*, Cambridge 1950.

Thompson, E. P.: *The Work of William Morris*, London 1977.

Thompson, E. P.: *William Morris, Romantic to Revolutionary*, London 1955 (rev. ed.).

Vallance, Aymer: *The Life and Works of William Morris*, London 1897.

Watkinson, Ray: *William Morris as Designer*, London 1990.

EXHIBITION CATALOGUES

*Gothic Revival, Architecture et arts décoratifs de l'Angleterre victorienne*, Éditions de la Réunion des Musées Nationaux, Paris 1999.

*William Morris*, edited by Linda Parry, Victoria & Albert Museum, London 1996.

# ACKNOWLEDGEMENTS
# DANKSAGUNG / REMERCIEMENTS

The authors would like to express their particular thanks to all those involved in this project at Taschen, Anthony Oliver for the new photography generated for the work and the following individuals and institutions, all of whom have contributed to the successful realization of this book:

Die Autoren möchten allen jenen ihren Dank aussprechen, die bei Taschen an diesem Projekt beteiligt waren, Anthony Oliver für die speziell angefertigten Neuaufnahmen und den folgenden Personen und Institutionen, die alle zur Realisierung des Buches beigetragen haben:

Les auteurs tiennent à exprimer leurs plus vifs remerciements à tous ceux qui ont contribué à la réalisation de cet ouvrage : les éditions Taschen pour leur engagement, Anthony Oliver pour le travail photographique spécialement réalisé à notre intention ainsi que les personnes et les institutions dont les noms suivent :

Ashmolean Museum, Oxford – Ann Steinburg
Mrs I. J. Birney, London
Bodleian Library, Oxford – Trisha Buckingham
British Museum, London
Castle Museum, Norwich
Christie's Images, London – Camilla Young
Fine Art Society, London – Annamarie Stapleton
Hammersmith & Fulham Archives & Local History Centre, London – Anne Wheeldon
Haslam & Whiteway, London – Michael Whiteway & Helen Dunstan
Edward & Doris Hollamby, Bexleyheath
Holy Trinity Church, London – Bishop Michael Marshall
National Portrait Gallery, London
National Trust Photographic Library, London – Edward Gibbons
Oxford Union Library, Oxford – David Johnson
Queen's College Hall, Cambridge – Jim Coulter
Royal Collection Enterprises Ltd., Windsor – Sarah Blake
Arthur Sanderson & Sons Ltd. Archive, Uxbridge – Frederika Launert
Society of Antiquaries, Kelmscott – Mrs Helen Webb
Sotheby's, London – Philippe Garner
Tate Gallery, London – Carlotta Gelmetti
V&A Enterprises, Victoria & Albert Museum, London – Nick Wise
William Morris Gallery, London – Norah Gillow & Peter Cormack
William Morris Society, London – David Rodgers

We would also like to thank our families for their encouragement and our daughters, Emelia and Clementine, for their good humour. Lastly, we would like to dedicate this book to the residents of Shilton in recognition of their efforts to preserve the nature and community of this rural Cotswold village.

Außerdem möchten wir unseren Familien für ihre Unterstützung und unseren Töchtern Emelia und Clementine für ihren Langmut danken. Wir widmen dieses Buch den Bewohnern von Shilton in Anerkennung ihrer Bemühungen, Natur und Gemeinschaft dieses Dorfes in den Cotswolds zu erhalten.

Nous aimerions également remercier nos familles pour les encouragements qu'elles nous ont prodigués et nos filles, Emelia et Clementine, pour leur bonne humeur. En dernier lieu, nous voudrions dédier ce livre aux habitants de Shilton en reconnaissance de leurs efforts pour préserver le site et la communauté de leur village rural des Cotswold.

# CREDITS
## BILDNACHWEIS / CRÉDITS

l. = left / links / à gauche

r. = right / rechts / à droite

t. = top / oben / ci-dessus

c. = centre / Mitte

b. = bottom / unten / ci-dessous

Ashmolean Museum, Oxford: 94

Birmingham Museum and Art Gallery, Birmingham: 148–149

Bodleian Library, Oxford: 156 l., 156 r., 159

British Museum, London: 30, 32 b.

Castle Museum, Norwich: 147 t.

Christie's Images, London: 27 b., 28 t., 57, 91 t., 127, 158 (Private Collection)

Fine Art Society, London: 31 b., 100 b., 126 l., 144, 155 b.

Hammersmith & Fulham Archives & Local History Centre, London: 17, 28 b., 32 t., 37, 39, 41 t., 41 c., 41 b., 47 t., 53, 66, 74, 75 t., 75 b., 137 b., 160, 162

Haslam & Whiteway, London: 2, 90, 98 t. r., 98 b. l., 98 b. r., 99, 103 t. l., 103 b. l., 103 b. r., 104, 105 t. l., 105 t. r., 105 b. l., 105 b. r., 107, 115, 120 t. r., 120 b. l., 121 b., 128 l., 132 t. l., 132 t. r., 133 b., 134 t., 134 b., 135, 137 t., 138 t., 138 b., 139 t., 139 b., 141, 142, 143

J. & B. Bolour, London: 155 t.

National Portrait Gallery, London: 6

National Trust Photographic Library, London: 76, 77, 78 t., 78 b., 79, 80, 81 t., 81 b., 82, 83 t., 83 b., 92, 109 b.

Anthony Oliver, London: 25, 35, 42 t., 47 b., 55, 58, 59 t., 60–61, 62 t. l., 62 t. r., 62 b. l., 62 b. r., 63, 64, 65 t. l., 65 t. r., 65 b. l., 65 b. r., 67, 68, 69 t., 69 b., 70, 71, 72 l., 72 r., 73 t., 73 b., 84, 85 t. l., 85 t. r., 85 b. l., 85 b. r., 124, 125 r.

Royal Collection Enterprises Ltd., Windsor: 86 (detail), 87

Arthur Sanderson & Sons Ltd. Archive, Uxbridge: 42 b., 110, 111, 112, 113, 114, 117 t., 117 b., 118 t. r., 118 b. l., 118 b. r., 120 t. l., 120 b. r., 121 t., 122 t. l., 122 t. r., 122 b. l., 122 b. r., 123

St Bride Printing Library: 164 l.

Tate Gallery, London: 23, 33

V&A Enterprises, Victoria & Albert Museum, London: 27 t. l., 27 t. r., 43 t., 59 b., 88, 89 t., 89 b., 91 b. l., 91 b. r., 95 t., 95 b., 96, 97, 101 t., 101 b., 102, 106, 109 t., 109 c., 116, 118 t. l., 126 r., 128 r., 129, 131, 133 t., 136, 146, 147 b., 150, 151, 153, 157, 163 t., 163 b., Endpaper / Vorsatzpapier / Pages de garde

William Morris Gallery, London: 18, 48 t., 48 b., 49, 93, 103 t. r., 119, 125 l., 130, 145, 152

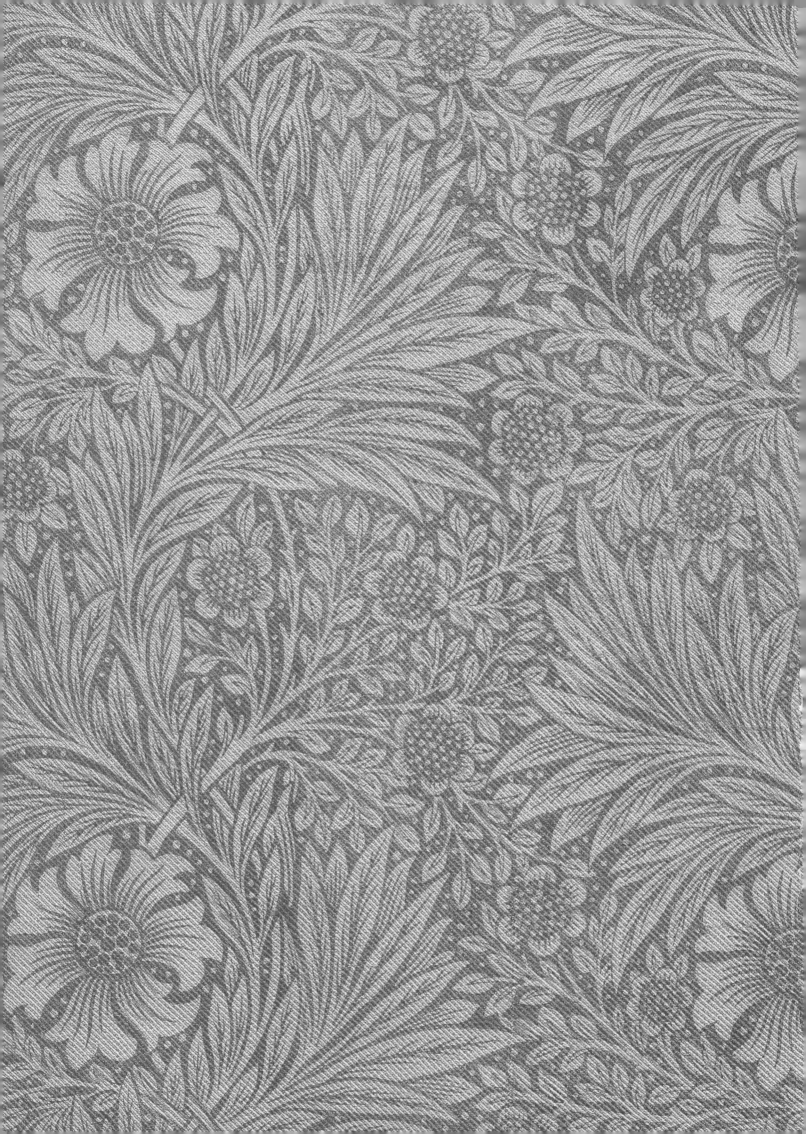